Candice Breitz

EXPOSICIÓN MÚLTIPLE/MULTIPLE EXPOSURE

MUSAC, Museo de Arte Contemporáneo de Castilla y León

Candice Breitz

EXPOSICIÓN MÚLTIPLE / MULTIPLE EXPOSURE

Este libro se publica con motivo de la exposición *Candice Breitz: Exposición Múltiple* organizada por MUSAC, Museo de Arte Contemporáneo de Castilla y León, León, España. 20 de enero-2 de mayo, 2007 *This book is published in conjunction with the exhibition Candice Breitz: Multiple Exposure organized by MUSAC, Museo de Arte Contemporáneo de Castilla y León, León, Spain. January 20-May 2, 2007*

Todas las imágenes/*All images*
Courtesy Francesca Kaufmann, Milan, Italy &
Jay Jopling/White Cube, London, UK

Pedimos disculpas si, por razones ajenas a nuestra voluntad, no han sido citadas algunas de las fuentes fotográficas.
We apologize if, due to reasons wholly beyond our control, some of the photo sources have not been listed.

Cubierta/*Cover*
Stills from *Karaoke,* 2000

ISBN (ACTAR): 978-84-96540-60-6
(TRADE EDITION)

ISBN (MUSAC): 978-84-935356-1-2
(MUSEUM EDITION, available only in museum)

DL B-4006-2007

Impreso en España/*Printed in Spain*

ACTAR
Roca i Batlle 2-4
E-08023 Barcelona
Tel. +34 93 418 7759
Fax +34 93 418 6707
info@actar.com

US Office
158 Lafayette Street, 5th Floor
New York, NY 10013
Tel. +1 212 966 2207
Fax. +1 212 966 2214
michael@actar.com
www.actar.es

MUSAC, Museo de Arte Contemporáneo de Castilla y León
Avenida de los Reyes Leoneses 24
E-24008 León
Tel. +34 98 709 0000
Fax. +34 98 709 1111
musac@musac.org.es
www.musac.org.es

Distribución/*Distribution*
Actar D
Roca i Batlle 2-4
08023 Barcelona
Tel. +34 93 417 4993
Fax +34 93 418 6707
office@actar-d.com
www.actar-d.com

PUBLICACIÓN/PUBLICATION

Editor/*Editor*
Octavio Zaya

Gestión de Proyecto/*Project Management*
Marta Gerveno

Diseño/*Design*
Ralf Henning

Coordinación Gráfica/*Graphic Coordination*
Manuel Cuyàs

Ensayos/*Essays*
Jessica Morgan
Octavio Zaya

Traducción/*Translation*
Dena Ellen Cowan
Carlos Mayor
Josephine Watson

Corrección de textos/*Copyediting*
Craig Burnett
Charles Gute

Impresión/*Printing*
Ingoprint SA

Candice Breitz
EXPOSICIÓN MÚLTIPLE/MULTIPLE EXPOSURE

EXPOSICIÓN/EXHIBITION

Comisario/*Curator*
Octavio Zaya

Coordinación General/*General Coordination*
Alex Fahl
Marta Gerveno

Registro/*Registrar*
Koré Escobar

Montaje/*Installation*
Exmoarte

Instalación Audiovisual/*AV Installation*
Cine Plus Media Project GmbH

Transporte/*Shipping*
Kraft Els, AG
Kroll Art & Projects GmbH

Seguros/*Insurance*
STAI

Con la colaboración de/*With the support of*

AGRADECIMIENTOS/ACKNOWLEDGEMENTS

Candice Breitz y Octavio Zaya quieren agradecer la confianza, la ayuda, el apoyo y la dedicación de las personas a continuación, sin las que este libro y la exposición no habrían sido posibles.
Candice Breitz and Octavio Zaya would like to acknowledge the trust, assistance, support and dedication of the following people, without whom this book and exhibition would not have been possible:

Sara Arrhenius

Jack Bakker

Marcella Beccaria

Konrad Bitterli

Roger Björkholmen

Darin Breitz

June & Louis Breitz

Craig Burnett

Alessio delli Castelli

Nicolette Cavaleros

Pierfrancesco Celada

María & Lorena de Corral

Rafael Doctor Roncero

Peter Doroshenko

Alex Fahl

Yoliswa Gärtig

Daniela Gareh

Dariush Ghatan

Benjamin Geiselhart

Candida Gertler

Francesca von Habsburg

Ralf Henning

Sabine Himmelsbach

Antonio Homem

Susannah Hyman

Jay Jopling

Jana Kaffka

Francesca Kaufmann

Sebastian Krügler

Michael Lantz

Lawrence Lessig

Jason Mandella

Rita Marley

Susan May

Bjørn Melhus

Jessica Morgan

Bettina Neuefeind

Ralph Niebuhr

Yoko Ono

Yana Peel

Agustín Pérez Rubio

Julia Pfeiffer

Ramón Prat

Chiara Repetto

Fabian Richter

Philip Roitmann

Shugo Satani

Janne Schäfer

Max Schneider

Colin Smikle

Ileana Sonnabend

Dolors Soriano

Raimar Stange

Martin Sturm

Sammy Szer

John Carstairs Spiers

The Spiers Family

Mark Vanmoerkerke

Alison Ward

Riccardo Zito

El montaje como técnica de fragmentación crítica, la cultura global como fuente de material artístico y el lenguaje como metáfora de comunicación social, son las constantes citadas sobre la obra de Candice Breitz. El cine de Hollywood y la música *pop* son habitados por la artista, que los traduce, penetra en sus significados y finalmente los re-escribe, trazando paisajes alternativos más visibles y legibles si cabe, donde proyectarnos, con los que identificarnos y en el que reconocemos nuestra subjetividad. El resultado permite, por un lado, una instantánea comprensión y accesibilidad a la iconografía, y por otro, un distanciamiento respecto al material original al eliminar la continuidad narrativa y la previsibilidad lineal que solemos asociar a este tipo de imágenes, fragmentando y descomponiendo la relación de esos lenguajes mediáticos con la formación y construcción de nuestras identidades, de nuestras representaciones y de cómo se nos percibe.

La reflexión sobre los efectos reales de la cultura del entretenimiento cargada de proyecciones e identificaciones que son más complejas de lo que aparentan, es precisamente uno de los pilares fundamentales sobre los que se construye la obra de Candice Breitz, y que ahora podemos contemplar en MUSAC, Museo de Arte Contemporáneo de Castilla y León, dentro del programa de exposiciones que la Junta de Castilla y León pone en marcha en 2007.

Comisariada por Octavio Zaya, *Candice Breitz: Exposición Múltiple* nos ofrece una ocasión excepcional para aproximarnos a la obra de la artista, que junto a todo el material adjunto de esta nueva publicación, nos ayudará no sólo a acercarnos a la obra de Breitz, sino a acceder a un espacio crítico sobre el uso de las imágenes y lenguajes como productos de la industria mediática cada vez más dominante así como los métodos e intenciones que se esconden tras ésta.

Silvia Clemente Municio
Consejera de Cultura y Turismo

Montage as a technique of critical fragmentation, global culture as a source of artistic material and language as a metaphor for social communication are the constants mentioned regarding Candice Breitz's work. Hollywood films and pop music are engaged by the artist, who translates them, penetrating their meanings and finally rewriting them, rendering alternative landscapes that are even more visible and more legible, where we can project ourselves, with which we can identify and in which we can recognize our subjectivity. On the one hand, the result instantaneously makes the iconography comprehensible and accessible, and on the other, it enables a distancing with respect to the original material, as the narrative continuity and linear visibility that we usually associate with these types of image is eliminated, thereby fragmenting and decomposing the relationship between those media languages and the formation and construction of our identities, our representations and how we are perceived.

Reflection on the real affects of entertainment culture, imbued with projections and identifications that are more complex than they seem, is precisely one of the basic foundations upon which Candice Breitz builds her work, which we can now contemplate at MUSAC, Museo de Arte Contemporáneo de Castilla y León, within the exhibition programme set in motion by the Junta de Castilla y León in 2007.

Curated by Octavio Zaya, *Candice Breitz: Multiple Exposure* affords us an exceptional opportunity to approach the artist's work, which, along with the material inside this new publication, will help us not only to better understand Breitz's work but also to gain access to a critique of the use of images and languages as products of the increasingly dominant media industry, as well as the methods and intentions that they conceal.

Silvia Clemente Municio
Councillor for Culture and Tourism

Contar con una exposición de Candice Breitz supone para MUSAC la continuación lógica de un proceso abierto que se remonta a los prólogos de nuestra actividad, y mediante el cual es nuestra intención mostrar de forma contundente el trabajo de artistas que están en un momento tan importante como es aquél que corresponde a la fase de consolidación de sus carreras. Y es así como esta muestra conecta directamente con los proyectos realizados previamente con Shirin Neshat, Dora García, Pipilotti Rist, Enrique Marty, Julie Mehretu, Felicidad Moreno o Muntean/Rosemblum en este mismo museo; artistas – curiosamente casi todos ellos mujeres – que están constituyendo los pilares del arte actual en el cual nosotros, como institución, intentamos aplicar el mayor de nuestros compromisos.

Con Breitz se subrayan pues, unas premisas que nos son tan propias y sobre las cuales las capacidades de la artista se despliegan en todo su esplendor a través tanto de la exposición como de la magnífica publicación que ahora reside en sus manos. La expresión de unos potenciales que, sin llegar a ser un volumen subido de tono o un grito a destiempo, materializan en último lugar, de manera equilibrada y firme, la aportación de una artista como Breitz al panorama del arte actual, donde la cultura audiovisual de masas – sin duda el verdadero arte contemporáneo de nuestro tiempo – es deconstruida y reconstrida para la consecución final de un nuevo espacio mucho más pulcro y duro, mucho más emotivo y directo.

Con el uso de lo implícito a tantas voces y tantos rostros pertenecientes al subconsciente visual occidental y su posterior descontextualización, Breitz ofrece nuevos significados – más poéticos si cabe – a los conceptos básicos por los que se rige nuestro *status quo* social. Comunicación en general y lenguaje en particular, configuran los ejes de su reflexión e investigación estética, donde el individuo juega una papel esencial, siempre con su propia voz, con su propia aportación, moviendo un coro social ficticio o ilusorio que no es otra cosa que la sociedad tan extraña y contradictoria en la que vivimos.

Sin la implicación tan directa y pasional que desde el principio de su carrera Octavio Zaya ha tenido con el trabajo de Candice, hubiera sido imposible realizar un trabajo de esta magnitud. Gracias a ambos por haber puesto lo mejor de vosotros mismos para que desde MUSAC podamos seguir teniendo el privilegio de mostrar lo mejor de los mejores artistas que configuran lo contemporáneo absoluto.

Rafael Doctor Roncero
Director MUSAC

Candice Breitz's exhibition at MUSAC is the logical continuation of a process that dates back to the beginning of our activities. It is our intention to compellingly showcase artists who are at a turning point as momentous as the period in which their careers are being established. And this is how this show connects directly to the projects produced previously at this museum, which include exhibitions by Shirin Neshat, Dora García, Pipilotti Rist, Enrique Marty, Julie Mehretu, Felicidad Moreno and Muntean/Rosenblum: these artists – interestingly, almost all of whom are women – are creating contemporary art milestones which we, as an institution, strive to support with our utmost commitment.

Breitz's work highlights certain premises that are dear to us and upon which the artist's vision is revealed in all its splendor, both through the exhibition and through the magnificent publication that you now hold in your hands. The potential expressed here, while not pretentious or inappropriately sensational, ultimately makes concrete Breitz's contribution to the contemporary art arena, where mass media culture – doubtless the true contemporary art of our time – is de-constructed and re-constructed for the final attainment of a new realm that is more clear and well-defined, more moving and direct.

With the use and subsequent de-contextualization of what is implicit to so many voices and so many faces belonging to the Western visual subconscious, Breitz brings new – even poetic – meanings to the basic concepts upon which our social *status quo* rests. Communication in general and language in particular shape the core of her aesthetic reflection and investigation, in which the individual plays an essential role, always with her own voice, her own contribution, moving a fictitious or illusory social chorus that is nothing less than the strange and contradictory society in which we live.

If Octavio Zaya had not been directly and passionately involved with Candice's work since the beginning of her career, it would have been impossible to produce a project of this magnitude. I thank both of you for having offered your very best, so MUSAC can continue to have the privilege of showing the best work by the best artists shaping the cutting edge of art.

Rafael Doctor Roncero
Director MUSAC

Contenidos/Contents

Octavio Zaya

Del Texto a la Acción en la obra de Candice Breitz

Del Texto a la Acción
en la obra de
Candice Breitz

Primera toma

A lo largo de la última década, Candice Breitz ha venido explorando, traduciendo, re-mezclando y editando los códigos e iconos de la cultura mediática contemporánea y el lenguaje de la industria del entretenimiento. Si en los montajes fotográficos con los que se dio a conocer internacionalmente exploraba la inestabilidad de la identidad y la violencia de la representación, en las vídeo-instalaciones que se desarrollaron a partir de aquéllos, y que ahora conforman el centro de su práctica artística, Breitz tiende a desvelar y a interrogar las imágenes fílmicas que toma del cine comercial, la televisión y los vídeos musicales. Deliberada y agresivamente, la artista re-organiza este material fílmico y lo aisla de su narrativa y funciones estéticas características y habituales. La obra que resulta atraviesa un terreno familiar, aunque sorprendente y fragmentario, que prescinde de la gramática y la sintaxis propia del material original. Por un lado, los paisajes mediáticos de Breitz exponen la maquinaria, y desarman los valores, de la industria mediática dominante. Por otro, sus obras reflexionan sobre los efectos reales que la cultura *pop* consigue generar y mantener, proyecciones e identificaciones que son más complejas de lo que aparentan.

Esas obras han establecido a Candice Breitz como una de las figuras artísticas centrales que abordan las inflexibles fisuras entre la cultura y el consumo, la experiencia y el lenguaje. En un sentido, tanto este libro como la exposición que acompaña recogen ejemplos de los múltiples aspectos que abarca la obra de Breitz en lo que se refiere a estos conceptos en el espacio mediático global, y en otro, subraya la importancia fundacional de lo que supone el procedimiento fotográfico de la exposición múltiple en el lenguaje de la práctica artística de Breitz. A partir del corte, la conjunción y el montaje de imágenes existentes y familiares, la artista re-expone el material encontrado abriendo la superficie, las conexiones, junturas y fronteras entre las imágenes/lenguajes para revelar la contrucción de la representación y la ideología de aquéllos. Como en el *karaoke* y el *sampling,* el material original se recicla, re-configura y altera. En el caso de Breitz, para acceder a un espacio crítico sobre el uso de la imágenes/lenguajes como productos de la industria mediática cada vez más dominante y los métodos e intenciones que se esconden tras esta.

Entre el original y la reproducción, lo visible y lo invisible, lo expuesto y lo borrado, la presencia y la ausencia, lo familiar y lo extraño, lo célebre y lo anónimo, Breitz desliza una obra artística que se apoya en complejas instalaciones vídeo-sónicas. De una parte, su intrincada tecnología permite que esa obra se escenifique como psicodrama donde proyectamos, con el que identificamos y en el que reconocemos nuestra subjetividad en el espacio de la cultura popular global de consumo. De otra parte, fragmenta y descompone la relación de esos lenguajes mediáticos con la formación y construcción de nuestras identidades, de nuestras representaciones y de cómo se nos percibe; la relación entre quienes somos y cómo nos imaginamos a nosotros mismos en el universo mediático capitalista globalizante; las formas en las que nuestras representaciones y las de otras culturas tergiversan y traicionan nuestros deseos y necesidades; las formas en que esas necesidades y deseos están mediatizadas a través de filtros como MTV y CNN, el cine de Hollywood, las representaciones turísticas y la pornografía.

Octavio Zaya

From Text to Action in the Work of Candice Breitz

Over the last decade, Candice Breitz has been probing, translating, re-mixing and editing the codes and icons of contemporary media culture and the language of the entertainment industry. In early photographic montages, she explored the instability of identity and the violence of representation. The compelling video installations that grew out of the earlier photographic works, and which have become central to her practice, tend to strip down and interrogate found footage borrowed from mainstream cinema, television and music video. Breitz isolates and aggressively redirects this footage away from its characteristically narrative and anesthetic functions. The resulting works traverse a familiar yet puzzling and fragmentary terrain, rescinding the grammar and syntax of the borrowed material. On the one hand, Breitz's mediascapes expose the machinery and tease out the values of the mainstream media industry. On the other, they reflect on the very real affect that pop culture is able to generate and sustain; projections and identifications that are more complex than they may at first seem.

These works have established Candice Breitz as one of the central artistic figures to tackle the rocky chasms between culture and consumerism, experience and language. On the one hand, both this book and the exhibition that it accompanies present examples of the multiple aspects of these concepts in global media space covered by Breitz's oeuvre; on the other, they underscore the seminal importance of the photographic logic of multiple exposure in Breitz's artistic practice. By cutting, editing and re-combining pre-existing and familiar images, the artist re-exposes her found material, opening up the surface, the connections, joints and borders between the images/languages to reveal the construction of their representation and ideology. As in karaoke and sampling, the original material is recycled, re-configured and altered; in Breitz's case, in order to gain access to a critical space concerning the use of images/languages as products of the increasingly dominant media industry and the methods and intentions it conceals.

Between the categories of original and reproduction, visible and invisible, exposed and erased, presence and absence, familiar and foreign, famous and anonymous, Breitz introduces an oeuvre based on complex sound and video installations. On the one hand, its intricate technology enables this oeuvre to be staged as a psychodrama with which we identify, into which we are projected and by means of which we grapple with our subjectivity within global popular consumer culture. On the other, it fragments the relationship between these media languages and the construction of our identities, our representations and the way in which we are perceived; the relationship between who we are and how we envisage ourselves in the globalized capitalist media universe; the ways in which our representations and those of other cultures distort and betray our desires and needs; the ways in which these needs and desires are mediated by filters such as MTV and CNN, Hollywood cinema, tourist representations and pornography.

The universe projected by Breitz's installations is the universe of the hyper-real. It is neither imitation nor copy, neither duplication nor parody. To paraphrase Baudrillard, it is a universe in which reality is

El universo que proyectan las instalaciones de Breitz es el universo de lo *hyper-real*. Ni se trata de una imitación ni de una copia, de una duplicación o de una parodia. Es, parafraseando a Baudrillard, el universo en el que la realidad se substituye por los signos de la realidad. Breitz, sin embargo, ni se propone analizar cómo esos medios construyen el mundo en el que vivimos ni los síntomas que crean. Ni pretende establecer una crítica deconstructiva sobre esos medios ni explorar cómo se forman esas celebridades. Candice Breitz se propone abrir, revelar y exponer el simulacro entre la realidad y la ficción, la experiencia y el lenguaje, las identidades y los medios que la representan, en esta realidad nuestra que promueve siempre la obsolescencia, la uniformidad y la semejanza.

Segunda toma

Frente a la obra de Breitz me sucede lo mismo que me pasa con el tiempo, que diría Ricoeur, en este caso porque cuando no se resiste al análisis lo desvía. Me supongo que sé bien lo que es esa obra suya, si es que nadie me pregunta sobre el asunto. Presumo que conozco lo que aborda, qué inferencias tiene y, en cierto modo, hasta donde se extiende. Sin embargo, si se la intentara explicar a quién pregunte, me quedaría perplejo. El problema es, en este caso, epistemológico, y en toda su complejidad, porque ¿cómo puedo aproximarme a mediar y reconciliar una obra que se debate entre los intersticios de su escepticismo y de su lenguaje? ¿Cómo puedo tender un puente entre lo que expone y cómo lo expone? ¿Cómo justificar su "exposición múltiple"? ¿Y qué quiero decir que ya no se esfuerce en decir la propia obra?

Ya en las postales turísticas *etno-kitsch* que presentó en la primera edición de la Bienal de Johanesburgo en 1995, precisamente en el momento de la transición del *Apartheid* a la democracia en Sudáfrica, Breitz se proponía exponer y revelar la representación visual de la imaginación occidental que había orientado y orientaba la realidad y visión de los "otros" (la mayoría negra) y determinaba las prácticas reales de la vida diaria, la sexualidad, la política, etc., en Sudáfrica. En este caso, todas estas postales etnográficas representaban mujeres negras indígenas y tribales con los pechos descubiertos en diferentes ambientes aparentemente tradicionales. Breitz no intervenía en ninguna de esas primeras postales que presentó en el espacio de *Black Looks, White Myths;*[1] sólo las desplazaba de su condición habitual como artefactos turísticos para emplazarlas en el contexto del museo. La apropiación no era el problema que Breitz advirtió casi de inmediato en la re-exposición de esas postales, sino las implicaciones de cómo las exponía.

Aparentemente, Breitz presentaba sus postales pseudo-etnográficas como evidencia de aquella imaginación occidental, de representación colonial, pero escondiendo la subjetividad de su discurso, como si lo que presentara fuera la verdad moral y estética, el verdadero carácter de lo que estaba "ahí fuera", como si su selección y su falta de intervención fueran actividades semánticamente neutrales. Esta forma de presentación moralizante planteaba, sin embargo, más cuestiones que las que trataba de exponer. En primer término, si uno se limita a reproducir como meras citas el material cuyo uso y abuso es precisamente el tema que se critica, ¿hasta qué punto la apropiación y la explotación que uno intenta criticar no repite el mismo gesto criticado? ¿Esa cita es fundamentalmente diferente del gesto criticado? ¿En qué sentido el emplazamiento de esa representación en el espacio aparentemente neutral del museo y la apropiación del

[1] *Black Looks, White Myths* [Semblantes Negros, Mitos Blancos] es el nombre de la exposición y el catálogo que concebí, con la asistencia de Tumelo Mosaka y Danielle Tilkin, como representación de España en la primera Bienal de Johanesburgo.

replaced by the signs of reality. Breitz goes well beyond analyzing how the media constructs the world in which we live and the symptoms that it creates. Nor does she rest at establishing a deconstructive critique of the media, or exploring how celebrity is formed. Indeed, she moves further to open, reveal and expose the simulacrum between reality and fiction, experience and language, identities and the media that represent them in this reality of ours that favors obsolescence, uniformity and similarity.

Take Two

Before Candice Breitz's oeuvre, I have the same impression as I do when I stand before time, as Ricoeur would say: in this case, because when it doesn't stand up to analysis it deflects it. I think I am familiar with her work, so long as nobody asks me about it. I imagine I know what she is dealing with, its inferences and somehow even its scope. However, upon endeavoring to explain it to whoever might tackle me on the subject, I am baffled. In this case, the problem is epistemological and extremely complex, for how am I to approach, mediate and reconcile myself with an oeuvre that is torn between the interstices of skepticism and language? How am I supposed to bridge the gap between what it exposes and how it is exposed? How can I come to terms with its "multiple exposure"? And what can I hope to express that hasn't already been expressed by the work itself?

In the ethno-kitsch tourist postcards that she presented for the first edition of the Johannesburg Biennial in 1995, when South Africa was undergoing the transition from Apartheid to democracy, Breitz already started to expose the visual representation of western imagination that had shaped and continued to shape the reality and vision of otherness (the black majority) and determined the real practices of everyday life, sexuality, politics, etc. in South Africa. In this case, all these ethnographic postcards depicted indigenous tribal women, their breasts exposed, in various seemingly traditional settings. Breitz did not yet intervene in any of the postcards that she presented in *Black Looks, White Myths*, but merely changed their usual role as tourist artifacts, by placing them in a museum context. Before thinking of appropriation when she re-exhibited these postcards, what sprang to mind were the implications of how they were shown.

Black Looks, White Myths is the title of the exhibition and catalogue that I devised, with the assistance of Tumelo Mosaka and Danielle Tilkin, to represent Spain at the first Johannesburg Biennial in 1995.

Breitz presented these pseudo-ethnographic postcards as evidence of the western imagination and its colonial representation, concealing the subjectivity of her discourse as if what she was presenting were moral and aesthetic truths, the true nature of what was "out there," as if her selection and lack of intervention were semantically neutral activities. Yet this form of moralizing presentation prompted more issues than those she was attempting to expose. In the first place, if the use and abuse of certain material is precisely the object of criticism, surely the appropriation and exploitation that she hopes to denounce is repeated in the quotations that people her reproductions? Are these essentially different from the gestures she criticizes? In what sense is the artist's appropriation and placing of such representations in the seemingly neutral space of the museum enough to transform the effect of the representation, of the image? Secondly, what seems to remain is the visual exhibition/presence of the representations, which consequently leads to another instance of colonial photography of sexual exploitation.

artista sin mayor intervención son suficientes para transformar el efecto de la representación, de la imagen? En segundo término, lo que parece mantenerse en cualquier sentido es la exposición/presencia visual de las mismas representaciones y, así, se le da el paso de nuevo a la fotografía colonial de explotación sexual.

Para Breitz era necesario, pues, un replanteamiento y re-ordenamiento en cuanto a su intervención en la obra y en torno a la naturaleza de la exposición propiamente dicha. No se trataba tanto de establecer una visión única, esencial, ni una presencia visible. Se trataba de plantear diferentes modos de visión, o cuando menos se requería una multiplicidad de perspectivas, una proliferación de puntos de vista para examinar y poner al descubierto las implicaciones representacionales de la visión dominante.[2]

Todas y cada una de esas cuestiones serán en adelante el transfondo sobre el que Candice Breitz desarrollará primero un conjunto de series fotográficas que abordan cuestiones en torno a las políticas de la identidad, y después un conjunto de instalaciones vídeo-sónicas que extienden el campo de interés de la artista hacia la cultura de masas y el papel del lenguaje en la formación del sujeto.

Tercera Toma

La obra fotográfica que Candice Breitz elaboró durante 1996 y 1997 – a partir de su traslado a los Estados Unidos para cursar sus estudios superiores en Teoría e Historia del Arte – vuelve a hacer uso de materiales encontrados, pero esta vez sus intervenciones sobre esos materiales informarán y marcarán en adelante cada una de las estrategias de sus proyectos futuros. Las series que inauguraron lo que yo entiendo como su "paso a la acción", *Ghost Series* (1994-1996), *Rainbow Series* (1996) y *Rorschach Series* (1997), son las que dieron origen a un largo, y a veces amargo, debate, particularmente en Sudáfrica, sobre las políticas de representación y la apropiación del "cuerpo negro" por "artistas blancos",[3] aunque existen otros proyectos inéditos que se elaboraron simultánea o inmediatamente después, que en algunos casos iluminan ciertos aspectos de las estrategias e intencionalidades de la artista.

En general, cada una de estas tres series es una agrupación de imágenes re-elaboradas, re-compuestas y re-fotografiadas del cuerpo y de fragmentos del cuerpo, y cada una de las series utiliza medios complementarios que en adelante van a originar y determinar el proceso de producción tanto de los proyectos fotográficos como de las instalaciones de canales múltiples y filmes. En *Ghost Series,* Breitz blanqueó los rostros y los cuerpos de mujeres negras sudafricanas en postales turísticas pseudo-etnográficas y posteriormente las re-fotografió y amplió, no solo para acentuar el carácter fantasmagórico con el que ya están imbuídas estas imágenes – en la elisión o borradura de la subjetividad de las mujeres en la imagen – sino, de modo más relevante, para exacerbar las leyes apropiativas que inscriben estas presencias como ausencias fetichizadas, exóticas y primitivas. Como explica Brian Axel, esta serie "ilumina cómo las propias características que valoran las políticas identitarias globalizadas (como demarcaciones naturales de la diferencia recuperable) son, de hecho, artefactos macabros de violencia irrecuperable – la colonialidad, el capitalismo, la nación, etc."[4] En esta serie, Breitz amplifica las prácticas específicas de proyección, identificación y apropiación, reconociéndolas como prácticas que pertenecen a las políticas y los esquemas de las fantasías culturales.

[2] Para el desarrollo de estas y otras cuestiones relacionadas con las políticas de análisis y exposición, ver Mieke Bal, *Double Exposures.* Nueva York & Londres: Routledge, 1996.

[3] Para un estudio amplio sobre las dimensiones del debate ver Brenda Atkinson (editor), *Grey Areas. Representation, Identity and Politics in Contemporary South African Art.* Johanesburgo: Chalkham Hill Press, 1999.

[4] Brian Keith Axel, "From Image to Enunciation." *Candice Breitz: Cuttings.* Linz: O.K Center for Contemporary Art Upper Austria, 2001; p. 57.

2 For a deeper study of these and other issues related to the politics of analysis and exhibition, see Mieke Bal, *Double Exposures*. New York & London: Routledge, 1996.

3 For a broader survey of the dimensions of this debate, see Brenda Atkinson (ed.), *Grey Areas: Representation, Identity and Politics in Contemporary South African Art*. Johannesburg: Chalkham Hill Press, 1999.

4 Brian Keith Axel, "From Image to Enunciation," in *Candice Breitz: Cuttings*. Linz: O.K Center for Contemporary Art, 2001; p. 57.

Breitz therefore moved on to re-think and re-arrange her intervention in the works and the nature of the exhibition itself. It was not so much a question of establishing a single, essential vision or a visible presence, but of setting out new modes of vision or at least multiple perspectives, a proliferation of points of view to examine and reveal the representational implications of dominant vision.[2]

Each and every one of these issues would subsequently become the background against which Candice Breitz would develop a set of photographic series that approached the politics of identity and a set of sound and video installations that extended her field of interest to include mass culture and the role of language in the construction of the subject.

Take Three

The photographic oeuvre produced by Candice Breitz during 1996 and 1997, following her move to the United States to study art history and theory, returned to the use of found materials, although now her intervention would establish the strategy of her future projects. The series that marked the onset of what I term her "move into action," the *Ghost Series* (1994-1996), *Rainbow Series* (1996) and *Rorschach Series* (1997), prompted a long and at times bitter debate, especially in South Africa, on the politics of representation and appropriation of "the black body" by "white artists,"[3] although other unpublished projects were created either simultaneously or else immediately afterwards, some of which shed light on certain aspects of the artist's strategies and intentions.

Broadly speaking, each of the three series is an ensemble of re-worked, re-composed and re-photographed images of the body and of fragments of the body, and each series turns to complementary media that determine, from then on, the production process of the photographic projects and of the multi-channel installations and films. In the *Ghost Series*, Breitz applied *Tippex* to the faces and bodies of black South African women on pseudo-ethnographic tourist postcards, leaving only their eyes and mouths visible behind these white masks. These were then re-photographed and enlarged, not only in order to highlight the phantasmagoric nature that already pervades them – in the elision or erasure of the subjectivity of the women in the image – but, more significantly, to exacerbate the laws of appropriation that categorize these presences as exotic and primitive fetishized absences. As we learn from Brian Axel, this series "illuminates how the very features valued by a globalized 'identity politics' (as natural delimitations of recoverable difference) are, in fact, macabre artifacts of unrecoverable violence – coloniality, capitalism, nationhood, etc."[4] In this series, Breitz extends the specific practices of projection, identification and appropriation, recognizing them as practices pertaining to the politics and scripts of cultural fantasies.

In her *Rainbow Series* (1996), Breitz takes this set of practices even further and presents the viewer with a polymorphically perverse version of the Surrealist "exquisite corpse." This series gestures deconstructively towards romanticized notions of hybridization and is resigned to the general impossibility of attaining a coherent subjectivity (given that the subject, no matter how you look at it, is always

5 Este símbolo fue adaptado a partir de "el pueblo arcoiris" que Desmond Tutu a su vez había introducido en el contexto sudafricano después de sus viajes a los Estados Unidos, donde Jesse Jackson lo había adoptado en la Coalición Arcoiris de diversos grupos e intereses con la que aspiró a la presidencia de los Estados Unidos en las elecciones de 1988. Pero el término ha sido utilizado previamente en los Estados Unidos en diferentes contextos sociopolíticos como metáfora de lo étnicamente diverso.

En *Rainbow Series* Breitz lleva aún más lejos este conjunto de prácticas y presenta al espectador una versión polimórficamente perversa del "cadáver exquisito" surrealista. Esta serie gesticula deconstructivamente hacia las nociones romantizadas de la hibridación, así como se resigna a la imposibilidad general de una subjetividad coherente (puesto que el sujeto es a todas luces siempre híbrido). Específicamente, las imágenes confrontan la mitología post-*Apartheid* sudafricana de una "Nación Arcoiris", una metáfora que venía a representar la nueva Sudáfrica que exponían Nelson Mandela y el CNA.[5] En su amalgama de incongruentes fragmentos de pornografía y etnografía, Breitz pone en escena una violenta de-composición y re-composición de cuerpos, cuerpos que no pueden escapar nunca de la fragmentación y la desfiguración que se mofa de ellos en su deseo de integridad y totalidad. Aunque no podemos acusar a Candice Breitz de equiparar o igualar deliberadamente el deseo inherente a las mitologías de la coherencia (sean individuales o nacionales) con el deseo libidinoso que estructura el efecto pornográfico, ella se inclina a hilvanarlos conjuntamente y despreocupadamente. De modo que a veces estos fotomontajes pueden leerse como una crítica de las estrategias raciales y culturales de la igualación y la borradura, y en otros momentos sugieren la posibilidad de una imaginación pornográfica alternativa, en la que el deseo no se puede reducir a la dialéctica del consumidor y lo consumido.

Rorschach Series, como *Rainbow Series,* se crea también a partir de fotomontajes ampliados fotográficamente y re-impresos, pero a diferencia de *Rainbow Series,* en la que prevalece la fragmentación, en *Rorschach Series,* al menos a primera vista, las imágenes parecen enlazarse en composiciones formalmente armoniosas. El sentido anterior (en *Rainbow Series*) de una yuxtaposición provisional de diferentes modos de experiencia y sistemas de significado, aquí da paso a una tensión diferente. Esta tensión, además del cruce de los fragmentos del cuerpo humano que se reflejan opuestos como en un espejo y la simetría que le ofrece un carácter eminentemente ornamental, se deriva fundamentalmente de la apertura que ofrecen a la otredad del espectador, como en la simetría y ambiguedad de la mancha del test de Rorschach. La mirada del espectador tiene la posibilidad de destruir el intento del artista de comunicarse y con ello la posibilidad de que la obra pueda transmitir con transparencia un sentido. Dejando atrás el antropomorfismo de las series anteriores, las criaturas que habitan *Rorschach Series* no son ni sujetos ni objetos, ni naturales ni culturales. En este estado ambivalente, la serie refleja tanto el deseo del objeto de consumo como la amenaza del sujeto abyecto.

Cuarta Toma

Ahora resultan evidentes los procesos y estrategias de producción de Candice Breitz y los temas que parecen preocuparle. En este sentido, de un lado la apropiación/cita y el montaje como técnicas de análisis y fragmentación críticas, y de otro el lenguaje como medio y vehículo – tanto de formación y construcción de la identidad como de sutura – serían algunos de los intereses y transacciones recurrentes que Candice Breitz desarrolla y perfecciona a lo largo de estos diez años de trabajo.

La apropiación/cita que establece Breitz en su obra fotográfica y posteriormente en sus instalaciones vídeo-sónicas no circula alrededor del tipo de arquetipo/apoteosis que le preocupaba a Benjamin Buchloh

hybrid). To be specific, the images confront the post-Apartheid South African mythology of a "Rainbow Nation," a metaphor that stood for the new South Africa presented by Nelson Mandela and the ANC.[5] In her mixture of unconnected pornographic and ethnographic fragments, Breitz enacts a violent de-composition and re-composition of bodies, bodies that can never escape the fragmentation and disfigurement which taunt them in their desire for integrity and wholeness. Although we cannot accuse Breitz of deliberately equating the desire inherent in the mythologies of coherence (be they individual or national) with the lustful desire that structures the pornographic effect, she tends to thread them together in a carefree manner. As a result, these photomontages can sometimes be read as a critique of the racial and cultural strategies of equation and erasure, while at other times they suggest the possibility of an alternative pornographic imagination in which desire cannot be reduced to the dialectics of consumer and consumed.

The *Rorschach Series* (1997), like the *Rainbow Series,* also derives from photographically enlarged and re-printed photomontages, yet unlike the *Rainbow Series,* where fragmentation prevails, the images in the *Rorschach Series,* at first sight at least, seem to cohere into formally harmonious compositions. The previous sense (in the *Rainbow Series*) of a provisional juxtaposition of modes of experience and systems of meaning is replaced here by a different tension which, in addition to the exchange of fragments of the human body reflected as opposites as if in a mirror, and to the symmetry that grants it an essentially ornamental quality, basically stems from the opening offered to the viewer's otherness, as occurs with the symmetry and ambiguity of the mark in the Rorschach Test. The gaze of the beholder holds the potential for destroying the artist's attempt to communicate, and therefore the possibility that the work may relay meaning transparently. Leaving the anthropomorphism of previous series behind, the creatures that inhabit the *Rorschach Series* are neither subjects nor objects, natural nor cultural. In this ambivalence, the series reflects both the desire for the object of consumption and the threat of the abject subject.

Take Four

The production processes and strategies followed by Candice Breitz and the themes that seem to interest her are now clear. On the one hand, appropriations/quotes and montage as techniques of critical analysis and fragmentation and, on the other, language as a medium and vehicle — for both the construction of identity and suture — are some of the main recurring interests she has developed and perfected over the past ten years.

The appropriations/quotes Breitz established in her photographic work and then in her sound and video installations do not embrace the reification that worried Benjamin Buchloh in the eighties and that appears as such in the simulations/appropriations of so-called Neo-Geo. The works created by Sherrie Levine, Ashley Bickerton, Peter Halley and Philip Taaffe were examples of cultural-artistic repetition that did not obey a deconstructive-critical intention apropos the commodification of culture but responded instead to a fetishistic/melancholy/cynical fascination and to a political resignation,

en los ochenta y que se manifiesta como tal con las simulaciones/apropiaciones del llamado Neo-Geo. Aquellas obras que crean desde Sherrie Levine hasta Ashley Bickerton, Peter Halley o Phillip Taaffe, respondían fundamentalmente a un tipo de reiteración artístico-cultural que no tenía una voluntad crítico-deconstructiva en relación a la mercantilización de la cultura, sino una fascinación fetichista/melancólica/cínica y una resignación política que vinieron a establecerse como una estética general del espectáculo y que, incluso en los casos en los que parecía tener una intencionalidad crítica inherente, no consiguió sino replicar o reforzar su caracter mercantil. La intencionalidad de la obra de Breitz es siempre deconstructiva y crítica, y en ningún caso cínica o melancólica. Si tiene una "apariencia" de fascinación fetichista en ciertos momentos de sus instalaciones más recientes, particularmente aquellas que son retratos/homenajes de reconocidas figuras de la música *pop* – Bob Marley, Madonna, Michael Jackson o John Lennon – se debe al formato que Breitz elige para problematizar la relación y actividad de referencia entre la imagen y su referente a partir del corte, la conjunción y el montaje – de imágenes existentes reconocibles – y de la mímesis.

En este sentido, *Babel Series* (1999) viene a representar – entre las instalaciones multicanal que la artista concibe entre 1999 y 2003 – el primer ejemplo en el que, en relación al signo-mercancía que se apropia Breitz (los vídeos musicales de artistas *pop* como Prince, Abba, Madonna, Wham o Police), no se establece un fetichismo que re-codifica la mercancía mítica, que diría Barthes, sino que se configura una contra-apropiación.[6] Esta pieza, que se presentó en la Bienal de Estambul de 1999, descompone cada una de las canciones de estos artistas famosos en constantes repeticiones, que por un lado evocan el habla de los niños y las primeras manifestaciones del aprendizaje mimético de una lengua – "da, da, da...", "ma, ma, ma...", "me, me, me..." o "pa, pa, pa..." – y por otro parecen disparatar la mismísima posibilidad de significación transparente al degenerar, en su presentación simultánea, en una cacofonía caótica a veces insoportable. Además, como nos recuerda Breitz, *Babel Series* insinúa que la introducción del sujeto en el lenguaje está irremediablemente modulada a través de los medios de comunicación globales.

En cierto modo, *Four Duets* (2000) viene a replantear, de una manera tal vez más sofisticada y sutil, la irrelevancia del referente, esta vez canciones de amor que se reducen simplemente a los pronombres personales "yo" y "tu", y los relacionados con estos. La instalación se plantea en torno a cuatro habitaciones diferenciadas por sus distintivos colores donde respectivamente se presentan monitores que se confrontan, mezclan y chocan con sus dobles para contocircuitar cualquier posibilidad de identificación y de proyección mientras establecen una relación esquizofrénica consigo mismos. Con *Karaoke* (2000), en cambio, Candice Breitz introduce en escena al consumidor mismo de estos vídeo-mercancías de la cultura popular. Esta instalación circular de diez monitores recrea la cacofonía de *Babel Series,* pero ahora con la repetición simultánea de la famosa canción *Killing Me Softly* de Roberta Flack que diez jóvenes ensayan, como cualquier cantante amater de *karaoke* con la letra de la canción en frente y detrás de estos, y en esta ocasión frente a la cámara de la artista. Lo que predomina aquí es la letra de la canción y el lenguaje en general. Aunque resulta difícil entender las palabras bajo la incomprensible disonancia de las diez voces, sin sincronización ni esfuerzo por armonizarlas, poco a poco empiezan a revelarse: "Singing my life with his words... Telling my whole life in his words..." [Cantando mi vida con sus palabras... Contando toda mi vida en sus palabras...]. Y más allá del ya reconocido interés de Breitz en el análisis del papel que juegan los

6 Para este tema ver Roland Barthes, *Mythologies*. Nueva York: Hill and Wang, c. 1972.

prompting a general aesthetics of spectacle that, even when it appeared to have an inherent critical intention, only managed to reinforce its commercial nature. Breitz's oeuvre is on the other hand always deconstructive and critical, never cynical or melancholy. If some of her recent installations at first appear to exert a fetishistic fascination, especially those that are portraits of and tributes to well-known pop stars – Bob Marley, Madonna, Michael Jackson or John Lennon – this is because of the format chosen by Breitz to problematize the relationship and the activity of reference between the image and its referent through cuts, combinations and montage – of pre-existing recognizable images – and through mimesis.

In this sense and in connection with the commodity-sign appropriated by Breitz (the musical videos by pop stars such as Prince, Abba, Madonna, Wham! or The Police), among the multi-channel installations the artist conceived between 1999 and 2003, the *Babel Series* (1999) is the first work in which the mythical commodity is not recoded by any fetishism, as Barthes would say, but takes shape as a counter-appropriation.[6] This piece, first presented at the Istanbul Biennial in 1999, breaks down each of the songs by these famous singers into continuous repetitions that on the one hand evoke children's speech and the early expressions of mimetic learning of a language – "da, da, da…", "ma, ma, ma…", "me, me, me…" and "pa, pa, pa…" – and on the other seem to make nonsense of the actual possibility of transparent meaning by relapsing, in their simultaneous presentation, into a chaotic cacophony that can be unbearable. Furthermore, Breitz reminds us with the *Babel Series,* that the introduction of the subject into language is inevitably modulated by the global media.

In some respects, *Four Duets* (2000) redefines, perhaps in a more sophisticated and subtle manner, the irrelevance of the referent, on this occasion love songs that are simply reduced to the personal pronouns "I" and "you" and related to these. The installation is conceived around four rooms, distinguished by different colors, containing screens that confront, combine and clash with their doubles to short-circuit any possibility of identification and projection while they set up a schizophrenic relationship with themselves. On the other hand, in *Karaoke* (2000), Breitz introduces the actual consumers of these video-goods taken from popular culture. This circular installation made up of ten screens recreates the cacophony of the *Babel Series,* but includes the simultaneous and asynchronous repetition of Roberta Flack's famous song *Killing Me Softly,* rehearsed by ten diverse people resembling any other amateur karaoke singer, with the lyrics in front and behind them, now facing the artist's camera. The most predominant features here are the lyrics and language in general. Although it is not easy to grasp the words under the dissonance of the ten voices, that are not synchronized and make no attempt to sing in harmony, they gradually begin to be heard: "Singing my life with his words…Telling my whole life in his words…" And beyond Breitz's well-known interest in analyzing the role played by the media in the construction of identity and in the linguistic origin of the formation of the self, in this installation she also problematizes the possible transparent relationship between the viewer and the referent. As Konrad Bitterli explains, *Karaoke* "brings together a diverse group of people (individuals from ten different cultural backgrounds and linguistic contexts), to reinterpret the lyrics of a song that has enjoyed worldwide popularity across several generations and nations. The *Karaoke*

[6] On this issue, see Roland Barthes, *Mythologies.* New York: Hill and Wang, c. 1972.

medios de comunicación en la construction de la identidad y en el origen linguístico de la formación del sujeto, en esta instalación Breitz también problematiza la posible relación transparente del espectador con el referente. Como explica Konrad Bitterli, *Karaoke* "reúne a un grupo diverso de gente (individuos de diez orígenes y contextos linguísticos diferentes) para re-interpretar las letras de una canción que ha disfrutado de popularidad universal a través de generaciones y naciones. Estos practicantes de *Karaoke* tienen poco en común además del hecho de que ninguno de ellos es nativo de lengua inglesa. Al cantar la canción en conjunto están implícitamente conectados entre sí a través de la apropiación mutua de las formas y los valores de una lengua extraña; en la absorción mutua de la cultura de masas a través de la que el inglés se da a conocer. De esta manera, sus voces se coagulan al tiempo que son asimilados en la cultura que se afana en conseguir el dominio global."[7]

Estas y otras estrategias se repiten, se desarrollan, se perfeccionan y se problematizan en las diferentes y complejas instalaciones multicanal que Candice Breitz ha venido produciendo sucesivamente a partir de *Karaoke* con la colaboración del público consumidor por excelencia, los dedicados fans de los artistas/referentes, respectivamente en *Legend (A Portrait of Bob Marley)* (2005), *Queen (A Portrait of Madonna)* (2005), *King (A Portrait of Michael Jackson)* (2006) y *Working Class Hero (A Portrait of John Lennon)* (2006). Lo que diferencia aquellas instalaciones de ésta es que con el retrato/homenaje que resulta de la múltiple mimetización de los fans con sus respectivos ídolos, la identificación con éstos y la transformación de éstos, Breitz construye, por un lado, realidades sintéticas que representan nuevos órdenes espacio-temporales donde las imágenes fragmentadas se reúnen de acuerdo con nuevos parámetros (para el retrato) donde la percepción ya no es contemplativa sino que está unida a la acción.[8] Por otro, estos retratos/homenajes no representan una mera duplicación sino una especie de "entendimiento creativo",[9] como diría Bakhtin, que no resulta nunca de una fusión o mezcla porque cada uno mantiene su propia unidad y totalidad "abierta", pero siempre se enriquecen.

Quinta Toma

Ahora también es evidente el interés y la reflexión de Breitz sobre la cultura *pop*. Y no podría ser de otro modo. Desde su llegada a los Estados Unidos, Breitz se sumergió de lleno en la cultura popular americana mientras estudiaba y analizaba la obra y los pormenores en torno a la figura de Andy Warhol en el programa de doctorado de la Universidad de Columbia. Breitz estaba, pues, necesariamente familiarizada con las distintas reacciones críticas y académicas que tanto la obra como la propia mitología de Warhol suscitaban en los Estados Unidos. Y así, no se le escapaba que si el debate en torno a su obra planteaba que, por un lado, esta fomentaba una aprensión crítica y subversiva de la cultura de masas y del poder de la imagen como mercancía, por otro sucumbía de manera inocente pero reveladora a su poder entorpecedor; y también que explotaba cínica y engañosamente una confusión endémica entre arte y *marketing*.

Consciente de la fascinación que ejerce el cine de Hollywood a escala global y de la maquinaria mitologizadora que representa, Breitz se aproxima a Hollywood de manera crítica y deconstructiva, considerando

7 Konrad Bitterli, "Intention versus Realisation." *Candice Breitz: Cuttings.* Op. cit., pp. 107-108.

8 Para este entendimiento del mimetismo infantil, consultar Walter Benjamin, "On the Mimetic Faculty." *Reflections.* Nueva York: Schocken Books, 1986.

9 M.M. Bakhtin, *Speech Genres and other Late Essays* (traducción de Vern W. McGee). Austin: Caryl Emerson & Michael Holmquist, 1986; pp. 6-7.

[7] Konrad Bitterli, "Intention versus Realisation," in *Candice Breitz: Cuttings,* op. cit., pp. 107-108.

[8] On this understanding of children's mimicry, see Walter Benjamin, "On the Mimetic Faculty," in *Reflections.* New York: Schocken Books, 1986.

[9] M. M. Bakhtin, *Speech Genres and other Late Essays.* Austin: Caryl Emerson and Michael Holmquist, 1986, pp. 6-7.

performers have little in common, other than the fact that none of them are native English speakers. As they sing the song alongside one another, they are implicitly connected to each other through their mutual appropriation of the forms and values of an alien language; in their mutual absorption of the mass culture through which English makes itself known. Their voices thus congeal in the very moment of their assimilation into a culture striving for global domination."[7]

These and other strategies are repeated, developed, perfected and problematized in the various complex multi-channel installations that Candice Breitz has been successively producing since *Karaoke,* with the collaboration of the consumer audience *par excellence,* the devoted fans of the stars/ referents, in *Legend (A Portrait of Bob Marley)* (2005), *Queen (A Portrait of Madonna)* (2005), *King (A Portrait of Michael Jackson)* (2005) and *Working Class Hero (A Portrait of John Lennon)* (2006), respectively. What distinguishes these installations from that one is the fact that thanks to the portrait/ tribute resulting from the multiple mimesis between fans and their respective idols, their identification with them and their transformation, on the one hand Breitz constructs synthetic realities that represent new spatio-temporal orders where fragmented images gather, following new parameters (for portraiture) and where perception is no longer contemplative but is linked to action.[8] On the other hand, these portraits/tributes do not represent a mere duplication but a sort of "creative understanding,"[9] as Bakhtin would say, that never leads to a merging or mixing because each one preserves its own unity and "open" totality, although they are mutually enhancing.

Take Five

Breitz's interest in and reflection on pop culture are now also evident, and it couldn't be otherwise. Upon her move to the United States in 1994, Breitz immersed herself completely in a study of American popular culture, while she studied and analyzed the work of Andy Warhol as a PhD student at Columbia University. As a result, Breitz was necessarily familiar with the different critical and academic reactions that Warhol's oeuvre and myth aroused in the States. She was therefore also aware that while his oeuvre was considered to encourage a critical and subversive apprehension of mass culture and the power of the image as a commodity, it succumbed, innocently yet revealingly, to its numbing power and cynically and deceitfully exploited an endemic confusion between art and marketing.

Aware of the fascination exerted by Hollywood cinema worldwide and of the mythologizing mechanism it represents, Breitz approaches Hollywood in a critical and deconstructive manner, paying particular attention to the illusion of the universality of the language of film that is promoted and ignoring the specific knowledge that can be found in a given text/context. In this sense, *Becoming* (2003) is presented as an atypical multi-channel installation, because for the very first time it introduces the artist personally as a substitute leading player. In actual fact, as Breitz intervenes in the roles of each of the seven Hollywood stars she has chosen (Cameron Diaz, Julia Roberts, Jennifer Lopez, Meg Ryan, Neve Campbell, Reese Witherspoon and Drew Barrymore), she makes her own debut as an actress. Breitz cuts and re-edits several scenes from the different films played by these actresses

particularmente la ilusión de la universalidad del lenguaje cinematográfico que se promueve para ignorar los conocimientos específicos que pueden estar funcionanado en un texto/contexto dado. *Becoming* (2003), así, se nos ofrece como una instalación multicanal atípica pues por primera vez nos presenta directamente a la artista como protagonista sustituto. En realidad, Candice Breitz se entromete en el papel de cada una de las siete estrellas de Hollywood que ha seleccionado (Cameron Diaz, Julia Roberts, Jennifer Lopez, Meg Ryan, Neve Campbell, Reese Witherspoon y Drew Barrymore) para su estreno como actriz. Breitz corta y re-monta diversas escenas de los diferentes filmes de estas actrices (eliminando a los actores que aparecían originalmente con ellas) y procede a imitar todos y cada uno de los movimientos de estas, literalmente más allá de cualquier parodia. La instalación se compone de siete piezas sobre pedestales. En cada uno de los pedestales Breitz sitúa dos monitores en una estructura de acero, como si fuera de espaldas uno del otro, que simultáneamente recogen, por un lado, una de las escenas "originales" con una de las actrices de Hollywood (digamos un fragmento de Julia Roberts en *Pretty Woman*) y, por otro, la re-actuación de Breitz, de tal manera que no podemos ver "el original" y "la copia" simultáneamente. Sin embargo, ambas escenas tienen la misma duración y la misma banda sonora. Lo que las diferencia y contrasta es el color de la escena "original" frente al blanco y negro de la cinta de Breitz.

Tratar de argumentar que esta instalación reflexiona sobre el modo en que el individuo contemporáneo mimetiza o sigue el ejemplo de los arquetipos de la cultura de masas me parece simplista. Ello ni respondería a la presencia de la artista ni abordaría un tema que ha interesado a Breitz desde el inicio de su carrera, el *copyright.* En todo caso, ese comentario no distinguiría la obra sino formal y técnicamente del programa del mismo nombre que concibió MTV para que los quinceañeros recrearan el vídeo de sus artistas preferidos. Además de esa lectura obvia, creo que esta obra literalmente ventrílocua es una crítica, tal vez sutil, como el anverso de la identificación proyectiva, sobre la fantasía de Hollywood de representar o hablar por la subjetividad de los espectadores, como es el caso de la re-actuación/"copia" de la escena de la artista, que se nos presenta inmersa en una fusión extática con otra voz y que nos habla desde dentro de ese otro espacio cultural del "original".

En *Soliloquy Trilogy* (2000), Breitz elabora tres cortos a partir de tres reconocidas películas de Hollywood, cortando y aislando del resto de la cinta cada una de las escenas donde aparece hablando el/la protagonista. Tanto el contexto de las escenas como los actores secundarios que aparecen entre las escenas seleccionadas donde el protagonista verbaliza han sido editados. El resultado es una serie de *clips* cinematográficos sin coherencia narrativa y sin otro sentido que el del culto a la personalidad de la estrella, en estos casos tres pesos pesados de Hollywood: Clint Eastwood en *Harry el sucio,* Jack Nicholson en *Las brujas de Eastwick* y Sharon Stone en *Instinto básico*. Sin embargo, la duración de cada uno de los tres cortos, que se corresponden exactamente con el tiempo que cada uno de los artistas tiene presencia verbal en las películas mencionadas, nos ofrece una situación inesperada. Para nuestra sorpresa, Clint Eastwood solo aparece hablando 6 minutos, 57 segundos y 22 frames a lo largo de *Harry el sucio*, y Sharon Stone, como en el caso de Eastwood, en la película que la hizo mundialmente famosa, solo aparece 7 minutos, 11 segundos y 3 frames! Ello, en efecto, subraya lo que ya ha apuntado Christopher Phillips: "Escuchar los soliloquios es trepidante; los cambios de humor y tono extremos y abruptos sugieren el habla psicópata. Y sin embargo nos

(removing the actors who originally appeared opposite them) and goes on to imitate each and every one of their movements, literally transcending all parody. The installation is made up of seven works on pedestals. Two screens in a steel structure stand back-to-back on each pedestal, simultaneously presenting one of the "original" scenes performed by one of the Hollywood actresses (an excerpt of Julia Roberts in *Pretty Woman,* for instance) and Breitz's re-performance of the same scene, so that "original" and "copy" can never be seen at the same time. While both scenes are of the same length and have the same soundtrack, what sets them apart is the color of the "original" scene as opposed to the black and white of Breitz's footage.

To claim that this installation reflects upon the way in which contemporary individuals mimic or take their cues from the archetypes of mass culture seems somewhat simplistic to me, for this neither explains the artist's presence, nor does it tackle the question of copyright that has interested Breitz from the very beginning of her career. In any event, the comment only establishes formal and technical distinctions between the work and the programme of the same name, which MTV conceived so that teenagers could recreate the videos of their favorite singers. In addition to this obvious interpretation, I consider this literally ventriloquist work is a subtle critique, like the obverse of projective identi-fication, of the Hollywood fantasy of representing the subjectivity of spectators, as in the case of the re-playing/"copy" of the artist's scene, where she appears immersed in an ecstatic fusion with another voice, speaking from within that other cultural space of the "original."

In the *Soliloquy Trilogy* (2000), Breitz produces three short films derived from three well-known Hollywood films, cutting and separating from the rest of the footage each of the scenes in which the star speaks. The end product is a series of film clips devoid of narrative coherence and characterized by the cult of the personality of the stars, three Hollywood heavyweights: Clint Eastwood in *Dirty Harry,* Jack Nicholson in *The Witches of Eastwick* and Sharon Stone in *Basic Instinct.* However, the resulting length of each of the three short films, which is equivalent to that of the verbal presence of each star in the aforesaid films, produces an unexpected situation. To our surprise, Clint Eastwood only speaks for 6 minutes, 57 seconds and 22 frames throughout *Dirty Harry,* and in the film that brought her inter-national acclaim, Sharon Stone only speaks for 7 minutes, 11 seconds and 3 frames! This merely confirms what Christopher Phillips had already suggested: "Listening to the *Soliloquies* is unnerving; the extreme, abrupt shifts of mood and tone are suggestive of psychotic speech. Yet we sit watching, fascinated, because there is a residual core of satisfaction: the pure iconic presence of the star, crudely distilled for our viewing pleasure."[10] This piece also stresses something we already know – that language requires a context and a community in order to signify, to make sense.

[10] Christopher Phillips, "Candice Breitz: Four Installations," in *Candice Breitz: Cuttings,* op. cit., p. 34.

Finally *Mother + Father* (2005), possibly Breitz's masterpiece, is once again the result of the meticulous research, analysis and selection that precedes each of the projects and works, be they photographs or installations, drawings or collages, she has been producing since 1994. As in the works previously discussed, Breitz resorts again to strategies of appropriation and depletion of meaning, fragmentation and juxtaposition of excerpts starting from cuts, edits and reconstructions that, as in most of her

10 Christopher Phillips, "Candice Breitz: Four Installations." *Candice Breitz: Cuttings.* Op. cit., p. 34.

sentamos mirando, fascinados, porque existe una esencia residual de satisfacción: la pura presencia icónica de la estrella, destilada crudamente para nuestro placer de mirar."[10] La pieza también enfatiza lo que ya sabemos: que el lenguaje requiere de un contexto y de una comunidad para que signifique, para que tenga sentido.

Finalmente, *Mother + Father* (2005), tal vez la obra magistral de Breitz, es, una vez más, el resultado del meticuloso trabajo de investigación, análisis y selección que precede siempre cada uno de los proyectos y obras, tanto fotografías como instalaciones, dibujos y *collages,* que Candice Breitz viene elaborando desde 1994. Como en las obras anteriores, Breitz vuelve a utilizar estrategias de apropiación y agotamiento de la significación, fragmentación y yuxtaposición de fragmentos a partir de cortes, montajes y reconstrucciones que, como en la mayoría de sus instalaciones audiovisuales, se acercan más al *cut-up* de William Burroughs y Brian Gysin que al *collage.* En este caso, gracias a la avanzada tecnología digital, el proceso es prácticamente imperceptible y consigue originar una nueva atribución del significado, que aunque no completamente coherente, termina por recuperar/redimir el objeto.

A partir de extractos de algunas de las películas más emblemáticas del Holywood contemporáneo – entre estas *Kramer contra Kramer, Postales desde el filo, Queridísima mamá, etc.* – y doce de sus actrices y actores míticos, Bretiz establece dos instalaciones paralelas y complementarias; de una parte seis mujeres (Faye Dunaway, Diane Keaton, Shirley MacLaine, Julia Roberts, Susan Sarandon y Meryl Streep) que proclaman y resienten su papel de madres; de otra seis hombres (Dustin Hoffman, Tony Danza, Harvey Keitel, Steve Martin, Donald Sutherland y Jon Voight) que expresan sus frustraciones como padres. Cada uno de los miembros de este reparto de Breitz ha sido extraído digitalmente de los contextos de las películas donde aparecieron originalmente, y reconstituido sobre un mismo fondo neutro, que le permite aparecer como si compartiera el mismo espacio que los otros cinco y estableciera con ellas/ellos comentarios y reacciones en torno a un supuesto y obtuso diálogo sobre la maternidad y paternidad. Nuestra familiaridad y reconocimiento, como en las otras obras de Breitz directamente relacionadas con el fan/consumidor, juegan un papel esencial para que esta obra se proyecte como un simulacro polifónico y psicodramático que nos permite replantear y repensar los extractos culturales sobre los que componemos nuestras narrativas personales y sobre los que proyectamos nuestras vidas.

Si es cierto que el arte dejó de ser hace ya tiempo la articulación visual más significante de la identidad y el valor cultural, y si en nuestra época de producción tecnológica de masas, de reproducción de imágenes y artefactos, de simulaciones, equivalencias y obsolescencia, parece incongruente el apego a los conceptos de la creatividad individual, la obra de Candice Breitz consigue que entendamos la influencia de las imágenes de la cultura de masas sobre nuestra experiencia colectiva y el origen linguísitco sobre el que se apoya nuestra identidad quebrada.

audiovisual installations, come closer to the cut-ups of William Burroughs and Brian Gysin than to collage. In this case, thanks to advanced digital technology, the process is virtually imperceptible and generates a new attribution of meaning that may not be entirely coherent yet manages to recover/redeem the object.

Starting with excerpts from some of the most emblematic films in contemporary Hollywood – including *Kramer vs. Kramer, Postcards from the Edge, Mommie Dearest,* etc. – and twelve mythical actors and actresses, Breitz sets up two parallel and complementary installations: on the one hand, six women (Faye Dunaway, Diane Keaton, Shirley MacLaine, Julia Roberts, Susan Sarandon and Meryl Streep) who proclaim and resent their role as mothers, and on the other, six men (Dustin Hoffman, Tony Danza, Harvey Keitel, Steve Martin, Donald Sutherland and Jon Voight) who express their frustrations as fathers. All of the members of Breitz's two parallel casts have been digitally extracted from the contexts of the films in which they originally appeared and then reconstructed on a similar neutral black ground, making them look as if they shared the same space as the others and were able to comment and react to a supposed and obtuse conversation on maternity or paternity. Our familiarity and recognition, as in other works by Breitz that are directly related to fans/consumers, prove essential for this work to be projected as a polyphonic psycho-dramatic simulacrum that allows us to reconsider the cultural excerpts on which we create our personal narratives and on which we project our lives.

If art has indeed long ago stopped being the most important visual articulation of identity and cultural value, and if in our age of mass technological production, image and artifact reproduction, simulation, equivalence and obsolescence, attachment to the concept of individual creativity no longer seems to make much sense, Candice Breitz's oeuvre helps us understand the influence exerted by mass culture images on our collective experience and the linguistic source on which we base our faltering identity.

Jessica Morgan

Una vida pautada

1 Michael Fried, *Absorption and Theatricality: Painting and Beholder in the Age of Diderot.* Berkeley: University of California Press, 1980.

2 Susan Sontag, *Sobre la fotografía* (traducción de Carlos Gardini). Barcelona: Edhasa, 1981; p. 47.

3 Véanse, por ejemplo, Christopher Phillips: "Candice Breitz: Four Installations" en Renate Plöch & Martin Sturm (editores), *Candice Breitz: Cuttings.* Linz: O.K Center for Contemporary Art Upper Austria, 2001; Nicolas Bourriaud, *Postproduction.* Nueva York: Lukas & Sternberg, 2002; y Marcella Beccaria (editor), *Candice Breitz.* Rívoli & Milán: Castello di Rivoli Museo d'Arte Contemporanea & Skira Editore S.p.A., 2005; su técnica de corte y montaje de material de medios de comunicación comerciales se interpreta, en palabras de Bourriaud, como un ataque contra "las secuencias y las cadenas esenciales para el espectáculo."

4 Walter Benjamin, *La obra de arte en la época de su reproductibilidad técnica* (traducción de Andrés E. Welkert). México D.F.: Ítaca, 2003.

El retrato ha sufrido una cantidad considerable de críticas a lo largo de los últimos años, y toda una serie de razones explica el deterioro de su eficacia como género. El carácter de celebración y auto-propaganda del retrato o el autorretrato – esencia misma del género – se ha convertido en algo irónico o jocoso en el arte contemporáneo. Sin embargo, lo más preocupante en relación con el retrato es la drástica mediación de las tecnologías y los sistemas de representación más avanzados. El conocimiento mediatizado que tenemos de nosotros mismos, de la mano de las dudas vertidas sobre el concepto tradicional de un yo coherente o unido, prácticamente ha borrado del mapa el objetivo de lograr un "parecido".

Hace ya algún tiempo que se reconoce el efecto de la mirada como fuerza activa y modificadora de la representación. Michael Fried señalaba en *Absorption and Theatricality: Painting and Beholder in the Age of Diderot* los problemas inherentes al acto básico encarnado por el retrato: una presentación del modelo destinada a ser contemplada.[1] En consecuencia, ya en el siglo dieciocho, el retrato como género era incapaz de cumplir el requisito que exigía que el cuadro negara o neutralizara la presencia del espectador. Si el prolongado proceso de observación necesario para llegar a pintar un retrato impedía impregnar el género de una mínima veracidad (la presentación no teatral del yo), la aparición de la fotografía planteó la posibilidad de atrapar un instante de franqueza involuntaria. Muchos fotógrafos de principios del veinte se propusieron captar a individuos que no fueran conscientes de que se los observaba. Inmortalizado en la calle, absorto en sus pensamientos, sumido en cualquier juego o acción, el retratado debía revelar un carácter que, de otro modo, se perdía en el resplandor del objetivo. Susan Sontag afirmaba en *Sobre la fotografía*: "Hay algo en la cara de la gente cuando no sabe que la están observando que nunca aparece en caso contrario."[2] El encantamiento de la fotografía con esa idea de la documentación secreta de la realidad ha dado lugar a un considerable conjunto de obras, pero la relación entre observador y sujeto no observado ha sido blanco de críticas, entre otras cosas por hacer hincapié en la acción diestra del fotógrafo, al que se atribuye la capacidad de identificar y aprehender una "verdad" que de otro modo nos resulta esquiva. Quizá en parte como consecuencia de ello, se ha producido un regreso evidente al retrato frontal en el cine y la fotografía en las dos últimas décadas. El encuentro directo entre modelo y productor y las distintas formas de orquestarlo – desde la observación neutral hasta la relación personal empática – caracterizan la obra de artistas que van de Thomas Ruff a Rineke Dijkstra, y de Phil Collins a Catherine Opie.

Si tenemos en cuenta la compleja historia del retrato, podría sorprendernos que Candice Breitz haya decidido adentrarse en un territorio tan contradictorio. Su obra hasta la fecha se ha destacado por un análisis del sujeto en relación con las tecnologías y los sistemas de representación. Como consecuencia de su examen de la relación entre el mundo del espectáculo y el desarrollo psico-social del individuo, la producción de Breitz se ha entendido, por lo general, como una crítica al efecto totalizador del primero.[3] Casi todos los estudios críticos sitúan la obra de la artista en la tradición surgida con la visión optimista del potencial de las tecnologías de reproducción mecánica que ofrece Walter Benjamin. En *La obra de arte en la época de su reproductibilidad técnica,* el autor preveía una nueva forma de subjetividad en sincronía con las últimas tecnologías. El cine debía liberar a hombres y mujeres de los confines de sus espacios privados y darles paso a una esfera colectiva. De acuerdo con los ideales socialistas de Benjamin, el cine podía re-estructurar la subjetividad misma y modificar la experiencia individual para alcanzar una percepción colectiva energizada.[4]

Jessica Morgan

A Scripted Life

[1] Michael Fried, *Absorption and Theatricality: Painting and Beholder in the Age of Diderot.* Berkeley: University of California Press, 1980.

[2] Susan Sontag, *On Photography.* New York: Farrar, Straus and Giroux, c. 1977; p. 37.

[3] See for example, Christopher Phillips, "Candice Breitz: Four Installations" in Renate Plöchl & Martin Sturm (editors), *Candice Breitz: Cuttings.* Linz: O.K Center for Contemporary Art Upper Austria, 2001; Nicolas Bourriaud, *Postproduction.* New York: Lukas & Sternberg, 2002; and Marcella Beccaria (editor), *Candice Breitz.* Rivoli & Milan: Castello di Rivoli Museo d'Arte Contemporanea & Skira Editore S.p.A., 2005; where her technique of cutting and editing mainstream media is interpreted as an attack on the "sequences and chains that are essential to spectacle" (Bourriaud).

[4] Walter Benjamin, "The Work of Art in the Age of Mechanical Reproduction" in Hannah Arendt (editor), *Illuminations* (translated by Harry Zohn). New York: Schocken Books, c. 1968.

The portrait has suffered considerable critique in recent years; a variety of reasons account for its decline in efficacy as a genre. The celebratory or self-aggrandizing qualities of the portrait or self-portrait – the foundations of the genre – have become ironic or playful in contemporary art. Most troubling for the portrait, however, is the drastic mediation of advanced technologies and systems of representation. Our mediated self-knowledge, in tandem with doubts about the traditional notion of a coherent or united self, has all but obliterated the objective of capturing "likeness."

The effect of the gaze has been acknowledged as an active and altering force in representation for some time. Michael Fried, in *Absorption and Theatricality: Painting and Beholder in the Age of Diderot,* pointed out the problems inherent in the basic action depicted in a portrait: the sitter's presentation of himself or herself to be beheld. As a result, even in the eighteenth century, portraiture as a genre was unable to comply with the demand that a painting negate or neutralize the presence of the beholder. If the lengthy process of observation required for portrait painting failed to achieve any notion of verity in portraiture (the un-theatrical presentation of self), the emergence of photography suggested the possibility of achieving a moment of inadvertent candor. Many early twentieth-century photographers set out to capture the subject unknowingly observed. Shot in the street, absorbed in thought, engaged in play or action, the subject was said to reveal a character that was otherwise lost in the glare of the camera lens. Susan Sontag, in *On Photography,* claimed that, "there is something on people's faces when they don't know they are being observed that never appears when they do."[2] Photography's enchantment with this idea of secretly documenting reality has produced an extensive body of work, but the relationship of observer/unobserved has been open to critique for, among other things, emphasizing the skillful action of the photographer, who is credited with an ability to identify and capture an otherwise elusive "truth." Perhaps in part as a result of this, there has been a notice-able return to the frontal portrait in film and photography of the last two decades. The direct encounter between subject and producer and the various ways in which this meeting is orchestrated – from neutral observation to empathetic acquaintance – characterizes the work of artists from Thomas Ruff to Rineke Dijkstra and from Phil Collins to Catherine Opie.

Given this complex history of the portrait, it is perhaps surprising that Candice Breitz should attempt to take on this conflicted territory. Breitz's work to date has been foregrounded by an analysis of the subject in relation to technologies and systems of representation. As a result of her examination of the relationship between entertainment culture and the psycho-social development of the individual, Breitz's work has in general been read as a critique of the totalizing effect of the entertainment industry.[3] Most critical studies situate Breitz's production in the lineage that originates with Walter Benjamin's optimistic vision for the potential of technologies of mechanical reproduction. In *The Work of Art in the Age of Mechanical Reproduction,* Benjamin envisions a new form of subjectivity, in sync with the latest technologies. Film was to release men and women from the confines of their private spaces and into a collective realm. In accordance with Benjamin's socialist ideals, film could restructure subjectivity itself, changing damaged individual experience into an energized collective perception.[4] The subject of critique by Theodor Adorno and the Frankfurt School and continuing today in the work of Benjamin

Objeto de crítica por parte de Theodor Adorno y la Escuela de Frankfurt, la percepción crítica imperante de la visión liberadora de Benjamin, que sobrevive hoy en la labor de Benjamin Buchloh y otros autores, es que las tecnologías han servido, por el contrario, para provocar la aparición de un control total, vinculado inexorablemente a las exigencias del consumo y el capitalismo. Estamos atrapados en ese sistema totalizador de consumismo y somos totalmente incapaces de huir de él.

En general, se ha considerado que la obra de Breitz se adhiere a una invectiva contra las fuerzas dominantes del mundo del espectáculo. De ser así, ¿dónde encajan sus recientes retratos de personajes famosos? Para su reanimación o re-autentificación del género, la artista ha elegido figuras tan sumamente sobre-condicionadas por su categoría mediática que la sola idea de captar algo que permita conocer mínimamente mejor su personalidad no parece en absoluto realista. De forma quizá más polémica, puede parecer, al menos a simple vista, que los retratos recientes de Breitz sugieren un resultado distinto a lo que indicaba su obra anterior, en cuanto a la relación del individuo con la cultura de masas. En lo que semejaría una inversión del desapacible panorama esbozado por la Escuela de Frankfurt, puede establecerse que Breitz aboga en su serie de retratos por una fuerza potencialmente liberadora dentro de la recepción de la cultura comercial.

¿Cómo afronta la artista, pues, el complejo proceso destinado a lograr el "parecido" en sus retratos? Hasta la fecha ha realizado cuatro de cantantes contemporáneos. El primero, *Legend (A Portrait of Bob Marley)* (2005) es una recreación del disco póstumo *Legend* del artista de *reggae* a cargo de treinta jamaicanos. A este le siguió *King (A Portrait of Michael Jackson)* (2005), una instalación de dieciséis canales con sendas interpretaciones del disco *Thriller* grabadas en Alemania; en *Queen (A Portrait of Madonna)* (2005), treinta italianos cantaban el recopilatorio *The Immaculate Collection;* y el más reciente ha sido *Working Class Hero (A Portrait of John Lennon)* (2006), producido en Newcastle con un grupo de veinticinco intérpretes británicos que han cantado el disco de Lennon en solitario *Plastic Ono Band*. Cada retrato se ha ajustado a un marco conceptual bastante riguroso que recuerda las condiciones determinadas para una prueba o análisis casi científicos: varios cantantes re-interpretan todo un álbum siguiendo el orden original de los temas (de modo que cada obra tiene la misma duración que el disco en sí); los artistas se eligen en función de su autenticidad como fans, no por su aspecto ni por sus cualidades vocales, actorales o rítmicas; se permite que las actuaciones se desarrollen de forma individual, sin apenas interferencias directivas de Breitz, y en la instalación final se ve a cada participante en un monitor o pantalla independiente, situado junto a los demás reinterpretando el mismo disco.

Las ambiciones de Breitz al realizar estas obras son diversas. En primer lugar, como se indica en el título de cada pieza, la artista crea un retrato de una estrella. En él no aparece el famoso por ninguna parte, sino que está confeccionado a base de varias representaciones individuales de sus seguidores que se convierten en retratos de los distintos participantes. Tiene también trascendencia en cada obra el lugar de grabación, ya que arroja luz sobre las características concretas de la región en cuestión y sobre la relación de sus habitantes con la figura protagonista. Por último, tenemos un retrato, o más bien un estudio semi-antropológico, de un grupo o segmento de población conocido como aficionados, "fans" o seguidores.

Buchloh and others, the prevailing critical perception of Benjamin's emancipatory vision is that technologies have instead served to bring about a total control, linked inexorably to the demands of consumption and capitalism. Trapped within this totalizing system of consumer culture, we are incapable of affecting any escape.

Breitz's work has in general been read as adhering to a critical polemic against the dominant forces of entertainment culture. What then are we to make of her recent portraits of celebrities? For her reanimation or re-authentication of this genre, Breitz has chosen figures so totally over-determined by their media status, that the idea of capturing anything approximating what might constitute an insight into their personalities seems utterly unrealistic. More controversially perhaps, her recent portraits can, at least at first glance, seem to suggest an alternative outcome for the individual's relationship to popular culture than that suggested by her earlier work. In an apparent reversal of the bleak outlook of the Frankfurt School, Breitz may be read to be arguing in her series of portraits for a potentially liberating force within the reception of commercial culture.

So how does Breitz set about the complex process of achieving "likeness" in her portraits? The artist has thus far produced four portraits of pop stars. The first, *Legend (A Portrait of Bob Marley)* (2005) is a re-enactment of the eponymous and posthumous Marley album by thirty Jamaicans. This was followed by *King (A Portrait of Michael Jackson)* (2005), a sixteen-channel installation of as many interpretations of the Thriller album, shot in Germany; *Queen (A Portrait of Madonna)* (2005), thirty Italians singing *The Immaculate Collection* album; and most recently *Working Class Hero (A Portrait of John Lennon)* (2006), produced in Newcastle with a cast of twenty-five predominantly British performers re-singing Lennon's solo album *Plastic Ono Band.* Each portrait has followed a rigorous conceptual framework that suggests the type of conditions established for a quasi-scientific test or analysis: the re-enactment by multiple singers of the entire album in the order of play (each work thus running as long as the album itself); performers are selected for their authenticity as fans rather than for their appearance or their ability to sing, act or dance; the performances themselves are allowed to take place individually with almost no directorial interference from Breitz; and for the final installation, each performer is visible on an identical individual monitor or screen, displayed adjacent to all other participants re-enacting the album.

Breitz's ambitions for these works are manifold. Firstly, as stated by the title of each work, she creates a portrait of a star. This portrait does not in fact feature the celebrity at all but is made up of multiple individual performances by fans. These solo acts become portraits of the different personae of the fans involved. Of additional import in each portrait is the location of the shoot, which offers insight into the particular characteristics of the given region and its population's relationship to the subject of the portrait. And finally, we have a portrait, or rather a quasi-anthropological study, of a group or classification that is the "fan" or enthusiast.

5 Roland Barthes, "La muerte del autor," en *El susurro del lenguaje. Más allá de la palabra y la escritura* (traducción de C. Fernández Medrano). Barcelona: Ediciones Paidós Ibérica, 1994.

Ocupémonos del cantante elegido para cada obra. La definición de "retrato" que hace Breitz es quizá un ejemplo extremado de lo que Roland Barthes ha dado en llamar texto "autoral": una lectura o un retrato del personaje famoso que consiste en su totalidad en interpretaciones del lector (a cargo de los grupos de seguidores hallados por la artista).[5] La lectura que hace Breitz del "retrato" sugiere, pues, que la representación del cantante es un reflejo de nuestra concepción o una proyección de ese personaje. Como si fuera un holograma, la tridimensionalidad que nos parece apreciar en la personalidad del famoso es resultado de su mediatización y, ante todo, nuestro propio acto de proyección o análisis. En las piezas de Breitz, el complejo efecto de la mirada (de aficionado a cantante, de cantante a cámara, de cámara a cantante y de nuevo a aficionado) parece haberse acelerado tanto que se ha perdido el control del volante, de modo que en la práctica el proceso de identificación ha borrado al famoso. Sus seguidores lo han fagocitado, y su interpretación del personaje público se convierte en el acto transformador que le permite existir. Se trata quizá del retrato más auténtico de un sujeto célebre que podría obtenerse: una amalgamación de nuestras distintas formas de identificación con la realidad prácticamente inexistente de una estrella de la canción.

De todos modos, el fan que actúa en las obras de Breitz no es un mero sustituto del escurridizo famoso. Y tampoco sugiere la pieza que esa identificación profunda con el icono mediático suponga una total renuncia a la individualidad. Si bien un encuentro inicial con cada una de estas obras multicanal, con esos retratos *a capella* cantados por un máximo de treinta intérpretes de forma simultánea, puede hacer pensar en una masa indiferenciada de impostores, no tardan en salir a la luz las idiosincrasias de cada uno de los participantes. Aunque la fuerza dominante de la cultura de masas haya hecho accesible o inevitable la exposición a la influencia del cantante, la forma en que se utiliza posteriormente dicha influencia varía de forma sorprendente. Entre los intérpretes de *King (A Portrait of Michael Jackson),* por ejemplo, nos encontramos no sólo con los esperados sombreros de ala negros, los guantes desparejados y las cazadoras de cuero que relacionamos con el atuendo del Jackson que conocemos, sino también con la ropa informal y bien planchada de un oficinista, el vestido de lentejuelas de una mujer que baila la danza del vientre durante toda su actuación y la dolorosa inseguridad del pelo rapado, los *piercings* y los tatuajes de un adolescente. Las diferencias en cuanto a la forma de bailar, al momento de hacerlo o incluso a si hacerlo o no, en cuanto a seguir la voz principal o los coros, o en cuanto a cómo comportarse en las pausas entre canciones, y la mayor animación o el mayor interés en la interpretación en función de canciones o frases concretas se entienden en esencia como rasgos de la personalidad. Todos los participantes son plenamente conscientes de la presencia de la cámara y, además, se entregan a la interpretación de un producto ajeno (o incluso una personalidad ajena). Sin embargo, casi parece que tal acto de suma inseguridad que, cabe destacar, se prolonga durante un período relativamente largo de 42 minutos y 20 segundos (la duración total del disco), permite la aparición de un complejo grupo de retratos. Breitz confiere una gran importancia a la función de los medios de comunicación y a la intranquilidad que puede provocar el objetivo, y la exageración de esos mismos efectos, que por lo general se considera que impiden profundizar en busca de resultados, da pie de forma inesperada a un retrato íntimo de los dieciseis participantes. El acto de la interpretación, en este caso también una manifestación exagerada de la identificación del fan, parece convertirse en una fuerza liberadora, que, en lugar de apagar la personalidad, permite que surja ante el objetivo. La estructura cuadriculada de la vídeo-instalación, que nos invita a contemplar las actuaciones

Roland Barthes, "The Death of the Author" in Stephen Heath (editor & translator), *Image, Music, Text.* New York: Hill and Wang, c. 1977.

To begin with the star of each work, Breitz's definition of "the portrait" is perhaps an extreme example of what Roland Barthes has called a "writerly" text: a reading or portrait of the celebrity that consists entirely of the interpretations of the reader (as performed by Breitz's communities of fans). Breitz's interpretation of a "portrait" thus suggests that the star's representation is a reflection of our own understanding or projection of that character. Like a hologram, the three-dimensionality that we think we see in the celebrity persona is a result of mass mediation, and above all of our own act of projection or construal. The complex effect of the gaze (from fan to star, from star to camera, from camera to star and back to fan) seems to have hurtled out of control in Breitz's portraits such that the star has in fact been erased through the process of identification. The celebrity is literally embodied by the fans, and their understanding of the persona of the star is the transformative act that enables the star to exist. Perhaps this is the most authentic portrayal of a celebrity possible: an amalgamation of our various forms of identification with the virtually non-existent reality of the star.

The performing fan in Breitz's work is, however, not merely a surrogate for the elusive celebrity. Nor does the work suggest that this extreme identification with the media icon involves a total relinquishing of individuality. While an initial encounter with each of these multi-channel works, with their *a capella* portraits sung by up to thirty performers simultaneously, may suggest an undifferentiated mass of impostors, it is not long before the idiosyncrasies of each participant begin to emerge. While the dominating force of popular culture may have made accessible or inevitable the exposure to the pop star's influence, the manner in which this influence is then used is strikingly various. Among the performers of *King (A Portrait of Michael Jackson)* for example, we see not only the expected black trilbies, single-gloved hands and leather biker-jackets that we associate with the guise of Jackson himself, but also the well-pressed, casual attire of an office worker, the sequined costume of a woman who belly dances her way through the performance, and the painful self-consciousness of an adolescent's cropped hair, piercings and tattoos. The difference in dance styles, when and if to dance, whether to follow the lead or backing vocals, or how to behave between tracks, and the increased animation of performance for particular songs or lines are all eminently readable as character traits. Each participant is acutely aware of the camera's presence and is moreover involved in the act of performing someone else's product (or even personality). And yet it seems almost as if this extreme act of self-consciousness, which importantly lasts for the relatively long period of 42 minutes and 20 seconds (the full duration of the original album), allows for the appearance of a complex group of portraits. Breitz's very foregrounding of the role of the media and the potentially stultifying effect of the camera lens, an exaggeration of those very effects that are in general acknowledged to prevent any real insight, unexpectedly results in an intimate portrait of the sixteen performers. The act of performance, which in this case is also an extreme manifestation of the fan's identification, itself appears to serve as a liberating force that, rather than diminishing personality, allows for its emergence under the glare of the camera itself. The grid-like structure of the video installation, by means of which we are invited to view the scripted performances side by side, works only to exaggerate the differences between the individual fans. In the tradition of other typological studies (from August Sander to Rineke Dijkstra), it is ultimately the differences that become apparent, rather than the social group's cohesion. The drone-like behavior expected of the fan as a consummate consumer is here trans-

pautadas una al lado de la otra, logra exagerar las diferencias existentes entre los participantes individuales. Siguiendo la tradición de otros estudios tipológicos (de August Sander a Rineke Dijkstra), al final son las diferencias las que salen a la superficie, y no la cohesión del grupo social. El comportamiento de rebaño que se espera del aficionado como consumidor consumado se transforma aquí de tal modo que, hecha la excepción de la presencia física de la estrella, se pone en primer término el acto de la interpretación creativa y surge la individualidad del fan.

No obstante, puede que una interpretación de los retratos que apunte a una hendidura o una brecha en el proceso de mercantilización cultural sea al mismo tiempo optimista y poco realista. Breitz ha hablado con interés de los equivalentes caseros de sus retratos que ha visto en *YouTube,* cantados por un público internacional de *ciberfans* deseosos de expresarse y de manifestar sus preferencias por determinados cantantes y temas. Se trata en su mayoría de consumidores adolescentes de puntos distantes del planeta que aportan exploraciones personales de las canciones que comparten como idioma común. La música *pop,* lengua franca comercial del siglo veintiuno, hace posible una comunicación intercultural que haría las delicias de los esperantistas más optimistas acelerada por Internet. Sin embargo, aunque podría desde luego defenderse que se aprecia una grieta en el mecanismo por lo demás perfecto del dominio cultural, debida a la interpretación y la redistribución incesantes de ese material por parte de sus usuarios, debemos preguntarnos cuánto va a durar. Es inevitable que tales momentos de emancipación sean re-asimilar por el proceso de mercantilización del que han logrado zafarse de forma momentánea. El éxito de *YouTube,* que en sí depende, por descontado, de la tecnología comercializable, ha generado ya, sin duda, una lista interminable de productos y programas que, de un volantazo, devuelven los actos independientes de los usuarios de la cultura de masas al sector empresarial del espectáculo. Es posible, del mismo modo, que los aficionados que cantan en los retratos de Breitz hayan encontrado un modo de comunicarse a través de su afiliación con Michael Jackson, pero no podemos llegar a considerarlo en absoluto una emancipación efectiva. Las frases pautadas que recitan son un claro indicador de las limitaciones que se encuentra la invención personal entre los seguidores de los ídolos de la cultura *pop.*

Más importante quizá que la forma en que los retratos de Breitz sondean las posibilidades y las limitaciones de la creatividad individual en el contexto de la cultura de masas, sea el regreso a un tema que la artista lleva ya algunos años analizando en su obra: la complejidad de la mente humana y su construcción y articulación mediante el lenguaje. Resulta de una coherencia absoluta con la labor de Breitz hasta el momento el que estos retratos sean cantados. La letra de las canciones (más que una imagen singular) demuestra la presencia de la estrella. Los participantes se presentan a través de las palabras del "otro", y a menudo en una lengua que no es la suya. No haber retocado ni la voz ni a los personajes es un rasgo típico de la obra de Breitz, que ha explorado a fondo el concepto de que la unidad del yo no es nunca un hecho reconocido. En su producción detectamos una conciencia constante de que la construcción de la propia identidad es un proceso de duración indefinida y de que el sujeto que experimenta se desarrolla sólo en relación con las tecnologías y los sistemas de representación y repetición. El yo surge, en la obra de Breitz, como zona de fricción en la que actúan fuerzas antagonistas. En la serie que nos ocupa, esto es sugerido, por un lado, por el sujeto que da título al retrato y que existe principalmente como voz incorpórea

formed such that, minus the physical presence of the star, the act of creative interpretation is fore-grounded and the individuality of the fan emerges.

But perhaps an interpretation of the portraits as identifying a gap or chink in the process of cultural commodification is both too optimistic and unrealistic. Breitz has spoken animatedly of watching the homemade equivalents of the portraits she has produced on *YouTube,* as sung by a global audience of online fans, eager to express themselves and their affiliations with various celebrities and songs. Predominantly teenage consumers, from far and wide, offer personal explorations of the music they share as a common language. Popular music, the commercial *lingua franca* of the twenty-first century, allows for a cross-cultural communication of the sort Esperanto enthusiasts could only dream of, accelerated by Internet communication. But while it may indeed be arguable that some crack in the otherwise seamless mechanism of cultural domination is identifiable in the relentless interpretation and redistribution of this material by its users, one wonders how long this will last. Inevitably such moments of emancipation are incorporated back into the process of commodification from which they managed to momentarily escape. *YouTube's* success, itself of course reliant on forms of marketable technology, has no doubt already spawned an endless array of products and programs, wrenching the independent actions of popular culture users back into the business of entertainment. The fans who perform in Breitz's portraits may similarly have found some means of communication through their affiliation with Michael Jackson, but this hardly constitutes an effective emancipation. Their scripted lines are a clear indicator of the limitations that are set for self-invention in the realm of fandom.

Perhaps more significant than the way Breitz's portraits probe the potential and limitations of individual creativity within the realm of mass culture, is their return to a subject that her work has analyzed for some years now: the complexity of the human mind and its construction and enunciation through language. It is entirely consistent with Breitz's work so far that these portraits are sung. Words (rather than a singular image) establish the presence of the star. The participants present themselves through the words of an "other," and often in a language that is not their mother tongue. The unfixing of voice and persona is typical of Breitz's work, which has thoroughly explored the notion that unity of self is never a given. There is a constant awareness in her work, that the construction of self-identity is an open-ended process, and that the experiencing subject develops only in relation to technologies and systems of representation and repetition. The self emerges, in Breitz's work, as a zone of friction in which antagonistic forces are at play. Within the series of portraits, this is suggested on the one hand by the titular subject of the portrait existing primarily as a disembodied voice that is the product of a conglomerate of diverging interpretations and, on the other, by the individual fans who collectively comprise the projected portrait, here condemned to performing their own self-identities through the guise of an idol. The lyrics that they sing are not their own (indeed, in many cases they were not even written by the pop star), such that the notion of an authentic, centered individual is fractured and further exaggerated by the presence of multiple competing voices uttering the same words. Many voices speak through the same mouth, or is it the same voice through many mouths? Breitz's work interrogates the notion of the coherent self by liberating the voice from the construct of a normalized or narrative representation of communication or self-expression.

producto de un conglomerado de interpretaciones divergentes, y por otro, por los individuos seguidores de cada cantante, que de forma colectiva componen el retrato proyectado, aquí condenados a interpretar sus propias identidades íntimas mediante el disfraz de un ídolo. Las palabras que cantan no son suyas (en realidad, en muchos casos ni siquiera las ha escrito el intérprete original), de modo que el concepto de individuo auténtico y centrado queda fracturado y aún más exagerado por la presencia de muchas voces que compiten repitiendo las mismas palabras. Muchas voces hablan por la misma boca, ¿o es la misma voz la que habla por muchas bocas? La obra de Breitz pone en duda la noción del yo coherente liberando la voz de la construcción de una representación narrativa o normalizada de la comunicación o la expresión personal.

La negativa a retocar la identidad es una constante en toda la obra de Breitz, y vale la pena estudiar si su preocupación por la relación poco firme entre subjetividad y lenguaje puede tener una raíz biográfica. Nacida y criada en Sudáfrica, Breitz ha hablado de la experiencia, alarmante y desconcertante, que supuso darse cuenta de pequeña de que en la mayoría de los casos era incapaz de comunicarse más que de un modo rudimentario con sus compatriotas, que en su gran mayoría no compartían su idioma materno. El cese abrupto de familiaridad expresiva resultante, al empezar a comprender que el lenguaje – o, en concreto, la falta de un idioma común – podía provocar una fisura de tal magnitud, ha desempeñado sin duda un papel destacado en la larga fascinación de la artista por la relación entre lenguaje y sujeto humano. Breitz hace la siguiente reflexión: "De niña, en Sudáfrica, me percaté vagamente de que el lenguaje funcionaba más como muro que como puente. Además de asegurarse de que los sudafricanos estuviéramos divididos en función de la raza, el gobierno se encargaba astutamente de que existiera una segmentación lingüística (en el colegio se enseñaba sólo la lengua materna, de modo que no había posibilidad de entenderse o comunicarse en otras). Dado que en Sudáfrica hay once idiomas, el espacio público estaba dominado por un amasijo lingüístico bastante babilónico – era perfectamente posible estar en el supermercado, el parque o la parada del autobús, rodeada de compatriotas, y no entender ni una palabra de lo que decían. Para mí, ésa era quizá la más artera de las muchas normas de 'división y gobierno' del *Apartheid,* en el sentido de que es poco probable que se produzca un motín entre una tripulación que no puede comunicarse de forma eficaz entre sí."

La artista ha regresado al proceso de inscripción de la identidad a través del lenguaje una y otra vez. *Babel Series* (1999), la primera de sus vídeo-instalaciones multicanal y la obra que podría decirse sirvió para lanzar su carrera, se presentó por primera vez en la Bienal de Estambul de 1999, y quizá es la que mejor recoge el trauma lingüístico que experimentó Breitz en Sudáfrica. Siete monitores presentan a sendos iconos de la música *pop* (de Freddie Mercury y Grace Jones a Madonna y Prince), que a simple vista interpretan un extracto de un vídeo musical reconocible. Sin embargo, se han reducido sus actuaciones de forma brutal a sonidos monosilábicos que se repiten en bucles infinitos. Prince tartamudea continuamente "ye, ye, ye...", mientras Madonna alega de forma incesante "pa, pa, pa...", etcétera. El volumen exagerado y la sofocante proximidad de los siete monitores, todos ellos instalados en un único espacio, provocan una cacofonía casi insoportable de balbuceos absurdos. Se ha hablado mucho de los ruidos pueriles a los que han quedado reducidas las palabras de los cantantes. Ese estado pre-lingüístico hace referencia tanto al consumo pasivo de cultura comercial como a nuestra aceptación homogeneizante de su lenguaje y su mensaje limitados. Al hablar de la instalación concreta de esa obra en Estambul – su primera contribución a una gran exposición

The unfixing of identity occurs throughout Breitz's work. It is worth examining whether her preoccupation with the slippery relationship between subjectivity and language may have a biographical root. Born and raised in South Africa, Breitz has described the alarming and discombobulating experience of coming to the realization, at an early age, that she was more often than not unable to communicate beyond a basic level with other South Africans, the large majority of whom did not share her mother tongue. The abrupt cessation of expressive familiarity that this entailed, with the onset of an understanding that language – or the lack of a common tongue – could result in such a complex fissure, has no doubt some large part to play in the artist's ongoing fascination with the relationship between language and the human subject. She has stated: "As a child growing up in South Africa, I was numbly aware of the fact that language was functioning more like a wall than like a bridge. In addition to ensuring that South Africans were racially divided, the government cunningly ensured that we were linguistically divided (you were only taught in your mother tongue at school, so there was no chance of understanding or communicating in other languages). Given the fact that South Africa has eleven languages, this meant that public space was governed by a somewhat Babylonian mash of language – it was absolutely possible to be in a supermarket or a park or at a bus stop, and to have fellow South Africans talking all around one, without being able to understand a single word. This was, in my opinion, perhaps the most devious of Apartheid's many 'divide and rule' policies, in the sense that mutiny is unlikely amongst crew members who can't communicate effectively with each other."

The process of the inscription of identity through language is one that Breitz has returned to over and over again. *Babel Series* (1999), the first of her multi-channel video installations and the work that arguably launched her career, was first installed at the Istanbul Biennial in 1999, and perhaps comes closest to embodying the type of linguistic upheaval that Breitz experienced growing up in South Africa. Seven monitors feature as many icons of pop music (from Freddie Mercury and Grace Jones to Madonna and Prince), each apparently performing an excerpt from a recognizable music video. But Breitz has brutally edited down their performances to monosyllabic utterances that are repeated in endless loops. Prince continuously stutters "ye, ye, ye..." while Madonna incessantly pleads "pa, pa, pa..." and so on. The extreme volume and stifling proximity of the seven monitors, all installed in a single space, brings about an almost unbearable cacophony of nonsensical babble. Much has been made of the infantile noises that the stars' utterances are reduced to. This pre-linguistic state signifies both the passive consumption of popular culture and our homogenizing acceptance of its limited language and message. Speaking about the specific installation of this work in Istanbul – one of her first contributions to a major international exhibition that took place beyond the mainstream, English-speaking art context – Breitz has remarked on her desire to make a work with potentially global meaning. How better to do this than with the nigh-universal expressions of pop music? Returning to Breitz's comments regarding the impossibility of communication in South Africa, however, we must evaluate what this supposedly universal language articulates. A discourse limited to the *clichéd* refrains of the most standard pop music is unlikely to offer the opportunity for complex understanding of or between cultures. The limited emotional and expressive content instead affords us the ability to bask momentarily in the shared associations of a love song or rock anthem, while following a script that

internacional organizada fuera de los grandes circuitos artísticos de habla inglesa – Breitz subrayó su deseo de realizar una obra con un significado potencialmente mundial. ¿Qué mejor forma de conseguirlo que con las expresiones casi universales de la música *pop*? No obstante, si recuperamos las observaciones de Breitz sobre la imposibilidad de la comunicación en Sudáfrica, debemos evaluar qué expresa ese lenguaje supuestamente universal. Un discurso limitado a los estribillos manidos de la música *pop* más convencional difícilmente ofrecerá la oportunidad de lograr un entendimiento complejo de las culturas o entre ellas. El contenido limitado desde el punto de vista emocional y expresivo nos permite, de todos modos, disfrutar de forma momentánea de las asociaciones compartidas de una canción de amor o un conocido tema de *rock,* siguiendo un guión que garantiza que el resultado no termine siendo inesperado. La lengua franca que se nos presenta en este caso es completamente superficial, como confirman los tartamudeos de los ídolos del *pop* de Breitz.

La artista suele hacer referencia en su obra al concepto que ella misma denomina "una vida pautada" – nuestra inevitable absorción del lenguaje y la conducta mediante la exposición a los medios de comunicación. En este caso el lenguaje es titubeante, incompetente y posiblemente alienante, en lugar de brindar un estado de comunicación liberada. Podría hacerse una comparación con la obra de una serie de artistas contemporáneos, desde Bruce Nauman hasta Eija-Liisa Ahtila, cuya producción ha regresado de modo similar y con insistencia, siguiendo la tradición de la interrogación del yo coherente a la que Samuel Beckett dedicó toda una vida, a la voz y a su relación con la mente potencialmente conflictiva. A pesar de constituir el medio principal de toda comunicación, el lenguaje resulta en el fondo inadecuado cuando se pretende encontrar una explicación al funcionamiento de la mente humana. Al igual que las de Nauman y Ahtila, las obras de Breitz se sirven de la voz incorpórea, que ocupa el cuerpo de forma repetitiva e incesante. Liberar la voz de ese modo permite hasta cierto punto plasmar la compleja relación entre el lenguaje y el proceso de individualización.

Karaoke (2000), por ejemplo, es una instalación de diez canales para la que Breitz solicitó a diez inmigrantes de Nueva York muy distintos que interpretaran en un karaoke *Killing Me Softly,* la canción sentimental que grabó originalmente Roberta Flack en 1973 y después versionó Lauryn Hill con The Fugees en 1996. Ninguno de los participantes en el *Karaoke* de Breitz es hablante nativo de inglés; algunos apenas tiene conocimientos básicos de la lengua (en concreto, uno tiene que recurrir a los silbidos para seguir la melodía, ya que no logra leer el texto de la pantalla). Instalada de acuerdo a una configuración circular, la obra obliga al espectador a colocarse en el centro para ver los monitores, que reproducen las imágenes en bucle, pero sin sincronizar, de modo que concentrarse en una sola voz requiere un enorme esfuerzo. Las miradas de los cantantes recorren a toda velocidad las pantallas en las que leen la letra de la canción, que acto seguido surge de sus labios de una forma extraña y desconcertante. El texto pone de relieve descaradamente las consecuencias de una cultura de masas y una economía globalizada dominadas por el inglés: "dulcemente me mata con sus palabras, dulcemente me mata…"

Los individuos a los que recurre Breitz tampoco salen muy bien parados cuando se expresan en su idioma materno, y una serie de obras de la artista, que se centran no obstante en la relación del espectador con

guarantees no unexpected outcome. The *lingua franca* on offer here is entirely superficial, as Breitz's stuttering pop stars confirm.

The notion of what Breitz calls "a scripted life" – our inevitable absorption of language and behavior through exposure to the media – is one that the artist frequently refers to in her work. Here language is hesitant, inadequate and potentially alienating, rather than proffering a state of liberated communication. A comparison to the work of a number of other contemporary artists could be made, from Bruce Nauman to Eija-Liisa Ahtila, whose work has similarly, in the tradition of Samuel Beckett's life-long interrogation of the coherent self, insistently returned to the voice and its potentially conflicted relationship to the mind. Language, though the primary means of all communication, is ultimately inadequate in the face of any explanation of the working of the human mind. Like those of Nauman and Ahtila, Breitz's works make use of the disembodied voice that repetitively and incessantly occupies the body. Liberating the voice in this way goes some way to representing the complex relationship between language and the process of individuation.

Karaoke (2000), for example, is a ten-channel installation for which Breitz asked ten diverse, immigrant New Yorkers to do a karaoke performance of *Killing Me Softly*, the sentimental hit originally recorded by Roberta Flack in 1973 and later re-released by Lauryn Hill with The Fugees in 1996. None of the performers in Breitz's *Karaoke* are native English speakers; some have only a slight grasp of the language (one in fact had to resort to whistling the song as he could not read the karaoke text). Installed in a circular configuration, the viewer must stand in the center of the installation in order to view the individual monitors, which play in a non-synchronized loop such that the ability to discern an individual voice requires a great deal of effort. The eyes of each singer move dartingly across the screens from which they read the lyrics of the song, which then emanate from their mouths with disconcerting strangeness. The lyrics blatantly highlight the effects of an English language-dominated mass culture and global economy: "killing me softly with his words, killing me softly..."

Breitz's subjects do not fare much better when articulating in their native tongue, however, and a series of works by the artist, although primarily concerned with the audience's relationship to the star, suggest the fallibility and alienation of one's own language. As in the *Babel Series*, for *Soliloquy Trilogy* (2000), Breitz took a knife to the celluloid, this time editing three well-known actors out of some of their best known roles, in each case reducing the original blockbuster down to the duration of the chosen star's vocal presence. Most striking of all is how short this total script is for each actor. Sharon Stone in *Basic Instinct* speaks for just over seven minutes; Clint Eastwood in *Dirty Harry* for just under this amount; and Jack Nicholson appears positively loquacious, clocking up fourteen minutes in *The Witches of Eastwick.* The resulting short films consist of non-linear, erratic, Tourette's-like enunciations as the protagonists speed-act their way through each film, involved in what, in Eastwood's case especially, has the feeling of a psychotic conversation with themselves. While the over-valued status of celebrity is one subject of analysis in these short films – which hilariously reveal the paucity of each performance – there is an utterly human or even humanizing side to the *Trilogy,* suggestive

6 La artista ha afirmado con respecto a los tres cortos de *Soliloquy Trilogy:* "Cada uno de ellos supone una incursión breve e incómoda en la gramática y la puntuación de la alienación del espectáculo. El trío de actores atrapados pasa a trompicones de las exposiciones informales a las proclamaciones y de ahí a las demandas para volver a la casilla de salida, sacudiéndose y retorciéndose como ciervos ante los focos de un coche que se aproxima. En ese sentido, la serie rinde homenaje a *Screen Tests* de Andy Warhol, donde la ausencia de guión, director y narrativa fuerza en ocasiones una relación directa y violenta entre un actor solitario atrapado ante una cámara y un público que trata en vano de explorar las profundidades del intérprete."

7 Por descontado, la obra de Breitz, como la de Warhol, se preocupa por la naturaleza del estrellato, pero refleja la dificultad, si no la imposibilidad, de tratar de fomentar esa búsqueda del artista a su paso. La fascinación por la fama que sentía Warhol se solapaba tanto con su propio deseo de alcanzarla (junto con la consiguiente posición económica) que funcionó desde el punto de vista artístico para producir una *Gesamtkunstwerk* sobre la naturaleza de la popularidad, el mercado, los medios y la producción artística en sí que difícilmente hallará rival.

la estrella, apuntan a la falibilidad y la alienación del lenguaje propio. Como para *Babel Series,* para *Soliloquy Trilogy* (2000) Breitz sacó las tijeras en la sala de montaje, en esta ocasión para recortar tres de las interpretaciones más conocidas de tres famosos actores y reducir la película original a la duración de la presencia vocal de la estrella en cuestión. Lo más sorprendente es comprobar lo corto que es el guión total de cada actor. En *Instinto básico,* Sharon Stone habla durante poco más de 7 minutos, y Clint Eastwood en *Harry el sucio* algo menos, mientras que Jack Nicholson parece todo un charlatán en *Las brujas de Eastwick,* con un total de 14 minutos de diálogo. Los cortometrajes resultantes consisten en articulaciones deslavazadas que hacen pensar en el síndrome de Tourette y en las que los actores recitan a toda prisa su papel en la película en lo que da la sensación de ser, sobre todo en el caso de Eastwood, un monólogo psicótico. Si bien uno de los puntos de análisis es la sobrevaloración de la fama en esos cortos – que revelan de forma hilarante las insuficiencias de las distintas actuaciones – *Trilogy* presenta un lado sumamente humano e incluso humanizante, que parece apuntar, lo mismo que las películas, hacia el monólogo interior a menudo alienante y la manifestación exterior que es resultado de la ineptitud del lenguaje a la hora de comunicar la experiencia del ser. Contemplar esos comentarios deslavazados es al mismo tiempo ser testigo de cómo sonaría nuestro monólogo interior diario si pudiéramos grabar la corriente de pensamientos inacabados y preguntas sin respuesta que son la constante de nuestra actividad mental cotidiana.

Breitz ha citado *Screen Tests* de Warhol como fuente de inspiración de *Soliloquy Trilogy,*[6] pero cuesta comprender cómo pueden relacionarse la banalidad intencionada y la quietud casi absoluta de la cámara y del intérprete de los estudios de Warhol con el montaje y la actuación frenéticos de la pieza de Breitz.[7] Lo más apremiante de la trilogía es lo que dicen los monólogos disparatados sobre la naturaleza de la comunicación lingüística y nuestra dependencia de un conjunto de respuestas emotivas preconcebidas. ¿Hasta qué punto corresponde a nuestras propias palabras la comprensión mediatizada de lo que significa estar enfadado o ser sensual o feliz? ¿Es posible utilizar el lenguaje de algún modo realmente auténtico? ¿En qué consiste la autenticidad de pensamiento o sentimiento, y cómo puede comunicarse cuando la inscripción del lenguaje exige el empleo de unos códigos tan limitados?

En la obra de Breitz, no sólo la lengua sino también los actos físicos sufren las restricciones de un guión preestablecido. No sólo tendemos a soltar banalidades preconcebidas al abrir la boca, sino que además acompañamos esos ruidos estandarizados con gestos también pautados. Antes de realizar *Becoming* (2003), Breitz estudió secuencias cortas de siete conocidas actrices de Hollywood y aprendió a reproducir fielmente las expresiones, los tics faciales, los encogimientos de hombros y los despliegues de emociones de mujeres como Julia Roberts en *Pretty Woman,* Meg Ryan en *Tienes un e-mail* o Reese Witherspoon en *Una rubia muy legal.* Cuando *Becoming* se presenta en su formato íntegro, como una instalación de catorce canales, las simulaciones de Breitz aparecen en siete monitores, cada uno de ellos emparejado con otro, la parte trasera del primero pegada a la del segundo, que rescata el fragmento original de la película, de modo que sólo se puede ver la interpretación de la actriz hollywoodiense o la de Breitz, pero no las dos a la vez. La voz de aquélla habla por las dos: el metraje original y la re-interpretación que de él hace Breitz están sincronizados a la perfección. Las actuaciones de la artista se diferencian de sus modelos por el empleo del blanco y negro, que contrasta con los colores chillones de la escena paralela, así como por la adopción

as the films are of the often alienating internal monologue and exterior utterance that is the result of the inadequacy of language to communicate the experience of being. To watch these erratic commentaries is also to witness what one might imagine our own internal daily monologue to sound like were we able to record the flow of unfinished thoughts and unanswered questions that are a constant of daily mental activity.

Breitz has referred to Warhol's *Screen Tests* as a point of inspiration for the *Soliloquy Trilogy,*[6] but it is hard to see how the intentional banality and near total stillness of camera and of subject in Warhol's studies could relate to the frenetic editing and acting of the *Soliloquy Trilogy.*[7] More pressing in Breitz's *Trilogy,* is what the nonsense monologues have to say about the nature of linguistic communication and our own reliance on a prescribed set of emotive responses. To what extent does the mediated understanding of what it is to be angry, sexy, or happy script our own words? Is it in fact possible to use language in any truly authentic manner? What is authenticity of thought or feeling, and how can it be communicated when the inscription of language necessitates the use of such limited codes?

In Breitz's work, it is not only our language that suffers from the restrictions of a set script, but our physical actions as well. Not only do we tend to utter prescribed banalities when we open our mouths, but furthermore to accompany these standardized noises with equally scripted gestures. Prior to shooting *Becoming* (2003), Breitz studied short sequences of seven well-known Hollywood actresses, in the process learning how to closely mimic the expressions, facial ticks, shrugs and emotive displays of the likes of Julia Roberts in *Pretty Woman,* Meg Ryan in *You've Got Mail!* and Reese Witherspoon in *Legally Blonde.* When *Becoming* is displayed in its full fourteen-channel installation format, Breitz's simulations are presented on seven screens, each of which is placed back to back with the original film excerpt, such that only the star's or Breitz's performance can be viewed at any given time. The voice of the Hollywood actress speaks both for the celebrity and for Breitz: the source footage and Breitz's re-performance of it are perfectly synchronized. The artist's performances are differentiated from the originals in each case by the use of black and white film, as opposed to the gaudy color of the source movies; as well as through Breitz's consistent adoption of a plain uniform of black trousers and white shirt for each take. As Jennifer Allen has observed, the consistency of Breitz's appearance and guise works to confuse the original/copy relationship, as the dominant seven-fold presence of Breitz (as opposed to the singular appearances of the seven different actresses) subtly suggests that she has in fact originated the actresses' performances, working behind the scenes to pull the strings of these marionettes on film.[9] This impression is exacerbated by the fact that the stars' voices emanate equally convincingly from Breitz's own moving lips. The apparently idiosyncratic gestures of the celebrity actresses are exposed as copy, selected from thousands of potentially available nuances that we all employ in our daily routines.

Breitz has recently turned her attention to parental roles in the double installation *Mother + Father* (2005), in which she extends her exploration of "the scripted life" to the psychologically rich terrain of learned and ascribed psychological behavior. The diptych consists of two six-channel installations

[6] Breitz has stated of the three short films in the *Soliloquy Trilogy* that, "Each is a short and uncomfortable journey into the grammar and punctuation of spectacular alienation. The trio of trapped protagonists lurch from casual utterance to proclamation to demand and back again, writhing and jerking like deer in the headlights of an oncoming car. In this sense, the series pays homage to Andy Warhol's *Screen Tests* in which the non-presence of a script, director and narrative at times forces a direct and violent relationship between a secluded actor trapped before a camera and an audience attempting in vain to probe the interior depths of this actor."

[7] Breitz's work is, of course, like Warhol's, concerned with the nature of the status of the star, but reflects the difficulty, if not impossibility, of attempting to further this artist's quest in his wake. Warhol's fascination with fame was so imbricated in his own desire to achieve the status of celebrity (along with its correlate wealth) that it functioned artistically to produce a *Gesamtkunstwerk* on the nature of celebrity, the market, media, and of artistic production itself, that is unlikely ever to be rivaled.

[8] Jennifer Allen, "Candice Breitz: From A to B and Beyond," in Suzanne Cotter (editor), *Candice Breitz: Re-Animations*. Manchester & Oxford: Cornerhouse Publications & Modern Art Oxford, 2003.

8 Jennifer Allen, "Candice Breitz: From A to B and Beyond," en Suzanne Cotter (editor), *Candice Breitz: Re-Animations*. Manchester & Oxford: Cornerhouse Publications & Modern Art Oxford, 2003.

por parte de Breitz de un uniforme sencillo consistente en pantalones negros y camisa blanca en todas las tomas. Como ha observado Jennifer Allen, la homogeneidad del aspecto de Breitz contribuye a confundir la relación entre original y copia, ya que la presencia dominante de la artista, multiplicada por siete (en contraste con las apariciones singulares de las siete actrices), sugiere con sutileza que es ella la que ha creado las interpretaciones de sus homólogas, trabajando entre bastidores para mover los hilos de las marionetas de la pantalla.[8] Esa impresión es exacerbada por el hecho de que las voces de las actrices surgen de forma igual de convincente de los labios de Breitz, que se mueven al unísono. Los gestos en apariencia idiosincrásicos de las actrices famosas quedan expuestos como copias seleccionadas de entre miles de matices disponibles potencialmente a los que todos recurrimos en nuestro quehacer diario.

Breitz ha trabajado recientemente la paternidad en la doble instalación *Mother + Father* (2005), en la que amplía su exploración de la "vida pautada" al terreno de gran caudal psicológico del comportamiento adquirido y atribuido. El díptico consta de dos instalaciones de seis canales (presentadas en espacios adyacentes), una de ellas con seis famosas madres cinematográficas (de Faye Dunaway en el papel de Joan Crawford en *Queridísima mamá* a Meryl Streep en *Kramer contra Kramer*) y otra con seis conocidos padres del celuloide (del cómico Steve Martin al macho Harvey Keitel). Recurriendo a su habitual proceso de montaje, mediante el cual de toda la cinta solamente se conserva la presencia del actor en la pantalla, con un fondo negro, Breitz sigue recortando los papeles de los actores hasta dejarlos reducidos en última instancia a su interpretación de padres emotivos. Susan Sarandon declara "¡Tú no podrías ser madre!", mientras que Streep insiste "¡Soy su madre!". Entre los hombres, Dustin Hoffman grita con agresividad "¡Maldita sea, maldita sea!" y Donald Sutherland anuncia con gran comicidad "Creo que ya sé por qué he venido... Creo que he venido a hablar de mí." La neurosis centra el comportamiento de las madres pautadas, mientras que el tono de los padres es en general de agresividad competitiva. Ellas se dedican a dar rienda suelta a su ansiedad sin cortapisas y ellos se sientan una y otra vez, dan portazos y, esporádicamente, aparecen y desaparecen de sus posiciones en la pantalla.

Esas acumulaciones de tópicos relacionados con los sexos a partir de representaciones cinematográficas de la paternidad no pueden descartarse tan fácilmente como simples perpetuaciones de esos tópicos, puesto que los retratos fraccionados del papel de madres y padres que resultan del proceso presentan un pertinaz parecido con la realidad. La cuestión que queda en el aire es, naturalmente, qué conexión existe entre nuestra recepción de la representación mediática de esas relaciones y esos papeles fundamentales y nuestra propia actuación en esos papeles en la vida cotidiana. La textura tartamudeante y vacilante tanto de la imagen como del lenguaje de *Mother + Father* — lo que la artista denomina el "tic digital" resultante de su proceso de montaje — tiene como resultado el discurso alienado que refleja con convicción el acalorado terreno psicológico de la paternidad. Van surgiendo afirmaciones, preguntas y expresiones varias de forma aparentemente incontrolable, remedando con incomodidad el campo emotivo de la interacción entre padres e hijos y la adopción de roles.

El estilo de montaje de Breitz (tanto en ese caso como en otros) exagera los cortes y desconecta los fotogramas. Su propuesta recuerda el credo fílmico materialista de defensores de ese acercamiento teórico al

(presented in adjacent spaces), which respectively bring together six well-known filmic mothers (from Faye Dunaway playing Joan Crawford in *Mommie Dearest* to Meryl Streep in *Kramer vs. Kramer*) and six familiar celluloid fathers (from the comedic Steve Martin to the macho Harvey Keitel). Performing her signature process of editing, whereby only the screen star's presence against a black background remains from the entire film, Breitz further edits down each actor's role so that each is ultimately reduced to the actor's performance as emotive parent. Susan Sarandon declares, "You couldn't be a mother!" while Streep insists, "I am his mother!" Among the fathers, Dustin Hoffman aggressively chants "God damn her, God damn her!" and Donald Sutherland hilariously states, "I think I know why I came here... I think I came here to talk about myself." Neurosis is the *modus operandi* of the scripted mothers, while the fathers' tone is in general one of competitive aggression. While the mothers are left to vent their anxiety unabated, the fathers perpetually sit down, slam doors and sporadically appear and disappear from their screen positions.

Breitz's accumulations of gendered *clichés* from filmic portrayals of parenthood cannot so readily be dismissed as mere perpetuations of those *clichés,* in that the resulting fractured portraits of mother-hood and fatherhood retain a nagging resemblance to reality. The question hanging in the air is, of course, what the connection is between our reception of the media representation of these fundamental relationships and roles, and our own performance of such roles in everyday life. The stuttering, jerking texture of both image and language in *Mother + Father* – what the artist refers to as the "digital twitch" resulting from her editing process – produces the kind of alienated utterances that are convincingly demonstrative of the heated psychological terrain of parenthood. Statements, questions and expressions issue forth in an apparently uncontrollable manner, uncomfortably mimicking the emotive ground of parent-child interaction and role-playing.

Breitz's editing style (both here and elsewhere) exaggerates the cuts and disconnects between frames. Her approach recalls the materialist film credo of such proponents of this theoretical approach to film-making as Peter Gidal. It is a given that to create narrative flow in film requires considerable editing, and the structuralist or materialist critique of commercial filmmaking's attempt to mask such a process is summarized in Gidal's declaration that, "where there is an edit, a cut, it must not be hidden."[9] In Breitz's work, the refusal to shy away from the basic structure of film – the cut – works simultaneously to suggest both the constructed nature of performance and the halting character of communication. Her brutal editing returns the cut to the film, thereby destroying any semblance of narrative flow, and additionally, given the concentration on speech acts in Breitz's body of work, affects an attack on the coherence of spoken communication.

But Breitz's work never fits entirely comfortably into such a materialist analysis. Though acutely critical of the limitations of commercial culture, her work nevertheless evinces a fascination with the experience that this culture offers. A diverging interpretation of narrative cinema to that of Gidal is revealingly offered by Stanley Cavell's 1971 book *The World Viewed: Reflections on the Ontology of Film.* While Gidal's call for the evidence of the cut and edit is one means by which to make apparent the

[9] Peter Gidal, *Materialist Film.* London: Routledge, 1989; p. 3.

9 Peter Gidal, *Materialist Film*. Londres: Routledge, 1989; p. 3.

cine como Peter Gidal. Es sabido que para crear una corriente narrativa en una cinta se hace necesario un gran esfuerzo de montaje, y la crítica estructuralista o materialista al intento del cine comercial de enmascarar ese proceso se resume en la siguiente afirmación de Gidal: "Cuando exista un corte, un montaje, no debe ocultarse."[9] En la producción de Breitz, el rechazo a huir de la estructura cinematográfica básica – el montaje – permite sugerir de forma simultánea tanto la naturaleza construida de la actuación como el carácter titubeante de la comunicación. La brutalidad de sus cortes destruye toda apariencia de corriente narrativa y, además, dada la concentración de actos del habla en la obra de Breitz, inflige un ataque a la coherencia de la comunicación oral.

De todos modos, la obra de Breitz no acaba nunca de encajar con total comodidad en un análisis tan materialista. Aunque critica con intensidad las limitaciones de la cultura comercial, su trabajo da asimismo señales de fascinación ante la experiencia que ofrece dicha cultura. Una interpretación del cine narrativo que resulta divergente de la de Gidal se ofrece de forma reveladora en el libro de 1971 *The World Viewed: Reflections on the Ontology of Film,* de Stanley Cavell. Mientras que la evidencia del corte y el montaje que solicita Gidal es un medio que permite poner de manifiesto la artificialidad de la corriente narrativa, el argumento de Cavell es que ese engaño o puesta en escena es, en realidad, un aspecto del cine que explica la intensa atracción que ejerce sobre nosotros, quizá el aspecto fundamental. Cavell sostiene que el cine satisface un ansia de reproducción mágica del mundo (un deseo que quizá ni siquiera reconocemos como propio) al permitirnos ver el mundo sin ser vistos, descargados de responsabilidad. Afirma lo siguiente: "Al ver películas, el sentido de la invisibilidad se convierte en una expresión de la intimidad o el anonimato modernos. Es como si la proyección del mundo explicara nuestras formas de desconocimiento y nuestra incapacidad de llegar a saber. La explicación no es tanto que el mundo nos deja de lado, sino que se nos desplaza de nuestra morada natural en él y se nos coloca a cierta distancia. La pantalla [...] provoca que el desplazamiento parezca nuestra condición natural."[10] Y prosigue: "El desplazamiento del mundo [provocado por el cine] confirma, e incluso explica, nuestro distanciamiento previo de él. El 'sentido de la realidad' que aporta una película es un sentido de esa realidad, de la que ya sentimos una distancia. De otro modo, aquello de lo que nos ofrece un sentido no contaría, para nosotros, como realidad."[11]

10 Stanley Cavell, *The World Viewed*. Cambridge: Harvard University Press, 1971; p. 39.

11 Íbid., Cavell, p. 226.

Del mismo modo que parece que Breitz utiliza los cortes de Gidal para hacer patente la falibilidad de la corriente fílmica, podría argumentarse que el trabajo de la artista se engarza con el concepto de cine de Cavell para ofrecer una explicación o una simulación de nuestra condición de desplazamiento. La obra de Breitz no se limita a un análisis de los efectos perniciosos de la cultura de masas, sino que también se ocupa de la complejidad de nuestra atracción por los productos del mundo del espectáculo. Como sugiere Cavell, dicha seducción no sólo revela la aspiración del espectador de amoldarse a la representación fílmica, sino más bien una forma de identificación con la propia distancia de la realidad que ya experimentamos en nuestro quehacer diario. Desde esa perspectiva, y para regresar a la serie de retratos con la que hemos empezado este análisis de la producción de Breitz, también podría sostenerse que la propia alienación de la estrella es lo que atrae al fan. No obstante, el talento de Breitz reside en su capacidad de ubicar ese distanciamiento en el mismo punto de comunicación mediante el cual aspiramos a superar esa lejanía: el lenguaje.

artificiality of narrative flow, Cavell's argument is that this deceit or staging is in fact an aspect, or even *the* aspect of cinema that explains our intense attraction to it. Cavell claims that cinema satisfies a wish for the magical reproduction of the world (a wish that we may not even recognize as our own), by enabling us to view the world unseen, free from responsibility. He writes: "In viewing films, the sense of invisibility is an expression of modern privacy or anonymity. It is as though the world's projection explains our forms of unknownness and our inability to know. The explanation is not so much that the world is passing us by, as that we are displaced from our natural habitation within it, placed at a distance from it. The screen... makes displacement appear as our natural condition."[10] He continues, "[Film's] displacement of the world confirms, even explains, our prior estrangement from it. The 'sense of reality' provided on film is a sense of that reality, one from which we already sense a distance. Otherwise the thing it provides a sense of would not, for us, count as reality."[11]

In the same way that Gidal's cuts appear to be used by Breitz to make apparent the fallibility of filmic flow, it could equally be argued that her work engages with Cavell's notion of cinema as supplying an explanation or simulation of our condition of displacement. Breitz's work is not limited to an analysis of the pernicious effects of mass culture, but is also concerned with the complexity of our attraction to the products of the entertainment industry. As Cavell suggests, this attraction is not merely characteristic of the viewer's aspiration to conform to filmic representation, but rather a form of identification with the very distance from reality that we already experience in the everyday. From this perspective, to return to the series of portraits with which I began this examination of Breitz's work, one could also argue that it is the very alienation of the star that attracts the fan in the first place. Breitz's talent, however, is in locating this estrangement in the very locus of communication through which we hope to overcome this distance: language.

10 Stanley Cavell, *The World Viewed*. Cambridge: Harvard University Press, 1971; p. 39

11 Ibid Cavell, p. 226.

Obras/Works

Podemos considerar que la primera vídeo-instalación de Candice Breitz, que data de 1999, es en muchos sentidos clave en su obra posterior, tanto por lo que tiene de exploración de la relación entre el lenguaje y la formación del sujeto como por lo que supone como robo y revisión entusiastas de la iconografía *pop*. La instalación consta de siete bucles monosilábicos y tartamudeantes, en cada uno de los cuales se roba un breve fragmento de un vídeo musical canónico que queda atrapado en su propia repetición infinita y ruidosa ante el espectador. Los bucles se reproducen de forma simultánea a gran volumen dentro de los confines de un único espacio, lo que tiene como resultado una sacudida cacofónica, una explosión de energía sonora. Los cuerpos de las estrellas secuestradas se han quedado congelados en el lenguaje, como autómatas en sus trances circulares y al mismo tiempo peculiarmente orgánicos en sus tics y sus sacudidas. Un pequeño fragmento hurtado de la canción *Papa Don't Preach* de Madonna nos la muestra gimiendo "pa, pa, pa..." Otro bucle extraído de *Bohemian Rhapsody* presenta a Freddie Mercury lamentándose "ma, ma, ma..." Por otro lado, Prince gimotea "ye, ye, ye..." mientras Grace Jones insiste "no, no, no..." Breitz extrae un cántico discordante de toda una serie de ritmos disonantes, unos balbuceos infantiles de múltiples capas que rayan en el caos más absoluto. El lenguaje se transforma en una sucesión de titubeos cuando la repetición merma el sentido y la posibilidad de lograr una comunicación coherente.

Según Martin Sturm, *Babel Series* nos devuelve "a una esfera en la que los sonidos conforman los módulos básicos de toda articulación y de todo sistema lingüístico. Las unidades de significado potencial se funden en inventarios de signos y se transforman sin jerarquía alguna en instrucciones que impulsan actos aún por realizar, aún por cobrar forma. Se trata de una esfera en la cual el significado

del sonido es variable y relativo, existe sólo fugazmente y en función de los contextos a los que corresponde. Aquí el sonido conserva la libertad de no estar inscrito en la especificidad de un sistema lingüístico. Sigue entretejido en una telaraña de inflexiones y entonaciones emocionales. Con formas que no dejan de variar, los ritmos que componen el sonido evocan de modo simultáneo la posibilidad y la imposibilidad de la comunicación universal. Cada oyente reivindica su significado de forma distinta. Los compases palpitantes no dan pie ni a una lengua franca ni a un esperanto que nos obligue a cumplir dieciseis reglas básicas para alcanzar una sintaxis internacional, sino que su falta de forma definida suscita en nosotros una conciencia crítica de nuestra segunda piel – el lenguaje – la piel que nos envuelve de forma casi claustrofóbica, la piel que se forma al rehacer y puntuar el sonido para formar palabras reconocibles, expresiones pronunciables, frases repetibles... Teniendo presente a Wittgenstein, escuchamos y observamos a esa multitud babilónica del *pop,* que lucha para liberarse del hechizo de la razón que nos ha lanzado el lenguaje."

Babel Series evoca con astucia un paralelismo entre las fases de la adquisición infantil del habla y los pasos que dan los consumidores para absorber la lengua franca de la cultura del mundo del espectáculo, masificada e internacional, de la actualidad. La reducción que hace la artista de las letras de la música *pop* a sílabas sin sentido nos recuerda el modo en el que la cultura de masas reduce a su público a un estado de infantilismo indefenso. En realidad, los sonidos repetitivos a los que recurre Breitz en esta obra no deberían considerarse balbuceos, ya que hacen referencia a la repetición intencionada de fonemas en la que se basa el significado lingüístico. No obstante, *Babel Series* parece indicar que la infantilización del receptor que perpetra la cultura de masas supone un regreso no a la felicidad

absoluta de la libertad pre-lingüística, sino al momento que marca el final de esa libertad: el momento en el que la maquinaria social del lenguaje empieza a imponer disciplina a las energías anárquicas del niño.

The first video installation by Breitz, dated 1999, in many respects remains a key to her subsequent work, both in its exploration of the relationship between language and subject-formation, and in its keen theft and revision of pop iconography. The installation consists of seven stuttering monosyllabic loops, each of which steals a fragment of footage from a canonical music video. Each of the seven fragments is trapped in repetition as it loops endlessly and noisily before the viewer. The loops are played simultaneously and at high volume within the confines of a single space, resulting in a cacophonous blast, an explosion of sonorous energy. The bodies of the kidnapped stars are frozen in language, both automaton-like in their circular trances and at the same time peculiarly organic in their twitches and jerks. A small fragment appropriated from Madonna's song *Papa Don't Preach* has her moaning "pa, pa, pa...." Another loop extracted from *Bohemian Rhapsody* has Freddie Mercury lamenting "ma, ma, ma...." Elsewhere, Prince whimpers "ye, ye, ye..." while Grace Jones insists "no, no, no...." Breitz bangs a jarring chant out of a series of dissonant beats, a multi-layered baby talk that approaches sheer pandemonium. Language morphs and mutates into babble as repetition erodes sense and the possibility of meaningful communication.

According to Martin Sturm, the *Babel Series* returns us "to a realm in which sounds constitute the basic modules of every utterance and of all linguistic systems. Units of potential meaning merge into inventories of signs and develop non-hierarchically into instructions that drive actions yet to be performed, yet to take shape. This is a realm in which the meaning of sound is variable and relative, existing only fleetingly and in relation to the contexts to which it attaches itself. Here sound is still free from inscription into the specificity of a linguistic system. Still woven into a web of emotional inflection and intonation. In ever-shifting forms, the beats that make up sound simultaneously evoke the possibility and impossibility of universal communication. Each listener claims their meaning in a different way. The throbbing beats coalesce neither into a *lingua franca,* nor into an Esperanto that forces us to follow sixteen basic rules towards a global syntax. Instead, their shapelessness arouses in us a critical awareness of our second skin – language – the skin that surrounds us almost claustrophobically. The skin that is formed as we refashion and punctuate sound into recognizable words, iterable phrases, repeatable sentences.... With Wittgenstein in mind, we watch and listen to this Babylonian throng of pop as it struggles to free itself from the spell of reason cast upon us by language."

The *Babel Series* evokes an astute parallel between the stages of the child's acquisition of speech and the steps through which consumers absorb the *lingua franca* of today's global mass entertainment culture. Breitz's reduction of pop music lyrics to nonsense syllables is a reminder of the manner in which mass culture reduces its audience to a state of helpless infantilism. In fact, the repeated phonetic sounds that Breitz utilizes here should not properly be considered babble at all, for they signal the kind of intentional repetition of sounds upon which linguistic meaning is founded. The *Babel Series* seems to suggest, however, that mass culture's infantilization of its audience involves a return not to the bliss of pre-linguistic freedom, but rather to the moment that marks the end of that freedom: the moment during which the social machine of language begins to discipline the infant's anarchic energies.

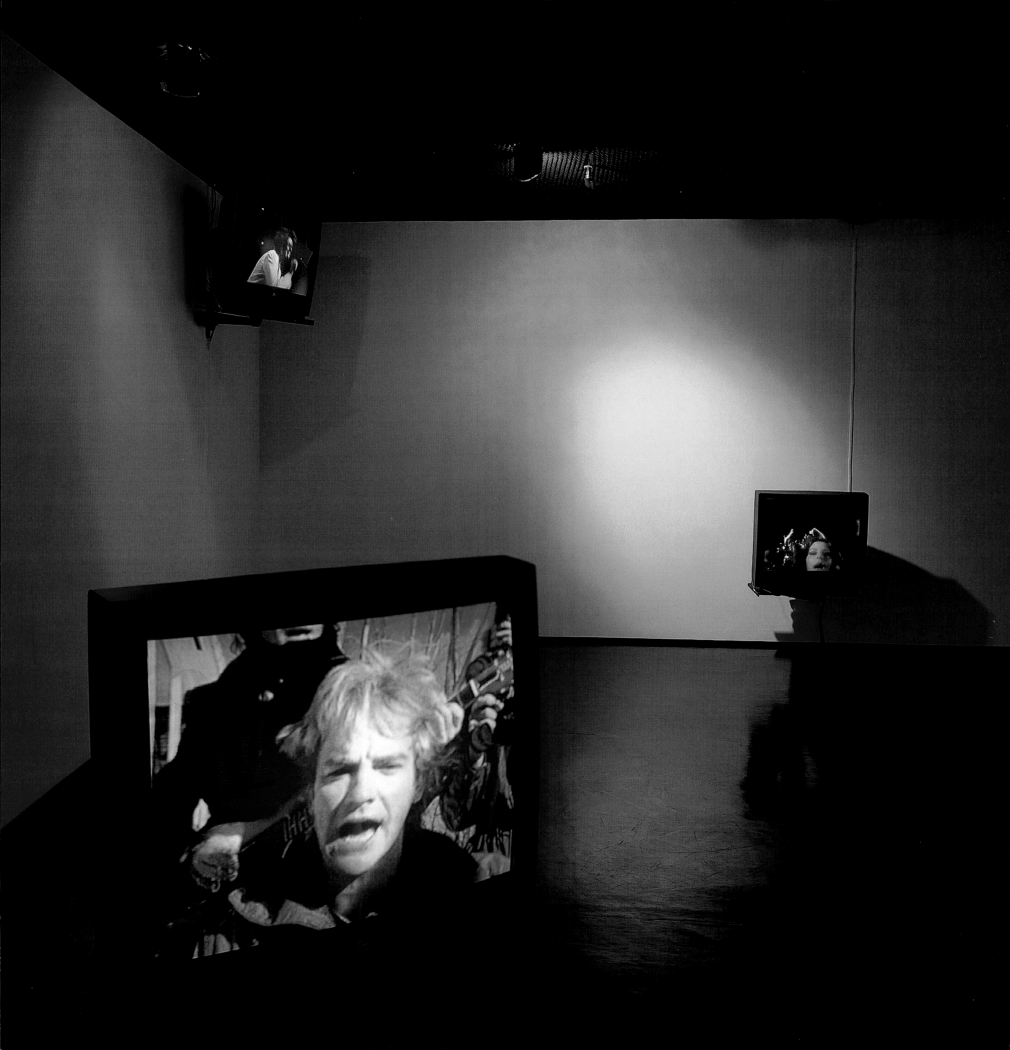

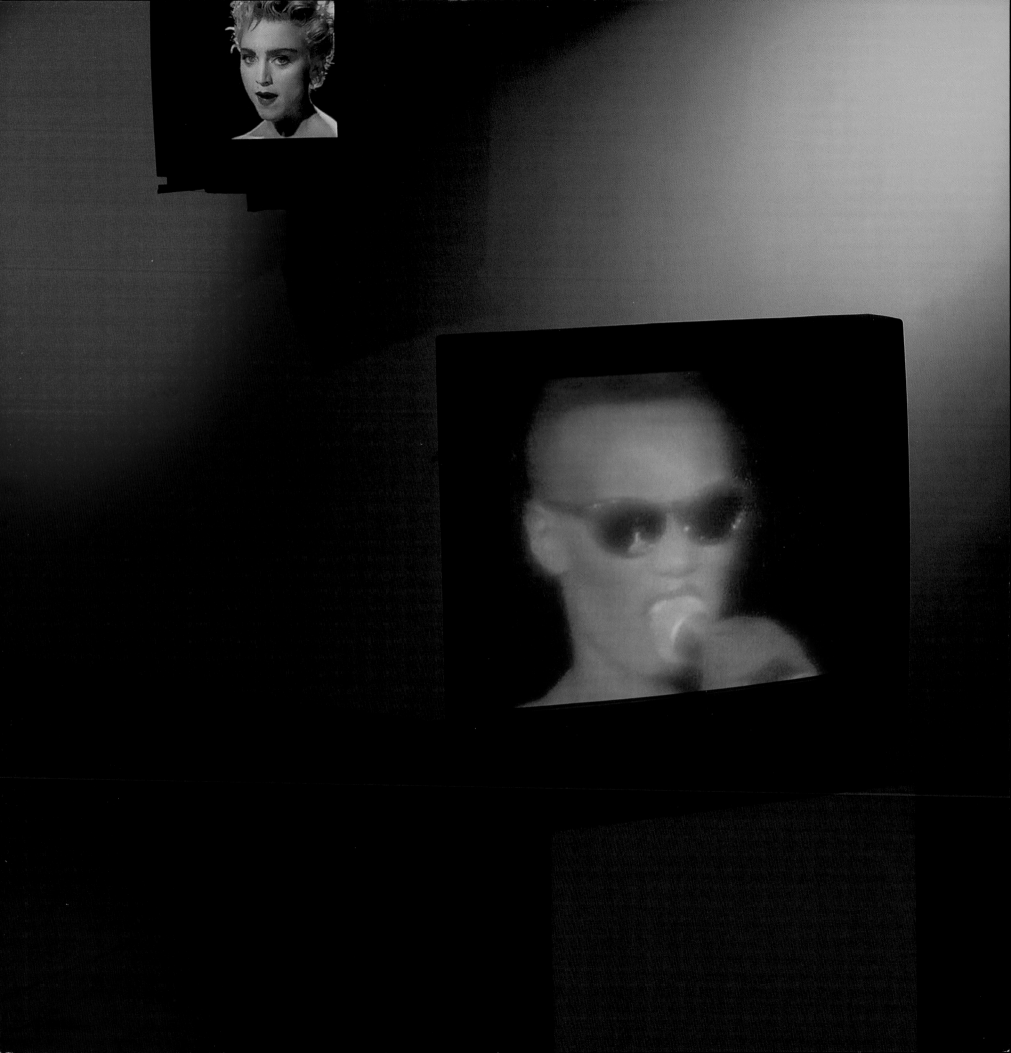

a aha a
a aha a
a aha a
a aha a
a aha a

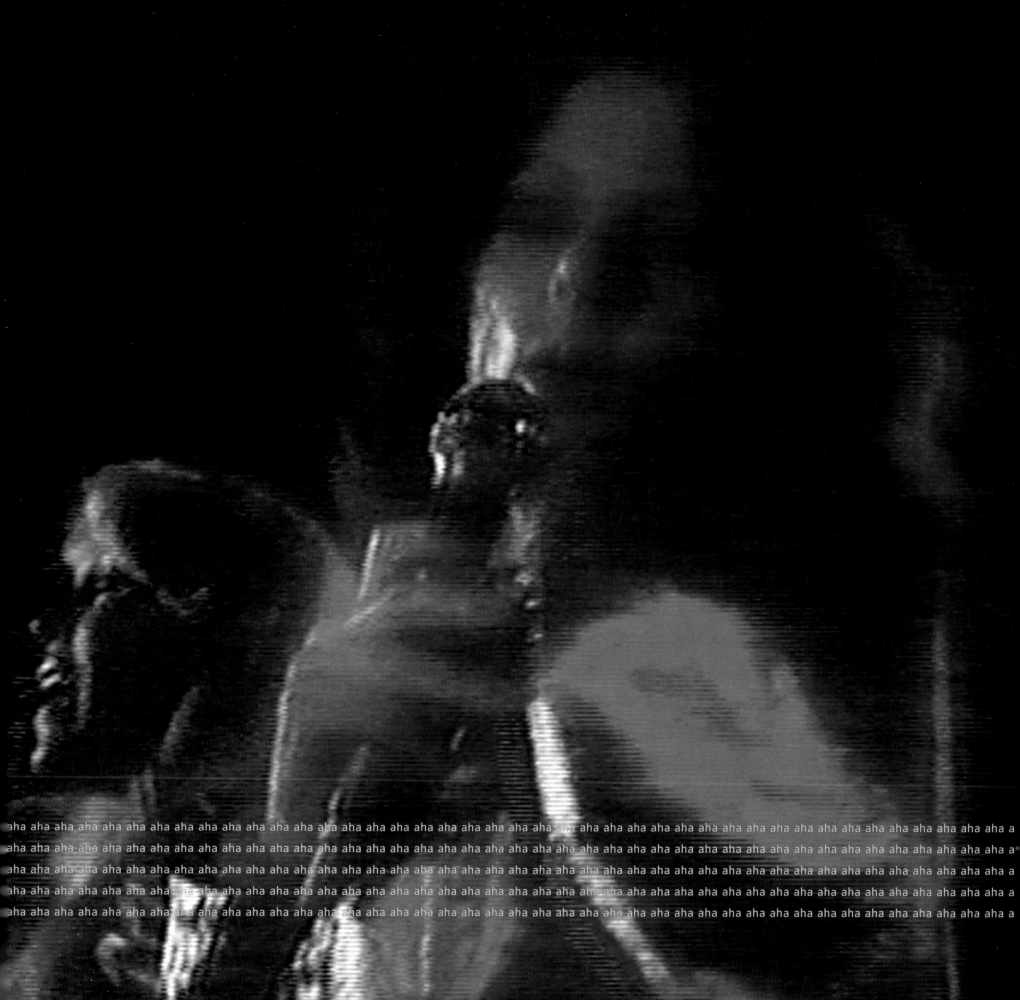

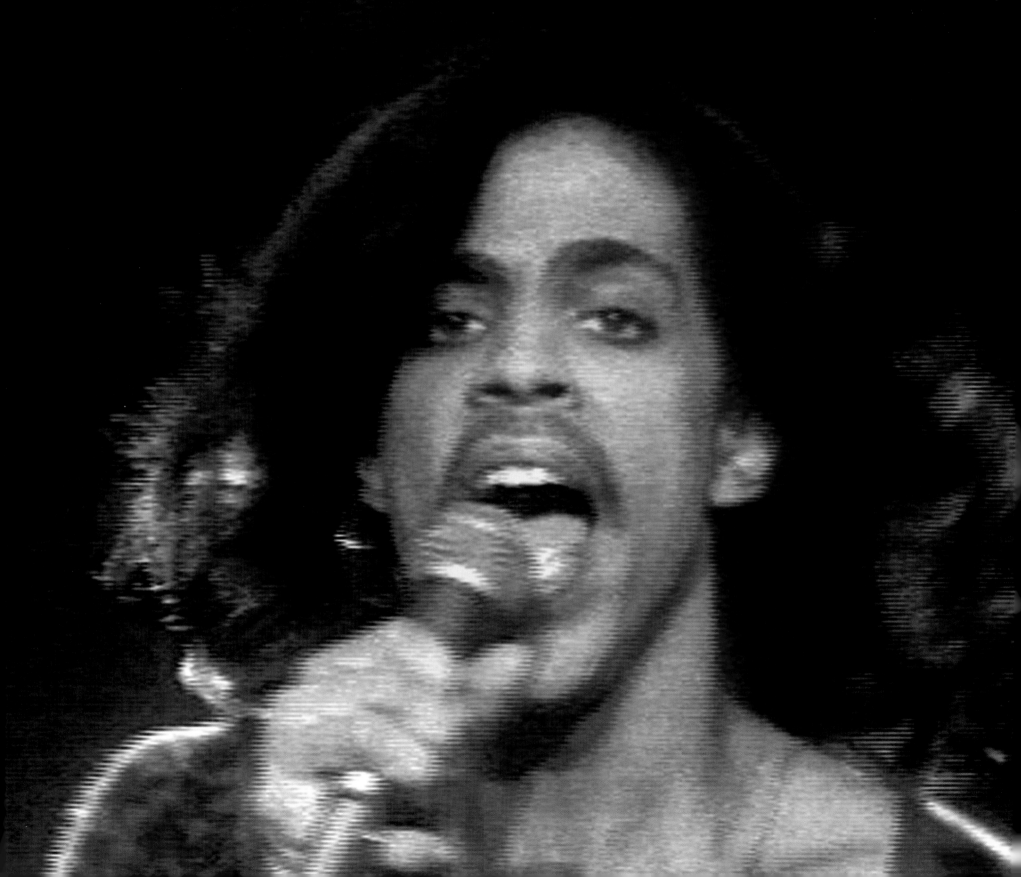

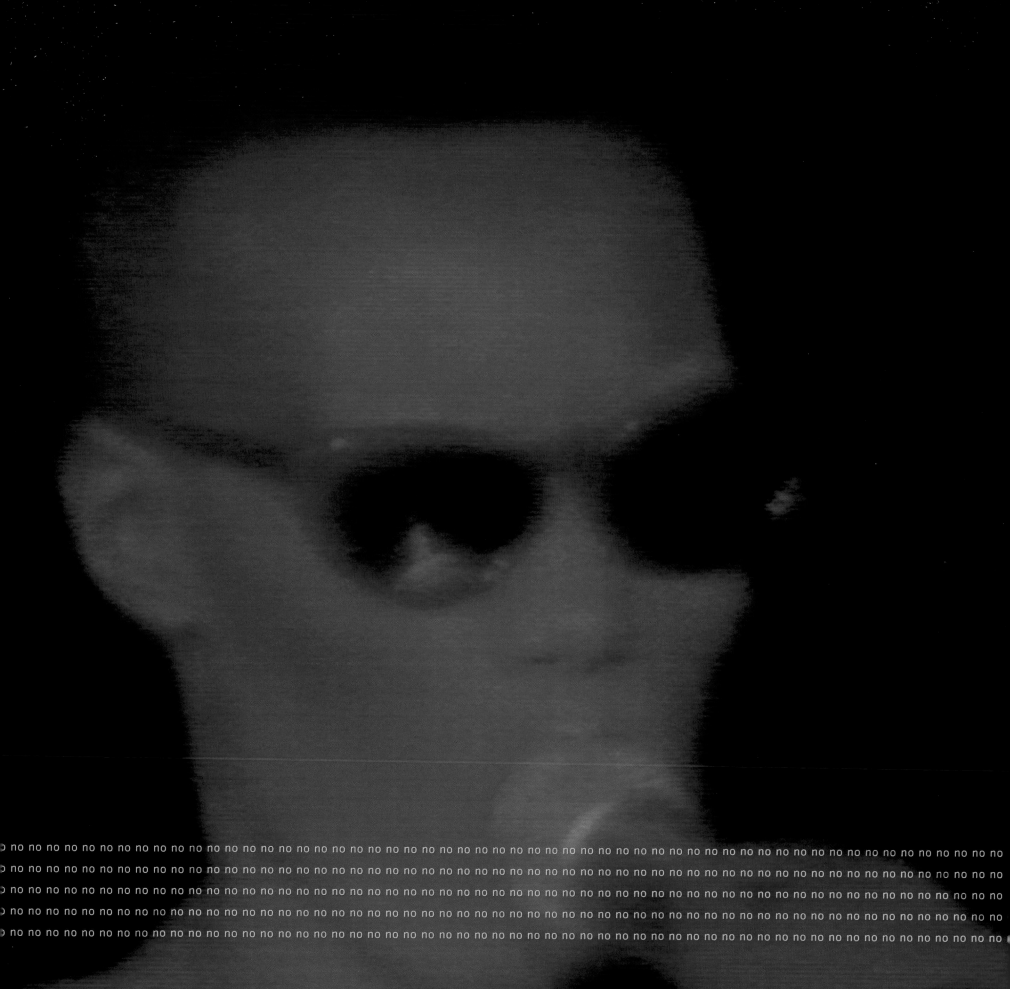

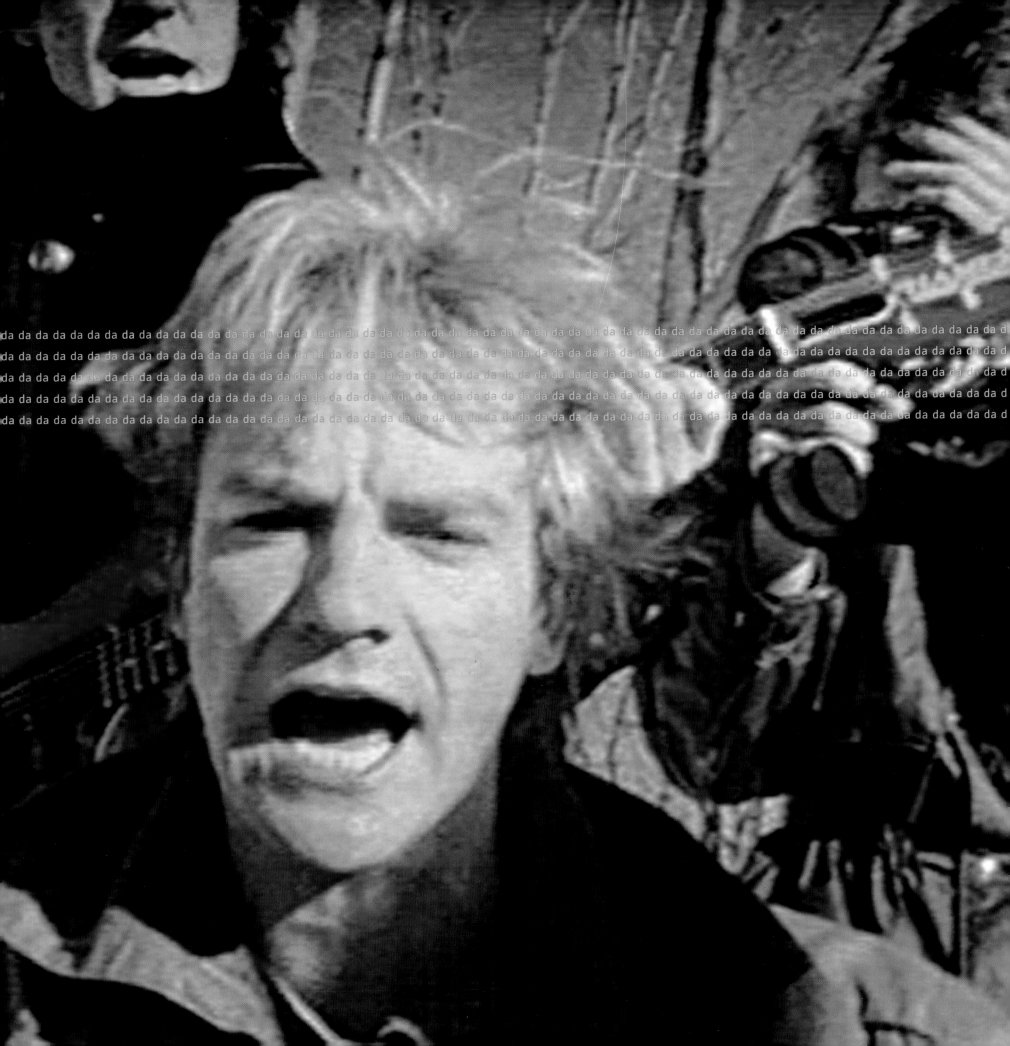

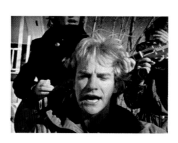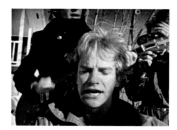

da da
da da
da da
da da

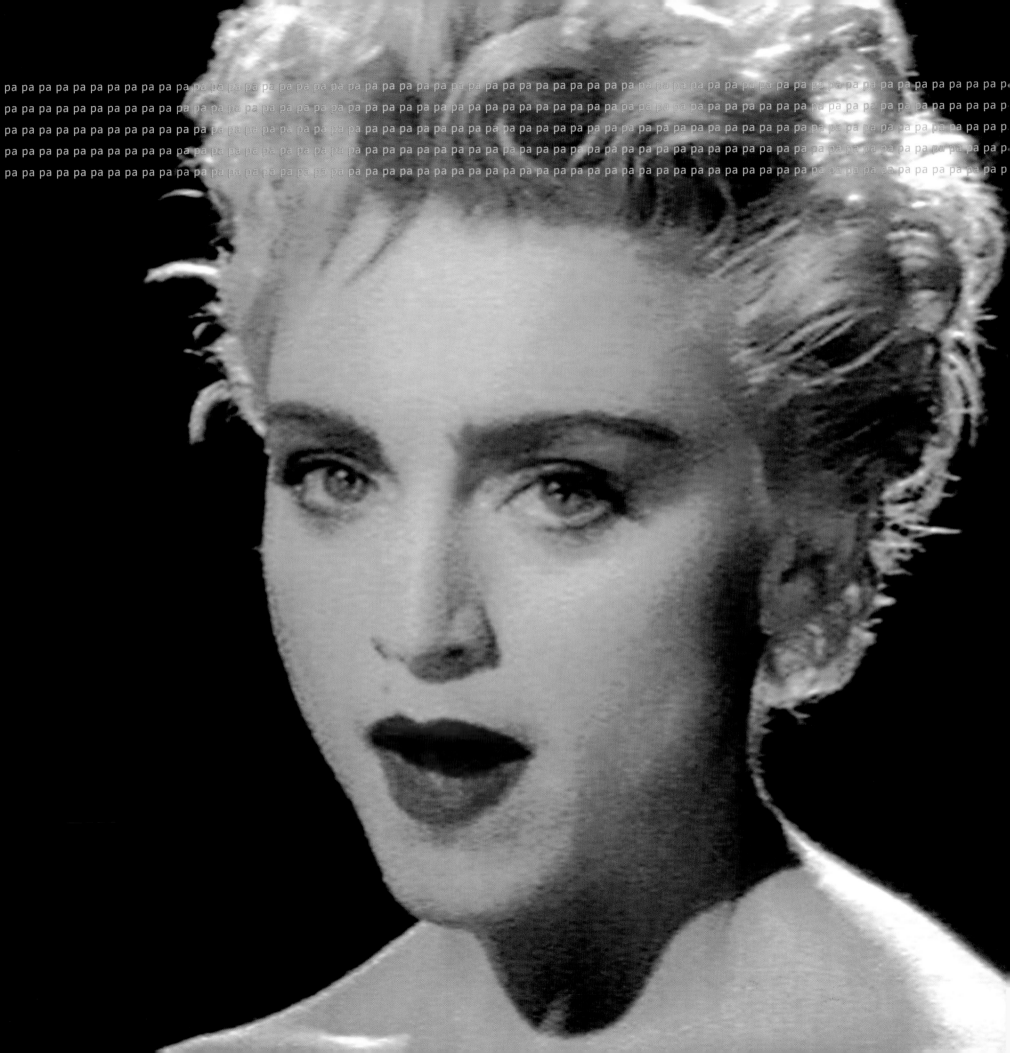

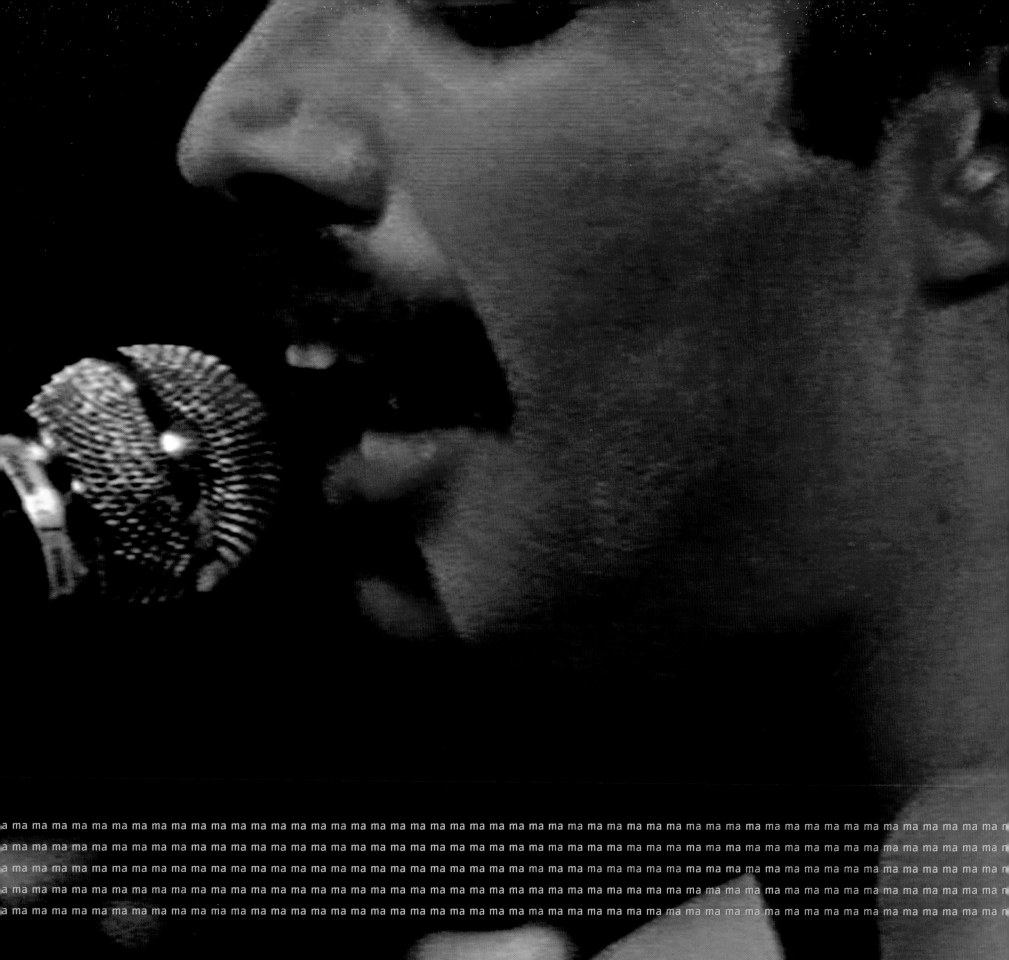

ma ma
ma ma
ma ma
ma ma

me me
me me
me me
me me
me me

En cada uno de los tres cortometrajes de *Soliloquy Trilogy* se toma una película conocida de Hollywood como punto de partida y se reduce a la actuación de un único protagonista al que se acosa y se aísla (mediante un proceso de corte y pegado), entresacándolo de todas las escenas en las que está presente desde el punto de vista vocal. Las tres cintas abordadas por Candice Breitz son *Harry el sucio* (Clint Eastwood), *Las brujas de Eastwick* (Jack Nicholson) e *Instinto básico* (Sharon Stone). Los procesos de montaje de la artista ponen a prueba de modo radical la fuerza del atractivo de las estrellas frente a la coherencia narrativa. El grueso legible de las cintas se desecha drásticamente y se recurre a un fondo monocromático, en concreto negro, para eliminar los momentos visuales en los que aparecen otros intérpretes de forma destacada y por lo tanto molesta mientras habla la estrella seleccionada. El hilo argumental y el telón de fondo contextual del largometraje original se desvanecen al mismo tiempo que los actores secundarios, y todo ello queda esparcido, metafóricamente, por el suelo de la sala de montaje. El resultado es el nacimiento de una relación excepcionalmente directa y algo violenta entre el actor segregado y el espectador, al que se permite un acercamiento casi escandaloso a la estrella. Las nuevas películas, formadas por una serie de secuencias aisladas y ensartadas de forma cronológica, reúnen toscamente todos los gruñidos y los susurros de la estrella en cuestión. El formato del soliloquio se despoja de su angustia trascendental y de la necesidad interna que suele acarrear. Por el contrario, los tres cortos de *Soliloquy Trilogy* se inspiran en la lógica falaz de la cuña de sonido. A medida que los soliloquios degeneran en el balbuceo narcisista *(Sharon)*, la repetición incomunicativa *(Clint)* o la diatriba frenética *(Jack)*, recordamos hasta qué punto depende el lenguaje del contexto y de la comunidad para dotarse de significado. Jessica Morgan señala: "*Trilogy* presenta un lado sumamente

humano e incluso humanizante, que parece apuntar, lo mismo que las películas, hacia el monólogo interior a menudo alienante y la manifestación exterior que es resultado de la ineptitud del lenguaje a la hora de comunicar la experiencia del ser. Contemplar esos comentarios deslavazados es al mismo tiempo ser testigo de cómo sonaría nuestro monólogo interior diario si pudiéramos grabar la corriente de pensamientos inacabados y preguntas sin respuesta que son la constante de nuestra actividad mental cotidiana."

La absorción del espacio y el contexto que rodeaban a los tres protagonistas tiene como resultado tres películas con una estructura circular inquietante. En estos torrentes verbales desenfrenados, los actores atrapados pasan dando bandazos de los sonidos fortuitos a la proclamación, a la exigencia y vuelta a empezar: se formulan preguntas que no hallan respuesta, se dejaban las observaciones sin réplica. "Escuchar los soliloquios incomoda; los cambios bruscos y profundos de humor y tono hacen pensar en un discurso psicótico, pero nos quedamos pegados a la silla, observando fascinados, porque queda un poso de satisfacción que es la mera presencia icónica de la estrella, aislada toscamente para que la disfrutemos en toda su pureza," asegura Christopher Phillips. Las obras de Breitz extraen la presencia aurática de las estrellas al tiempo que exponen con toda su vulgaridad la mecánica de la iconicidad. Sus montajes sirven para exacerbar el hecho de que los personajes de Hollywood apenas evolucionan o cambian a lo largo de las películas, sin duda en cierta medida debido a que nuestro placer como consumidores de cultura de masas se basa en una presencia célebre estandarizada que se mantiene inalterable eternamente.

Los tres cortometrajes de *Soliloquy Trilogy* son:

Soliloquy (Clint), 1971-2000
Soliloquy (Jack), 1987-2000
Soliloquy (Sharon), 1992-2000

Each of the three short films in the *Soliloquy Trilogy* takes a well-known Hollywood movie as its starting point, zooming in on a single protagonist who is stalked and isolated (cut-and-pasted) out of every scene in which s/he is vocally present. The three films tackled by Breitz are *Dirty Harry* (Clint Eastwood), *The Witches of Eastwick* (Jack Nicholson) and *Basic Instinct* (Sharon Stone). Breitz's editing procedures radically test the power of star appeal versus narrative coherence. The legible body of each film is dramatically cut away. A monochrome black screen is dropped in to edit out those visual moments in which other actors are distractingly prominent while the chosen star speaks. The storyline and the contextual backdrop of the original feature film vanish along with the secondary actors, all now relegated to the mute realm of the proverbial cutting room floor. The result is an unusually direct and somewhat violent relationship between the secluded actor and the viewer, who is granted an almost obscene access to the star. Composed of a series of film clips isolated and chronologically strung together, the new films crudely distil every grunt and murmur of the designated star. The soliloquy form is stripped of its transcendental angst and of the inner necessity that it usually implies. Instead, the three films in the *Soliloquy Trilogy* are driven by the non-sequitur logic of the sound bite. As the *Soliloquies* devolve into narcissistic babble *(Sharon)*, taciturn repetition *(Clint)* or manic tirade *(Jack)*, one is reminded of the extent to which language depends on context and community for its meaning. Jessica Morgan points out that "there is an utterly human or even humanizing side to the *Trilogy*, suggestive as the films are of the often alienating internal monologue and exterior utterance that is the result of the inadequacy of language to communicate the experience of being. To watch these erratic commentaries is also to witness what one might imagine our own internal daily monologue to sound like were we able to record the flow of unfinished thoughts and unanswered questions that are a constant of daily mental activity."

The sucking up of the space and context around each of the protagonists results in three films that are disturbingly circular in structure. In these spiraling word-flows, the trapped protagonists lurch from casual utterance to proclamation to demand and back again: questions are asked but never answered, comments are left without response. "Listening to the *Soliloquies* is unnerving; the extreme, abrupt shifts of mood and tone are suggestive of psychotic speech. Yet we sit watching, fascinated, because there is a residual core of satisfaction: the pure iconic presence of the star, crudely distilled for our viewing pleasure" (Christopher Phillips). Breitz's films distil the auratic presence of the stars even as they vulgarly expose the mechanics of iconicity. Her edits serve to exacerbate the fact that the Hollywood characters barely evolve or change through the duration of the movies, no doubt to some extent because our pleasure as mass culture consumers is predicated on a standardized celebrity presence that remains eternally, unalterably the same.

The three short films in the *Soliloquy Trilogy* are:

Soliloquy (Clint), 1971-2000
Soliloquy (Jack), 1987-2000
Soliloquy (Sharon), 1992-2000

Soliloquy Trilogy

SOLILOQUY

(Clint)

00:06:57:22

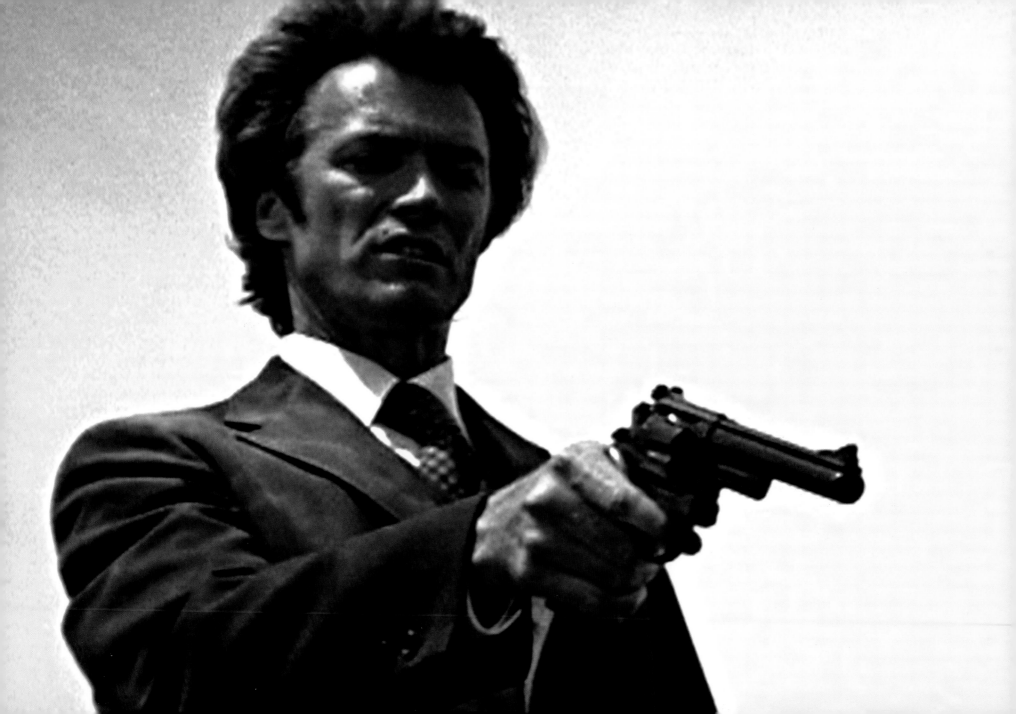

SOLILOQUY

(Jack)

00:14:06:25

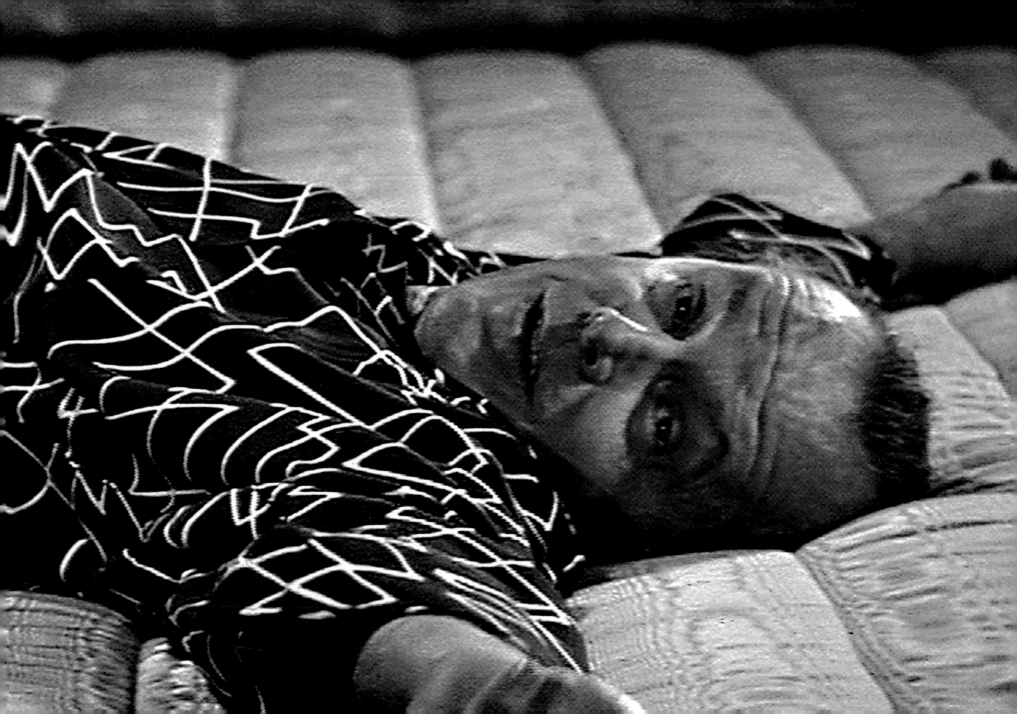

SOLILOQUY

(Sharon)

00:07:11:03

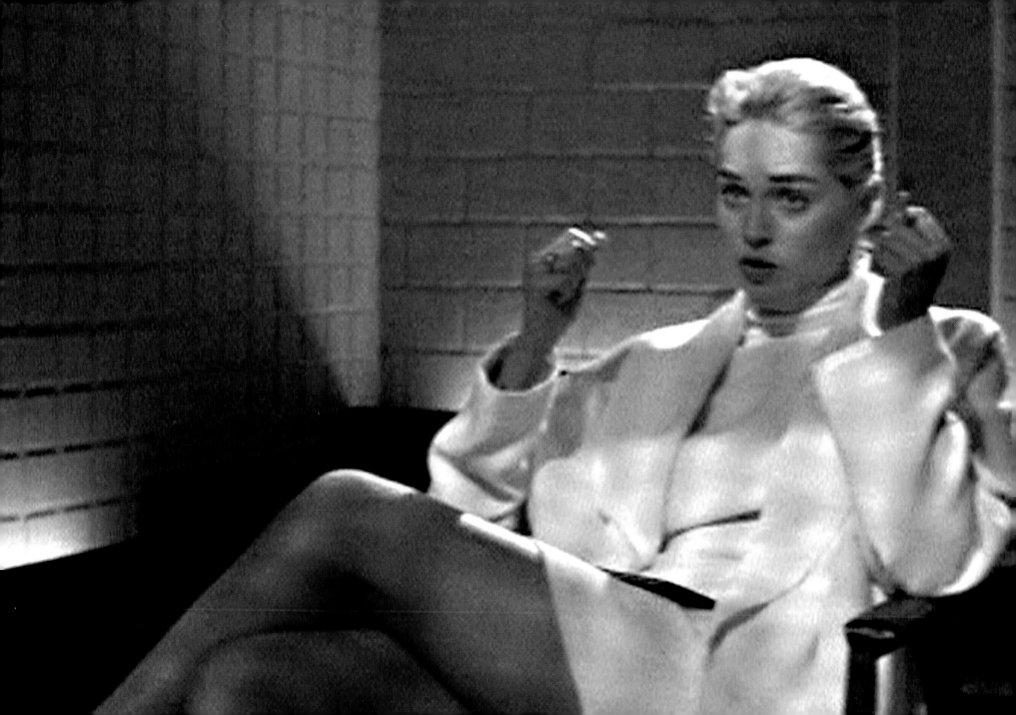

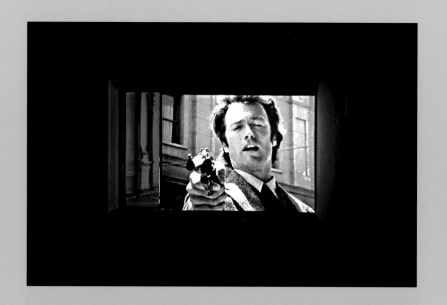

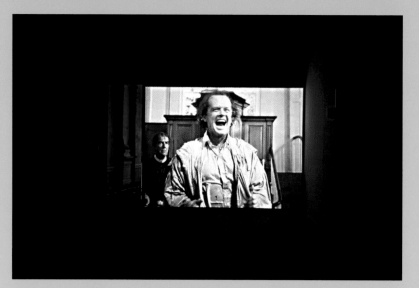

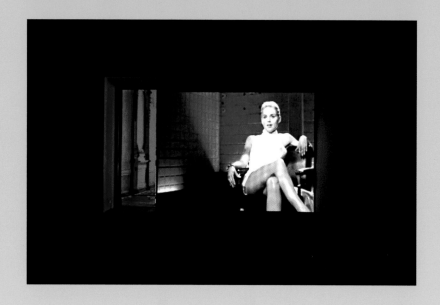

Four Duets (2000) consiste en un análisis semi-arqueológico de casi medio siglo de canciones románticas. Las interpretaciones que sirven de materia prima para la obra — pero que al final únicamente sobreviven al proceso de montaje como cadenas mutiladas de monosílabos balbuceantes — son *Close To You* de Karen Carpenter (1970), *Hopelessly Devoted To You* de Olivia Newton-John (1978), *Thorn In My Side* de Annie Lennox (1986), y por último *I Will Always Love You* de Whitney Houston (1999). Candice Breitz mete la tijera digital a esas cuatro canciones, especialmente obsesionada con los pronombres personales y los adjetivos posesivos, de modo que reduce las canciones a los momentos en los que aparecen un "I" [yo] o un "you" [tú], elementos deícticos que el hablante posee sólo de forma momentánea en el instante de la enunciación, y que sirven de marcadores lingüísticos de la diferencia entre el yo y el otro. En una pantalla de *Double Olivia,* por ejemplo, las palabras de la cantante quedan reducidas únicamente a los pronombres personales "I" y "me" [mí], junto con el adjetivo "my" [mi], aislados y repetidos en un tartamudeo entrecortado y violento que recuerda a un enfermo del síndrome de Tourette, mientras que en el segundo monitor de la misma instalación de dos canales otro montaje de las mismas imágenes nos deja con un "you, you, you" entonado de forma encantadora y atrapado en un bucle de "corta y pega" igualmente repetitivo.

Al despojar los temas de todo menos los mismos elementos básicos, Breitz extrae la sencilla lógica que permite a la canción sentimental lograr su efecto: "Las melodías y los arabescos de la canción [romántica] se construyen invariablemente entre los polos básicos de un 'yo' y un 'tú' — un transmisor y un receptor identificables. Aunque, por descontado, las cosas no son nunca tan sencillas: el 'tú' de la canción *pop* debe ser lo bastante etéreo como para que

millones de oyentes se identifiquen de forma simultánea con él, pero todo ello sin dejar de mantener una distancia de seguridad. Todos los receptores deben tener la impresión de que su relación con el 'yo' imaginario encarnado por el cantante *pop* es de algún modo única — más liberada, más apasionada, más apropiada — por lo que tiene más posibilidades de satisfacer las necesidades de ese 'yo'. Pero ésa es sólo una parte de la ecuación. El 'yo' con el que nos topamos al identificarnos con el intérprete — con su aspecto, con cada uno de sus gestos extravagantes — es por descontado también un 'yo'. Este 'yo' crea, necesariamente, un espacio adecuado no sólo para una experiencia de escucha empática, sino también para que el receptor pueda revivir, mediante la canción, el dramatismo, el dolor y el placer que comporta ser un 'yo'." (Frank Wagner)

Las cuatro cantantes se dirigen a su público desde los monitores duplicados, y los "yos" y los "tus" se mezclan sin orden ni concierto y colisionan. El proceso de identificación y proyección se cortocircuita cuando cada una de ellas hace frente a su extraño doble. La artista pone en primer plano los mecanismos de identificación firmemente afianzados en la estructura binaria de la canción romántica, con lo que sitúa al espectador entre los paréntesis del yo y el otro, representados aquí en los cuatro casos por una cantante pop sorprendentemente desdoblada — una Annie, Olivia, Karen o Whitney doble — e inmersa en un diálogo esquizofrénico consigo misma. Las relaciones de ensueño entre el yo y el otro caen en un ciclo que en ocasiones resulta violentamente onanista y en otro momento, prácticamente autista. Breitz enfrenta al "yo" y al "tú" que son los ingredientes estables de toda canción sentimental — en un ciclo de deseo febril y en cierto modo masturbatorio — dramatizando la batalla por los puntos de coincidencia que podríamos decir que resulta inherente a todo acto de comunicación.

Los títulos de las cuatro instalaciones de dos canales de la serie *Four Duets* son:

Double Karen (Close To You), 1970-2000
Double Olivia (Hopelessly Devoted To You), 1978-2000
Double Annie (Thorn In My Side), 1988-2000
Double Whitney (I Will Always Love You), 1992-2000

Four Duets (2000) is a quasi-archaeological survey of nearly half a century of sentimental love songs. The songs that serve as the source material for the work – but which ultimately survive the editing process only as mutilated chains of stammering pronouns – are, Karen Carpenter's *Close To You* (1970), Olivia Newton John's *Hopelessly Devoted To You* (1977), Annie Lennox's *Thorn In My Side* (1985) and Whitney Houston's *I Will Always Love You* (1999). Digitally hacking away at each song in turn, Breitz fixates particularly on the personal pronouns, reducing the songs to nothing more than those moments that reference an "I" or a "you" (indexical shifters that are owned by the speaker only momentarily in the moment of enunciation, and which serve as linguistic markers of the difference between the self and the other). On one screen of *Double Olivia,* for example, the singer's lyrics are reduced to nothing more than the personal pronouns "Me," "My" and "I," now isolated and repeated in a violently staccato Tourette's-like stutter, while on the second screen of the same dual-channel installation, an alternate edit of the same footage leaves us with only a dreamily intoned "you, you, you," looping in a similarly recursive cut-and-paste cycle.

As she strips each song down to the same basic elements, Breitz teases out the simple logic by means of which the love song exerts its effect: "The melodies and arabesques of the [love] song invariably unfold between the basic poles of an 'I' and a 'you' – an identifiable sender and receiver. Naturally though, it's never quite this simple: the 'you' of the pop song must be vague enough to allow millions of listeners to simultaneously identify and yet keep a safe distance. Each listener must feel that his or her relation to the imaginary 'I' embodied by the pop star is somehow unique – more liberated, more passionate, more appropriate – and thus better able to fulfill the needs of the 'I.' But this is only one side of the equation. The 'I' that we encounter as we identify with the singer – with her Look, with each of her extravagant gestures – is of course also an imaginary 'I.' This 'I' necessarily creates a space not only for an empathetic listening experience, but indeed a space in which the listener might, through the song, re-live the drama, the pain, and the joy of being an 'I.'" (Frank Wagner)

As the four singers address themselves from their paired television monitors, their "I" and their "you" messily mingle and collide. The process of identification and projection is short-circuited as each confronts her own uncanny double. Giving center stage to the mechanisms of identification that are firmly entrenched in the binary structure of the love song, Breitz positions the viewer parenthetically between the self and the other, represented here in all four instances by an eerily bifurcated pop star – a doubled Annie, Olivia, Karen or Whitney – set in schizophrenic dialogue with herself. The fantasy relations of self and other collapse into a cycle that is at times violently onanistic, and at other moments virtually autistic. Breitz pits the "I" and the "you" that are the stable ingredients of every love song against each other – in a feverish and somewhat masturbatory cycle of desire – dramatizing the battle for common ground that is arguably inherent to every act of communication.

The titles of the four dual-channel installations in the *Four Duets* series are:

Double Karen (Close To You), 1970-2000
Double Olivia (Hopelessly Devoted To You), 1977-2000
Double Annie (Thorn In My Side), 1985-2000
Double Whitney (I Will Always Love You), 1999-2000

Four Duets

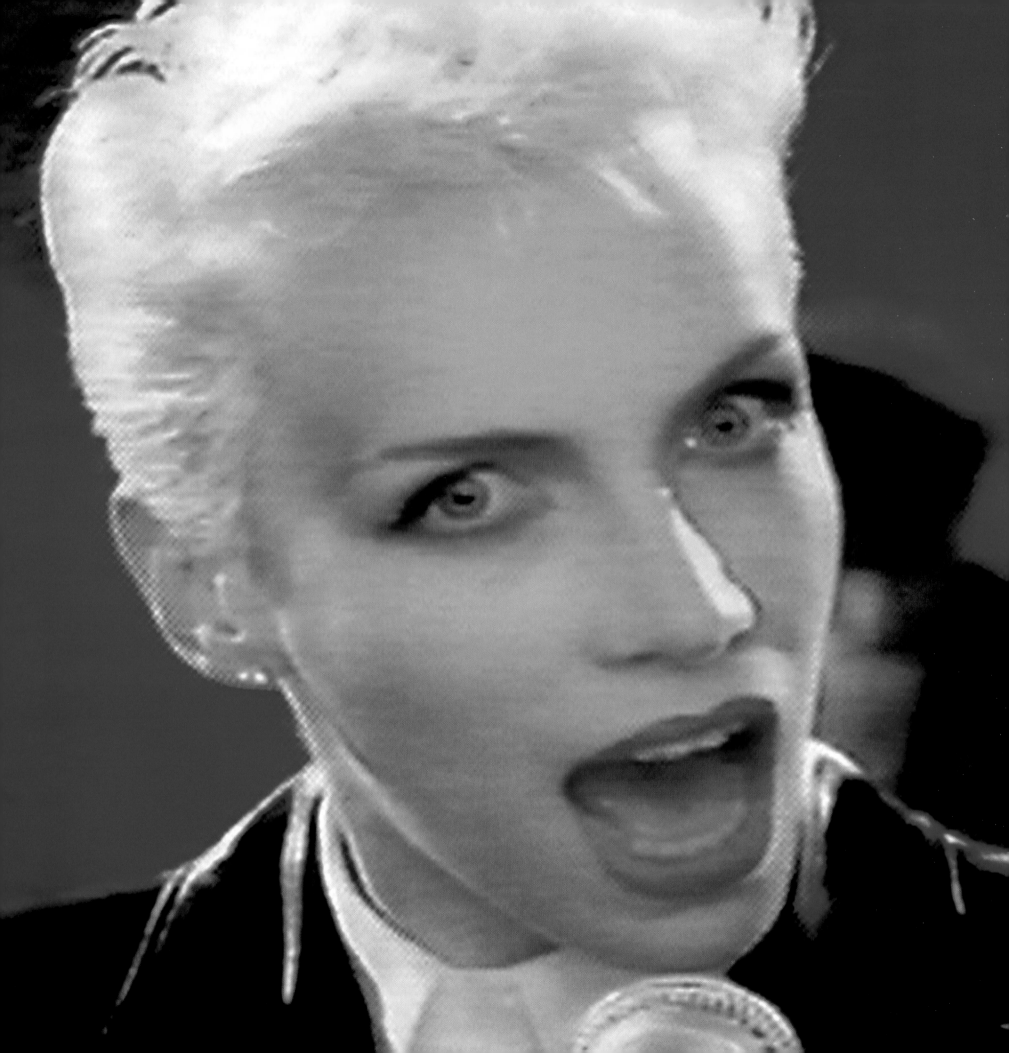

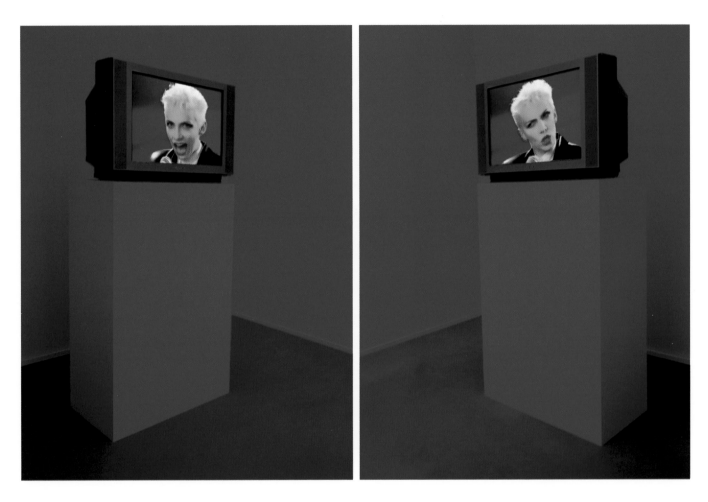

I YOU

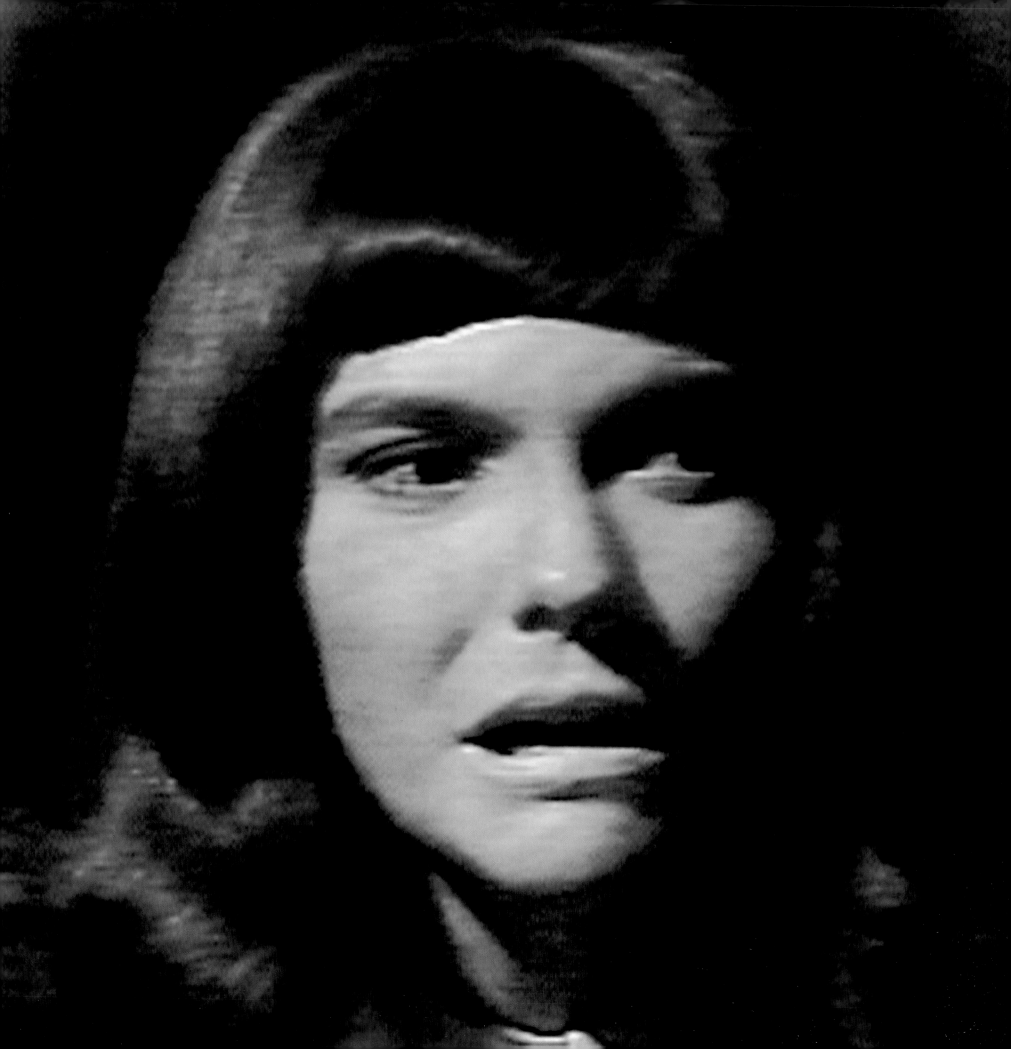

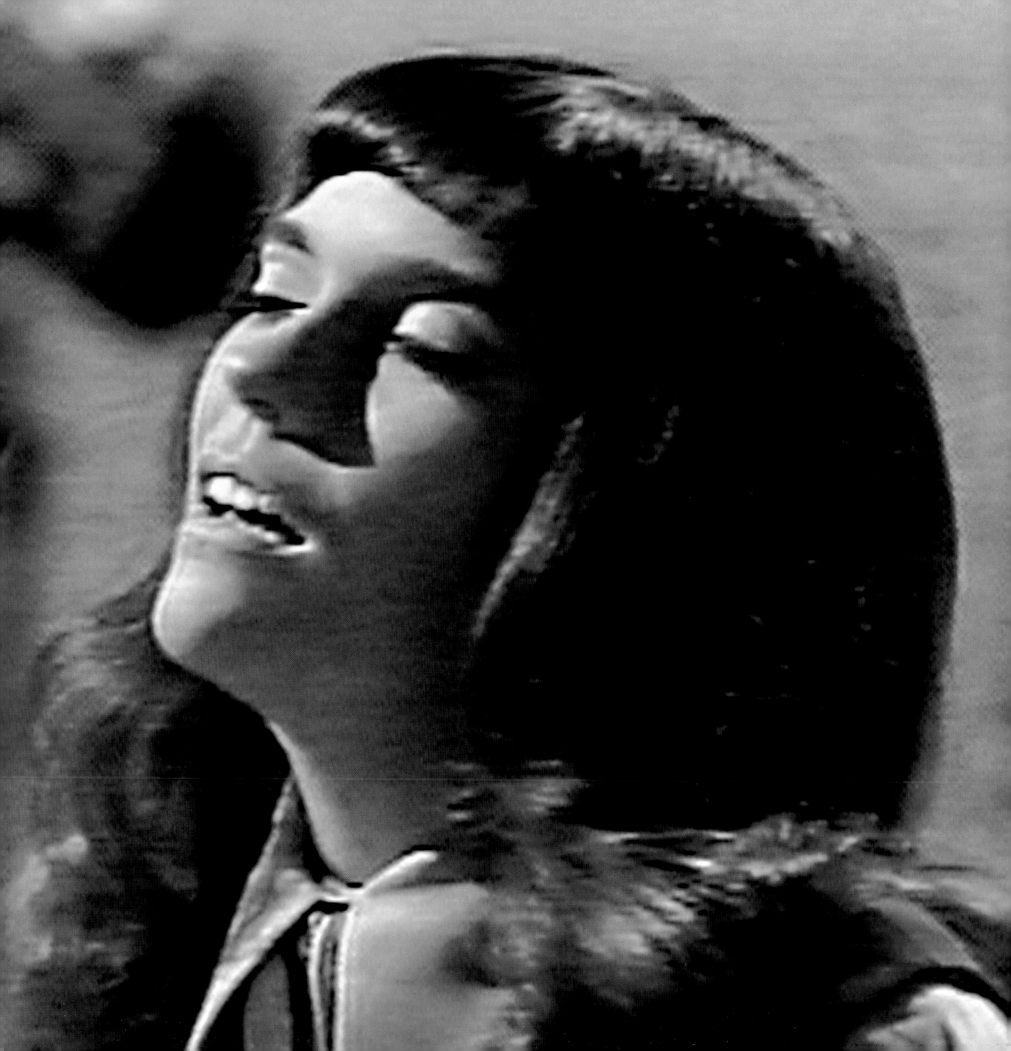

YOU

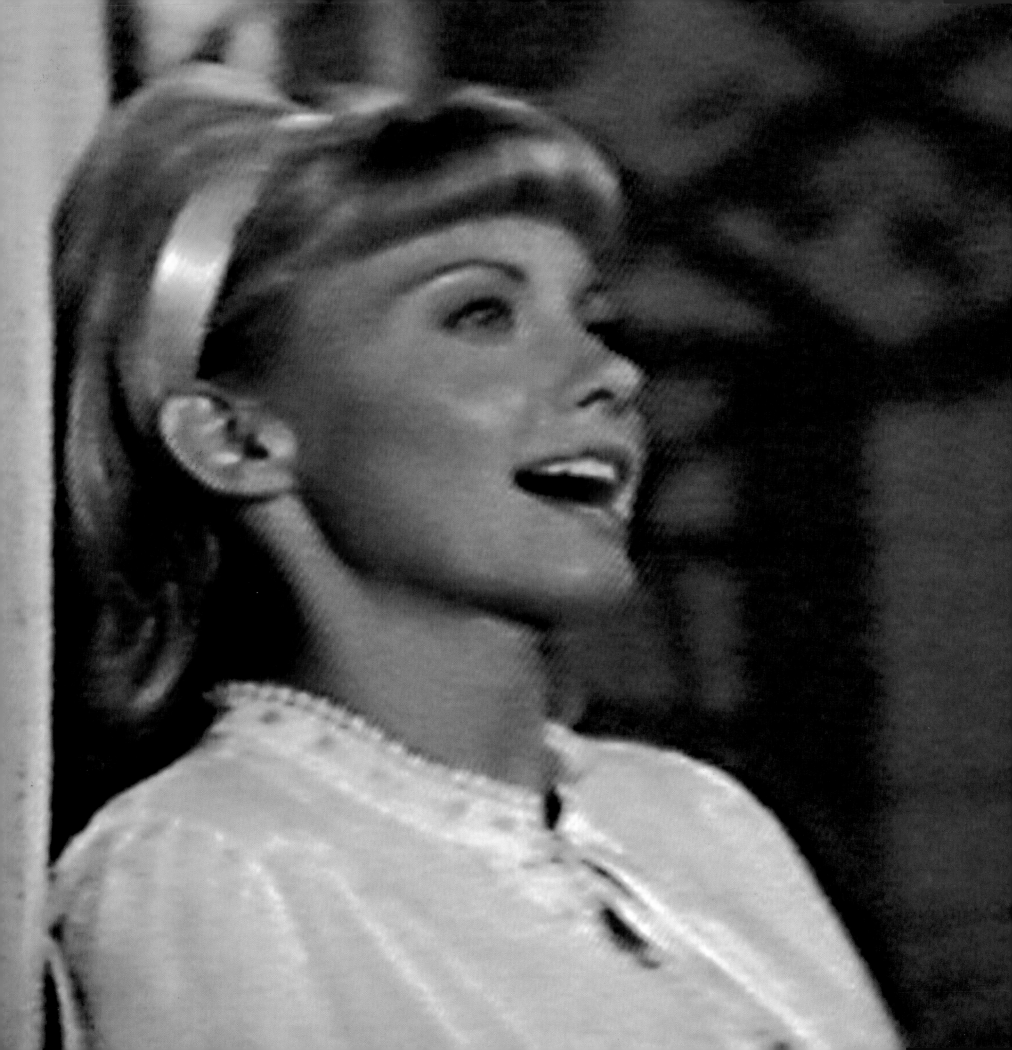

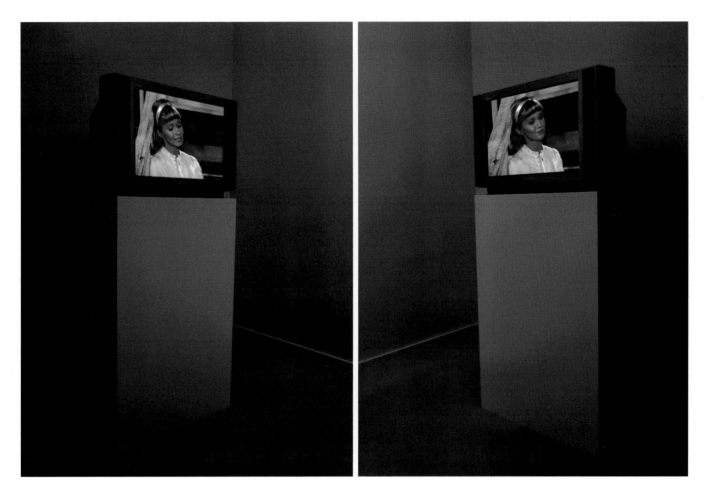

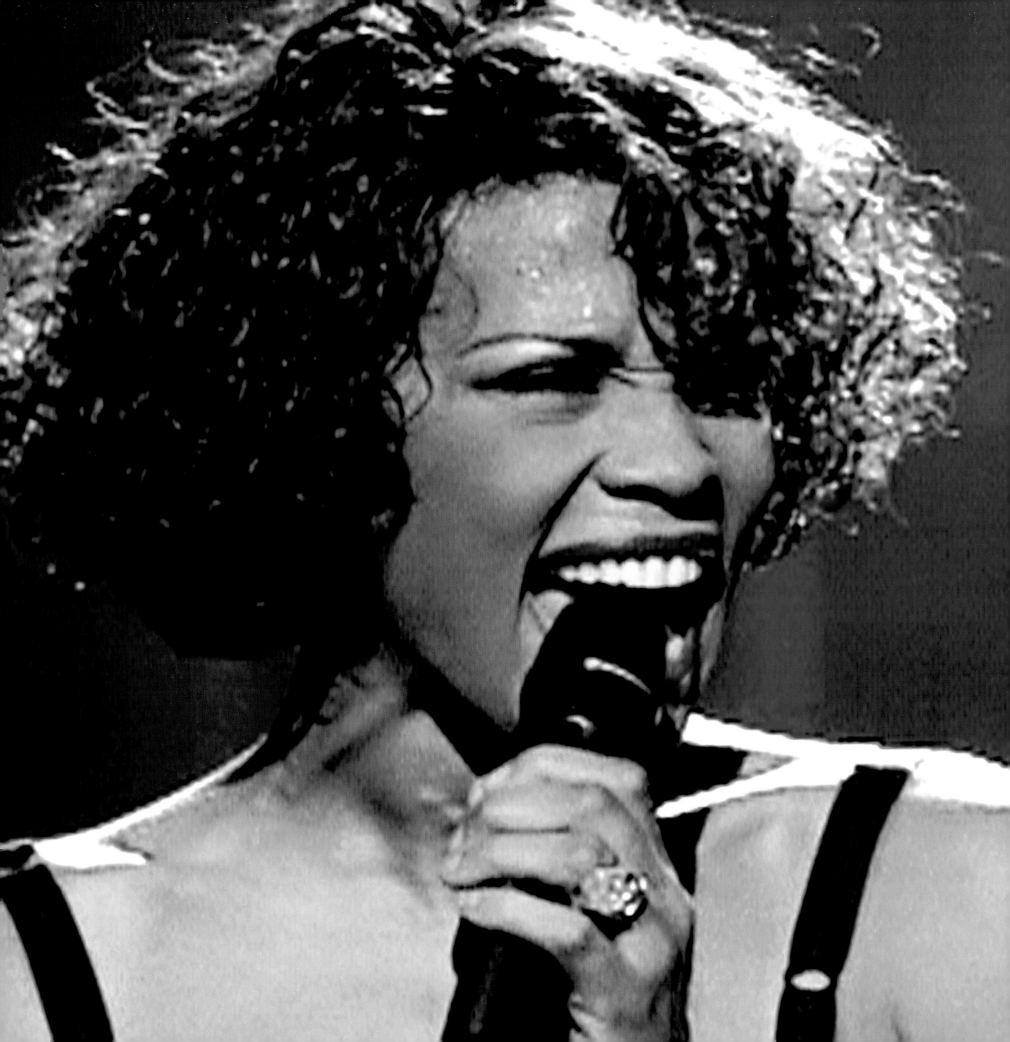

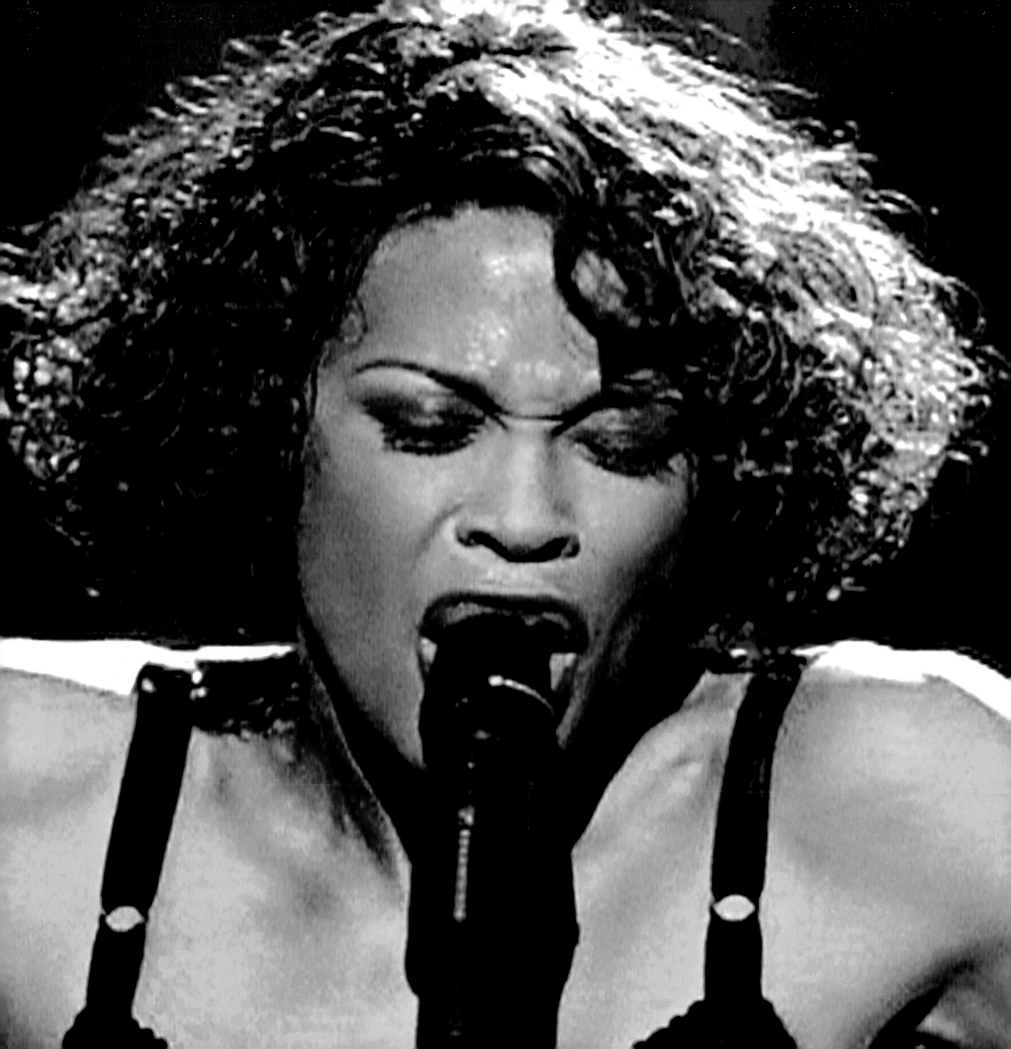

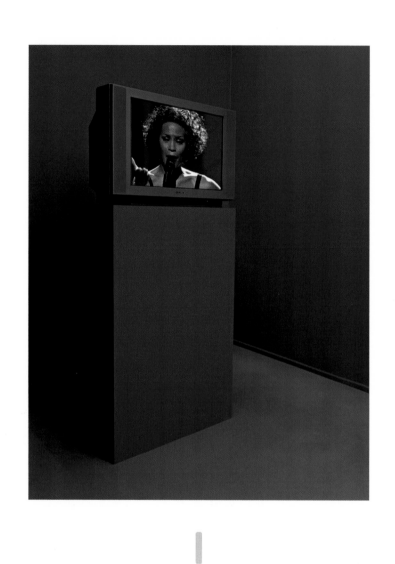

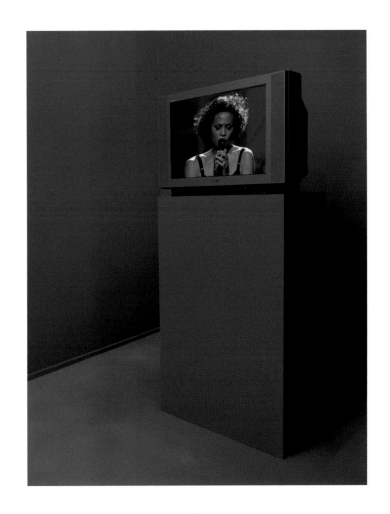

YOU

Por cada uno de los monitores de la instalación de nueve canales *Diorama* (2002) ronda un personaje arquetípico entresacado de la serie televisiva *Dallas*. Tras recopilar y enlazar numerosos cortes de cada uno de los nueve protagonistas del culebrón, Breitz encierra a los miembros de la familia Ewing en sendas vitrinas televisivas. Figuras como J. R. Ewing y su madre, Ellie, adoptan encarnaciones sorprendentemente conmovedoras. Estos fantasmas de nuestro pasado televisivo reciente regresan a nuestras vidas como antiguos novios, acosándonos, y despiertan en nuestro interior una mezcla de fascinación y repugnancia. Los miembros del clan corean de forma simultánea un completo catálogo de dilemas cotidianos y traumas íntimos de la vida familiar mientras reflexionan sobre el nacimiento y la muerte, el matrimonio y el divorcio, el suicidio y la traición. El patriarca, Jock Ewing, gruñe: "Mi barbacoa, mi casa, mi barbacoa, mi casa," mientras la benévola matriarca, Ellie, confiesa: "Siempre lloro en las bodas, siempre lloro en las bodas." Sue Ellen, la esposa achispada del primogénito, J. R., repite entre dientes: "Quiero un divorcio rápido y sin complicaciones, quiero un divorcio rápido y sin complicaciones," mientras Pam, la mujer del hermano menor, Bobby, suplica: "¿Y qué pasa con el amor? ¿Y qué pasa con el amor?" Breitz coreografía una serie de relaciones sometidas a cambios constantes mientras los tartamudeantes Ewing se insultan, se obsesionan unos con otros y rivalizan por el poder familiar.

Dallas era conocida por atormentar a sus seguidores con la promesa de un giro o desvío argumental inminente y, sin embargo, paradójicamente, dependía de un grupo estable de personajes emparentados y de comportamiento tranquilizadoramente consecuente. Esa lógica mantuvo absortos a espectadores de todo el mundo semana a semana durante trece años, con la promesa de la incertidumbre que, no obstante, devolvía a la audiencia a unos parámetros previsibles

y cómodos a intervalos regulares. Breitz disecciona críticamente los productos de los espectáculos de masas, pero con cuidado de no perder nunca de vista los recuerdos privados y los aspectos de relevancia personal que se entretejen en todas las formas de consumismo cultural, hasta las más degradadas. La artista proyecta su mirada etnográfica en acontecimientos conocidos del rancho Southfork y con ello sugiere que debemos empezar a analizar la cultura que consumimos si queremos acercarnos a un concepto creíble de historia "natural".

En *Diorama,* los disfuncionales Ewing sustituyen no sólo a los millones de familias teleespectadoras que quedaron embelesadas con las vicisitudes ficticias de *Dallas,* sino también a la atemporalidad de las luchas familiares en sí. Liberados de argumento y narrativa, y representados en forma de árbol genealógico vídeo-panorámico, los Ewing se ven obligados a dramatizar la fragilidad intrínseca a la existencia familiar. *Diorama* recupera el tema de la familia defectuosa que aparecía con frecuencia en la mitología griega y que desde entonces ha resurgido de forma obsesiva en la creación literaria. El hecho de que seguimos fascinados por las tribulaciones familiares se hace evidente, más que en ningún otro lugar, en la exploración de *Dallas* como diorama contemporáneo que hace Breitz. La instalación confiere una importancia épica a las relaciones familiares, volviendo a poner en escena la saga más primaria con un reparto también sumamente primario: un padre, una madre y sus descendientes... En eso, la obra conecta tanto con la anterior *Babel Series* como con otra creación posterior de la artista, *Mother + Father.*

Cada edición de *Diorama* ha sido producida en una ciudad distinta, utilizando muebles desechados que Breitz recupera de tiendas de segunda mano de cada lugar en el momento de montar la instalación.

Diorama fue un encargo de Artpace San Antonio, en Tejas, donde se presentó por vez primera a principios de 2002. La obra ha sido creada de nuevo posteriormente en Miami, Dubrovnik, Londres y Ámsterdam. Aunque cambien las ubicaciones, como si de otros tantos salones desperdigados por el mundo televidente se tratara, los bucles que repiten los monitores se mantienen en todas las versiones de la pieza.

Each of the monitors in the nine-channel installation *Diorama* (2002) is haunted by an archetypal character isolated from the television series *Dallas*. Having collected and looped numerous sound bites for each of the nine main players in the soap opera, Breitz restrains each Ewing family member in a separate televisual vitrine. Figures like J. R. Ewing and Miss Ellie are reincarnated in surprisingly moving guises. These ghosts from our recent viewing pasts return to us like ex-lovers, goading us, and indeed sparking in us a simultaneous fascination and disgust. The family members simultaneously chant an exhaustive catalogue of the daily dilemmas and intimate traumas of family life as they reflect on birth and death, marriage and divorce, suicide and betrayal. The patriarch Jock Ewing growls, "my barbecue, my house, my barbecue, my house," as the benevolent matriarch Ellie Ewing confesses, "I always cry at weddings, I always cry at weddings...." Eldest son J.R. Ewing's tipsy wife Sue Ellen hisses, "I want a clean and fast divorce, I want a clean and fast divorce," while his younger brother Bobby's wife Pam pleads, "But what about love, but what about love...." Breitz choreographs an ever-shifting series of relationships as the stuttering Ewings insult each other, fixate on each other, and vie for family power.

Dallas was notorious for tantalizing its viewers with the promise of an impending twist or plot diversion, yet paradoxically depended on a stable cast of family members who were reassuringly consistent in their behavior. This logic kept a global audience engrossed week after week, for thirteen years: the promise of suspense that nevertheless returned the viewer to comfortable predictability at regular intervals. As she critically dissects the products of mainstream entertainment, Breitz is assiduous in never losing sight of the private memories and personal significances that are woven into even the most degraded forms of cultural consumerism. Casting her ethno-graphic eye on familiar events at Southfork Ranch, she wryly suggests that we must start with the culture that we consume if we are to approach any credible notion of a "natural" history.

In *Diorama,* the dysfunctional Ewings stand in not only for the millions of viewing families who fell spellbound to the fictional trials and tribulations of *Dallas,* but also for the timelessness of family struggle itself. Set free from plot and narrative, and represented in the form of a videoscaped family tree, the Ewings are made to dramatize the very fragility of family being. *Diorama* returns to the theme of flawed family that haunted Greek mythology, and has since resurfaced obsessively in prose and literature. That we continue to be captivated by family saga is nowhere clearer than in Breitz's distillation of *Dallas* as contemporary diorama. The installation grants an epic significance to family relations, restaging the most primal of sagas with the most primal of casts: a father, a mother, and their offspring.... In so doing, it both recalls the artist's earlier *Babel Series* and anticipates her later installations *Mother + Father.*

Each edition of *Diorama* has been produced in a different city, using discarded furniture that the artist excavates from local second-hand shops at the time of exhibiting the installation. *Diorama* was commissioned by Artpace San Antonio, Texas, where it was first shown in early 2002. The work has subsequently been remade in Miami, Dubrovnik, London and Amsterdam. Though the setting changes, like so many living rooms scattered around the television-viewing world, the loops played back on the monitors remain consistent in each version of the installation.

Diorama

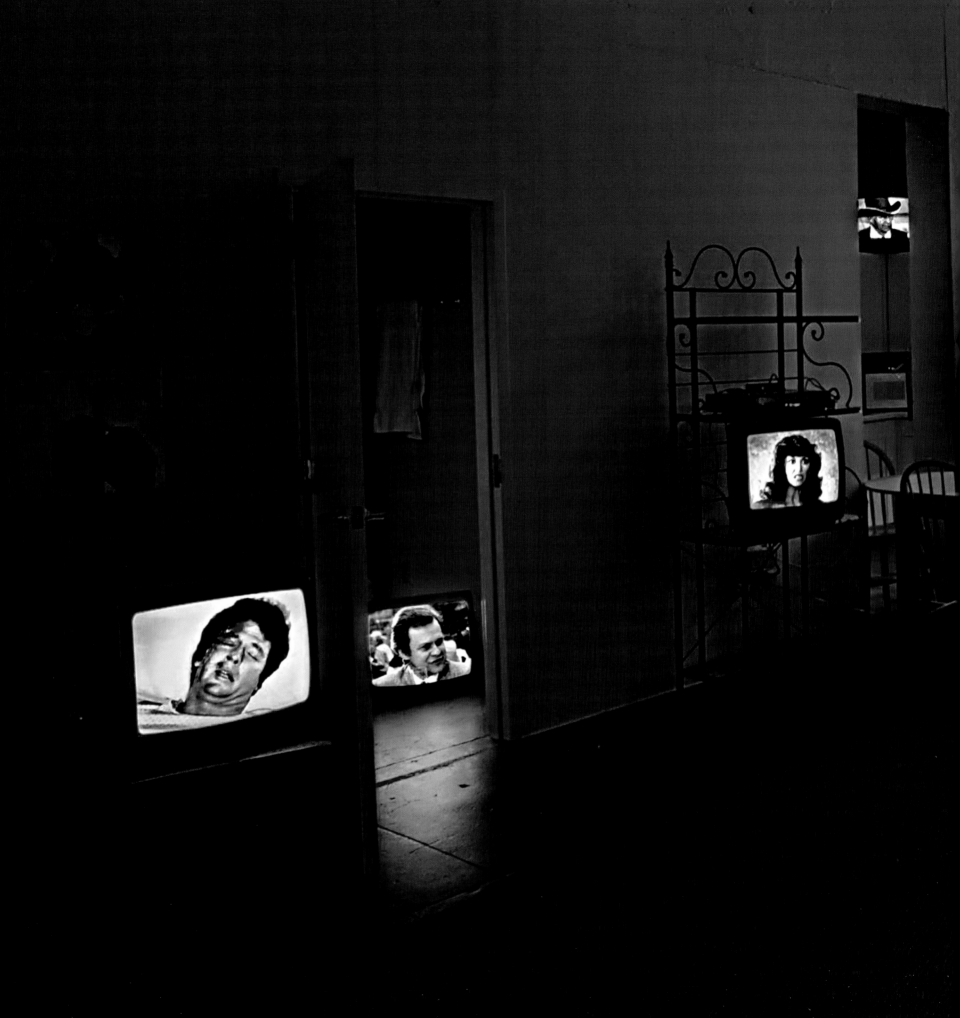

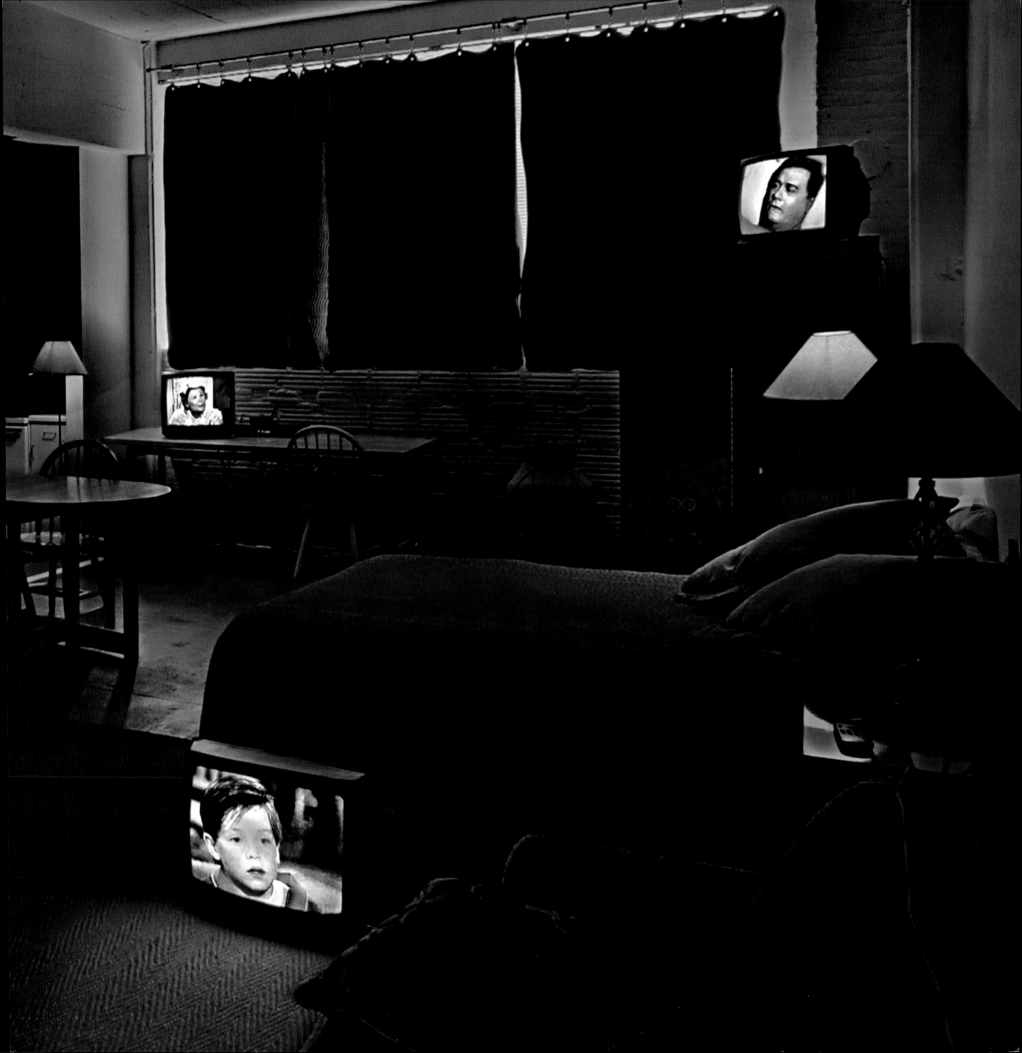

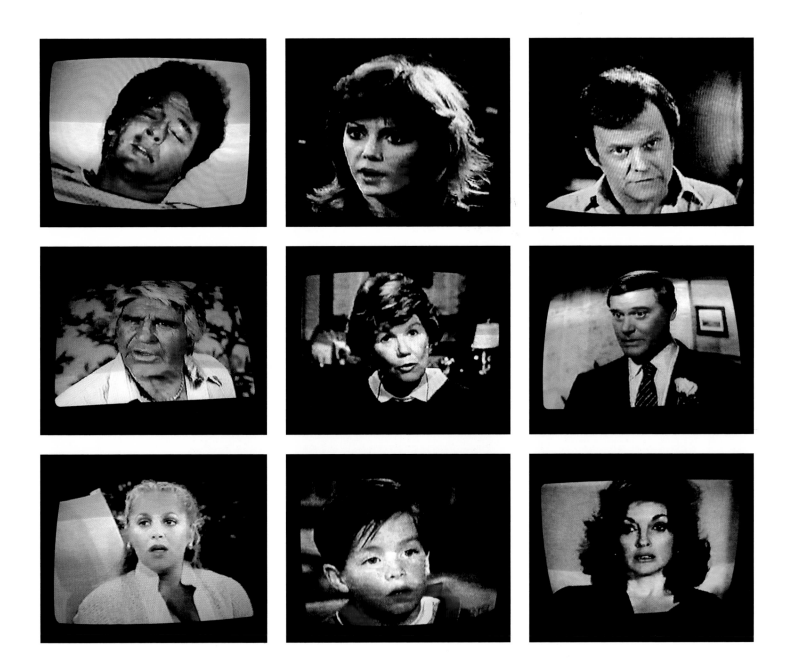

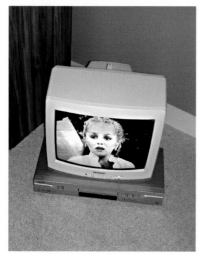 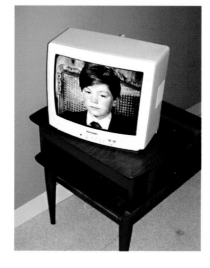 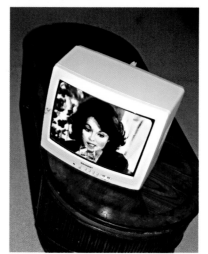

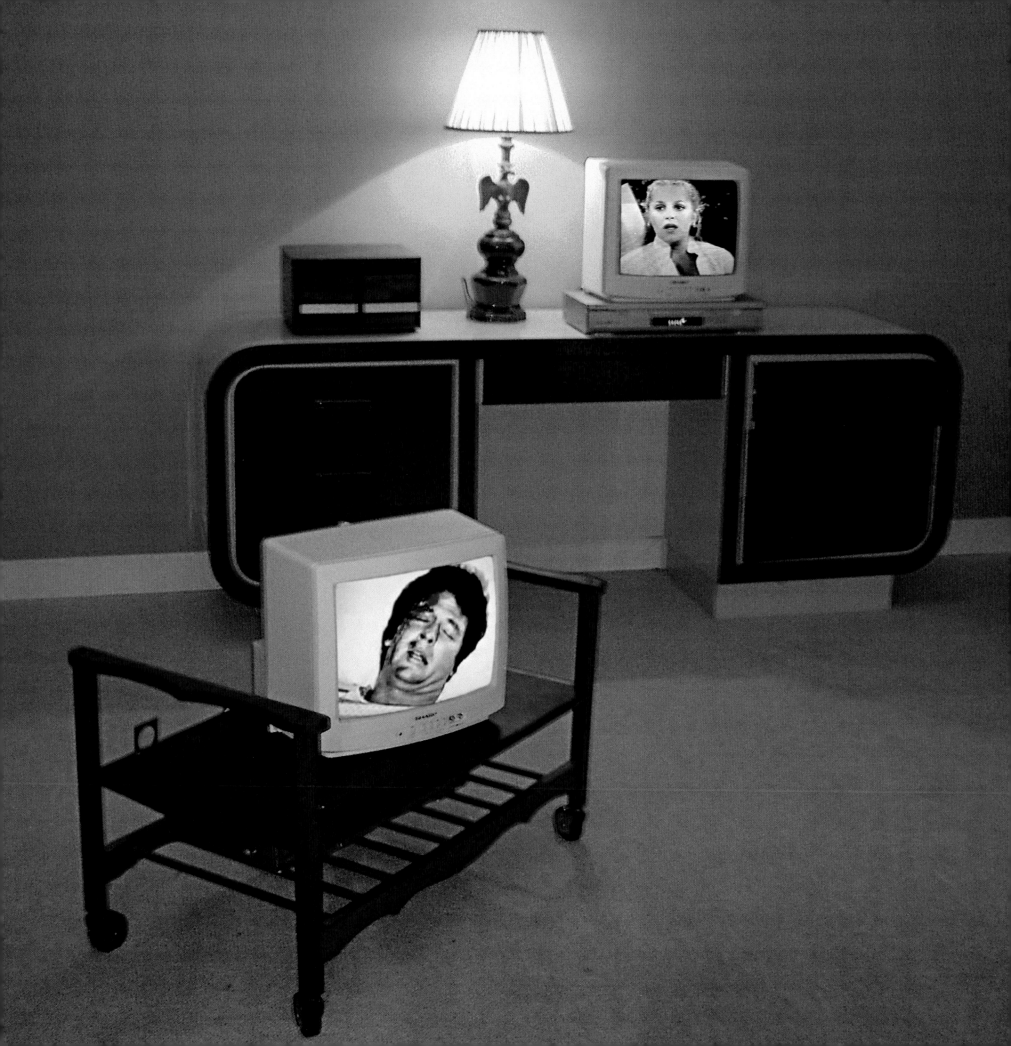

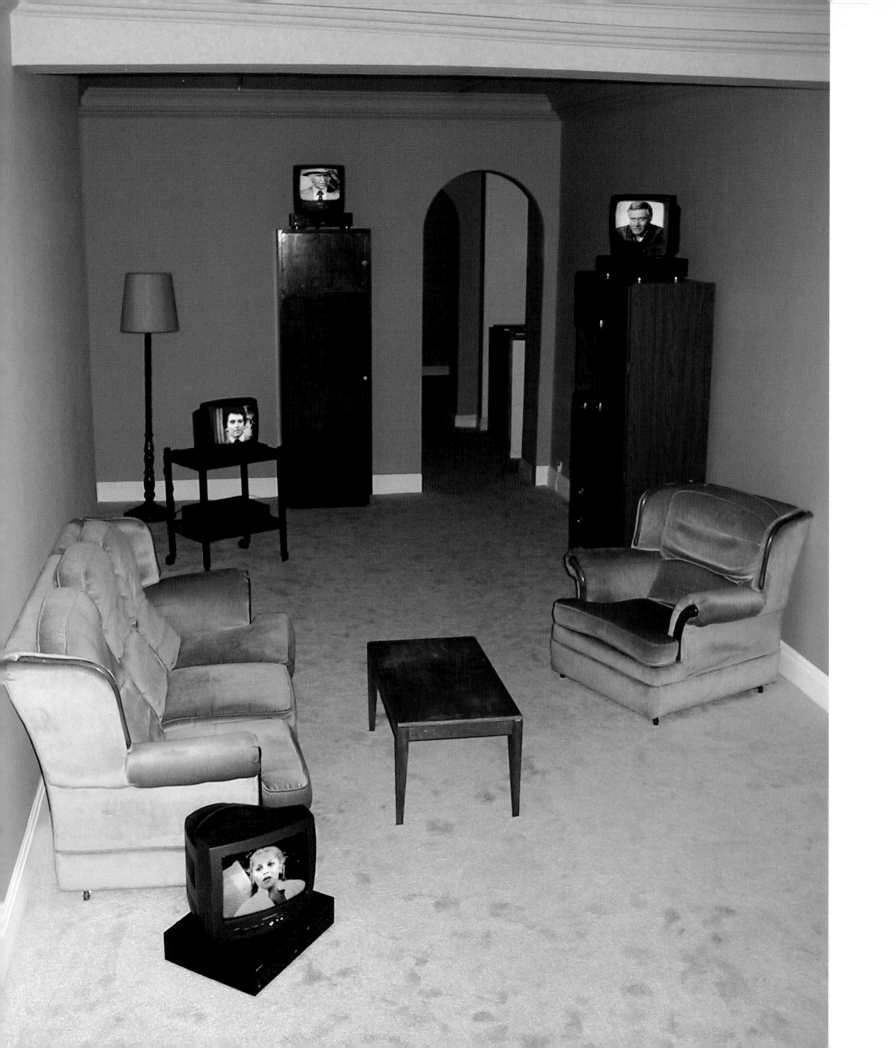

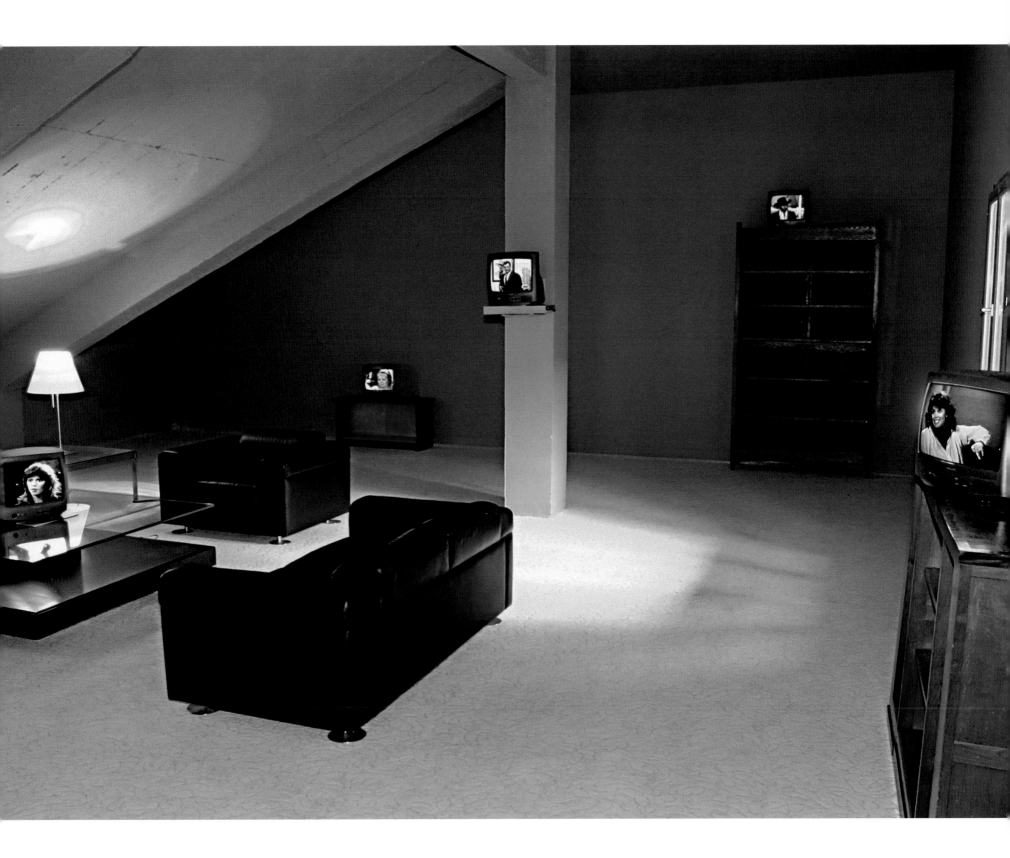

Seis actrices de Hollywood se mueven nerviosamente unas al lado de las otras, sobre un fondo negro y austero que se extiende por una estructura semicircular con otras tantas pantallas de plasma, mientras viven apasionadamente los rituales de la maternidad. En una segunda instalación en paralelo, seis intérpretes masculinos igualmente reconocibles pasan por los avatares de la paternidad. Los monitores funcionan como vitrinas de un museo de historia natural, si bien en lugar de encerrar a animales disecados albergan fragmentos de Faye Dunaway, Diane Keaton, Shirley MacLaine, Julia Roberts, Susan Sarandon y Meryl Streep (*Mother,* 2005), o bien retales de Tony Danza, Dustin Hoffman, Harvey Keitel, Steve Martin, Donald Sutherland y Jon Voight (*Father,* 2005).

Los actores de *Mother* y de *Father,* arrancados digitalmente de sus películas respectivas, han quedado liberados de sus ataduras tradicionales y pueden interpretar dos nuevos cortos dramáticos escritos por Candice Breitz. Resurgen de la mesa de montaje de la artista reciclados y empujados a ocupar composiciones organizadas con rigidez, para aparecer en sus respectivas pantallas de modo rítmico y obsesivo, agrupados brevemente en momentos de coherencia narrativa para luego recorrer a toda prisa escenas que carecen de la más mínima lógica y en las que su interpretación de la paternidad es tan absurda como neurótica. Si se compara a los actores con instrumentos, podría decirse que Breitz los toca aquí como nunca fueron tocados antes, sonsacándoles un guión operístico que cataloga y destripa los valores que la cultura dominante tiende a naturalizar y que no se personifican en ningún lado mejor que en los papeles primarios y normativos que interpretan las madres y los padres que pueblan los guiones de los éxitos de taquilla: la madre abnegada que vive en estado de histeria perpetua ("¡Todo lo que he hecho lo he hecho porque te quiero!") o el

padre sobreprotector que se entrega a la preservación eterna de la virginidad de su hija ("Ningún chico se presenta en esta casa y se lleva a mi hija sin que yo sepa quién es, dónde vive, quiénes son sus padres...").

Con independencia de una astuta disección de la vida familiar (que tiene ecos de una instalación anterior, *Diorama*), Breitz nos ofrece la paternidad como metáfora de la relación existente entre la estrella y su fan. En el fondo, ¿no son los padres los modelos que sus hijos pretenden emular? ¿Y no es cierto que el mundo del espectáculo busca cada vez más usurpar el papel de los padres y que los espectadores jóvenes aspiran más y más a emular a los modelos que ven en la pantalla? Al apropiarse el papel que tradicionalmente interpretaban los padres, los medios de comunicación pretenden (y logran cada vez más a menudo) alcanzar el mismo efecto deseado por los progenitores: la reproducción de sus propios valores sociales y su conciencia política. Hollywood se compone – según parece sugerir la obra de Breitz – de una serie de personajes autoritarios que desean moldear a los espectadores a su imagen y semejanza. Sin embargo, la artista parece dar a entender que no hace falta deshacerse por completo de esa cultura, sino evitar consumirla como un producto acabado y tomarla en su lugar como una mera materia prima.

Por un lado, cuando Breitz arrebata las riendas a Hollywood parece ofrecernos una oportunidad de dirigir en lugar de ser dirigidos, una ocasión de desafiar el espectáculo, plantándole cara en lugar de estar eternamente sujetos a su mirada paralizante. Por otro, mientras los actores sampleados se mueven a sacudidas y se retuercen torpemente nos da la impresión de que la relación entre Breitz y su reparto no es la que se establece entre una titiritera omnipotente y sus marionetas, sino más bien un

claro tira y afloja destinado a determinar quién acabará controlando la producción del significado: los que hacen las películas o los que las ven.

Twitching alongside each other against a stark black backdrop that stretches across a semi-circular structure of six plasma screens, six Hollywood actresses passionately perform the rites of motherhood. In a second parallel installation, six equally recognizable actors go through the motions of fatherhood. The plasma screens function like glass display cases in a museum of natural history, except that rather than caging desiccated animals, they house fragments of Faye Dunaway, Diane Keaton, Shirley MacLaine, Julia Roberts, Susan Sarandon and Meryl Streep (*Mother,* 2005); as well as snippets of Tony Danza, Dustin Hoffman, Harvey Keitel, Steve Martin, Donald Sutherland and Jon Voight (*Father,* 2005).

Having been digitally extracted from their respective movies, the cast members of *Mother* and *Father* are free of their usual trappings, free to perform two new dramas scripted by Candice Breitz. The actors emerge from Breitz's mixing-desk recycled and coerced into tautly arranged compositions, flashing onto their respective screens rhythmically and obsessively, now grouping themselves briefly into moments of narrative coherence, then careening through wildly nonsensical scenes in which their performance of parenthood is as absurd as it is neurotic. If actors might be thought of as instruments, Breitz plays them here like they've never been played before, coaxing out of them an operatic screenplay that catalogues and guts the values that mainstream entertainment tends to naturalize. These values are nowhere better personified than in the primary and normative roles played by the *Mothers* and *Fathers* who populate blockbuster scripts: the self-denying mother who exists in a state of perpetual hysteria ("Everything I did, I did out of love for you!"), or the over-protective father who dedicates himself to the eternal preservation of his daughter's virginity ("No boy comes in this house and takes my daughter anywhere, unless I know who he is, where he lives, who his parents are...").

Above and beyond an astute dissection of family life (which recalls her earlier installation, *Diorama*), Breitz offers us parenthood as a metaphor for the relationship between the star and the fan. For are not parents the role models that their children seek to emulate? And is it not the case that the entertainment industry increasingly seeks to usurp the role of parenthood for itself, with young viewers aspiring, more and more, to emulate the role models projected on the silver screen? In encroaching upon the role traditionally played by the parent, the media seeks and increasingly achieves the same effect desired by the parent: the reproduction of its own social values and political consciousness. Hollywood is composed – Breitz's work seems to suggest – of a cast of authoritarian characters who would shape and mould viewers in their own image. Yet, she seems to imply, there is no need to do away with this culture entirely; rather, an imperative to avoid consuming it as finished product, and instead, to treat it as mere raw material.

On the one hand, as Breitz grabs the reins from Hollywood, she seems to offer us a chance to direct rather than to be directed, a chance to stare down the spectacle rather than remaining endlessly subject to its paralyzing gaze. On the other hand, as the sampled actors awkwardly jerk and writhe through her scripts, one senses that the relationship between Breitz and her cast is not so much a relationship between an all-controlling puppet-master and her marionettes, but rather an earnest tug-of-war to determine who will ultimately control the production of meaning: those who make the movies or those who watch them.

Mother + Father

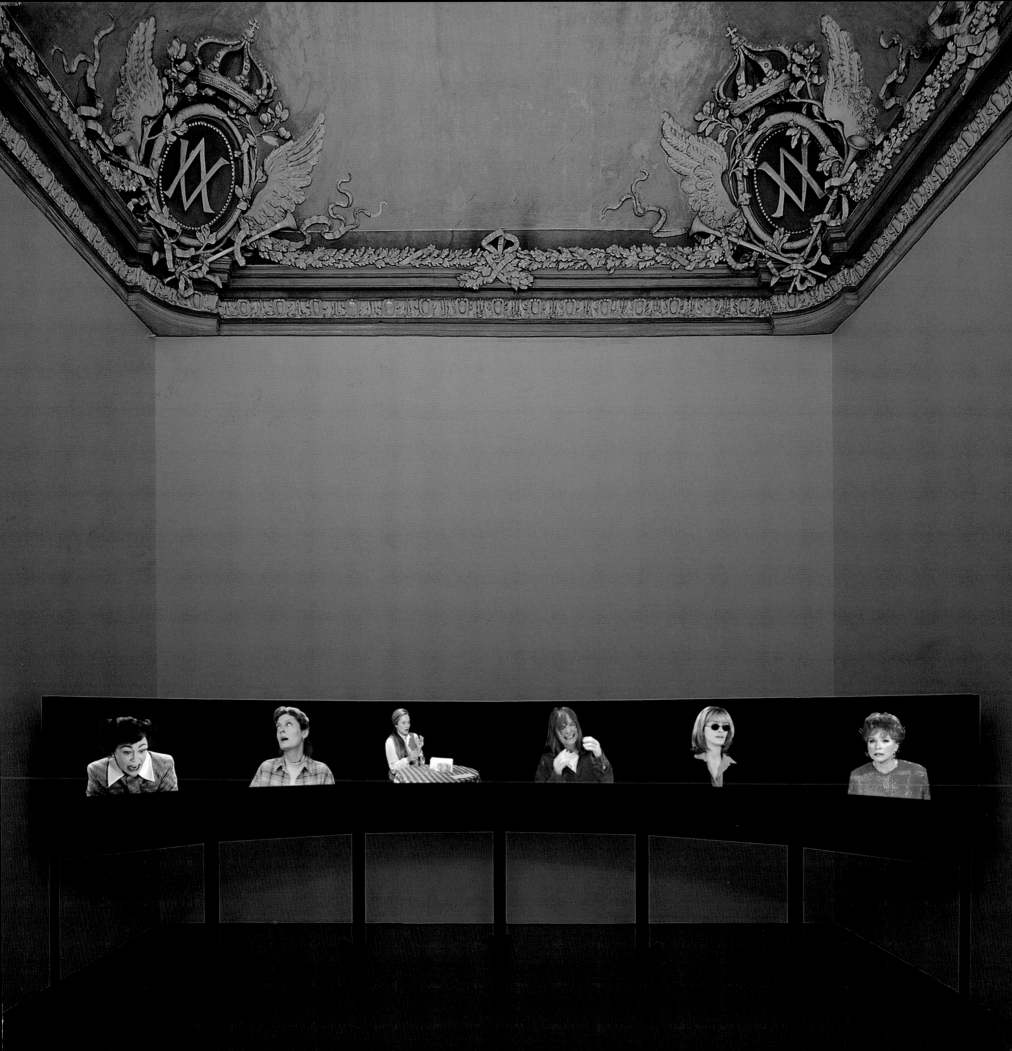

...didn't want you to see me get upset... I hate getting upset... *Julia Roberts:* I never wanted to be a mom! *Faye Dunaway:* I'm scared! *Julia Roberts:* Carrying it alone the rest of my life... *Faye Dunaway:* I'm scared! *Julia Roberts:* ...always being compared to you. *Faye Dunaway:* I'm scared! *Julia Roberts:* ...perfect! *Susan Sarandon:* What do I have that you don't? *Julia Roberts:* You're Mother Earth Incarnate! *Sarandon laughs patronizingly.* *Julia Roberts:* You know every story... *Sarandon laughs patronizingly.* *Julia Roberts:* ...every wound... every memory... their whole lives' happiness is wrapp... *...randon laughs patronizingly.* *Julia Roberts:* Look down the road, to her wedding: fluffing her dress – telling her: "No woman has ever looked so beautiful!" – and my fear is, that she'll be thinking... *Faye Dunaway:* After all those years.... *Julia Roberts:* "I wish my mom were here!" *Faye Dun... ...ought it could happen to me. *Meryl Streep:* Ha-ah! Ha-ah! Ha-ah! *The mothers laugh together awkwardly, in a state of discomfort. Meryl Streep:* Last time you saw me I was in, uh, pretty bad shape... I was... I was... I was... *Diane Keaton:* How long did you feel that way? *Meryl Streep:* All... like somebody's wife, or somebody's mother, or somebody's daughter. *Shirley MacLaine:* Tsk, tsk, tsk, tsk, oh dear! *Diane Keaton:* I really think you have to understand that you see, with, um, Brian, we just stopped having sex a long time before we split up... *Meryl Streep:* I never knew wh... *MacLaine:* Oh dear, oh dear, oh dear! *Meryl Streep:* And that's why I had to go away... *Shirley MacLaine:* Tsk, tsk, tsk, tsk, oh dear! *Diane Keaton:* I was frigid with him, and, well I'd, I'd always been frigid... *Meryl Streep:* But every time I talked to my ex-husband about it, he wouldn't listen... I could understand him wanting someone else, because sex between us was so um, nothing. *Meryl Streep:* During the last five years of our marriage... *Diane Keaton:* It was nothing... *Meryl Streep:* ...I was becoming more and more unhappy. *Shirley MacLaine:* I had a nervous breakdown... ...e failed... *Meryl Streep:* He just wasn't there for me... *Diane Keaton:* I never really felt very, um, er, erotic around him. *Meryl Streep:* And because of his attitude towards my fears, and his inability to deal with my feelings, I had come to have almost no self-esteem, no self-esteem, no... ...esteem, no self-esteem... no self-esteem... *Faye Dunaway:* How sad that is... *Meryl Streep:* No self-esteem, no self-esteem, no self-esteem... *Diane Keaton:* I could understand him wanting someone else, because sex between us was so um, nothing. I could understand him wanting some... ...sex between us was so um, nothing. *Meryl Streep:* It's me, it's my fault. It's me, it's my fault. It's me, it's my fault. It's me, it's my fault. It's me, it's my fault.... *We see Dunaway jogging obsessively and hear her breathing heavily as she runs. MacLaine repeatedly punches her lap. Meryl Stre... ...therapist... a really good one! *Diane Keaton:* My life changed, and, and I, I, I really think... *Meryl Streep:* ...and I feel better about myself, than I ever have in my whole life, and I've learned a great deal about myself. *Susan Sarandon:* Why are you telling me this? *Julia Roberts:* I never want... *Diane Keaton:* Yeah, well... *Susan Sarandon:* You know what your problem is? You are so self-involved – you couldn't be a mother... *Meryl Streep:* Well I've learned that I love... *Diane Keaton:* Yeah, well... *Meryl Streep:* ...my little boy. *Diane Keaton:* Well... *Susan Sarandon:* Why are you tel... ...ane Keaton:* What? *Faye Dunaway:* W-What? W-What? W-What? *Diane Keaton:* What? *Susan Sarandon:* Woooow! *Faye Dunaway:* Tina darling, guess what?! *Diane Keaton:* What? *Susan Sarandon:* Why are you telling me this? *Diane Keaton:* Oh I don't know. I really don't know but I uh, I hear... ...e... *Susan Sarandon:* Wow! (incredulous) Oooooh! (at a loss for words) *Diane Keaton:* Yeah, well... well... *Shirley MacLaine:* Dear, it's no good feeling sorry for yourself... *Diane Keaton:* I felt I, I honestly, I honestly didn't feel... *Shirley MacLaine:* ...you're gonna have to overcome these difficu... ...on: ...that, that there was a need for... *Susan Sarandon:* Wow! *Diane Keaton:* ...all the rules and the lines. *Susan Sarandon:* Oooh! *Diane Keaton:* I mean, I mean, I mean, I mean... *Susan Sarandon:* She sees her father naked, in the shower, with another woman, for the first time... *Diane Keaton:* We h... ...n naked around her, it's true, but, but, but... *Susan Sarandon:* And you think it would be better for her, if everyone just pretends nothing happened? *Diane Keaton:* It was... we were all of us, we were very happy... *Meryl Streep:* At the time I left I felt that there was something terribly wr... ...that my son would be better off without me. I realized, after getting into therapy, that I wasn't such a terrible person... *Julia Roberts:* No! No! No! No! No! *Meryl Streep:* And, just because I needed some kind of creative or emotional outlet other than my child, that didn't make me unfi... ...n *Susan Sarandon:* You know what your problem is? You are so self-involved – you couldn't be a mother... *Shirley MacLaine:* Everything I did, I did out of love for you I might have done wrong sometimes... how can you do everything right? *Meryl Streep:* I know I left my son... *Faye Dun... ...did that. *Meryl Streep:* I know that's a terrible thing to do... *Faye Dunaway:* I'd have rather cut off my hand... *Meryl Streep:* Believe me, I have to live with that every day of my life... *Diane Keaton:* It was, it was a mistake! *Faye Dunaway:* I'm sorry I did that. *Susan Sarandon:* I did ev... *Diane Keaton:* We both made mistakes. *Shirley MacLaine:* Will you please tell me what is this awful thing I did? *Susan Sarandon:* It is not my job to make it easier for you! It is my job to take care of those children... *Meryl Streep:* Don't, don't try to bully me. *Susan Sarandon:* And they don... ...you. *Meryl Streep:* What makes you so sure he doesn't want me? *Shirley MacLaine:* I promised myself I would not do this... and look at me... *Meryl Streep:* I am still his mother. *Susan Sarandon:* This is not about you, this is not your problem! *Faye Dunaway:* Now you're trying to stab me in t... ...arandon:* This is not your problem! *Diane Keaton:* I just, I don't wanna lose her... *Meryl Streep:* I don't know how anybody can possibly believe that I have less of a stake in mothering that little boy... *Shirley MacLaine:* I was just so excited about seeing my daught... ...want my son! *Susan Sarandon:* Can I see my son now please? *Faye Dunaway:* My daughter... *Meryl Streep:* I want my son! *Shirley MacLaine:* My daughter doesn't like it when I talk... *Susan Sarandon:* Do you realize what could have happened to your son? *Meryl Streep:* I want my son! *Shirley... ...re my responsibility, you're my daughter... *Faye Dunaway:* My own... daughter. *Shirley MacLaine:* My daughter wants to talk to me... *Meryl Streep:* I know I left my son... *Faye Dunaway:* Who do you think you're talking to? *Shirley MacLaine:* Well... well... well. *Faye Dunaway:* Who do you thi... ...to? *Shirley MacLaine:* YOU ONLY REMEMBER THE BAD STUFF, DON'T YOU? *Diane Keaton:* I remember Brian saying, "Oooh... *Meryl Streep:* I remember once he said that I probably... *Shirley MacLaine:* YOU ONLY REMEMBER THE BAD STUFF, DON'T YOU? You only remember the bad stuff! *Di... ...I don't you think I'm taking the rap too? Huh? How about for the rest of my life? GET AWAY FROM ME... JUST GET AWAY... GET AWAY FROM ME... LEAVE ME ALONE!... *Susan Sarandon:* It's okay, it's okay... *Diane Keaton:* LEAVE ME ALONE! GO! GOOOO! *Susan Sarandon:* Oh my sweetie, it's ok... ...f slapping is heard, as Dunaway repeatedly and rhythmically slaps somebody who is invisible to us. *Meryl Streep:* Now don't you, don't, don't make me go in there please, please don't make me.... Now don't you, don't, don't make me go in there please, please don't make me... Now don't y... ...ake me go in there please, please don't make me.... Now don't you, don't, don't make me go in there please, please don't make me... *Faye Dunaway:* AAHHHHHHH... YOU HATED ME... I THOUGHT YOU WANTED TO BE MY DAUGHTER... AAHHHHHHH... YOU HATED ME... I THOUGHT YOU WANTE... ...GHTER... AAHHHHHHH.... *A symphony of hysterical sobbing, screaming and slapping, accompanied by the sound of glass breaking, a thumping piano, dogs barking and the contents of a kitchen being violently hurled. Shirley MacLaine:* I am still here! I am still here! I am still here... ...I here! Sarandon and Roberts roll their heads from side to side anxiously. *Faye Dunaway:* DON'T FUCK WITH ME, don't fuck with me, don't fuck with me! DON'T FUCK WITH ME, don't fuck with me, don't fuck with me! *All:* Why? Why? Why? Why? *Faye Dunaway:* Why, WHY, why, WHY, why, W... ...u give me the RESPECT? I don't ask much from you girl... *Diane Keaton:* I don't know! I don't know! *Faye Dunaway:* Why can't you give me the RESPECT that I'm entitled to? *Diane Keaton:* I don't know! *Meryl Streep:* Well, I don't know! *Faye Dunaway:* Why can't you treat me, the way that I... ...by any stranger on the street? *Shirley MacLaine:* I do not blame me for my misfortunes or for my drinking... *Meryl Streep:* I am still his mother! *Diane Keaton:* Does it, uh, really matter? *Meryl Streep:* I am still his mother! *Shirley MacLaine:* You feel sorry for yourself half the time, fo... ...er of a mother like me... *Diane Keaton:* You're a good mother Anna... you're a good mother Anna... *Susan Sarandon:* You couldn't be a mother... *Diane Keaton:* Everybody knows, you're a good mother... *Susan Sarandon:* You couldn't be a mother! You couldn't be a mother! You couldn't be a... ...naway:* I could be a mother and a father. I could be a mother and a father. *Meryl Streep:* I was his mommy for... five and a half years. *Mother:* I'M ASHAMED TO BE YOUR MOTHER! *Julia Roberts:* I wish my mom was here! *Mother:* I'M ASHAMED TO BE YOUR MOTHER! *Mother:* I've always trie... ...other to you... *Shirley MacLaine:* I wish that my mother had been as concerned about me when I was a little girl... *Julia Roberts:* I never wanted to be a mom! *Shirley MacLaine:* Mother, mother, mother! *Mother:* I'M ASHAMED TO BE YOUR MOTHER! *Shirley MacLaine:* I'm Suzanne's mother! I... ...her! *Meryl Streep:* I'm his mother! *Julia Roberts:* You're Mother Earth Incarnate... *Mother:* I'M ASHAMED TO BE YOUR MOTHER! *Meryl Streep:* I'm his mother! *Julia Roberts:* I wish my mom were here! *Meryl Streep:* I'm his mother! *Shirley MacLaine:* Well of course she'll listen to you, you're not her... ...I'M ASHAMED TO BE YOUR MOTHER! *Meryl Streep:* I'm his mother! *Julia Roberts:* I never wanted to be a mom! *Shirley MacLaine:* Am I too late for the family thing? Am I too late for the family thing? Am I too late for the family thing? Am I too late for the family thing? *The mothers gather... ...wards them and hug them, joyously, frenziedly. Roberts looks on, childless and confused. Diane Keaton:* Eat something Molly, alright? *All:* NO! NO! NO! NO! *Diane Keaton:* Eat something Molly, alright? *All:* Yes! Yes! Yes! Yes! *Faye Dunaway:* You haven't touched your lunch... *Meryl Streep + Di... ...I didn't, no I did not! *Faye Dunaway:* You haven't touched your lunch... *Meryl Streep + Diane Keaton:* Yes I did! *Faye Dunaway:* Why must everything be a contest? *Susan Sarandon:* WELL! Well that's what parenting is all about little girl! *Faye Dunaway:* I took the best job I could find, so... ...r sister could eat and have a place to sleep and some clothes on your back... *Shirley MacLaine:* Everything I did, I did out of love for you! *Susan Sarandon:* WELL! Well that's what parenting is all about little girl! *Diane Keaton:* Mhmm! Mhmm! Mhmm! Mhmm! Mhmm! Mhmm! *Susan Sarandon... ...iane Keaton:* Mhmm! *Susan Sarandon:* Are you here? *Shirley MacLaine:* Am I here? *Susan Sarandon:* Because you don't seem like you're really here? *Shirley MacLaine:* Am I here? Am I here? *Faye Dunaway:* I feel that discipline, mixed with love, is such a good recipe! *Susan Sarandon:* Are y... ...MacLaine:* And I'm here, and I'm here, and I'm here! *Susan Sarandon:* You haven't been here from the beginning, worrying every minute of every day that the decisions you're making are gonna shape the people that they are going to be... *Shirley MacLaine:* But I'm here, but I'm here! *Fa...

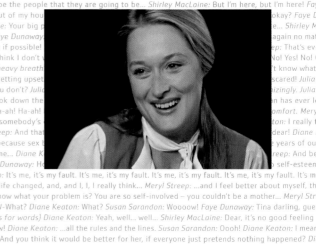

...eel that discipline... in heeeeeeere! *Faye Dunaway:* ...on: Get out of my hou... okay? *Faye C... ...don't go... *Meryl S... ...yl Streep:* I'm leaving you! *Faye Dunaway:* ... me... *Shirley MacLaine:* Your big p... ...Shirley... ...only interested in... ...usan Sarandon:* This is ridiculous... ...ve you anymore... *Faye Dunaway:* ...again no ma... ...or ask, or do... D... ...ne: Don't blame me! I do not bla... ...ol snack: refrigerate if possible! ...ep: That's ev... ...naway: EAT YOU... ...: I've always tried to be a goodYou don't really think I don't w... ...No! Yes! No! ...o! *Faye Dunaway:* Wh... ...always wanted a kid... I want adespair. Keaton's heavy breath... ...t know what... *Julia Roberts:* Wh... ...n do this! *Susan Sarandon:* Y... ...get upset... I hate getting upset... ...scared! ...l it alone the rest... ...ng compared to you. *Faye Dunaw... ...izingly. Julia... ...every story... ...at do I have that you don't? *Juli... ...zingly. *Julia... ...very memory... their whole lives'... ...an has ever li... ...*Julia Roberts:* Look down the... ...me. *Meryl Streep:* Ha-ah! Ha-ah!... ...body's mother, or somebody's... ...omfort. Mery... ...ee you saw me I was in, uh, pretty... ...How long did you feel that wa... ...tion: I really w... ...understand that... ...before we split up... *Meryl Stree... ...oh dear! *Meryl Streep:* And tha... ...dear! Diane... ...id with him, and,... ...lked to my ex-husband about it... ...ing someone else, because sex b... ...years of ou... ...ane Keaton:* It was... ...ley MacLaine:* I had a ne... ...st wasn't there for me... *Diane K... ...eep: I never knew... ...ude towards my fears, no s... ...ave almost no self-esteem, no s... ...self-esteem... *Faye Dunaway:* Ho... ...eep: ...self-esteem

I could understand him wanting someone else, because sex between us was so um, nothing. I could understand him wanting someone else, because sex between us was so um, nothing. *Meryl Streep:* It's me, it's my fault. It's me, it's my fault. It's me, it's my fault. It's me, it's my fault. It's me, it's my fault. It's m... *We see Dunaway jogging obsessively and hear her breathing heavily as she runs. MacLaine repeatedly punches her lap. Meryl Streep:* I got myself a therapist... a really good one! *Diane Keaton:* My life changed, and, and I, I, I really think... *Meryl Streep:* ...and I feel better about myself, than I ever have in... ...my whole life, and I've learned a great deal about myself. *Susan Sarandon:* Why are you telling me this? *Julia Roberts:* I never wanted to be a mom! *Susan Sarandon:* You know what your problem is? You are so self-involved – you couldn't be a mother... *Meryl Stre... ...ned that I love... *Diane Keaton:* Yeah, well... *Meryl Streep:* ...my little boy. *Diane Keaton:* Well... *Susan Sarandon:* Why are you telling me this? *Diane Keaton:* What? *Faye Dunaway:* W-What? W-What? W-What? *Diane Keaton:* What? *Susan Sarandon:* Woooow! *Faye Dunaway:* Tina darling, gue... ...eaton:* What? *Susan Sarandon:* Why are you telling me this? *Diane Keaton:* Oh I don't know. I really don't know but I uh, I hear you blaming me... *Susan Sarandon:* Wow! (incredulous) Oooooh! (at a loss for words) *Diane Keaton:* Yeah, well... well... *Shirley MacLaine:* Dear, it's no good feeling... *...Diane Keaton:* I felt I, I honestly, I honestly didn't feel... *Shirley MacLaine:* ...you're gonna have to overcome these difficulties. *Susan Sarandon:* ...that, that there was a need for... *Susan Sarandon:* Wow! *Diane Keaton:* ...all the rules and the lines. *Susan Sarandon:* Oooh! *Diane Keaton:* I mea... ...I mean... *Susan Sarandon:* She sees her father naked, in the shower, with another woman, for the first time... *Diane Keaton:* We had been naked around her, it's true, but, but, but... *Susan Sarandon:* And you think it would be better for her, if everyone just pretends nothing happened? *Di... ...was... we were all of us, we were very happy... *Meryl Streep:* At the time I left I felt that there was something terribly wrong with me, and that my son would be better off without me. I realized, after getting into therapy, that I wasn't such a terrible person... *Julia Roberts:* No! No! No! No!... ...And, just because I needed some kind of creative or emotional outlet other than my child, that didn't make me unfit to be a mother. *Susan Sarandon:* You know what your problem is? You are so self-involved – you couldn't be a mother... *Shirley MacLaine:* Everything I did, I did out of... ...ight have done wrong sometimes... how can you do everything right? *Meryl Streep:* I know I left my son... *Faye Dunaway:* I'm sorry I did that. *Meryl Streep:* I know that's a terrible thing to do... *Faye Dunaway:* I'd have rather cut off my hand... *Meryl Streep:* Believe me, I have to live... ...ay of my life... *Diane Keaton:* It was, it was a mistake! *Faye Dunaway:* I'm sorry I did that. *Susan Sarandon:* I did everything right... *Diane Keaton:* We both made mistakes. *Shirley MacLaine:* Will you please tell me what is this awful thing I did? *Susan Sarandon:* It is not my job to make it e... ...s my job to take care of those children... *Meryl Streep:* Don't, don't try to bully me. *Susan Sarandon:* And they don't wanna be with you. *Meryl Streep:* What makes you so sure he doesn't want me? *Shirley MacLaine:* I promised myself I would not do this... and look at me... *Meryl Streep:* I ar... ...*Susan Sarandon:* This is not about you, this is not your problem! *Faye Dunaway:* Now you're trying to stab me in the back? *Susan Sarandon:* This is not your problem! *Diane Keaton:* I just, I don't wanna lose her... *Meryl Streep:* I don't know how anybody can... ...that I have less of a stake in mothering that little boy... *Shirley MacLaine:* I was just so excited about seeing my daughter! *Meryl Streep:* I want my son! *Susan Sarandon:* Can I see my son now please? *Faye Dunaway:* My daughter... *Meryl Streep:* I want my son! *Shirley MacLaine:* My daughte... ...then I talk... *Susan Sarandon:* Do you realize what could have happened to your son? *Meryl Streep:* I want my son! *Shirley MacLaine:* You're my responsibility, you're my daughter... *Faye Dunaway:* My own... daughter. *Shirley MacLaine:* My daughter wants to talk to me... *Meryl Streep:* I know... ...aye Dunaway:* Who do you think you're talking to? *Shirley MacLaine:* Well... well... well. *Faye Dunaway:* Who do you think you're talking to? *Shirley MacLaine:* YOU ONLY REMEMBER THE BAD STUFF, DON'T YOU? *Diane Keaton:* I remember Brian saying, "Oooh.... *Meryl Streep:* I remember... ...t probably... *Shirley MacLaine:* YOU ONLY REMEMBER THE BAD STUFF, DON'T YOU? You only remember the bad stuff! *Diane Keaton:* Well don't you think I'm taking the rap too? Huh? How about for the rest of my life? GET AWAY FROM ME... JUST GET AWAY... GET AWAY FROM ME... LEAVE... ...usan Sarandon:* It's okay, it's okay... *Diane Keaton:* LEAVE ME ALONE! GO! GOOOO! *Susan Sarandon:* Oh my sweetie, it's okay... *The music of slapping is heard, as Dunaway repeatedly and rhythmically slaps somebody who is invisible to us. Meryl Streep:* Now don't you, don't, don't make... ...ease, please don't make me.... Now don't you, don't, don't make me go in there please, please don't make me... Now don't you, don't, don't make me go in there please, please don't make me... Now don't you, don't, don't make me go in there please, please don't make me.... *Faye Dunaway:* AAHH... ...TED ME... I THOUGHT YOU WANTED TO BE MY DAUGHTER... AAHHHHHHH... YOU HATED ME... I THOUGHT YOU WANTED TO BE MY DAUGHTER... AAHHHHHHH.... *A symphony of hysterical sobbing, screaming and slapping, accompanied by the sound of glass breaking, a thumping piano, a... ...d the contents of a kitchen being violently hurled. Shirley MacLaine:* I am still here! I am still here! I am still here! I am still here! I am still here! Sarandon and Roberts roll their heads from side to side anxiously. *Faye Dunaway:* DON'T FUCK WITH ME, don't fuck with me, don't fuck with... ...ITH ME, don't fuck with me, don't fuck with me! *All:* Why? Why? Why? Why? *Faye Dunaway:* Why, WHY, why, WHY, why, WHY? Why can't you give me the RESPECT? I don't ask much from you girl... *Diane Keaton:* I don't know! I don't know! *Faye Dunaway:* Why can't you give me the RESPEC... ...to? *Diane Keaton:* I don't know! *Meryl Streep:* Well, I don't know! *Faye Dunaway:* Why can't you treat me, the way that I would be treated by any stranger on the street? *Shirley MacLaine:* I do not blame me for my misfortunes or for my drinking... *Meryl Streep:* I am still his moth... ...Does it, uh, really matter? *Meryl Streep:* I am still his mother! *Shirley MacLaine:* You feel sorry for yourself half the time, for having a monster of a mother like me... *Diane Keaton:* You're a good mother Anna... you're a good mother Anna... *Susan Sarandon:* You couldn't be a mother... *Di... ...rybody knows, you're a good mother... *Susan Sarandon:* You couldn't be a mother! You couldn't be a mother! You couldn't be a mother! *Faye Dunaway:* I could be a mother and a father. I could be a mother and a father. *Meryl Streep:* I was his mommy for... five and a half years. *Mother:*... ...BE YOUR MOTHER! *Julia Roberts:* I wish my mom was here! *Mother:* I'M ASHAMED TO BE YOUR MOTHER! *Mother:* I've always tried to be a good mother to you... *Shirley MacLaine:* I wish that my mother had been as concerned about me when I was a little girl... *Julia Roberts:* I never wa... ...hirley MacLaine:* Mother, mother, mother! *Mother:* I'M ASHAMED TO BE YOUR MOTHER! *Shirley MacLaine:* I'm Suzanne's mother! I'm Suzanne's mother! *Meryl Streep:* I'm his mother! *Julia Roberts:* You're Mother Earth Incarnate... *Mother:* I'M ASHAMED TO BE YOUR MOTHER! *Meryl Streep:* I'm his mother... ...berts:* I wish my mom were here! *Meryl Streep:* I'm his mother! *Shirley MacLaine:* Well of course she'll listen to you, you're not her mother... *Mother:* I'M ASHAMED TO BE YOUR MOTHER! *Meryl Streep:* I'm his mother! *Julia Roberts:* I never wanted to be a mom! *Shirley MacLaine:* Am I la... ...hing? Am I too late for the family thing? Am I too late for the family thing? Am I too late for the family thing? *The mothers gather their children towards them and hug them, joyously, frenziedly. Roberts looks on, childless and confused. Diane Keaton:* Eat something Molly, alright? *All:* NO!... ...ne Keaton:* Eat something Molly, alright? *All:* Yes! Yes! Yes! Yes! *Faye Dunaway:* You haven't touched your lunch... *Meryl Streep + Diane Keaton:* No, I didn't, no I did not! *Faye Dunaway:* You haven't touched your lunch... *Meryl Streep + Diane Keaton:* Yes I did! *Faye Dunaway:* Why must... ...st? *Susan Sarandon:* WELL! Well that's what parenting is all about little girl! *Faye Dunaway:* I took the best job I could find, so that you and your sister could eat and have a place to sleep and some clothes on your back... *Shirley MacLaine:* Everything I did, I did out of love for you! *Susa... ...ELL! Well that's what parenting is all about little girl! *Diane Keaton:* Mhmm! Mhmm! Mhmm! Mhmm! Mhmm! Mhmm! *Susan Sarandon:* Are you here? *Diane Keaton:* Mhmm! *Susan Sarandon:* Are you here? *Shirley MacLaine:* Am I here? *Susan Sarandon:* Because you don't seem like you're rea... ...MacLaine:* Am I here? *Faye Dunaway:* I feel that discipline, mixed with love, is such a good recipe! *Susan Sarandon:* Are you here? *Shirley MacLaine:* And I'm here, and I'm here, and I'm here! *Susan Sarandon:* You haven't been here from the beginning, worrying every minute of... ...decisions you're making are gonna shape the people that they are going to be... *Shirley MacLaine:* But I'm here, but I'm here! *Faye Dunaway:* I feel that discipline, mixed with love, is such a good recipe! *Shirley MacLaine:* And I'm heeeeeeere! *Faye Dunaway:* I feel that discipline, mixed w... ...a good recipe! *Susan Sarandon:* Get out of my house... get out... *Diane Keaton:* Why don't you just leave me alone, okay? *Faye Dunaway:* Please don't go... *Meryl Streep:* I'm leaving you! *Faye Dunaway:* Don't leave me here... *Meryl Streep:* I'm leaving you! *Faye Dunaway:* Please! Please! Mer... ...aking him with me... *Shirley MacLaine:* Your big problem is, you're too impatient... *Meryl Streep:* I have no patience... *Shirley MacLaine:* You're only interested in instant gratification! *Meryl Streep:* He's better off without me. *Susan Sarandon:* This is ridiculous! *Shirley MacLaine:* Don't... ...reep: And I don't love you anymore... *Faye Dunaway:* Please don't leave, because if you do, you'll never come back in again no matter what you say, or ask, or do... *Shirley MacLaine:* So what are you suggesting we do? *Shirley MacLaine:* Don't blame me! I do not blame my mother for my mist... ...arandon:* After-school snack: refrigerate if possible! Band-Aids, Neosporin, hand wipes, Kleenex, Tylenol... *Meryl Streep:* That's everything! *Faye Dunaway:* EAT YOUR LUNCH! You will eat everything on that plate! *Shirley MacLaine:* I've always tried to be a good mother to you... *Meryl Strea... ...ing! *Shirley MacLaine:* You don't really think I don't want you to do well do you dear? *All:* I do! Yes! No! Yes! No! Yes, "No! Yes! No! Oh no no no no no! *Faye Dunaway:* You know what's missing in my life? I want a baby. You know I've always wanted a kid... I want a baby... *Loop to beginning.*... ...dly, in a chorus of despair. Keaton's heavy breathing exacerbates the general air of distress. Faye Dunaway:* I don't know what I'm gonna do... *Julia Roberts:* Why didn't you tell me? *Shirley MacLaine:* I promised myself I would not do this! *Susan Sarandon:* You know why? *Shirley MacLai... ...ant you to see me get upset... I hate getting upset... *Julia Roberts:* I never wanted to be a mom! *Faye Dunaway:* I'm scared! *Julia Roberts:* Carrying it alone the rest of my life... *Faye Dunaway:* I'm scared! *Julia Roberts:* ...always being compared to you. *Faye Dunaway:* I'm scared! *Julia... *...Susan Sarandon:* What do I have that you don't? *Julia Roberts:* You're Mother Earth Incarnate! *Sarandon laughs patronizingly. Julia Roberts:* You know every story... *Sarandon laughs patronizingly. Julia Roberts:* ...every wound... every memory... their whole lives' happiness is wrappin...

...Oh dear, oh dear, oh dear! *Meryl Streep:* And that's why I had to go away... *Shirley MacLaine:* Tsk, tsk, tsk, tsk, oh dear! *Diane Keaton:* I was frigid with him, and, well I'd, I'd always been frigid... *Meryl Streep:* But every time I talked to my ex-husband about it, he wouldn't listen... *Diane* ...understand him wanting someone else, because sex between us was so um, nothing. *Meryl Streep:* During the last five years of our marriage... *Diane Keaton:* It was nothing... *Meryl Streep:* ...I was becoming more and more unhappy. *Shirley MacLaine:* I had a nervous breakdown when my *Meryl Streep:* He just wasn't there for me... *Diane Keaton:* I never really felt very, um, er, erotic around him. *Meryl Streep:* And because of his attitude towards my fears, and his inability to deal with my feelings, I had come to have almost no self-esteem, no self-esteem, no self-esteem,... no self-esteem... *Faye Dunaway:* How sad that is... *Meryl Streep:* No self-esteem, no self-esteem, no self-esteem... *Diane Keaton:* I could understand him wanting someone else, because sex between us was so um, nothing. I could understand him wanting someone else, en us was so um, nothing. *Meryl Streep:* It's me, it's my fault. It's me, it's my fault. It's me, it's my fault. It's me, it's my fault. It's me, it's my fault... *We see Dunaway jogging obsessively and hear her breathing heavily as she runs. MacLaine repeatedly punches her lap. Meryl Streep:* I got ...a really good one! *Diane Keaton:* My life changed, and, and, I, I, I really think... *Meryl Streep:* ...and I feel better about myself, than I ever have in my whole life, and I've learned a great deal about myself. *Susan Sarandon:* Why are you telling me this? *Julia Roberts:* I never wanted to be ...aton: Yeah, well... *Susan Sarandon:* You know what your problem is? You are so self-involved – you couldn't be a mother... *Meryl Streep:* Well I've learned that I love... *Diane Keaton:* Yeah, well... *Meryl Streep:* ...my little boy. *Diane Keaton:* Well... *Susan Sarandon:* Why are you telling me th ...n: What? *Faye Dunaway:* W-What? W-What? W-What? *Diane Keaton:* What? *Susan Sarandon:* Woooow! *Faye Dunaway:* Tina darling, guess what?! *Diane Keaton:* What? *Susan Sarandon:* Why are you telling me this? *Diane Keaton:* Oh I don't know. I really don't know but uh, I hear you blami ...randon: Wow! (incredulous) Ooooh! (at a loss for words) *Diane Keaton:* Yeah, well... well... *Shirley MacLaine:* Dear, it's no good feeling sorry for yourself... *Diane Keaton:* I felt I, I honestly, I honestly didn't feel... *Shirley MacLaine:* ...you're gonna have to overcome these difficulties. *Diane* ...hat there was a need for... *Susan Sarandon:* Wow! *Diane Keaton:* ...all the rules and the lines. *Susan Sarandon:* Oooh! *Diane Keaton:* I mean, I mean, I mean, I mean... *Susan Sarandon:* She sees her father naked, in the shower, with another woman, for the first time... *Diane Keaton:* We h ...ound her, it's true, but, but, but... *Susan Sarandon:* And you think it would be better for her, if everyone just pretends nothing happened? *Diane Keaton:* It was... we were all of us, we were very happy... *Meryl Streep:* At the time I left I felt that there was something terribly wrong with ...son would be better off without me. I realized, after getting into therapy, that I wasn't such a terrible person... *Julia Roberts:* No! No! No! No! No! *Meryl Streep:* And, just because I needed some kind of creative or emotional outlet other than my child, that didn't make me unfit to be a r ...arandon: You know what your problem is? You are so self-involved – you couldn't be a mother... *Shirley MacLaine:* Everything I did, I did out of love for you! I might have done wrong sometimes... how can you do everything right? *Meryl Streep:* I know I left my son... *Faye Dunaway:* I'm right ...y Streep: I know that that's a terrible thing to do... *Faye Dunaway:* I'd have rather cut off my hand... *Meryl Streep:* Believe me, I have to live with that every day of my life... *Diane Keaton:* It was, it was a mistake! *Faye Dunaway:* I'm sorry I did that. *Susan Sarandon:* I did everything right... ...We both made mistakes. *Shirley MacLaine:* Will you please tell me what is this awful thing I did? *Susan Sarandon:* It is not my job to make it easier for you! It is my job to take care of those children... *Meryl Streep:* Don't, don't try to bully me. *Susan Sarandon:* And they don't wanna be w ...eep: What makes you so sure he doesn't want me? *Shirley MacLaine:* I promised myself I would not do this... and look at me... *Meryl Streep:* I am still his mother. *Susan Sarandon:* This is not about you, this is not your problem! *Faye Dunaway:* Now you're trying to stab me in the back? ...is not your problem! *Faye Dunaway:* FORGET IT! *Diane Keaton:* I just, I don't wanna lose her... *Meryl Streep:* I don't know how anybody can possibly believe that I have less of a stake in mothering that little boy... *Shirley MacLaine:* I was just so excited about seeing my daughter! *Meryl ...son! Susan Sarandon:* Can I see my son now please? *Faye Dunaway:* My daughter... *Meryl Streep:* I want my son! *Shirley MacLaine:* My daughter doesn't like it when I talk... *Susan Sarandon:* Do you realize what could have happened to your son? *Meryl Streep:* I want my son! *Shirley MacLaine* ...onsibility, you're my daughter... *Faye Dunaway:* My own... daughter. *Shirley MacLaine:* My daughter wants to talk to me... *Meryl Streep:* I know I left my son... *Faye Dunaway:* Who do you think you're talking to? *Shirley MacLaine:* Well... well... well... *Faye Dunaway:* Who do you think you're ...ey Streep: YOU ONLY REMEMBER THE BAD STUFF, DON'T YOU? *Diane Keaton:* I remember Brian saying, "Oooh.... *Meryl Streep:* I remember once he said that I probably.... *Shirley MacLaine:* YOU ONLY REMEMBER THE BAD STUFF, DON'T YOU? You only remember the bad stuff! *Diane Keat* ...I think I'm taking the rap too? Huh? How about for the rest of my life? GET AWAY FROM ME... JUST GET AWAY... GET AWAY FROM ME... LEAVE ME ALONE! *Susan Sarandon:* It's okay, it's okay... *Diane Keaton:* LEAVE ME ALONE! GO! GOOOO! *Susan Sarandon:* Oh my sweetie, it's okay... *The* ...is heard, as Dunaway repeatedly and rhythmically slaps somebody who is invisible to us. *Meryl Streep:* Now don't you, don't, don't make me go in there please, please don't make me.... Now don't you, don't, don't make me go in there please, please don't make me.... Now don't you, don ...go in there please, please don't make me.... Now don't you, don't, don't make me go in there please, please don't make me.... *Faye Dunaway:* AAHHHHHHH... YOU HATED ME... I THOUGHT YOU WANTED TO BE MY DAUGHTER... AAHHHHHHH... YOU HATED ME... I THOUGHT YOU WANTED T ...ER... AAHHHHHHH... *A symphony of hysterical sobbing, screaming and slapping, accompanied by the sound of glass breaking, a thumping piano, dogs barking and the contents of a kitchen being violently hurled. Shirley MacLaine:* I am still here! I am still here! I am still here! I am still h ...Sarandon and Roberts roll their heads from side to side anxiously. *Faye Dunaway:* DON'T FUCK WITH ME, don't fuck with me, don't fuck with me! DON'T FUCK WITH ME, don't fuck with me, don't fuck with me! *All:* Why? Why? Why? Why? *Faye Dunaway:* Why, WHY, why, WHY, why, WHY? W ...me the RESPECT? I don't ask much from you girl... *Diane Keaton:* I don't know! I don't know! *Faye Dunaway:* Why can't you give me the RESPECT that I'm entitled to? *Diane Keaton:* I don't know! *Meryl Streep:* Well, I don't know! *Faye Dunaway:* Why can't you treat me, the way that I would ...ny stranger on the street? *Shirley MacLaine:* I do not blame my mother for my misfortunes or for my drinking... *Meryl Streep:* I am still his mother! *Diane Keaton:* Does it, uh, really matter? *Meryl Streep:* I am still his mother! *Shirley MacLaine:* You feel sorry for yourself half the time, for ...of a mother like me... *Diane Keaton:* You're a good mother Anna... you're a good mother Anna... *Susan Sarandon:* You couldn't be a mother... *Diane Keaton:* Everybody knows, you're a good mother... *Susan Sarandon:* You couldn't be a mother! You couldn't be a mother! You couldn't be a m ...away: I could be a mother and a father. I could be a mother and a father. *Meryl Streep:* I was his mommy for... five and a half years. Mother: I'M ASHAMED TO BE YOUR MOTHER! *Julia Roberts:* I wish my mom was here! Mother: I'M ASHAMED TO BE YOUR MOTHER! Mother: I've always tried ...ther to you... *Shirley MacLaine:* I wish that my mother had been as concerned about me when I was a little girl... *Julia Roberts:* I never wanted to be a mom! Mother: I'M ASHAMED TO BE YOUR MOTHER! *Shirley MacLaine:* I'm Suzanne's mother! I'm ...ner! Meryl Streep:* I'm his mother! *Julia Roberts:* You're Mother Earth Incarnate... Mother: I'M ASHAMED TO BE YOUR MOTHER! *Meryl Streep:* I'm his mother! *Julia Roberts:* I wish my mom was here! *Meryl Streep:* I'm his mother! *Shirley MacLaine:* Well of course she'll listen to you, you're not her r ...I'M ASHAMED TO BE YOUR MOTHER! *Meryl Streep:* I'm his mother! *Julia Roberts:* I never wanted to be a mom! *Shirley MacLaine:* Am I too late for the family thing? Am I too late for the family thing? Am I too late for the family thing? Am I too late for the family thing? *The mothers gather ...ards them and hug them, joyously, frenziedly. Roberts looks on, childless and confused. Diane Keaton:* Eat something Molly, alright? *All:* NO! NO! NO! NO! *Diane Keaton:* Eat something Molly, alright? *All:* Yes! Yes! Yes! Yes! *Faye Dunaway:* You haven't touched your lunch... *Meryl Streep + Dia ...I didn't, no I did not! *Faye Dunaway:* You haven't touched your lunch... *Meryl Streep + Diane Keaton:* Yes I did! *Diane Keaton:* I did out of love for you! *Susan Sarandon:* Why must everything be a contest? *Susan Sarandon:* WELL! Well that's what parenting is all about little girl! *Faye Dunaway:* I took the best job I could find, so ...ne Keaton: Mhmm! Susan Sarandon:* Are you here? *Shirley MacLaine:* Am I here? *Susan Sarandon:* Because you don't seem like you're really here? *Shirley MacLaine:* Am I here? Am I here? *Faye Dunaway:* I feel that discipline, mixed with love, is such a good recipe! *Susan Sarandon:* Are you ...acLaine: And I'm here, and I'm here, and I'm here! *Susan Sarandon:* You haven't been here from the beginning, worrying every minute of every day that the decisions you're making are gonna shape the people that they are going to be... *Shirley MacLaine:* But I'm here, but I'm here! *Faye* ...er that discipline, mixed with love, is such a good recipe! *Shirley MacLaine:* And i'm heeeeeeere! *Faye Dunaway:* I feel that discipline, mixed with love, is such a good recipe! *Susan Sarandon:* Get out of my house... get out... *Diane Keaton:* Why don't you just leave me alone, okay? *Faye* ...on't go... *Meryl Streep:* I'm leaving you! *Faye Dunaway:* Don't leave me here... *Meryl Streep:* I'm leaving you! *Faye Dunaway:* Please! Please! *Meryl Streep:* I'm not taking him with me... *Shirley MacLaine:* Your big problem is, you're too impatient... *Meryl Streep:* I have no patience... *Shirley* ...nly interested in instant gratification! *Meryl Streep:* He's better off without me. *Susan Sarandon:* This is ridiculous! *Shirley MacLaine:* Don't blame me! *Meryl Streep:* And I don't love you anymore... *Faye Dunaway:* Please don't leave, because if you do, you'll never come back in again no mat ...ow... Diane Keaton:* So what are you suggesting we do? *Shirley MacLaine:* Don't blame me! I do not blame my mother for my misfortunes... *Susan Sarandon:* After-school snack: refrigerate if possible! Band-Aids, Neosporin, hand wipes, Kleenex, Tylenol... *Meryl Streep:* That's ...away: EAT Y...

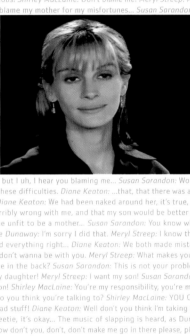

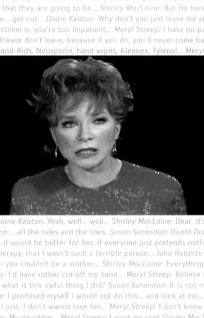

...away: What? *Susan Sarandon:* Why are you telling me this? *Diane Keaton:* Oh I don't know. I really don't know but uh, I hear you blaming me... *Susan Sarandon:* Wow! (incredulous) Ooooh! (at a loss for words) *Diane Keaton:* Yeah, well... well... *Shirley MacLaine:* Dear, it's no good feeling s ...Diane Keaton:* I felt I, I honestly, I honestly didn't feel... *Shirley MacLaine:* ...you're gonna have to overcome these difficulties. *Diane Keaton:* ...that, that there was a need for... *Susan Sarandon:* Wow! *Diane Keaton:* ...all the rules and the lines. *Susan Sarandon:* Oooh! *Diane Keaton:* I mean, ...mean... *Susan Sarandon:* She sees her father naked, in the shower, with another woman, for the first time... *Diane Keaton:* We had been naked around her, it's true, but, but, but... *Susan Sarandon:* And you think it would be better for her, if everyone just pretends nothing happened? ...is... we were all of us, we were very happy... *Meryl Streep:* At the time I left I felt that there was something terribly wrong with me, and that my son would be better off without me. I realized, after getting into therapy, that I wasn't such a terrible person... *Julia Roberts:* No! No! No! No! No! ...And, just because I needed some kind of creative or emotional outlet other than my child, that didn't make me unfit to be a mother... *Susan Sarandon:* You know what your problem is? You are so self-involved – you couldn't be a mother... *Shirley MacLaine:* Everything I did, I did out of ...ght have done wrong sometimes... how can you do everything right? *Meryl Streep:* I know I left my son... *Faye Dunaway:* I'm sorry I did that. *Meryl Streep:* I know that that's a terrible thing to do... *Faye Dunaway:* I'd have rather cut off my hand... *Meryl Streep:* Believe me, I have to live ...of my life... *Diane Keaton:* It was, it was a mistake! *Faye Dunaway:* I'm sorry I did that. *Susan Sarandon:* I did everything right... *Diane Keaton:* We both made mistakes. *Shirley MacLaine:* Will you please tell me what is this awful thing I did? *Susan Sarandon:* It is not my job to make it e ...my job to take care of those children... *Meryl Streep:* Don't, don't try to bully me. *Susan Sarandon:* And they don't wanna be with you. *Meryl Streep:* What makes you so sure he doesn't want me? *Shirley MacLaine:* I promised myself I would not do this... and look at me... *Meryl Streep:* I am ...Susan Sarandon:* This is not about you, this is not your problem! *Faye Dunaway:* Now you're trying to stab me in the back? *Susan Sarandon:* This is not your problem! *Faye Dunaway:* FORGET IT! *Diane Keaton:* I just, I don't wanna lose her... *Meryl Streep:* I don't know how anybody can ...hat I have less of a stake in mothering that little boy... *Shirley MacLaine:* I was just so excited about seeing my daughter! *Meryl Streep:* I want my son! *Susan Sarandon:* Can I see my son now please? *Faye Dunaway:* My daughter... *Meryl Streep:* I want my son! *Shirley MacLaine:* My daughter ...en I talk... *Susan Sarandon:* Do you realize what could have happened to your son? *Meryl Streep:* I want my son! *Shirley MacLaine:* You're my responsibility, you're my daughter... *Faye Dunaway:* My own... daughter. *Shirley MacLaine:* My daughter wants to talk to me... *Meryl Streep:* I know ...ve Dunaway:* Who do you think you're talking to? *Shirley MacLaine:* Well... well... well... *Faye Dunaway:* Who do you think you're talking to? *Shirley MacLaine:* YOU ONLY REMEMBER THE BAD STUFF, DON'T YOU? *Diane Keaton:* I remember Brian saying, "Oooh.... *Meryl Streep:* I remember ...I probably.... *Shirley MacLaine:* YOU ONLY REMEMBER THE BAD STUFF, DON'T YOU? You only remember the bad stuff! *Diane Keaton:* Well don't you think I'm taking the rap too? Huh? How about for the rest of my life? GET AWAY FROM ME... JUST GET AWAY... GET AWAY FROM ME... LEAVE ...san Sarandon:* It's okay, it's okay... *Diane Keaton:* LEAVE ME ALONE! GO! GOOOO! *Susan Sarandon:* Oh my sweetie, it's okay... *The music of slapping is heard, as Dunaway repeatedly and rhythmically slaps somebody who is invisible to us. Meryl Streep:* Now don't you, don't, don't make m ...ase, please don't make me.... Now don't you, don't, don't make me go in there please, please don't make me.... Now don't you, don't, don't make me go in there please, please don't make me.... Now don't you, don't, don't make me go in there please, please don't make me.... *Faye Dunaway:* AAHHH ...ED ME... I THOUGHT YOU WANTED TO BE MY DAUGHTER... AAHHHHHHH... YOU HATED ME... I THOUGHT YOU WANTED TO BE MY DAUGHTER... AAHHHHHHH... *A symphony of hysterical sobbing, screaming and slapping, accompanied by the sound of glass breaking, a thumping piano, do ...the contents of a kitchen being violently hurled. Shirley MacLaine:* I am still here! I am still here! I am still here! I am still here! I am still here! Sarandon and Roberts roll their heads from side to side anxiously. *Faye Dunaway:* DON'T FUCK WITH ME, don't fuck with me, don't fuck with me! ...TH ME, don't fuck with me, don't fuck with me! *All:* Why? Why? Why? Why? *Faye Dunaway:* Why, WHY, why, WHY, why, WHY? Why can't you give me the RESPECT? I don't ask much from you girl... *Diane Keaton:* I don't know! I don't know! *Faye Dunaway:* Why can't you give me the RESPECT ...to? *Diane Keaton:* I don't know! *Meryl Streep:* Well, I don't know! *Faye Dunaway:* Why can't you treat me, the way that I would be treated by any stranger on the street? *Shirley MacLaine:* I do not blame my mother for my misfortunes or for my drinking... *Meryl Streep:* I am still his mothe ...Does it, uh, really matter? *Meryl Streep:* I am still his mother! *Shirley MacLaine:* You feel sorry for yourself half the time, for having a monster of a mother like me... *Diane Keaton:* You're a good mother Anna... you're a good mother Anna... *Susan Sarandon:* You couldn't be a mother... *Dia ...rybody knows, you're a good mother... *Susan Sarandon:* You couldn't be a mother! You couldn't be a mother! You couldn't be a mother! *Faye Dunaway:* I could be a mother and a father. I could be a mother and a father. *Meryl Streep:* I was his mommy for... five and a half years. Mother: ...BE YOUR MOTHER! *Julia Roberts:* I wish my mom was here! Mother: I'M ASHAMED TO BE YOUR MOTHER! Mother: I've always tried to be a good mother to you... *Shirley MacLaine:* I wish that my mother had been as concerned about me when I was a little girl... *Julia Roberts:* I never wanted ...rley MacLaine:* Mother, mother, mother! Mother: I'M ASHAMED TO BE YOUR MOTHER! *Shirley MacLaine:* I'm Suzanne's mother! I'm Suzanne's mother! *Meryl Streep:* I'm his mother! *Julia Roberts:* You're Mother Earth Incarnate... Mother: I'M ASHAMED TO BE YOUR MOTHER! *Meryl Streep:* I'm his ...erts: I wish my mom was here! *Meryl Streep:* I'm his mother! *Shirley MacLaine:* Well of course she'll listen to you, you're not her mother... Mother: I'M ASHAMED TO BE YOUR MOTHER! *Meryl Streep:* I'm his mother! *Julia Roberts:* I never wanted to be a mom! *Shirley MacLaine:* Am I ...ing? Am I too late for the family thing? Am I too late for the family thing? *The mothers gather their children towards them and hug them, joyously, frenziedly. Roberts looks on, childless and confused. Diane Keaton:* Eat something Molly, alright? *All:* NO! ...e Keaton:* Eat something Molly, alright? *All:* Yes! Yes! Yes! Yes! *Faye Dunaway:* You haven't touched your lunch... *Meryl Streep + Diane Keaton:* No, I didn't, no I did not! *Faye Dunaway:* You haven't touched your lunch... *Meryl Streep + Diane Keaton:* Yes I did! *Faye Dunaway:* Why must everyt ...? Susan Sarandon:* WELL! Well that's what parenting is all about little girl! *Faye Dunaway:* I took the best job I could find, so that you and your sister could eat and have a place to sleep and some clothes on your back... *Shirley MacLaine:* Everything I did, I did out of love for you! *S* ...LI Well that's what parenting is all about little girl! *Diane Keaton:* Mhmm! Mhmm! Mhmm! Mhmm! Mhmm! Mhmm! *Susan Sarandon:* Are you here? *Diane Keaton:* Mhmm! *Susan Sarandon:* Are you here? *Shirley MacLaine:* Am I here? *Susan Sarandon:* Because you don't seem like you're real ...acLaine: Am I here? Am I here? *Faye Dunaway:* I feel that discipline, mixed with love, is such a good recipe! *Susan Sarandon:* Are you here? *Shirley MacLaine:* And I'm here, and I'm here, and I'm here! *Susan Sarandon:* You haven't been here from the beginning, worrying every minute of e ...decisions you're making are gonna shape the people that they are going to be... *Shirley MacLaine:* But I'm here, but I'm here! *Faye Dunaway:* I feel that discipline, mixed with love, is such a good recipe! *Shirley MacLaine:* And I'm heeeeeeere! *Faye Dunaway:* I feel that discipline, mixed with ...good recipe! *Susan Sarandon:* Get out of my house... get out... *Diane Keaton:* Why don't you just leave me alone, okay? *Faye Dunaway:* Please don't go... *Meryl Streep:* I'm leaving you! *Faye Dunaway:* Don't leave me here... *Meryl Streep:* I'm leaving you! *Faye Dunaway:* Please! Please! *M* ...aking him with me... *Shirley MacLaine:* Your big problem is, you're too impatient... *Meryl Streep:* I have no patience... *Shirley MacLaine:* You're only interested in instant gratification! *Meryl Streep:* He's better off without me. *Susan Sarandon:* This is ridiculous! *Shirley MacLaine:* Don't bla ...eep: And I don't love you anymore... *Faye Dunaway:* Please don't leave, because if you do, you'll never come back in again no matter what you say, or ask, or do... *Diane Keaton:* So what are you suggesting we do? *Shirley MacLaine:* Don't blame me! I do not blame my mother for my misfo ...randon: After-school snack: refrigerate if possible! Band-Aids, Neosporin, hand wipes, Kleenex, Tylenol... *Meryl Streep:* That's everything! *Faye Dunaway:* EAT YOUR LUNCH! You will eat everything on that plate! *Shirley MacLaine:* I've always tried to be a good mother to you... *Meryl Streep* ...ng! Shirley MacLaine:* You don't really think I don't want you to do well do you dear? *All:* I do! Yes! No! Yes! No! Yes, No! Yes! No! Oh no no no no no! *Faye Dunaway:* You know what's missing in my life? I want a baby. You know I've always wanted a kid... I want a baby... *Loop to beginning. The* ...in a chorus of despair. Keaton's heavy breathing exacerbates the general air of distress. *Faye Dunaway:* I don't know what I'm gonna do... *Julia Roberts:* Why didn't you tell me? *Shirley MacLaine:* I promised myself I would not do this! *Susan Sarandon:* You know why! *Shirley* ...nt you to see me get upset... I hate getting upset... *Julia Roberts:* I never wanted to be a mother... *Susan Sarandon:* I'm scared! *Julia Roberts:* Carrying it alone the rest of my life... *Faye Dunaway:* I'm scared! *Julia Roberts:* ...always being compared to you. *Shirley MacLaine:* Julia Roberts ...Susan Sarandon:* What do I have that you don't? *Julia Roberts:* You're Mother Earth Incarnate! *Sarandon laughs patronizingly. Julia Roberts:* You know every story... *Sarandon laughs patronizingly. Julia Roberts:* ...every wound... every memory... their whole lives' happiness is wrapped up ...laughs patronizingly. Julia Roberts:* Look down the road, to her wedding: fluffing her dress – telling her: "No woman has ever looked so beautiful!" – and my fear is, that she'll be thinking... *Faye Dunaway:* After all those years.... *Julia Roberts:* "I wish my mom was here!" *Faye Dunaway* ...could happen to me. *Meryl Streep:* Ha-ah! Ha-ah! Ha-ah! *The mothers laugh together awkwardly, in a state of discomfort. Meryl Streep:* Last time you saw me I was in, uh, pretty bad shape... I was... I was... *Diane Keaton:* How long did you feel that way? *Shirley MacLaine:* All my life, ...body's wife, or somebody's mother, or somebody's daughter. *Shirley MacLaine:* Tsk, tsk, tsk, tsk, oh dear! *Diane Keaton:* I really think you have to understand that you see, with, um, Brian, we just stopped having sex a long time before we split up... *Meryl Streep:* I never knew who I was who ...body's wife, or somebody's mother, or somebody's daughter. *Shirley MacLaine:* And that's why I had to go away... *Shirley MacLaine:* Tsk, tsk, tsk, tsk, oh dear! *Diane Keaton:* I was frigid with him, and, well I'd, I'd always been frigid... *Meryl Streep:* But every time I talked to my ex-husband about it, he wouldn't listen...

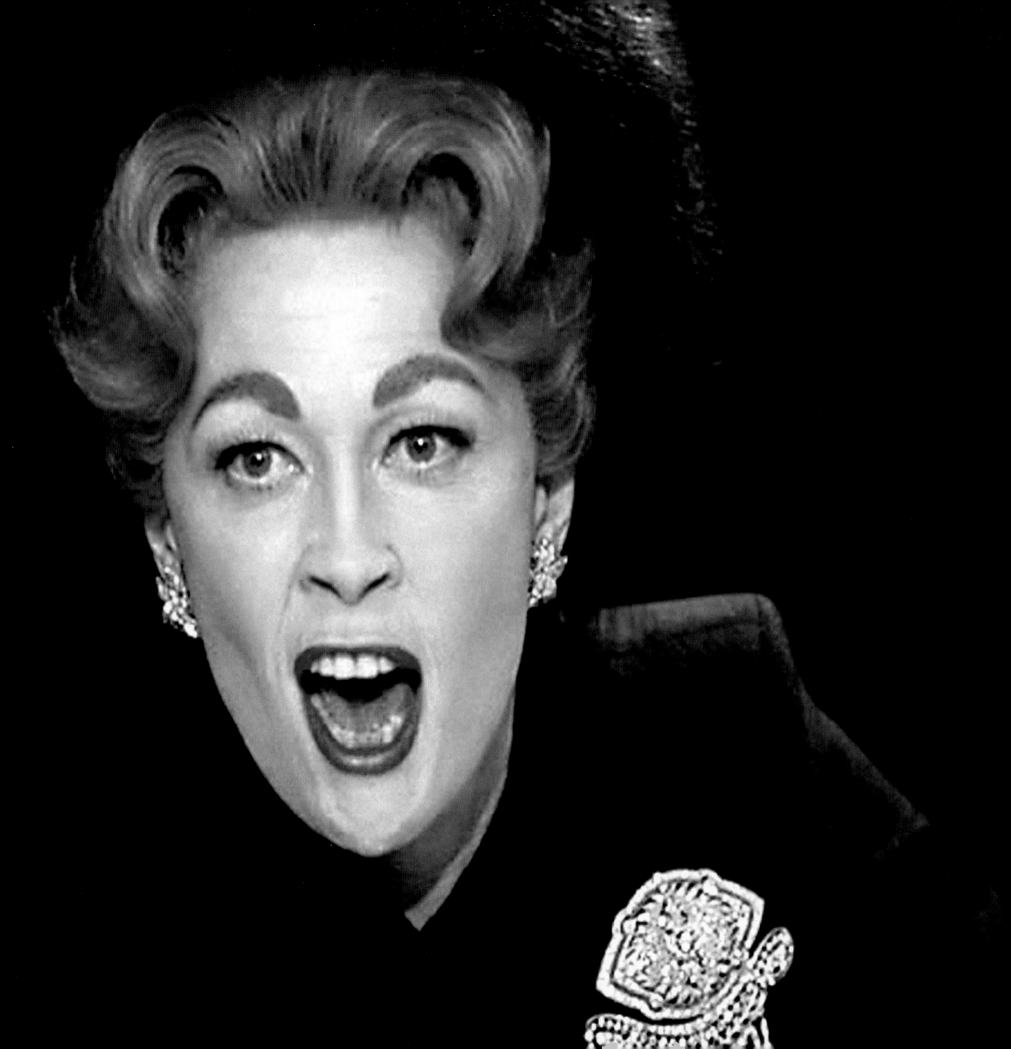

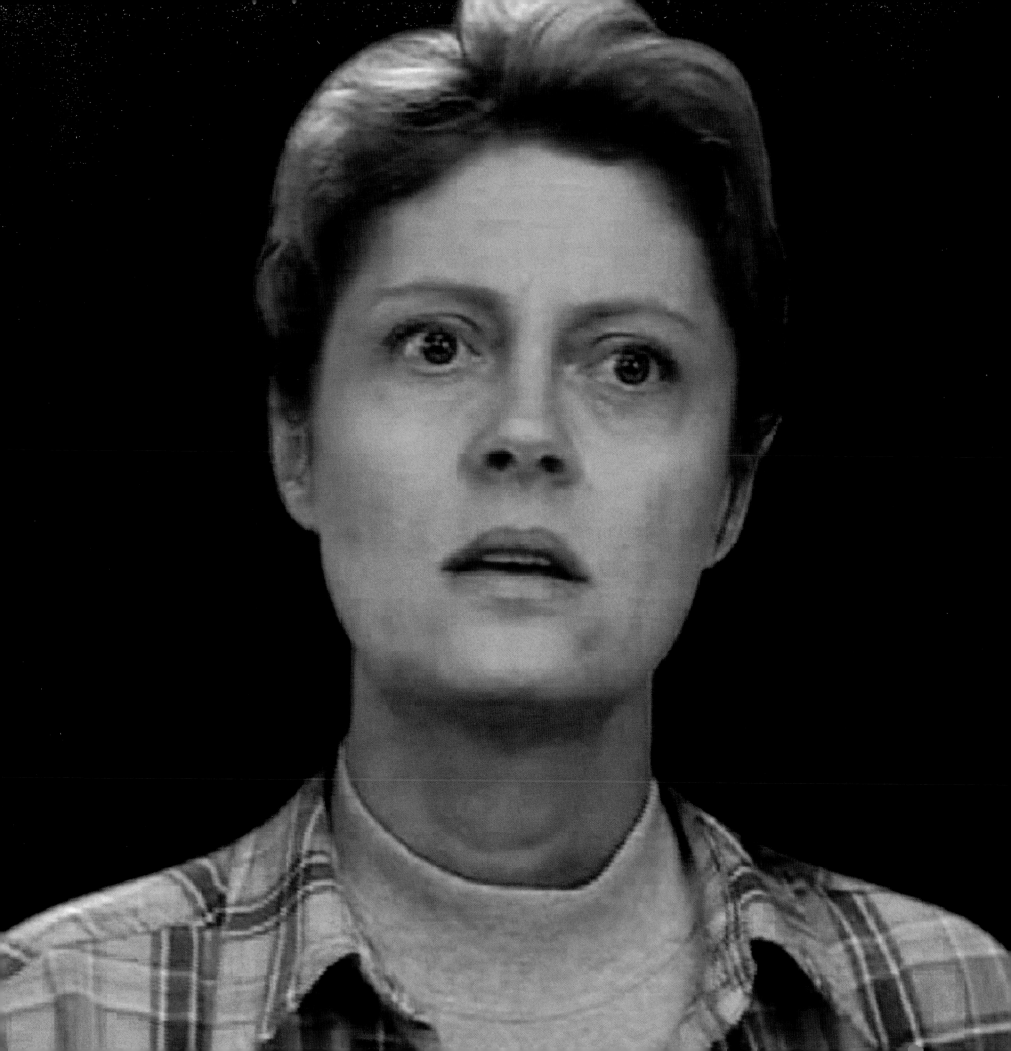

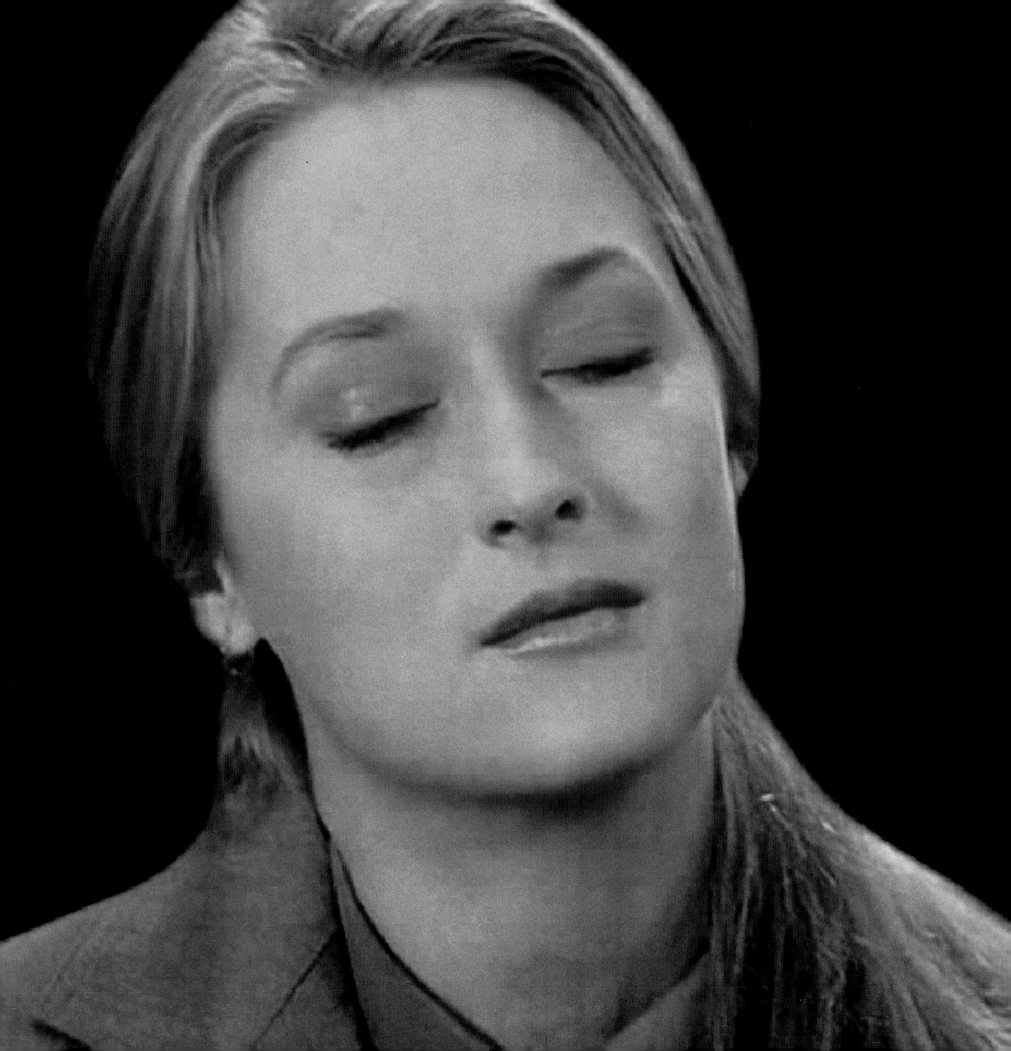

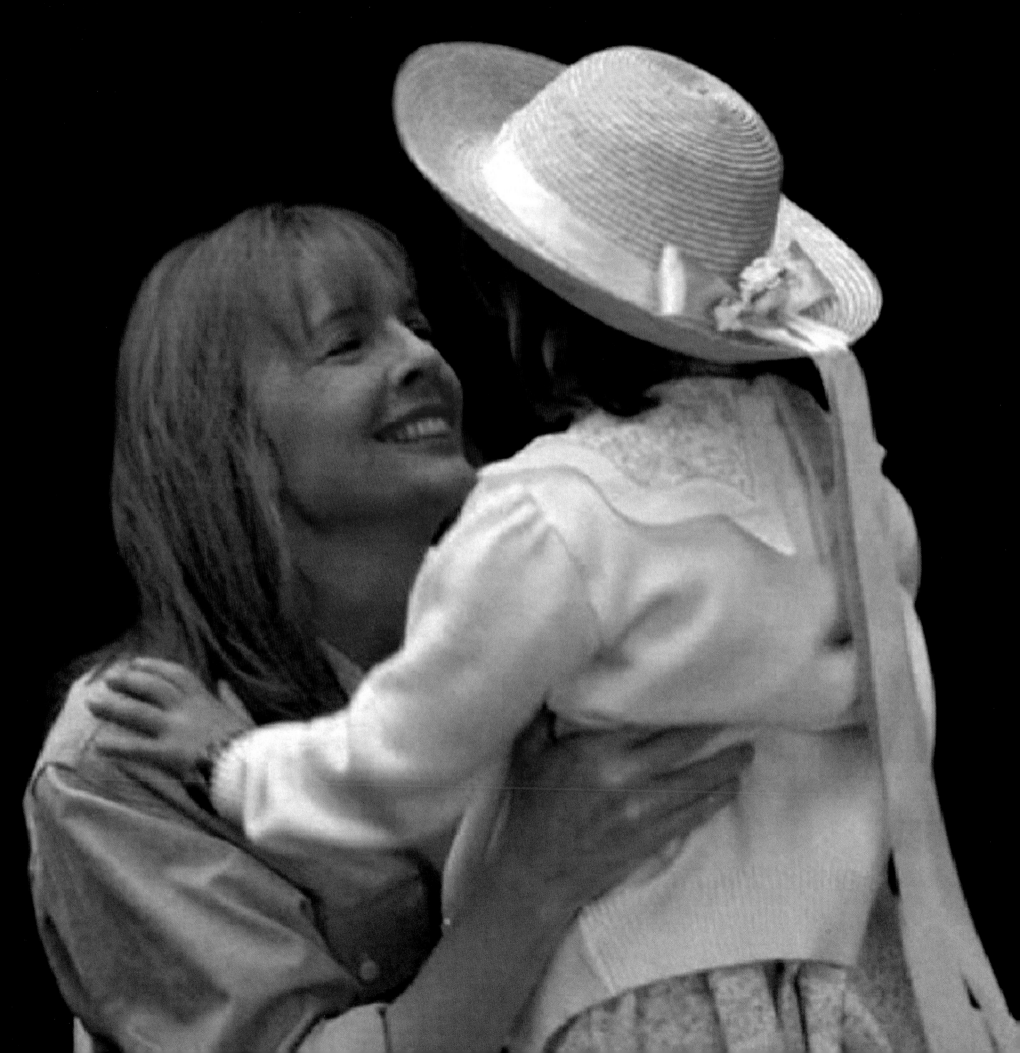

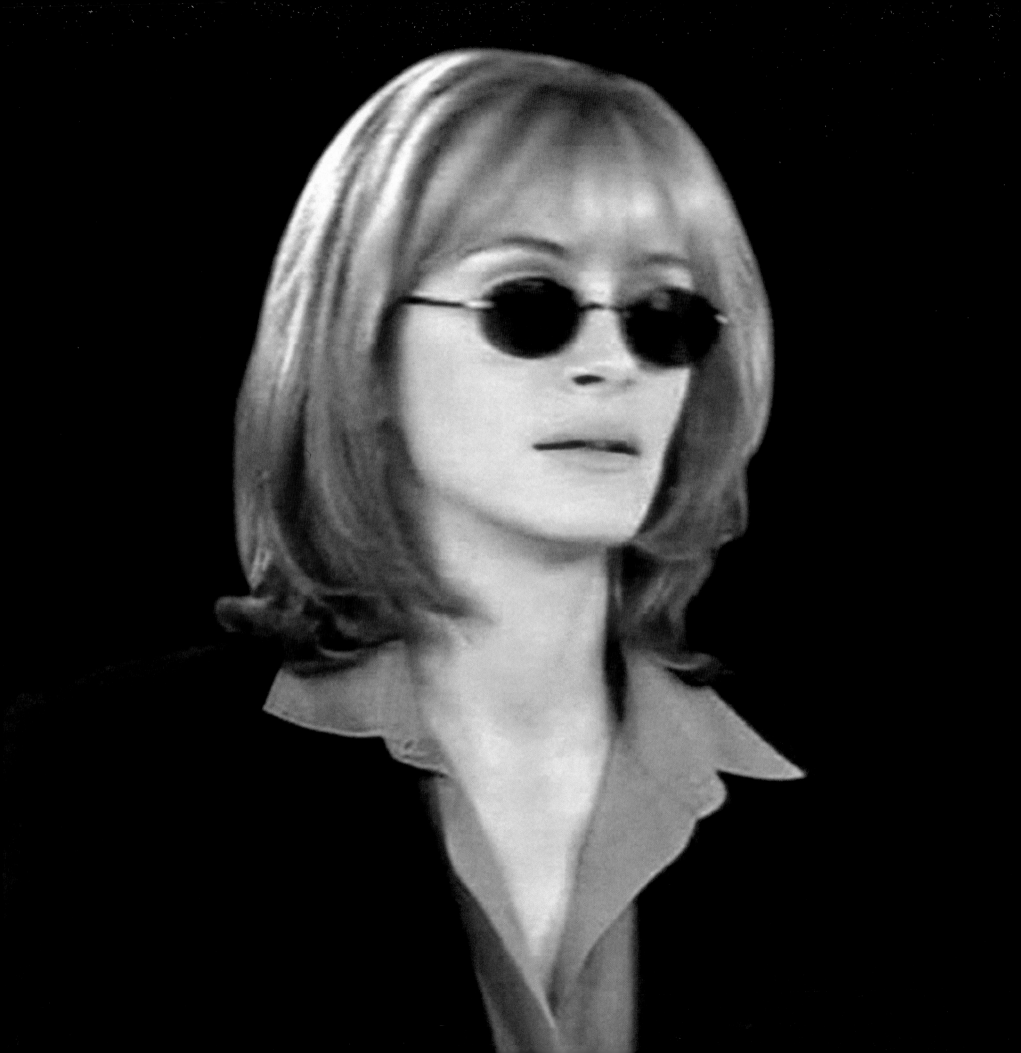

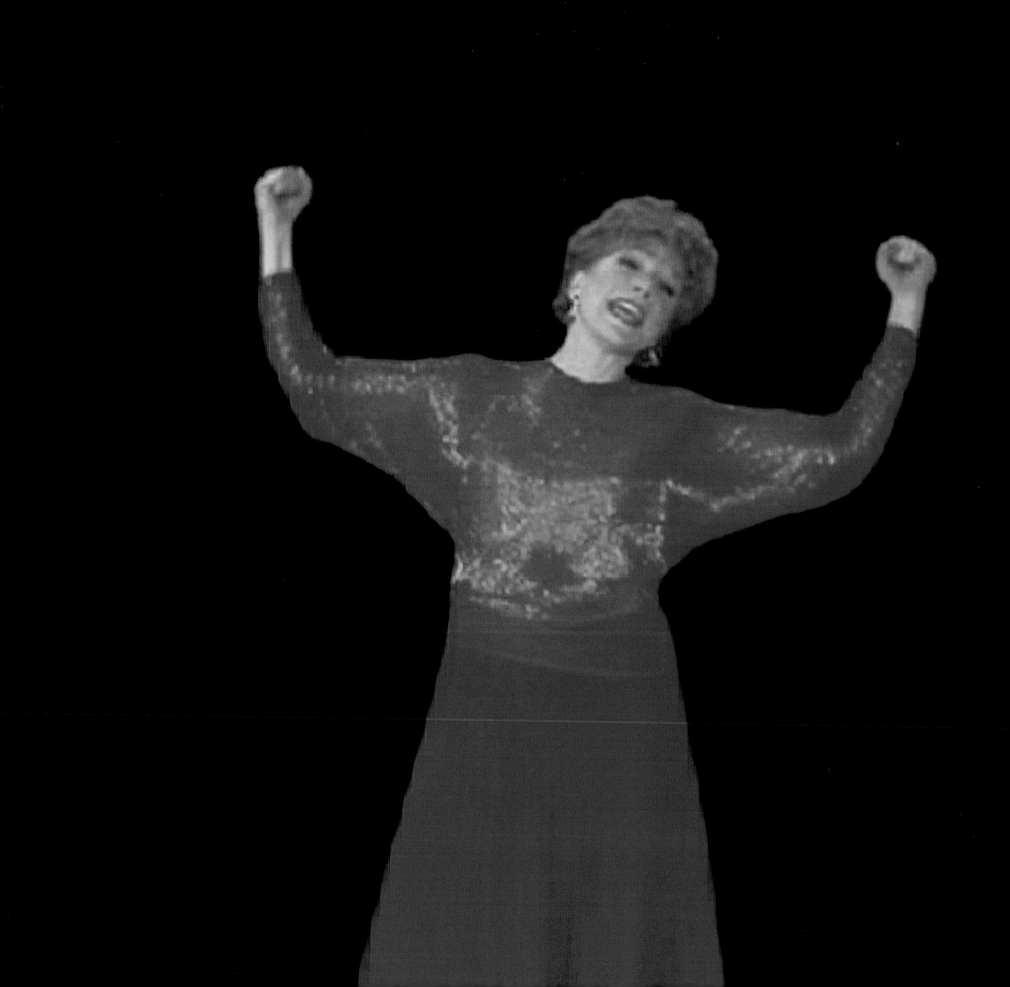

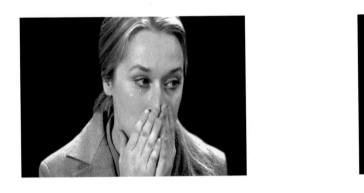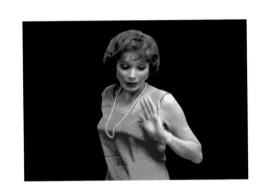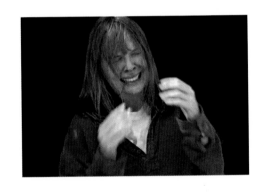
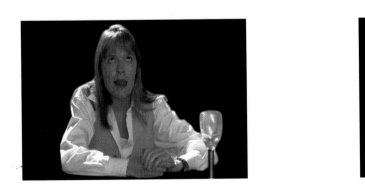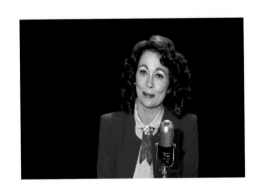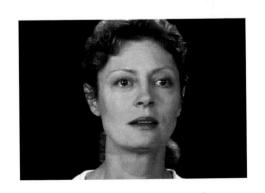

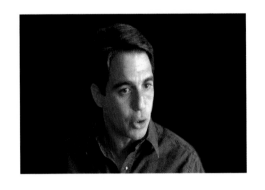 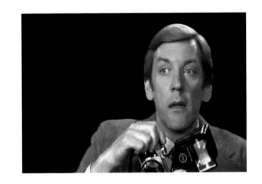 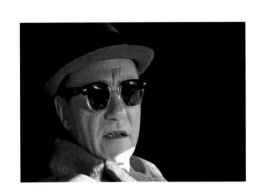

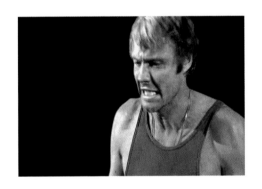 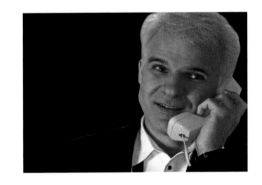 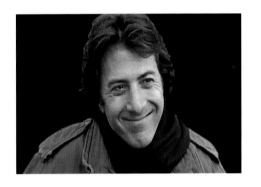

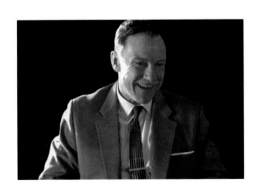 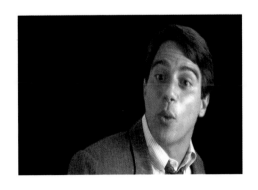 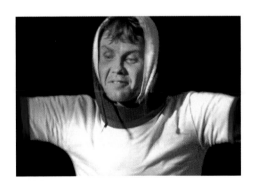

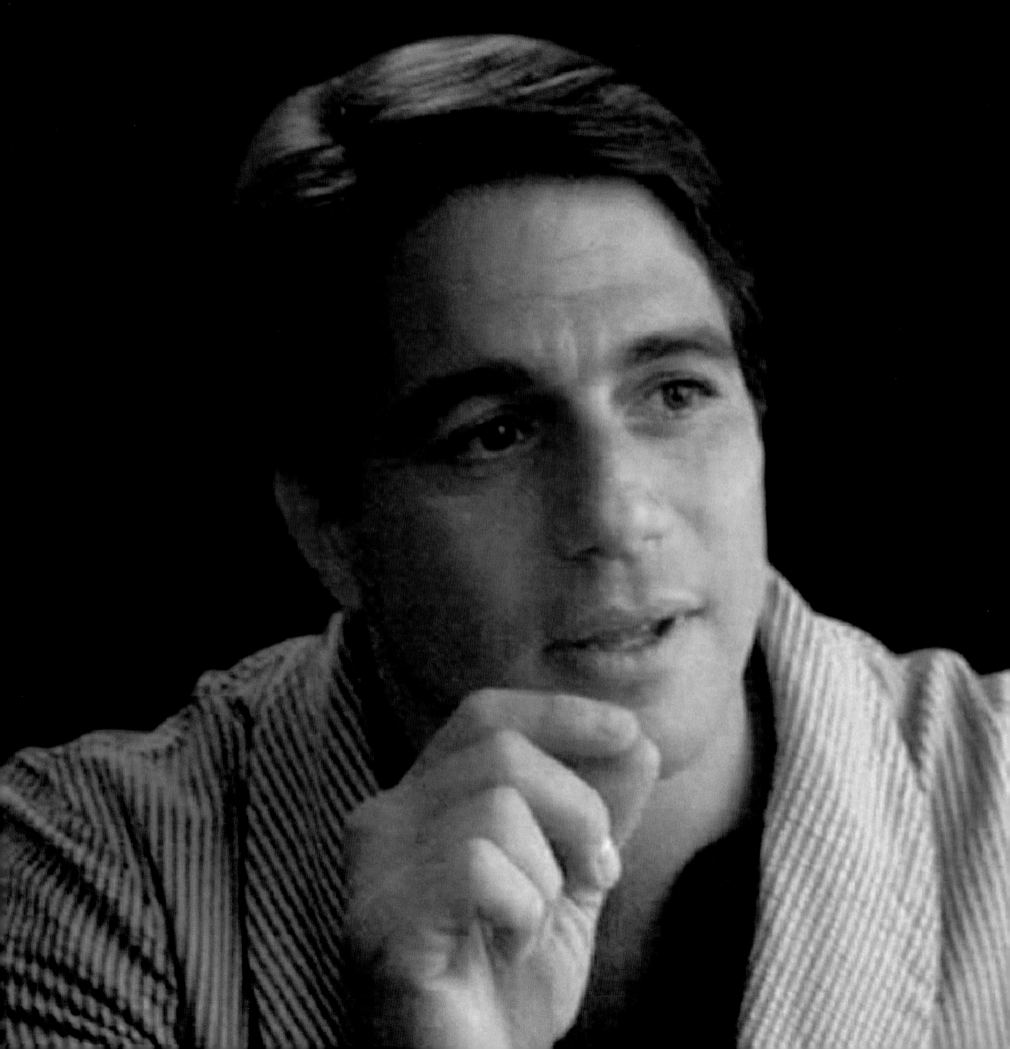

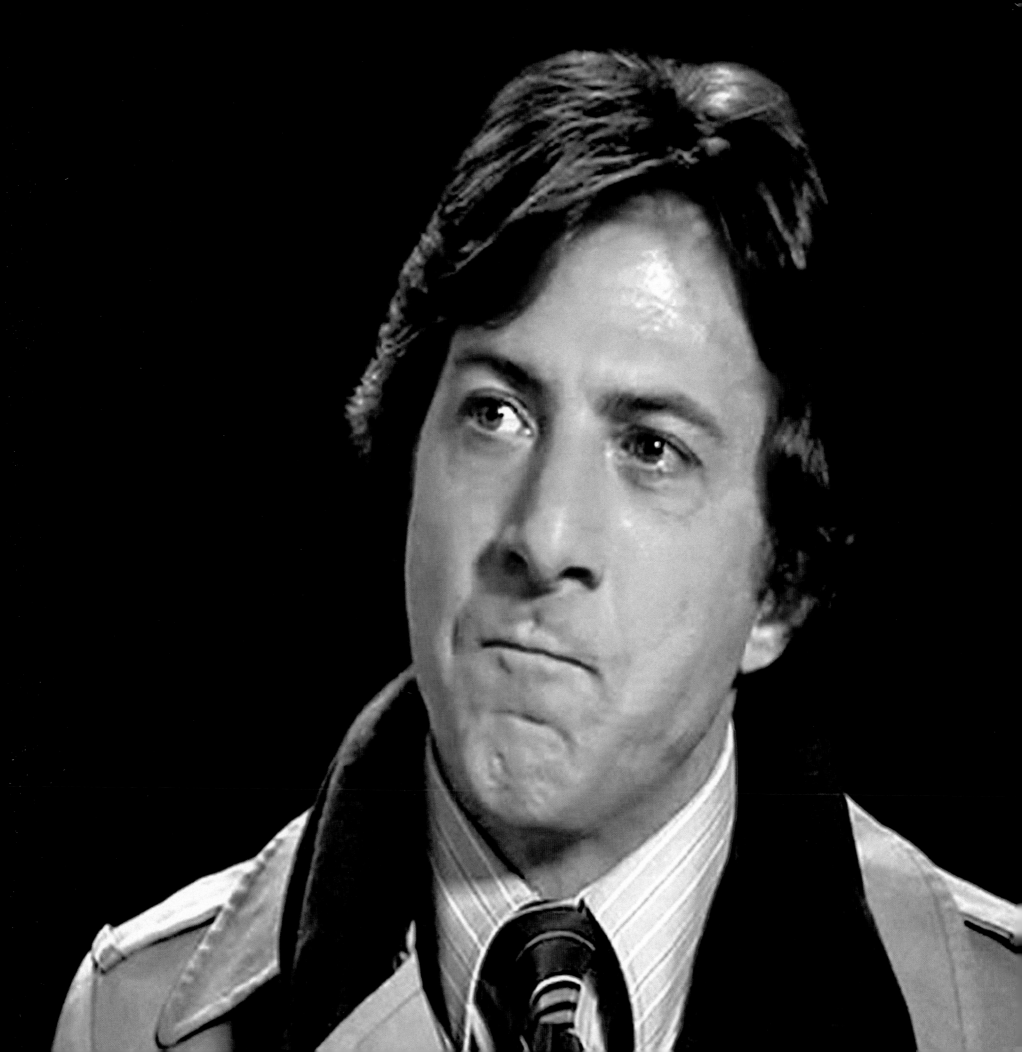

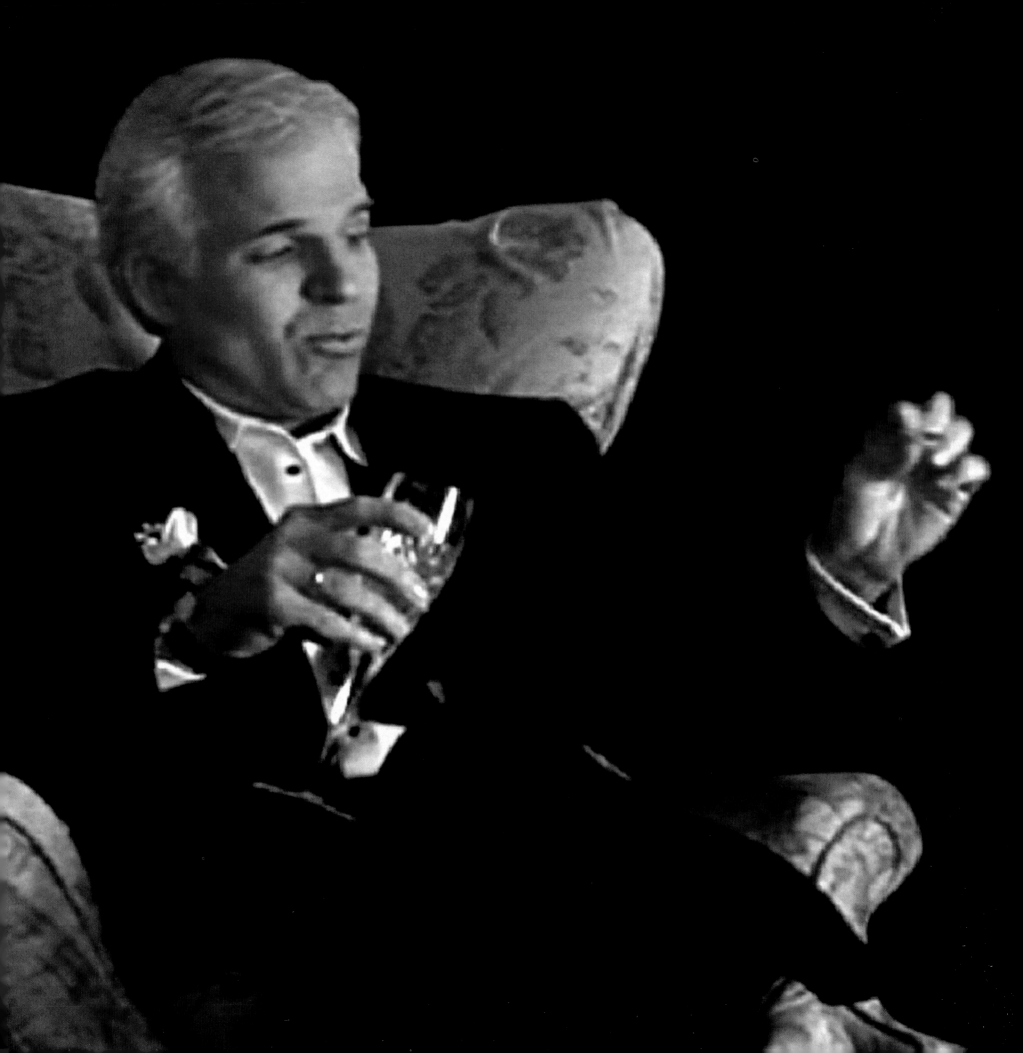

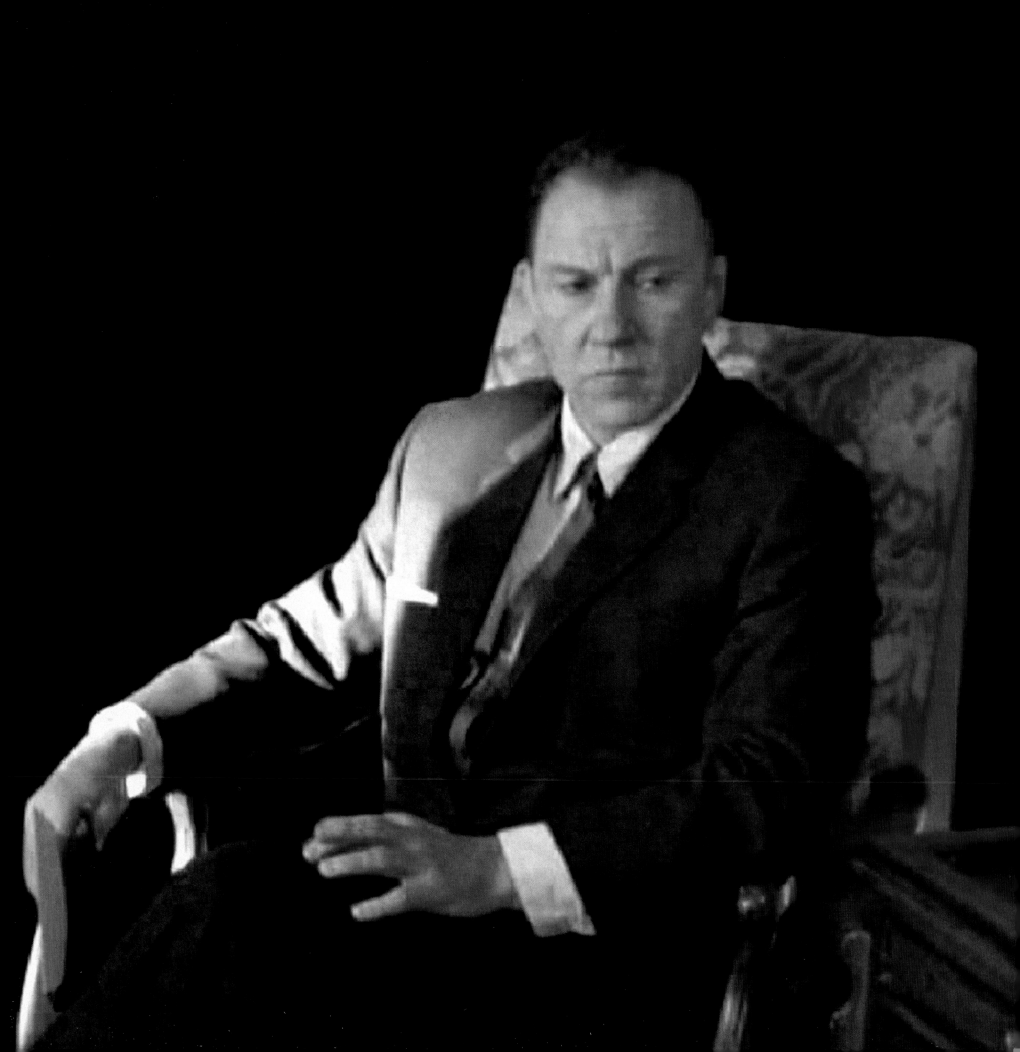

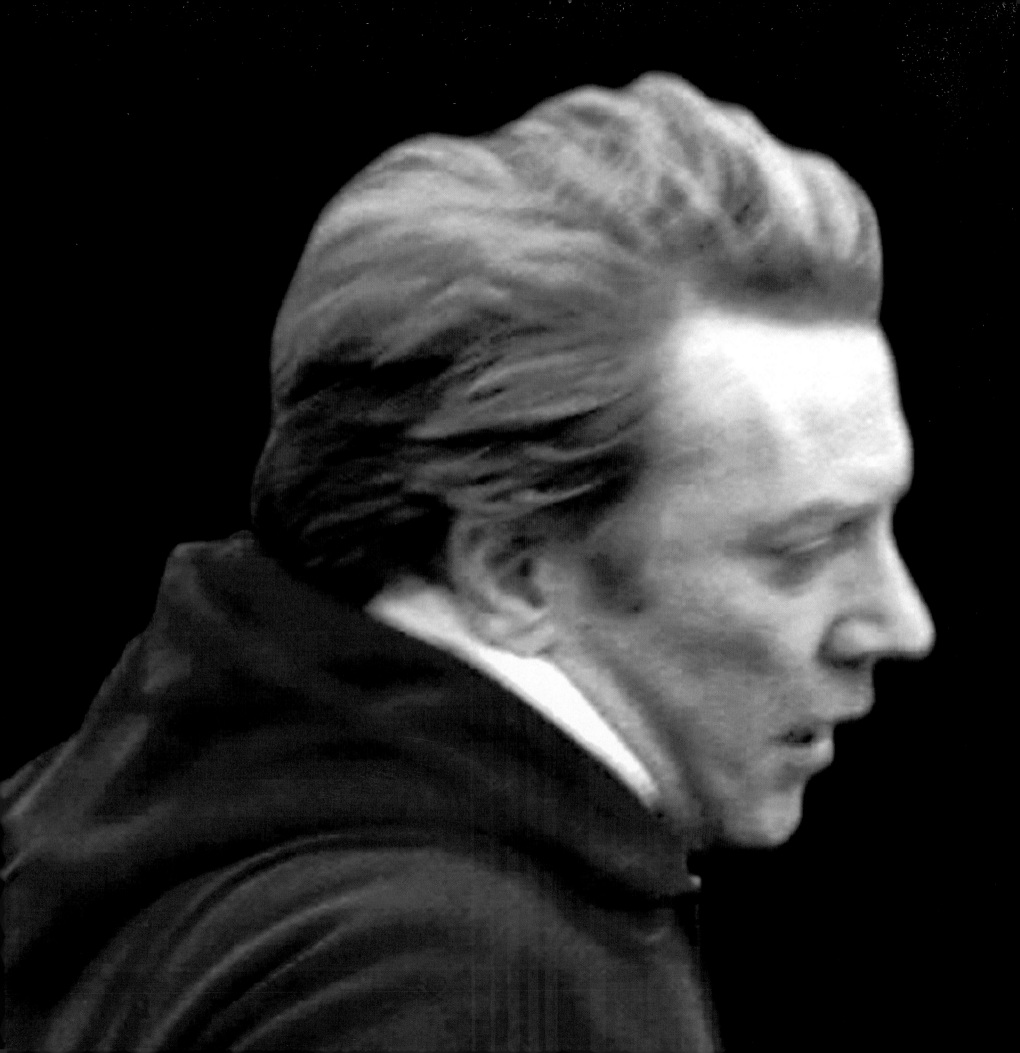

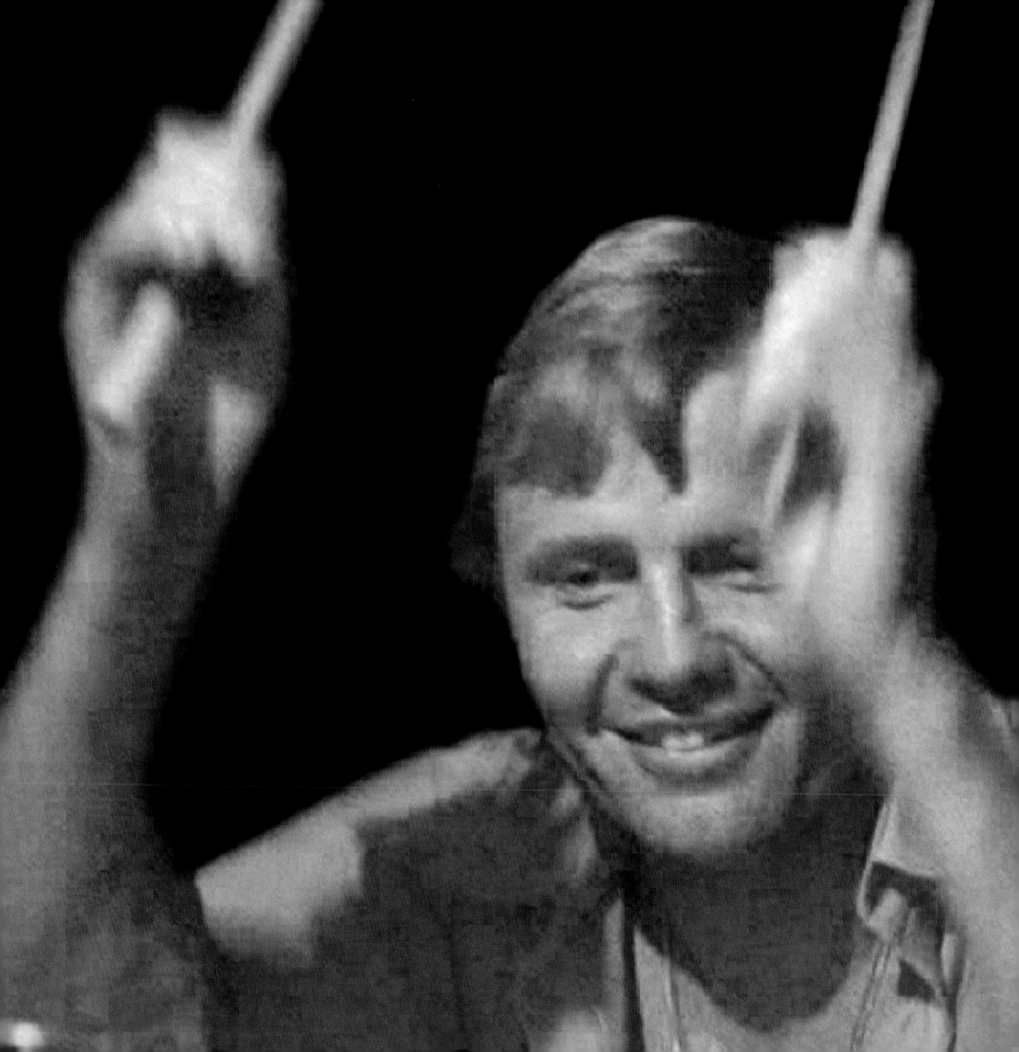

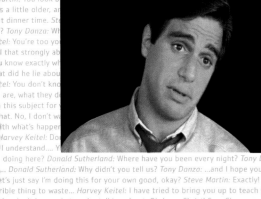
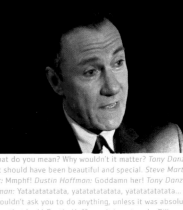

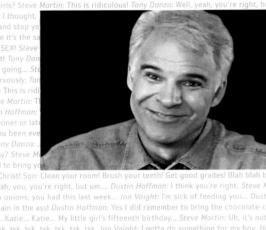
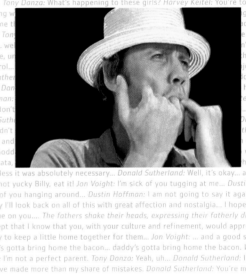

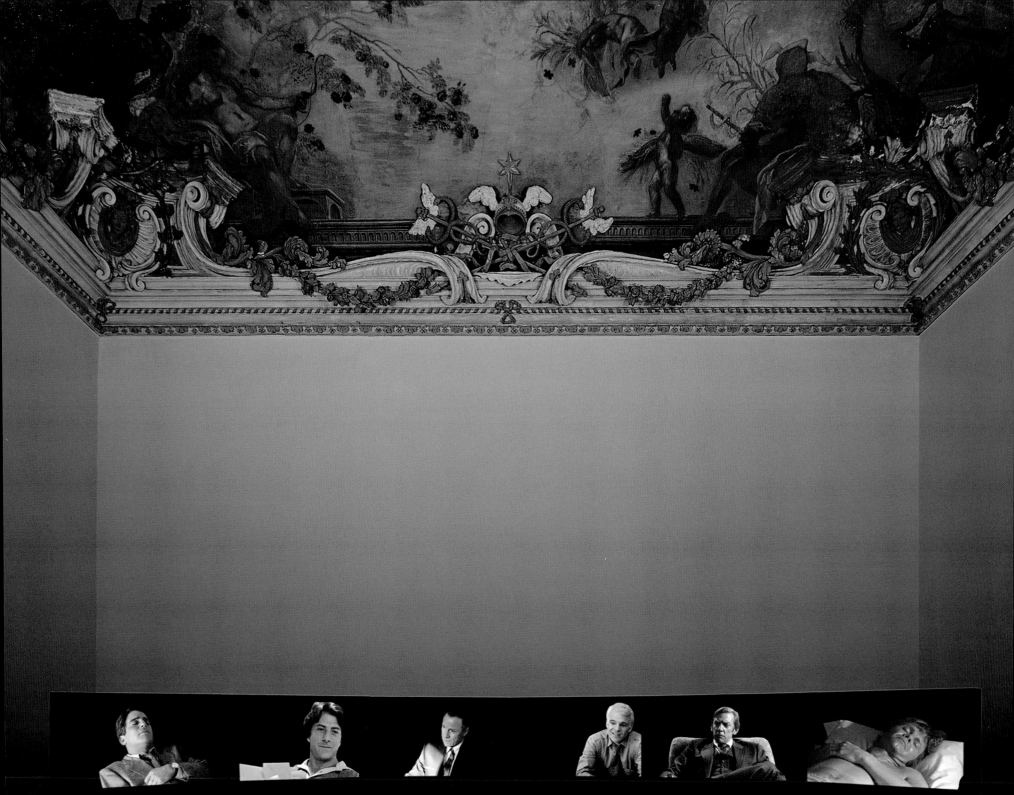

En su instalación *Becoming* (2003), Candice Breitz se mete con cierta incomodidad en la piel de famosas actrices de Hollywood (Cameron Díaz, Julia Roberts, Jennifer Lopez, Meg Ryan, Neve Campbell, Reese Witherspoon y Drew Barrymore). Tras cortar y pegar breves intervenciones de esas estrellas procedentes de varias películas (un proceso que también le sirve para aislarlas eliminando a los actores que aparecían junto a ellas), Breitz reinterpreta sus actuaciones con toda la precisión y el cuidado posibles. Al ir reproduciendo cada una de las secuencias, se hace visible poco a poco una gramática que por lo general suele quedar enmascarada: el registro un tanto limitado de gestos y expresiones corrientes que tienen a su disposición las actrices (y, por lo tanto, la propia Breitz), habla de los confines de la subjetividad de los medios de comunicación, del acartonado vocabulario de la existencia que nos vende la maquinaria de Hollywood.

Becoming se presenta como una serie de siete instalaciones de dos canales. En cada una de ellas se han colocado dos televisores cuyas partes traseras están en contacto: el primero reproduce las imágenes "originales", mientras que en el segundo aparece la interpretación de Breitz. El original y la copia están unidos como siameses, no sólo porque se presentan mano a mano y porque tienen la misma duración, sino también porque comparten una única voz: la banda sonora hollywoodiense original sustenta tanto la secuencia de origen como la versión de Breitz, de modo que se tornan inseparables. La voz de las actrices de Hollywood se expresa, pues, no sólo a través de las propias actrices, sino también a través de Breitz. Esa presencia ajena ocupa y dirige el cuerpo de Breitz, de modo que todas y cada una de las nuevas películas resultantes podrían describirse como una especie de *karaoke* corporal. La ubicación de las instalaciones de doble cara de modo que se toquen las partes traseras de los monitores

frustra la contemplación simultánea de las dos secuencias y obliga al espectador a dar vueltas en torno a la obra para comparar la interpretación frontal y la trasera. "En toda la serie," escribe Jennifer Allen, "Breitz lleva el mismo atuendo sencillo (pantalones negros, blusa blanca). Por un lado, al eliminar a los interlocutores que antes se dirigían a las actrices recortadas de distintas películas, Breitz hace hincapié en su categoría de iconos: sus rostros bien iluminados tienen la fuerza suficiente para brillar por sí solos en la pantalla, parece decirnos la artista con ese gesto. Por otro, al multiplicarse por siete en las películas calcadas en blanco y negro que completan al instalación, Breitz empieza a parecer el máster – el original del que se derivan todas las demás actuaciones. [...] Al apropiarse de la banda sonora de cada corto y, con ello, sacrificar su propia voz por completo y convertirse en organismo huésped de las voces de las actrices de partida, Breitz logra que las siete se reduzcan de modo simultáneo a un único cuerpo: el suyo. Al remedar todos y cada uno de sus movimientos, sus gestos empiezan a perder magia, singularidad, atractivo aurático. La sorpresa inicial de la diferencia se invierte de forma que los originales se confunden fácilmente con copias."

Becoming explora hasta qué punto la identidad bebe cada vez más de los prototipos creados por los medios de comunicación. A la inversa, puede entenderse que la obra insinúa que los iconos cinematográficos alcanzan el estrellato precisamente porque – por encima de los tópicos que perpetúan – nos imaginamos que se trata de personas "de carne y hueso". Estas palabras de Siegfried Kracauer, de los años veinte, nos indican que ya había detectado esa reciprocidad: "El cine y la vida se reflejan mutuamente, ya que las jovencitas que salen a trabajar toman como modelo a las estrellas que ven en la pantalla. Podría ser, no obstante, que las más

hipócritas de esas estrellas se basaran, en realidad, en la vida real." Por cierto, el título de la instalación de Breitz hace referencia a un programa de la MTV en el que los adolescentes tienen la oportunidad de reinterpretar un vídeo musical de su cantante preferido.

In her installation *Becoming* (2003), Breitz slips awkwardly into the roles of seven popular Hollywood actresses (Cameron Diaz, Julia Roberts, Jennifer Lopez, Meg Ryan, Neve Campbell, Reese Witherspoon and Drew Barrymore). Having cut-and-pasted short sequences of these actresses out of various films (in the process isolating the actresses by eliminating the actors who appeared opposite them), Breitz re-enacts their performances as precisely and earnestly as possible. As she puts herself through each routine, a grammar that is usually masked slowly makes itself visible: the somewhat narrow range of familiar gestures and expressions available to the actresses (and thus to Breitz herself), points to the limits of media subjectivity, to the wooden vocabulary of being that is sold to us by Hollywood.

Becoming is presented as a series of seven dual-channel installations. In each case, two televisions are set back-to-back: the first monitor displays the "original" footage, while the second monitor plays back Breitz's performance. The original and copy are bound together like Siamese twins – not only by their back-to-back presentation and their identical duration – but also because they share the same voice: the original Hollywood soundtrack underlies both the source clip and the Breitz version, making the two inseparable. The voice of each Hollywood actress is thus expressed not only through the actress herself, but also through Breitz. This alien presence occupies and directs Breitz's body, such that each of the resulting new films might be described as a kind of body-karaoke. The back-to-back positioning of each double-sided installation frustrates the simultaneous viewing of the two pieces of footage, forcing the viewer to circle around the work in order to compare the front and rear performances. "Throughout the series," Jennifer Allen writes, "Breitz wears the same simple attire (black pants, white blouse). On the one hand, by eliminating the

interlocutors who once addressed the actresses now cut-and-paste out of various movies, Breitz emphasizes the actresses' status as icons: their well-lit faces are powerful enough to shine alone on the screen, she seems to tell us, with this gesture. On the other hand, as she multiplies herself seven times over in the black-and-white copycat films that complete the installation, Breitz starts to look like the master-copy – the original from which all of the other performances derive [...]. While appropriating the soundtrack of each original clip as her own, and thus sacrificing her voice entirely as she becomes host to the voices of the source actresses, Breitz simultaneously reduces the seven actresses to her own body. As she apes their every motion, their gestures begin to lose their magic, their singularity, their auratic appeal. The initial shock of difference is inverted such that the originals are now easily mistakable for copies [...]."

Becoming probes the extent to which identity increasingly takes its cues from media-produced prototypes. Inversely, the work might be read to suggest that screen icons achieve stardom precisely because – beyond the *clichés* that they perpetuate – ultimately, we imagine these stars as "real" people. Writing in the twenties, Siegfried Kracauer had already detected this loop: "Film and life reflect each other because the little working ladies model themselves on the stars they see on the screen. It may however be the case that the most hypocritical of these stars are in fact based on real life." Incidentally, the title of Breitz's installation alludes to an MTV program, in which teenagers are given the chance to re-perform a music video starring their favorite pop star.

Becoming

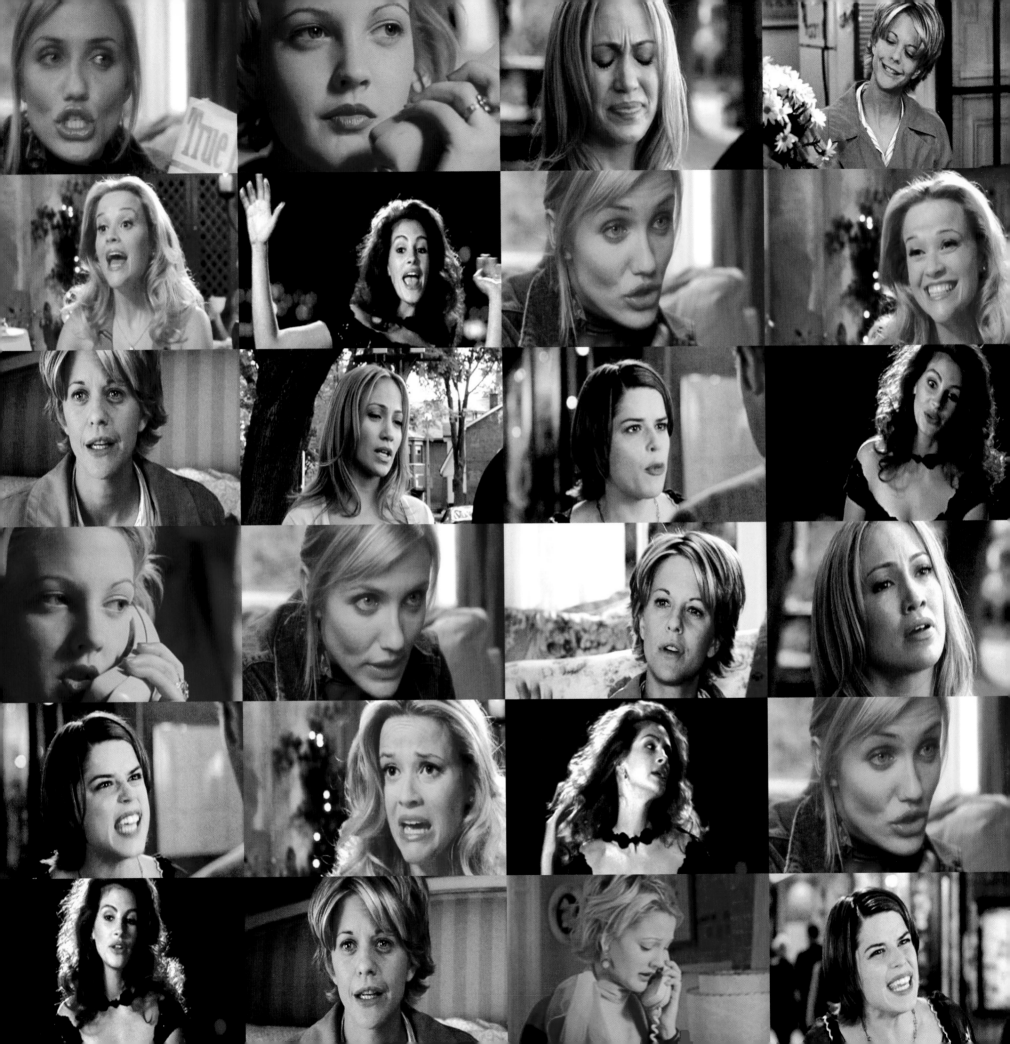

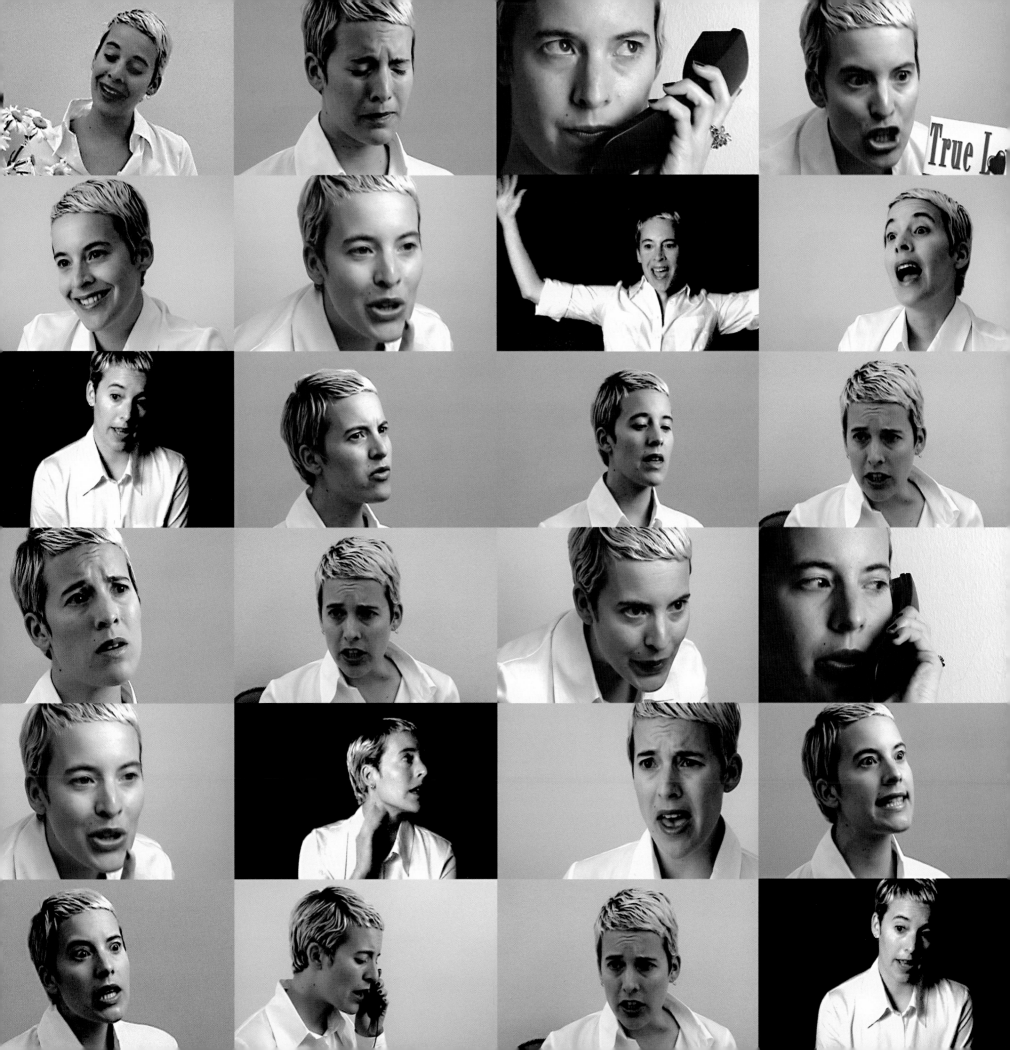

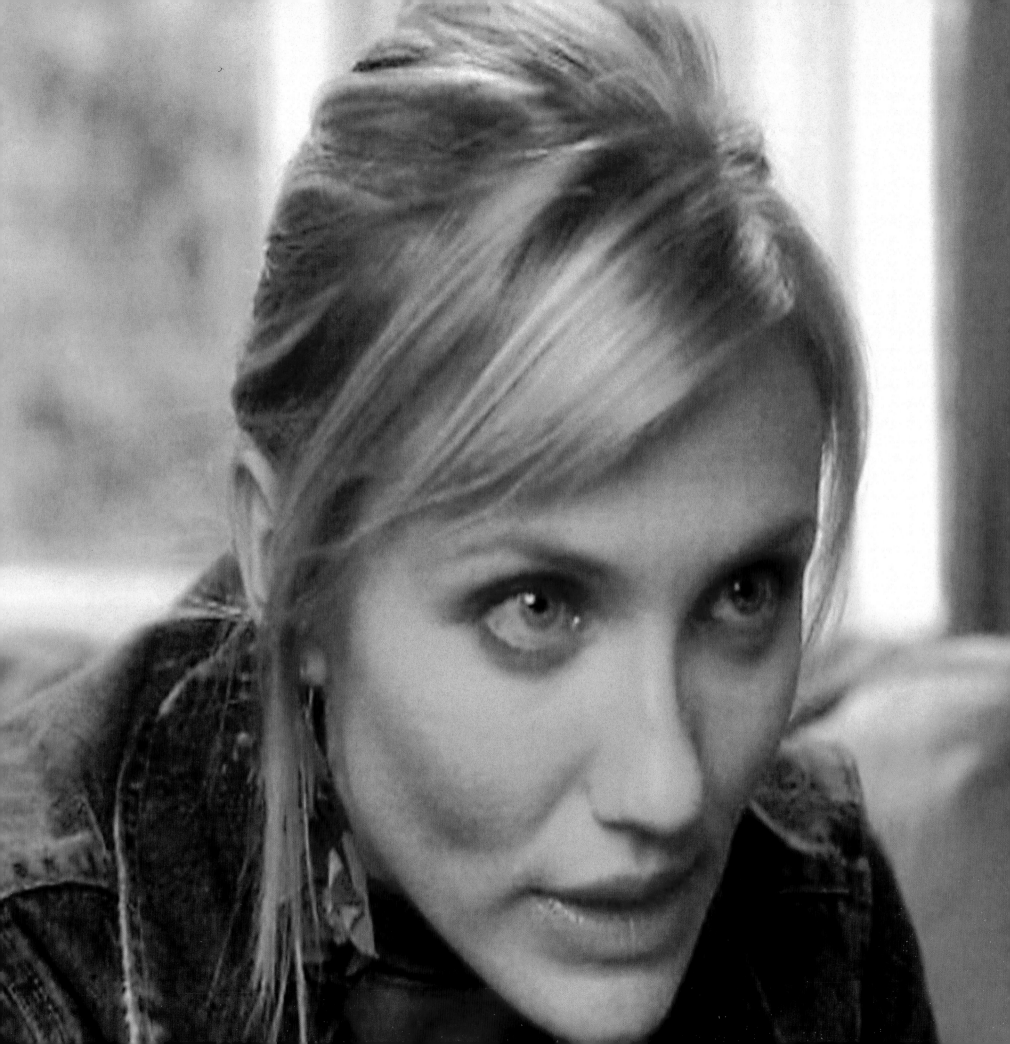

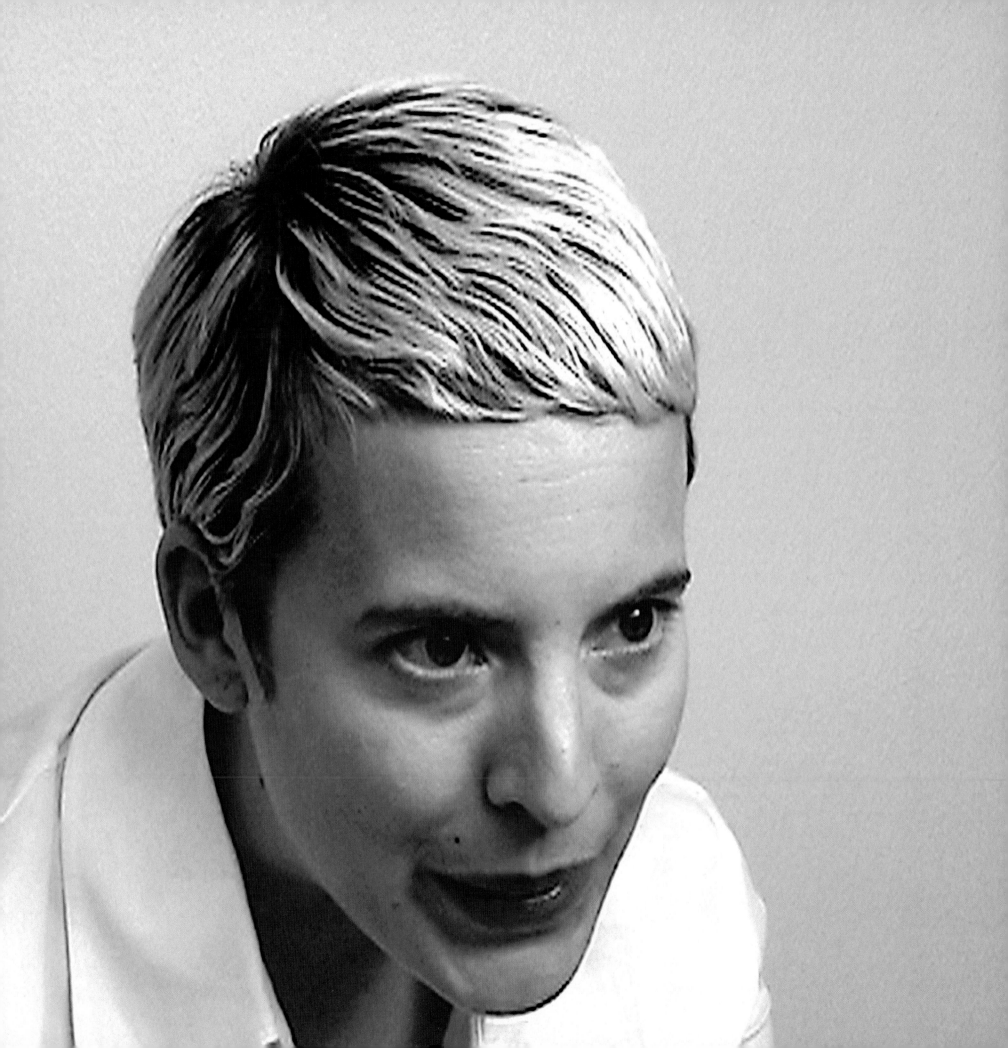

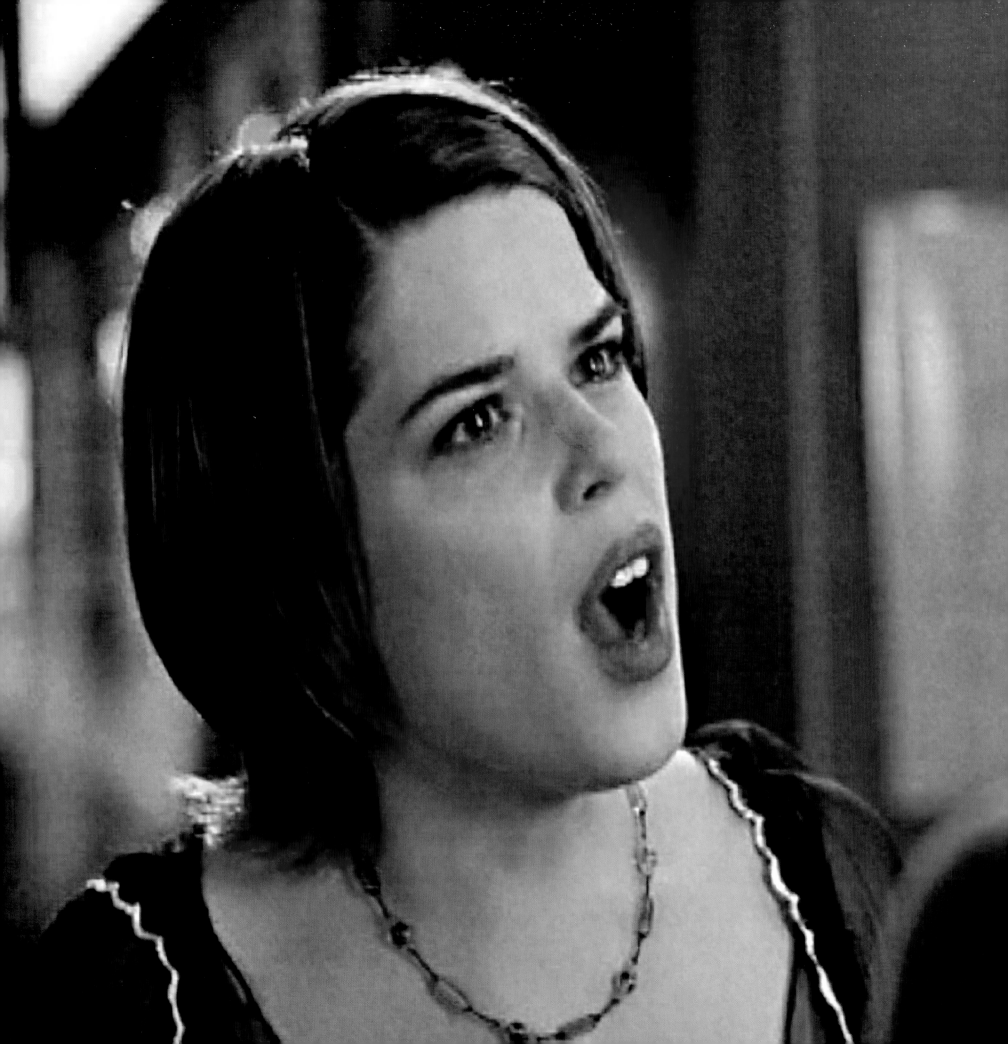

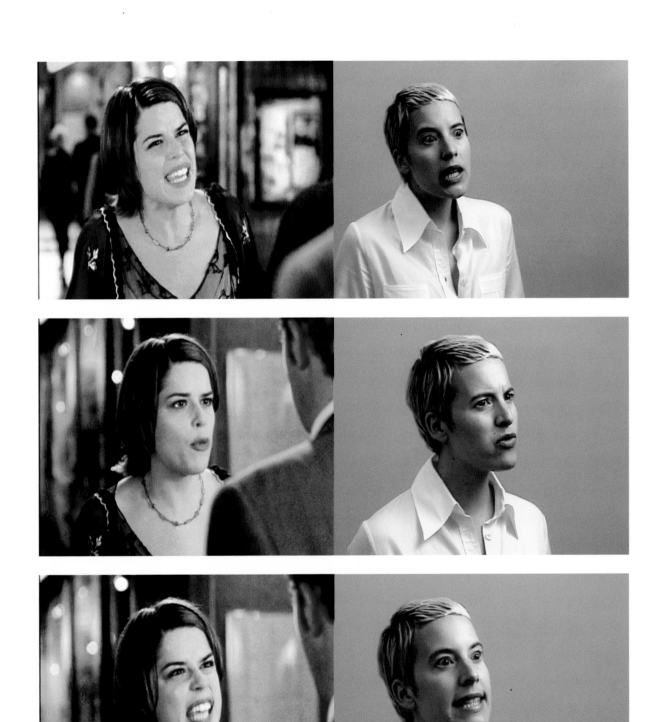

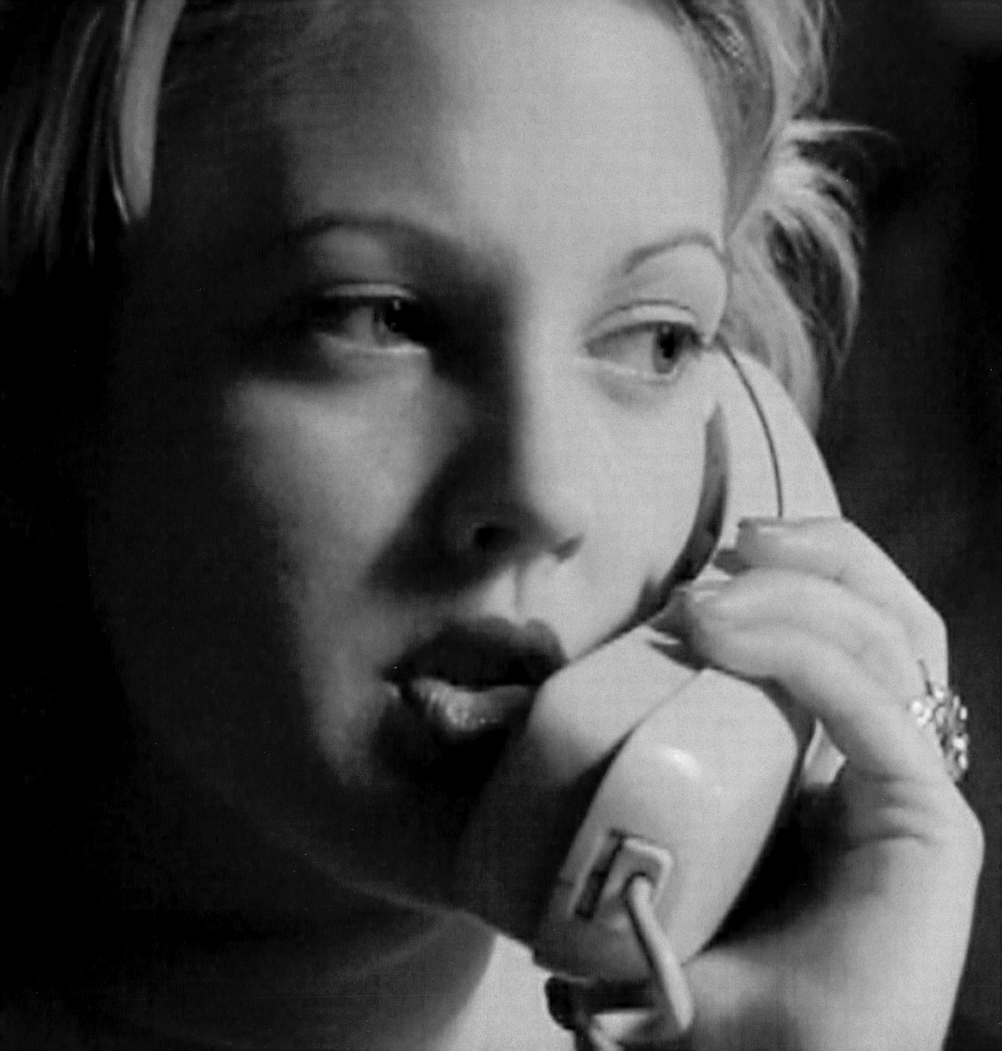

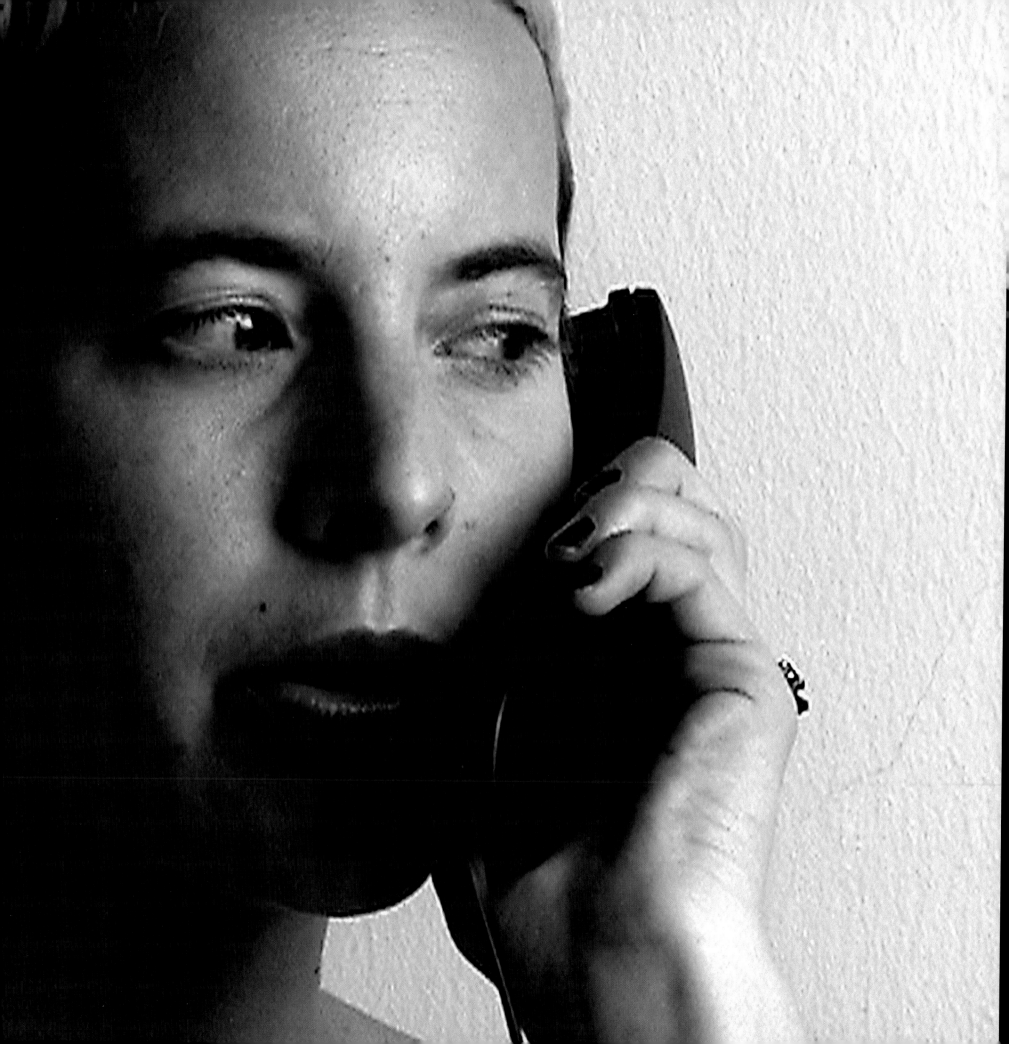

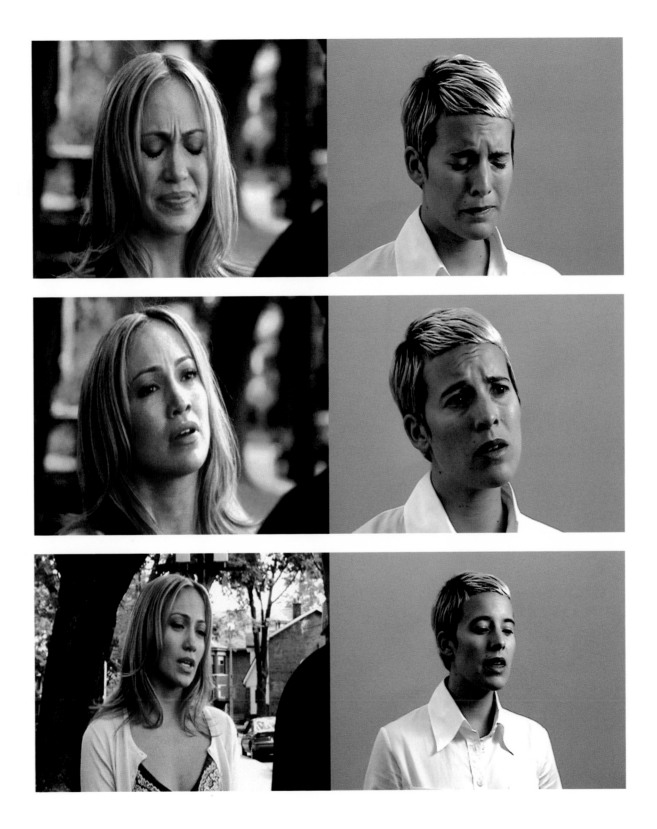

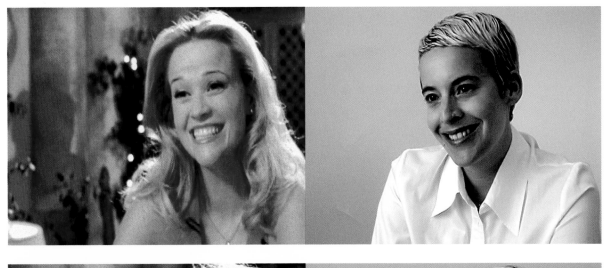
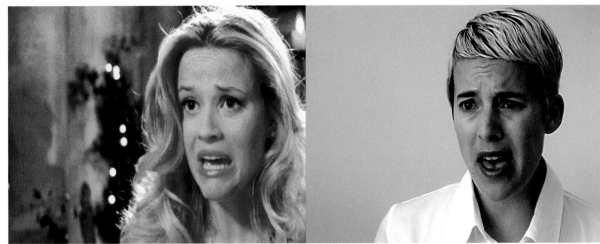
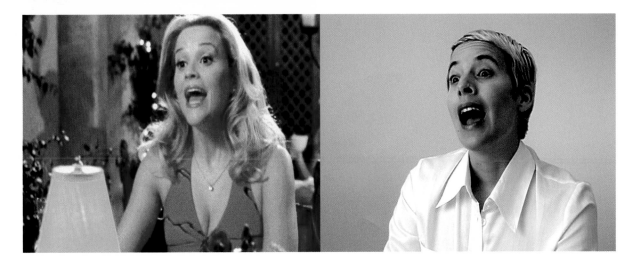

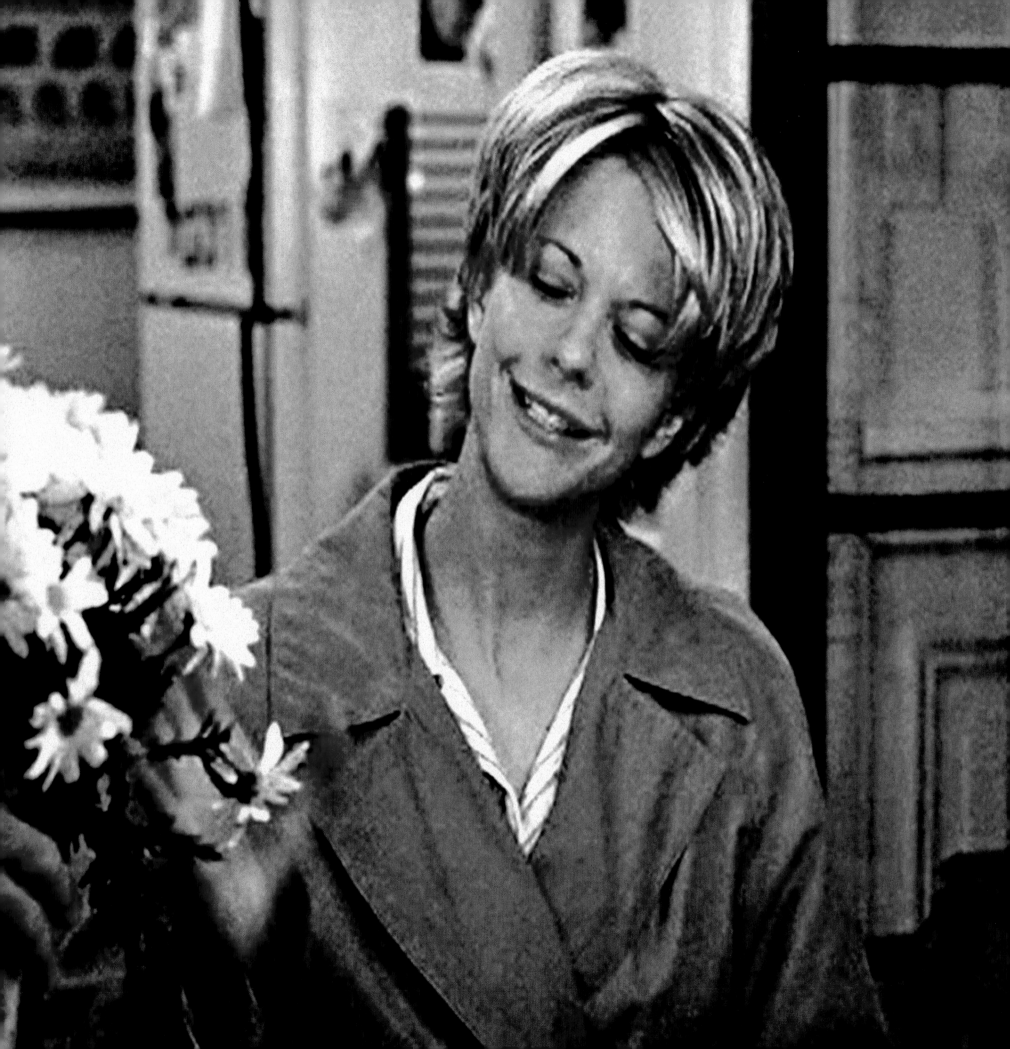

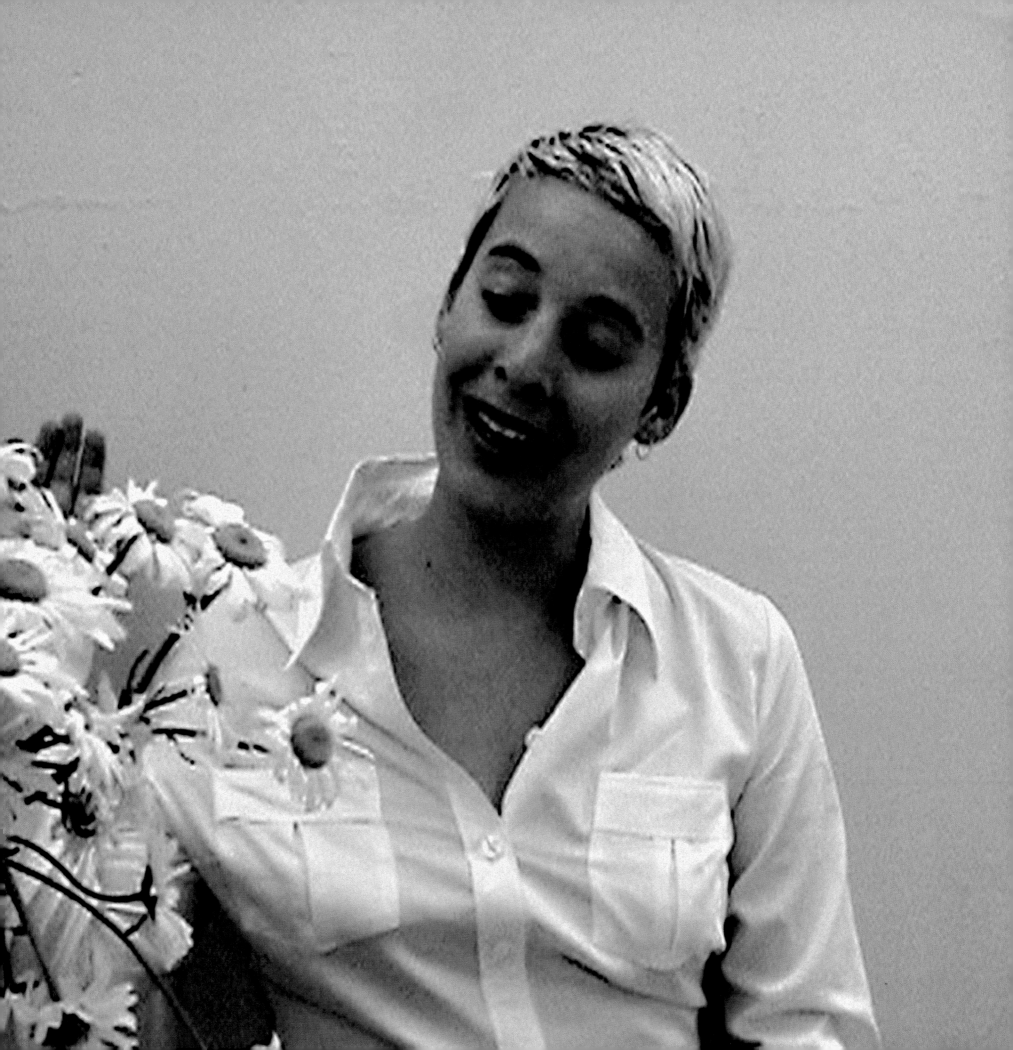

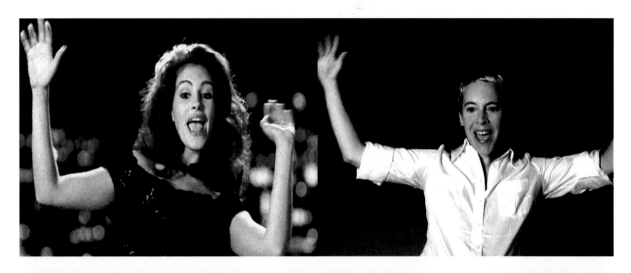

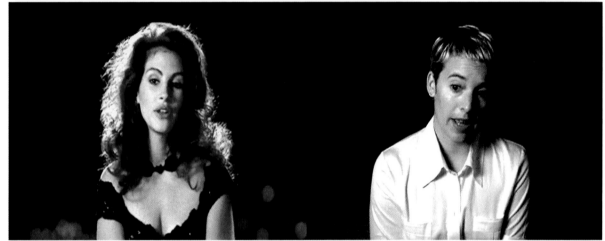

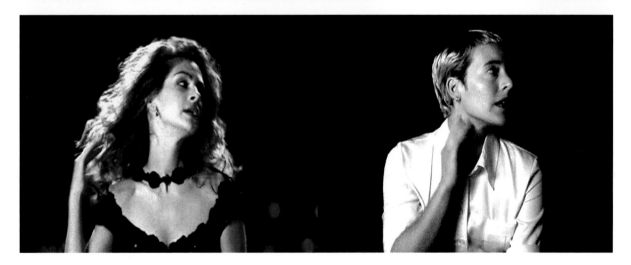

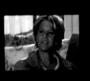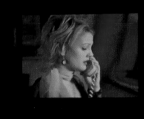

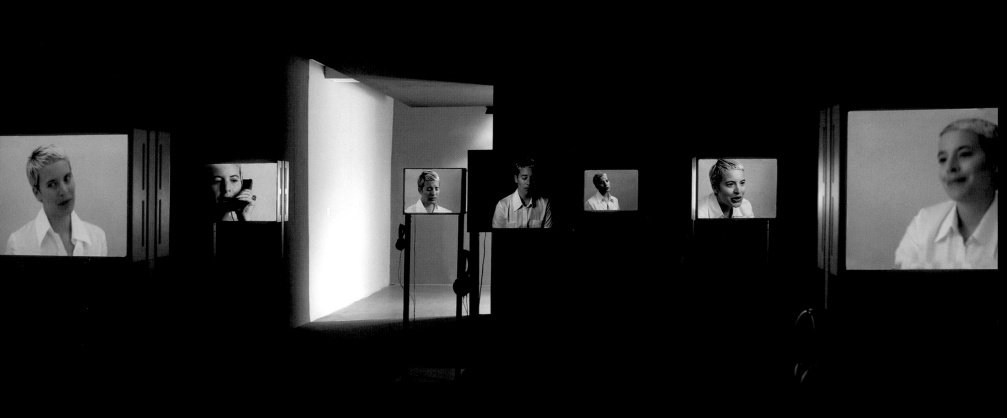

Karaoke se grabó a principios del año 2000, poco después de que Breitz terminara su primera vídeo-instalación, titulada *Babel Series* (1999). En esta ocasión ocuparon la posición destacada cantantes anónimos que sustituían a las estrellas del *pop* que habían dominado la pieza anterior. Juntas, las dos instalaciones introducen la mirada bifocal que ha seguido definiendo la actividad de Breitz. En obras posteriores, la artista ha regresado con ahínco obsesivo a la compleja relación dialéctica entre los "álguienes" que ocupan la pantalla grande y aurática, y la colectividad mucho más numerosa formada por "nadies", seres anónimos que se sientan en silencio y alejados de la pantalla, absorbiendo sus imágenes, identificándose, proyectándose en ella. Esa dialéctica se evoca más concretamente en la instalación de aires siameses *Becoming* (2003) – que sitúa a una serie de *starlets* de Hollywood espalda contra espalda con "nadies" relativamente austeros (interpretados por la propia Breitz) – pero es un tema central en las dos líneas paralelas de su producción: por un lado, en los ataques agresivos a los valores de la cultura mediática dominante que se desprenden de sus obras basadas en imágenes halladas *(Babel Series, Soliloquy Trilogy, Four Duets, Diorama)*; y, por el otro, en los estudios relativamente dóciles del consumidor de la cultura de masas, desde *Karaoke* y hasta la compleja antropología de los fans que surge de retratos como *Legend, King* y *Queen*. Si las piezas confeccionadas con material encontrado que nacen con *Babel Series* pueden entenderse como intentos de interrumpir y re-escribir las narrativas previsiblemente deslavazadas de la cultura dominante, la serie de obras que nace con *Karaoke* parece fijarse en los propios destinatarios de dichas narrativas deslavazadas: los receptores de la cultura de masas. La lectura de las líneas paralelas de la trayectoria de Breitz en función de esa relación mutua e invertida parece indicar que, en el fondo, no son la cultura de la fama ni el público que la consume de buena gana

los que centran el interés de la artista, sino la red, hasta cierto punto intangible, de deseo e identificación que los vincula de forma tan inextricable.

Karaoke sitúa al espectador en el centro de un anillo de diez televisores, cada uno de los cuales emite la versión en karaoke que hace una persona distinta de una misma canción romántica: *Killing Me Softly*. La reproducción simultánea de las distintas interpretaciones, que no están sincronizadas, se convierte en un caos melancólico. Las palabras de los distintos cantantes parecen alejadas de los labios de los que surgen, ya que la experiencia acumulativa impide al espectador seguir una sola voz durante más de un par de frases, antes de que quede apagada por la música de la multitud. La canción romántica es emblemática en este caso de la violencia intrínseca al lenguaje, ya que, si bien nos promete la oportunidad de compartir nuestros pensamientos más íntimos con alguien, también nos recuerda que no tenemos más remedio que hacerlo sirviéndonos de sentimientos y frases derivados de un repertorio que no nos pertenece.

No resulta necesariamente evidente el hecho de que ninguno de los cantantes de *Karaoke* tiene el inglés como lengua materna. Todos ellos respondieron a la petición de Breitz de intérpretes cuyo idioma propio podía ser cualquiera menos el inglés, con lo que se conformó un grupo con bases lingüísticas tan diversas como el tamil, el ruso, el vietnamita o el español. *Karaoke* remeda la universalidad de *We Are The World* mientras refleja los sacrificios y las concesiones inevitables en una puesta en escena estética demasiado sencilla de una esfera pública unificada. Si existe algún remedo de colectividad, lo forja el consumo compartido de una cultura de masas cada vez más universalizada. *Karaoke,* que se adelanta a las posteriores exploraciones de la cultura de los fans que haría la artista, es una reflexión

sobre el profundo anhelo de proyección pública que experimenta el individuo.

Karaoke was shot in early 2000, shortly after Breitz had completed her first video installation, the *Babel Series* (1999). This time anonymous singers take center stage, replacing the pop stars who dominated the earlier composition. Together, the two installations introduce the bifocal gaze that has continued to define Breitz's practice. In subsequent works, she has returned obsessively to the complex dialectical relationship between the "somebodies" who occupy the auratic silver screen, and the much larger community of anonymous "nobodies" who sit at a silent remove from the silver screen, absorbing from, identifying with, and projecting onto it. This dialectic is evoked most concretely in Breitz's Siamese-twin-like installation *Becoming* (2003) – which arranges a series of Hollywood starlets back-to-back with a relatively austere nobody (played by Breitz herself) – but is of central concern throughout the two parallel strands of her oeuvre: on the one hand, in the aggressive attacks on the values of mainstream media culture that can be discerned in her found footage works *(Babel Series, Soliloquy Trilogy, Four Duets, Diorama)*; and on the other, in the artist's relatively gentle studies of the consumer of popular culture, beginning with *Karaoke,* and leading into the complex anthropology of the fan that emerges in portraits such as *Legend, King* and *Queen.* If the found footage works originating with the *Babel Series* can be read as endeavors to interrupt and rewrite mainstream culture's predictably seamless narratives, then the series of works that can be traced back to *Karaoke* seem to focus on the very audience for whom such seamless narratives are designed: the users of pop culture. Reading the parallel strands of Breitz's practice in this inverted relationship to each other suggests that ultimately it is neither the culture of celebrity, nor the audience that readily consumes that culture, which is of primary interest to the artist; but rather, the somewhat intangible web of desire and identification that binds the two so inextricably to each other.

Karaoke locates the viewer in the center of a ring of ten televisions, each of which broadcasts one individual's Karaoke version of the same love song: *Killing Me Softly.* The simultaneous playback of the different renditions, being unsynchronized, results in a melancholic pandemonium. The words issuing from the individual singers appear to be estranged even from the very lips that issue them, since the cumulative experience disables the viewer from following any single voice for more than a couple of lines, before that voice gets drowned in the music of the crowd. The love song is emblematic here of the violence that is intrinsic to language, for even as it promises us the opportunity to unburden our most intimate thoughts, it reminds us that we have no choice but to do so by means of sentiments and phrases derived from a repertory that is not our own.

Not necessarily obvious, is the fact that none of the performers in *Karaoke* are native English speakers. Each responded to Breitz's search for individuals whose mother tongue could be any language *except* English, resulting in a group of performers from language backgrounds as diverse as Tamil, Russian, Vietnamese and Spanish. *Karaoke* mimics *We Are The World* universalism even as it reflects on the sacrifices and losses that are inevitable in a too easy aesthetic staging of a unified public sphere. If there is a semblance of communality here, it is one forged in the shared consumption of an increasingly global popular culture. Anticipating Breitz's later explorations of the culture of the fan, *Karaoke* reflects on the acute longing of the individual for public registration.

Karaoke

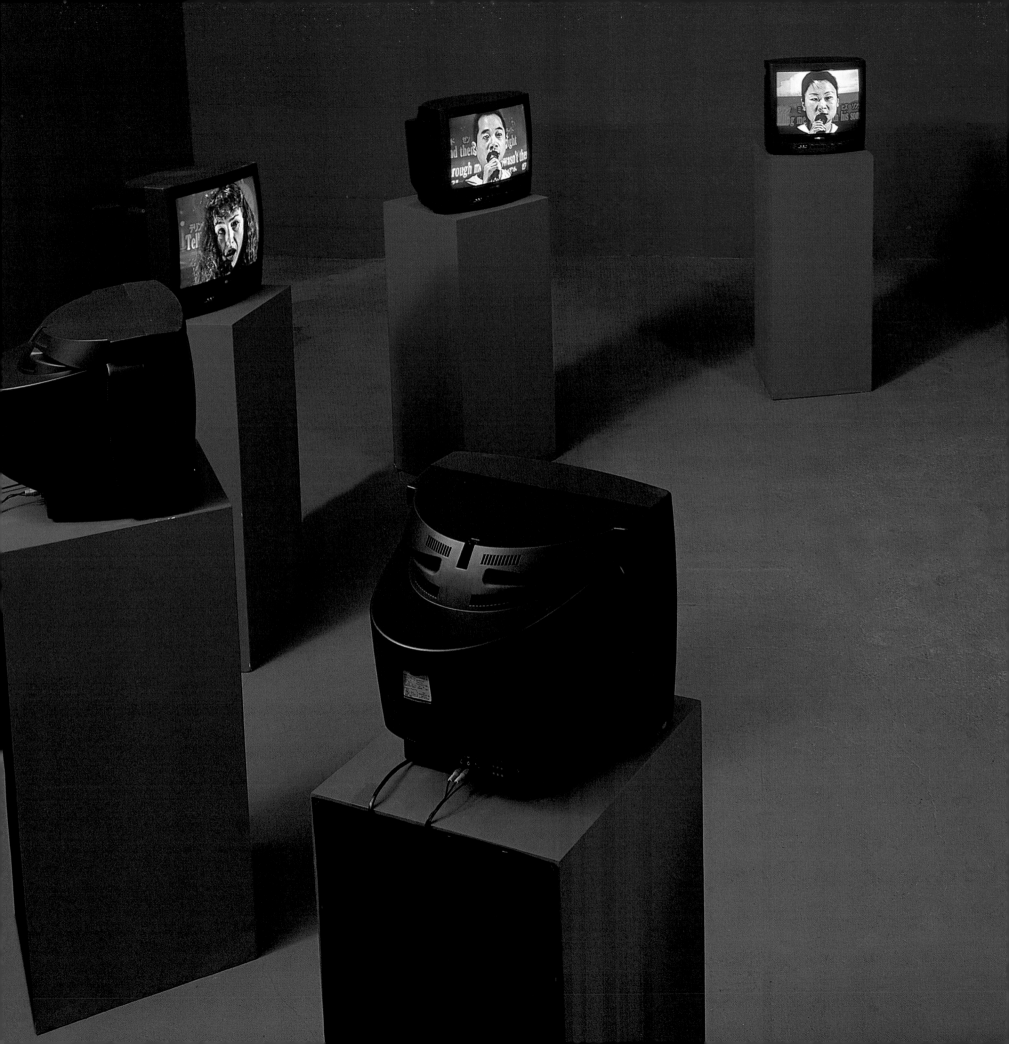

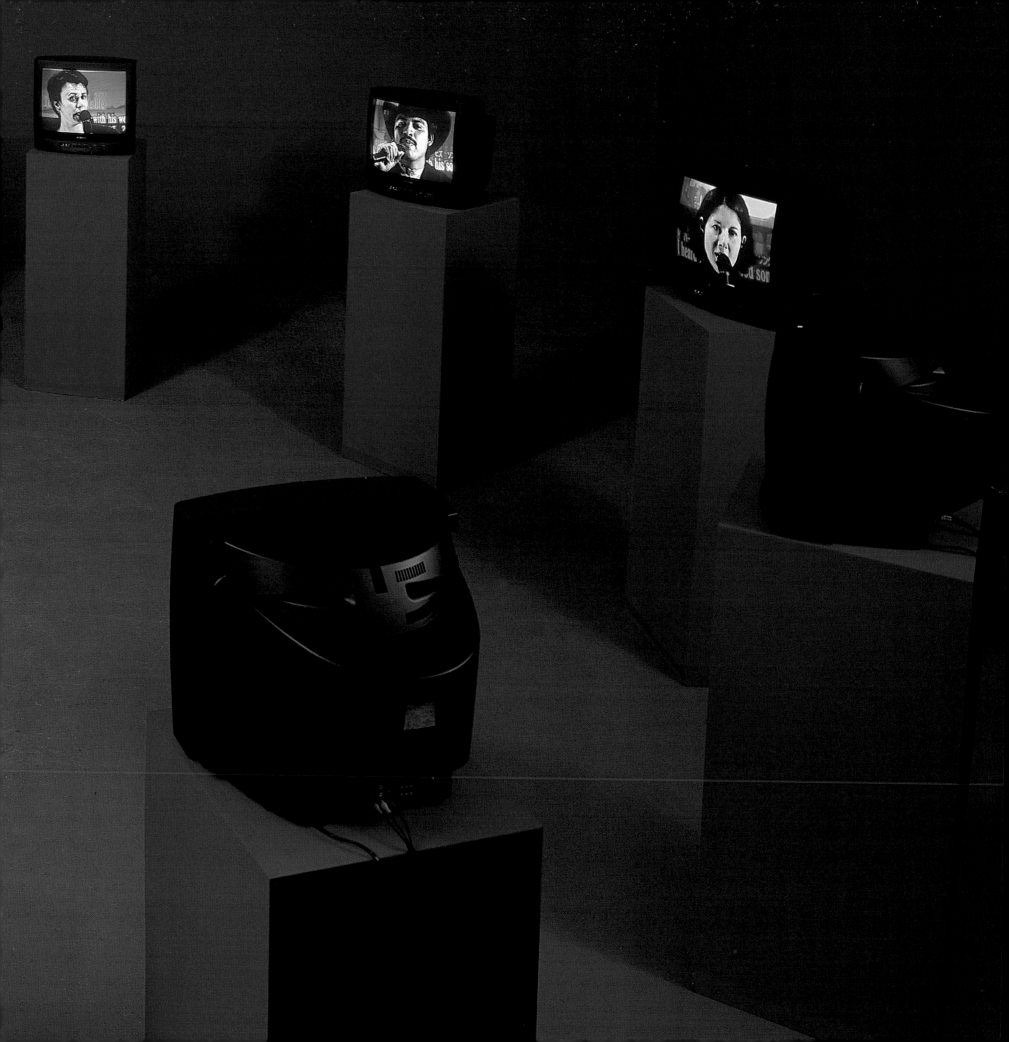

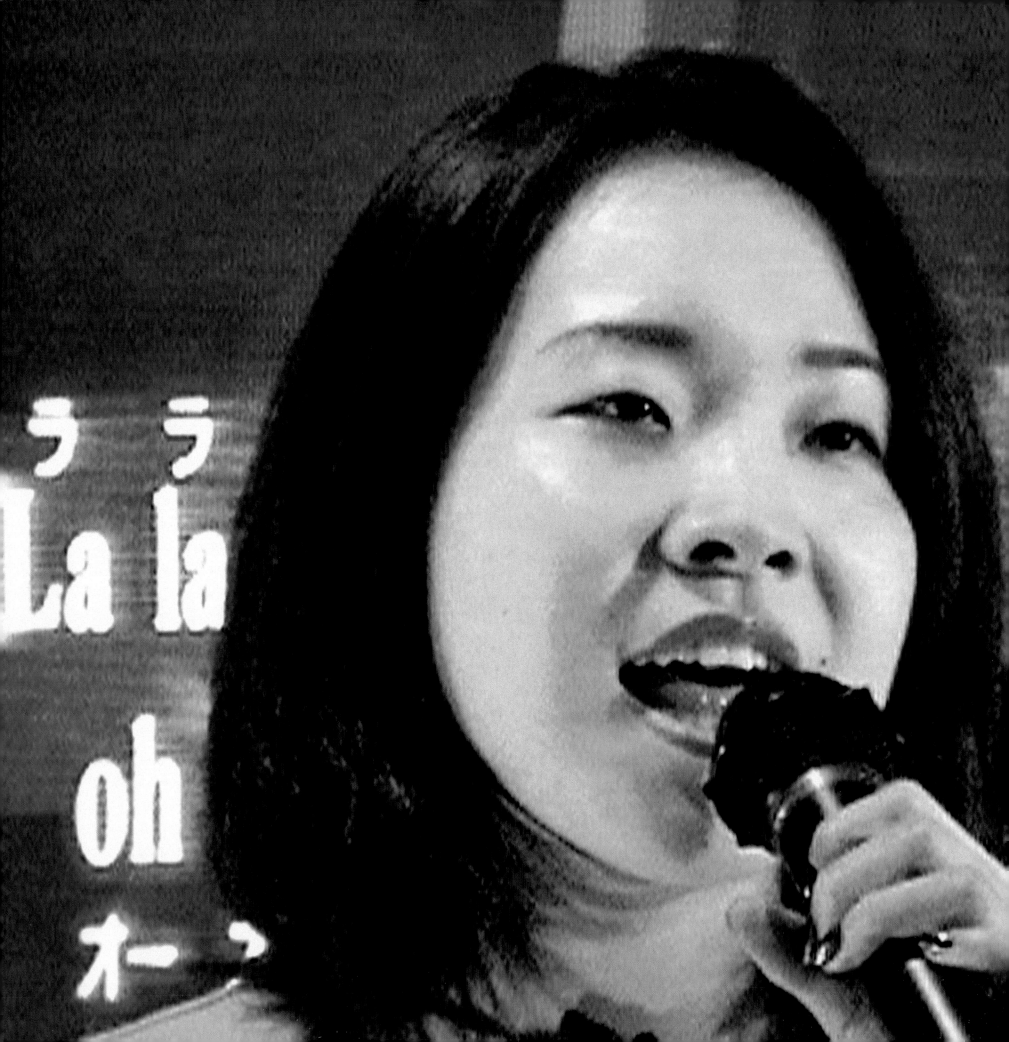

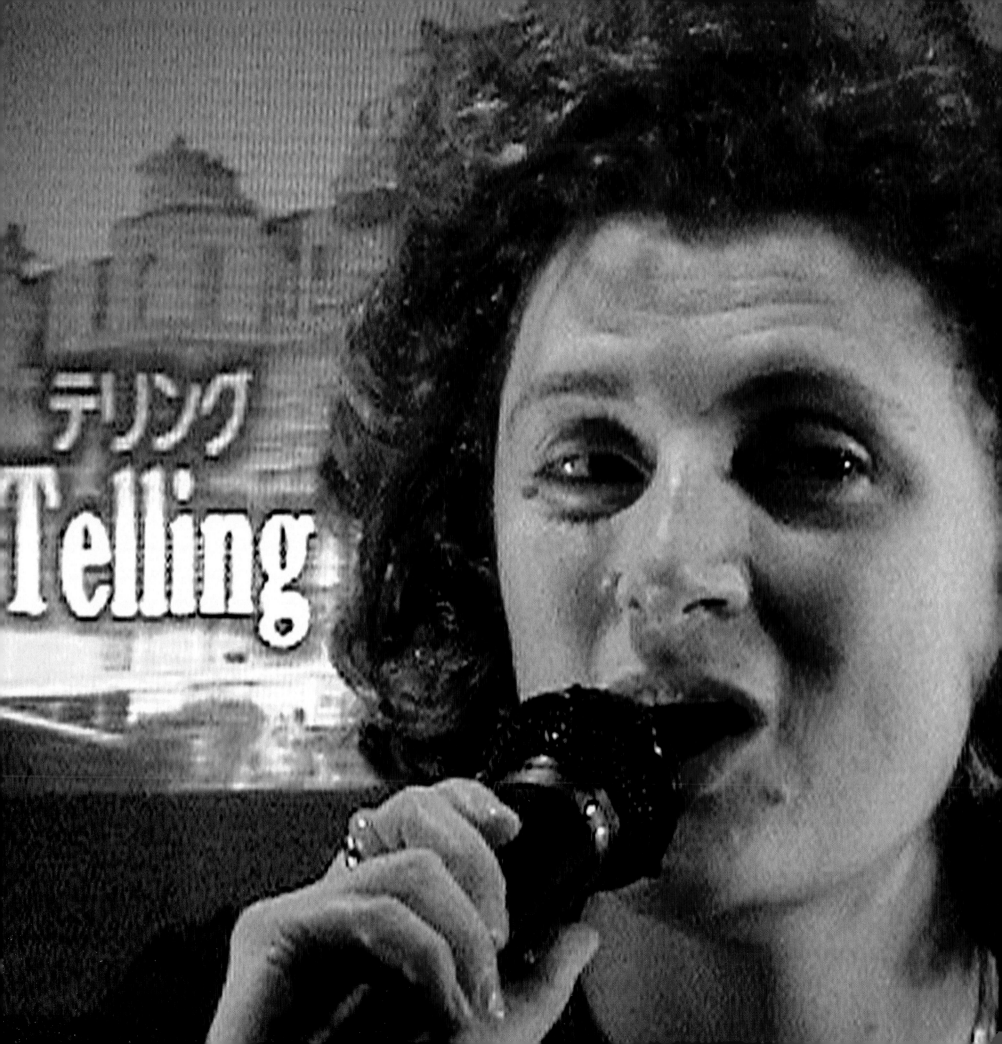

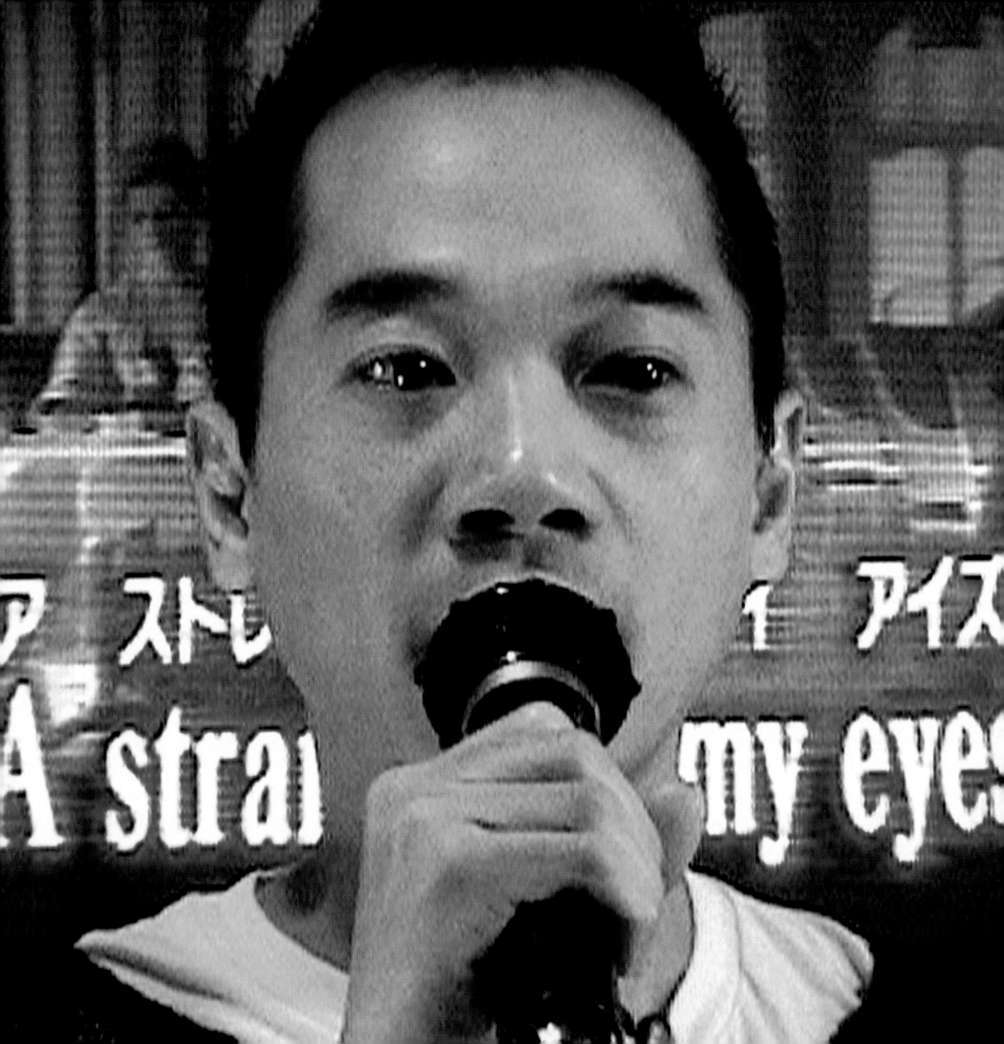

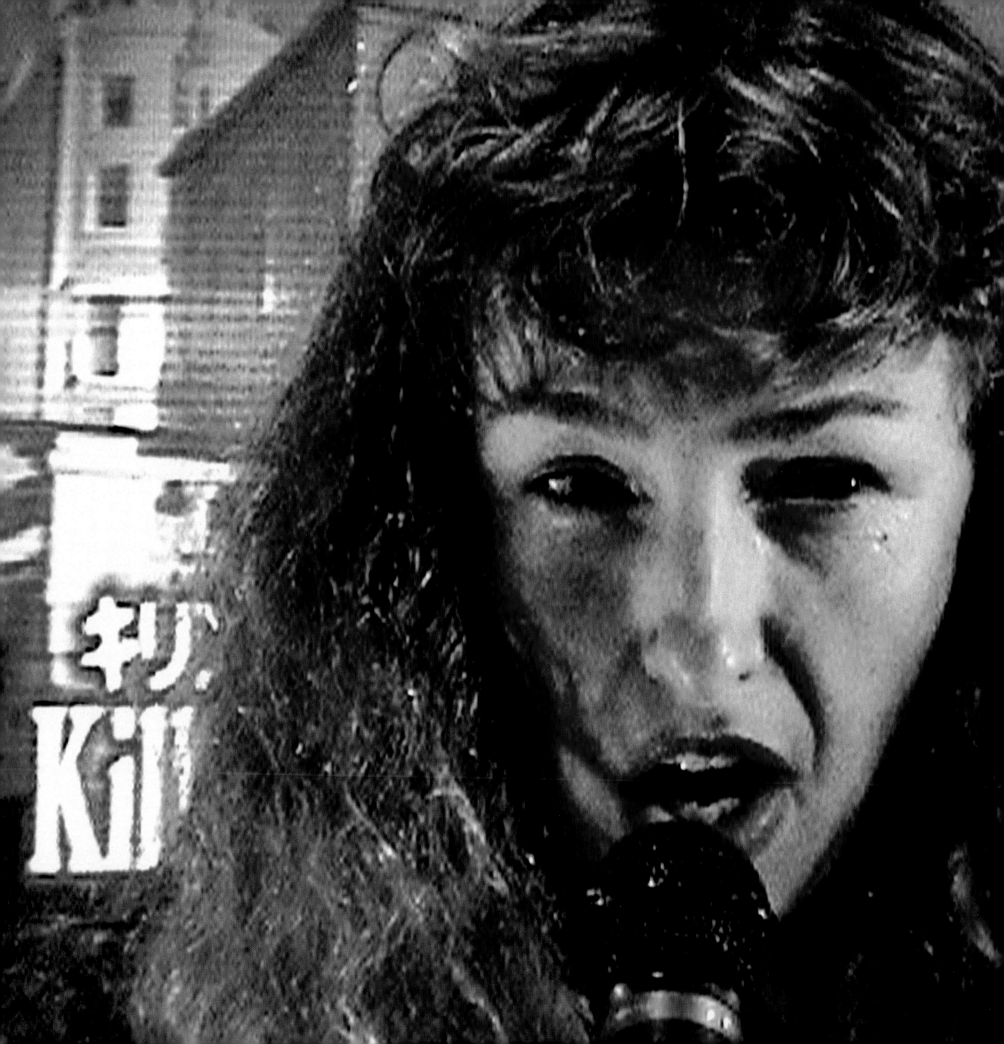

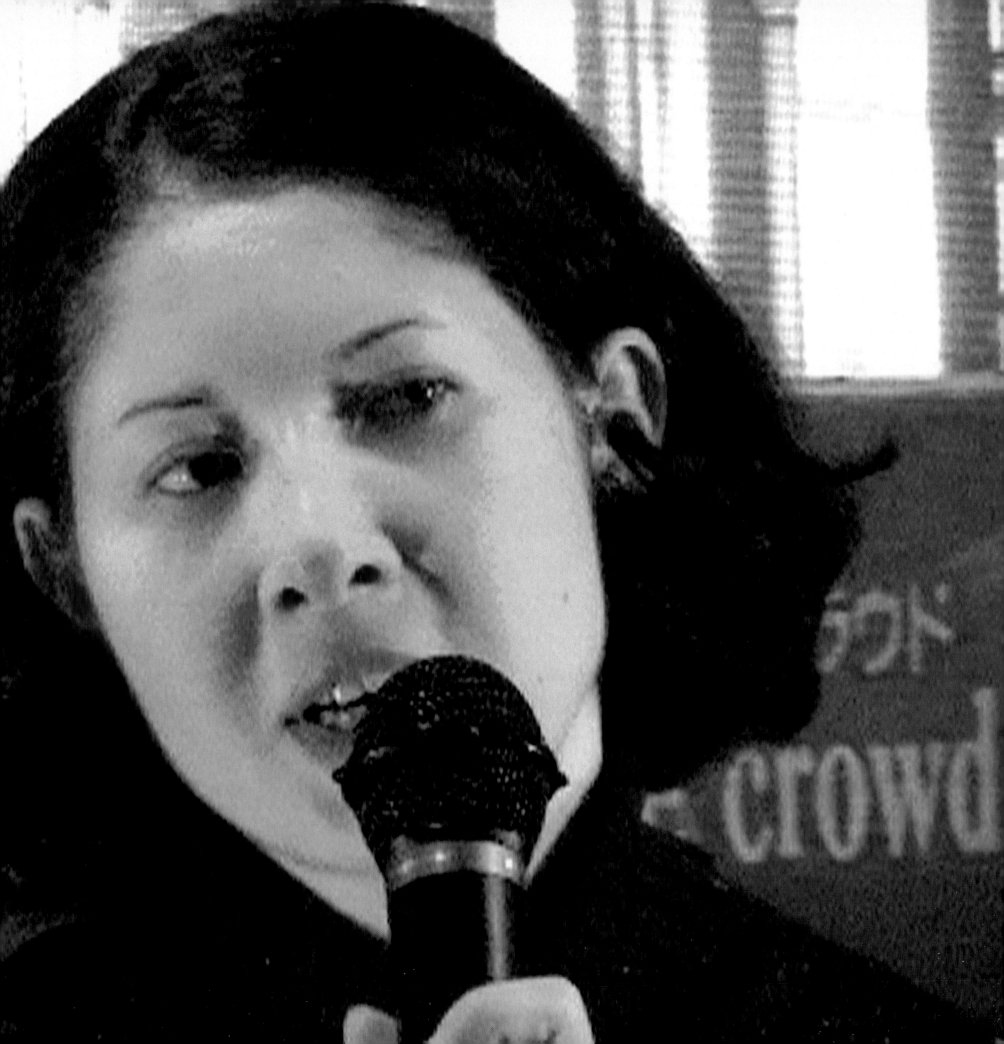

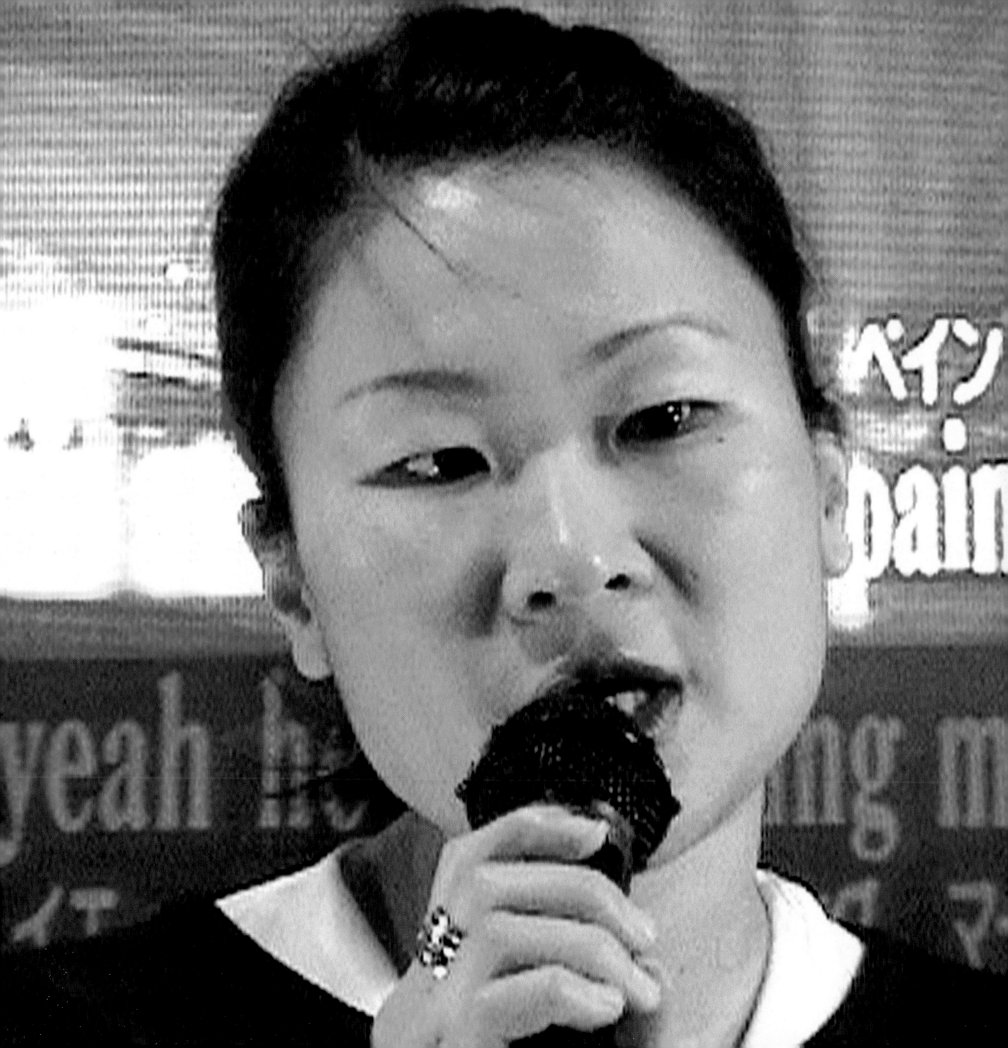

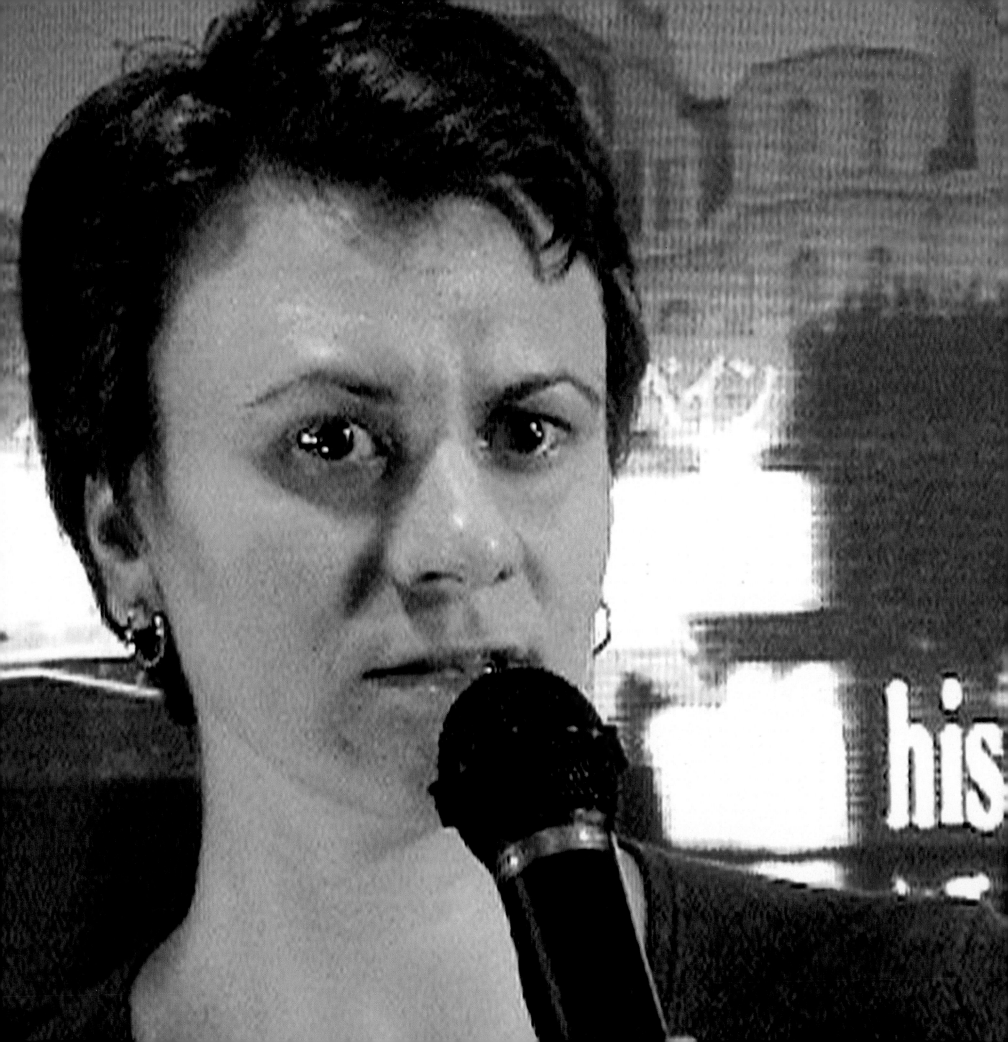

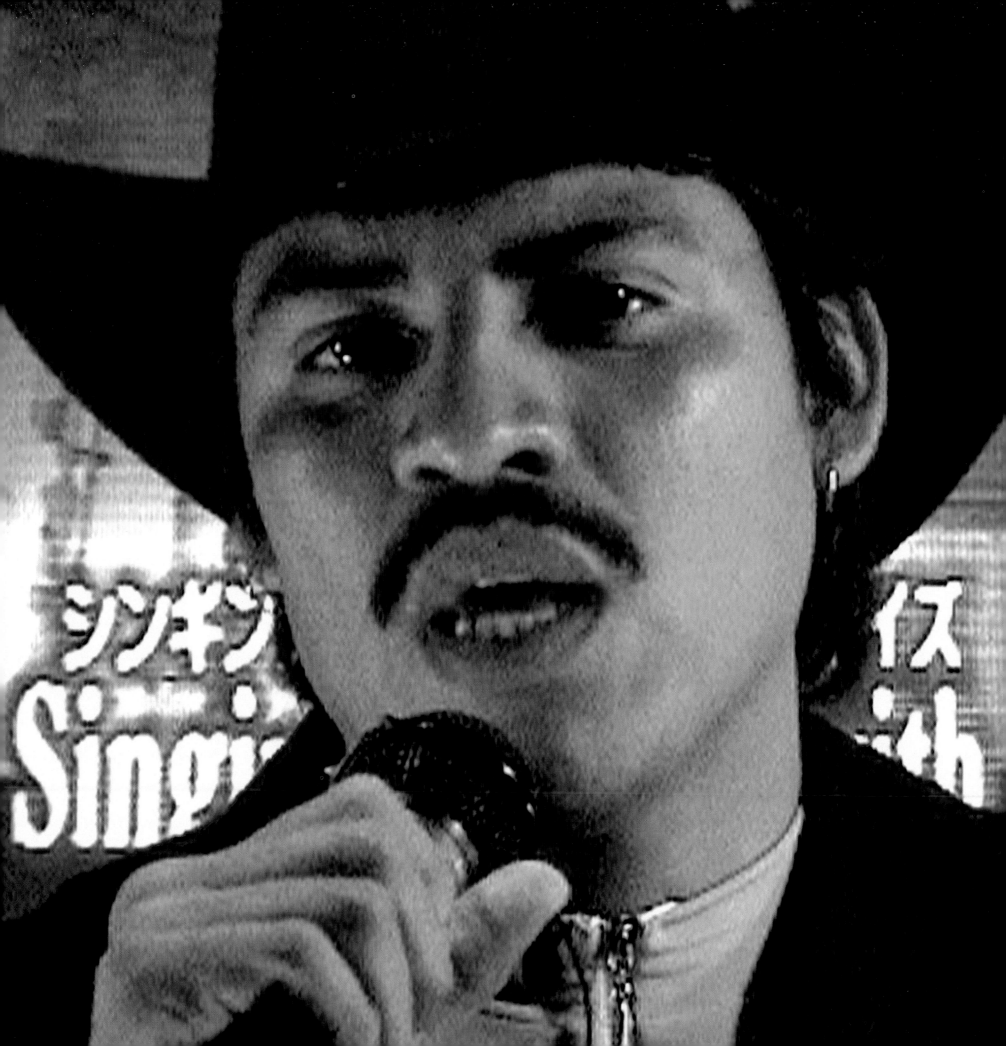

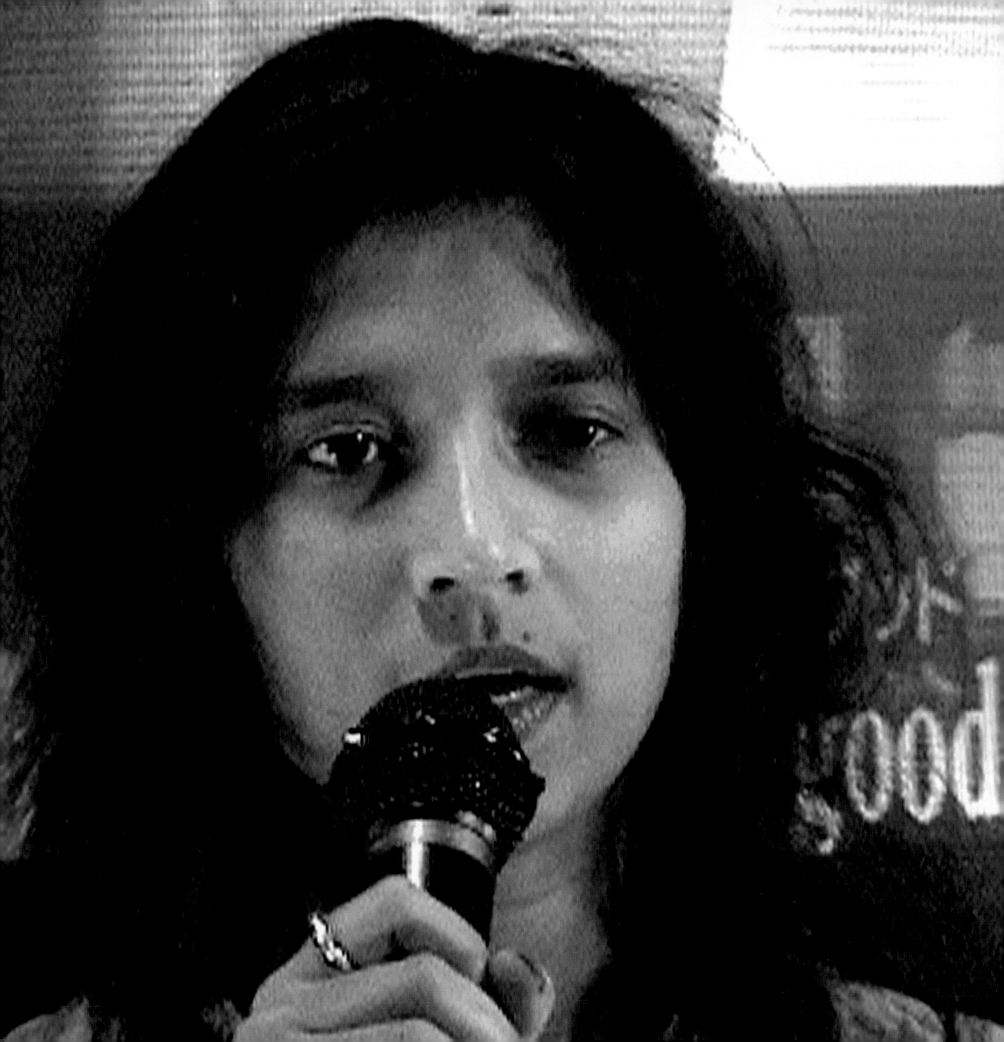

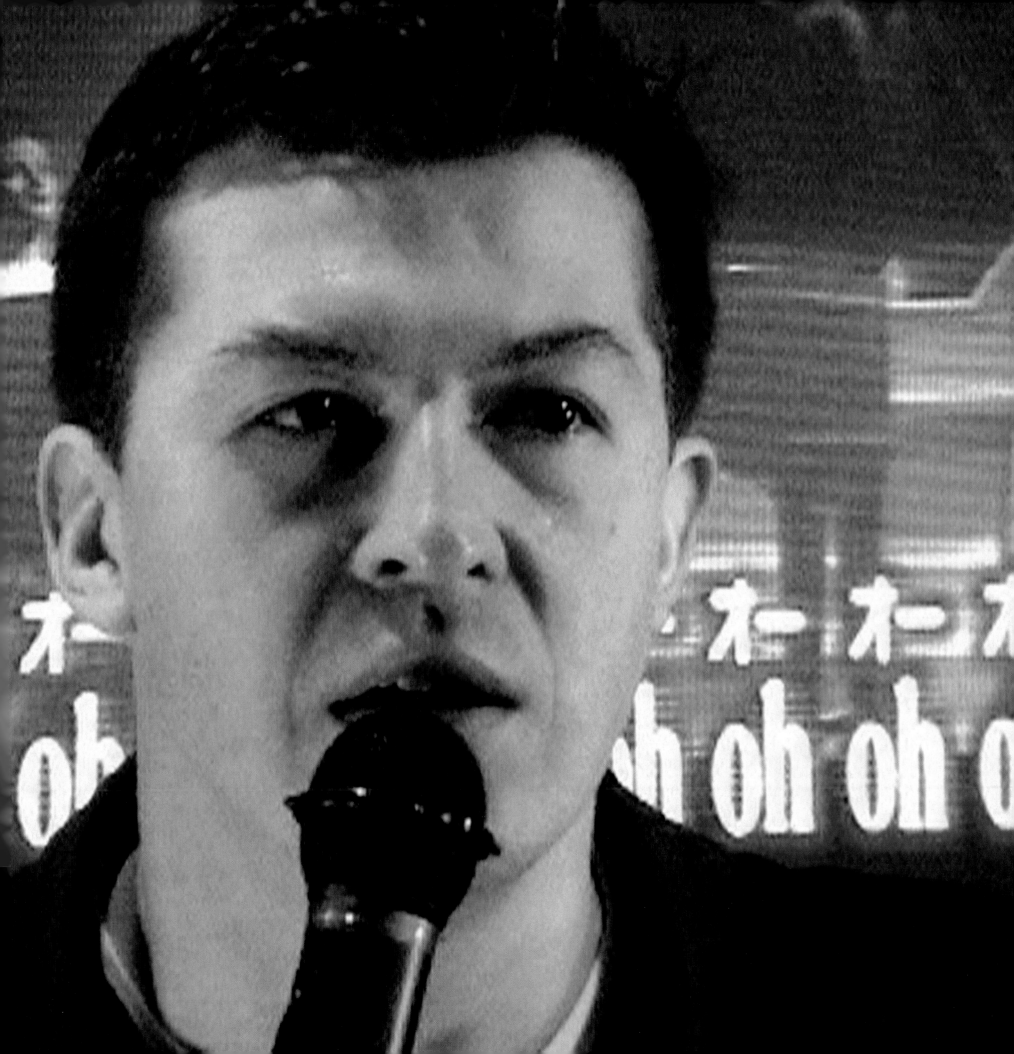

El conjunto de experimentos recientes de Breitz en el género del retrato se podría describir como un estudio antropológico en curso sobre los fans. Desde la pieza *Legend (A Portrait of Bob Marley)*, rodada en Jamaica en 2005, Breitz ha establecido estudios de retratos provisionales en Berlín, para *King (A Portrait of Michael Jackson)*, en Milán, para *Queen (A Portrait of Madonna)* y en Newcastle, para *Working Class Hero (Portrait of John Lennon)*. Hasta ahora, los retratos han seguido la misma lógica de procedimiento, definidos por el mismo estricto marco conceptual. En cada caso, Breitz se propone en primer lugar identificar los apasionados fans del icono musical objeto del retrato, poniendo anuncios en periódicos, revistas y *fanzines,* así como en Internet. Las personas que responden a esa primera llamada (centenares, como era de esperar) pasan entonces por una rigurosa serie de procedimientos diseñada para excluir a los fans menos convencidos del famoso en cuestión, para poder llegar al grupo de participantes final.

De modo que los individuos que aparecen en estas obras se han identificado como fans y han sido incluidos en ellas justamente por esa razón; todos los demás factores – su aspecto, su talento para cantar, actuar o bailar, su sexo y su edad – se consideran irrelevantes en el proceso de selección. A cada uno de los elegidos se le ofrece la oportunidad de re-interpretar un álbum completo, desde el primer tema al último, en un estudio de grabación profesional. Así pues se establecen las bases de un estudio tipológico mientras cada participante entra en el estudio para ofrecer su versión del mismo álbum bajo las mismas condiciones básicas. Una vez marcados los parámetros de la experiencia, Breitz deja que las actuaciones transcurran con poca interferencia de la dirección. Cada fan decide la ropa que vestirá, si utilizará o no atrezo, cómo se dirigirá a la cámara, si bailará o no y en qué momento, si seguirá la voz solista o al coro, cómo se comportará entre temas, y si imitará la grabación original o bien se distanciará interpretativamente de ella. Siendo variados, como conjunto los retratos se caracterizan por una tensión fascinante entre las condiciones inflexibles bajo las que se produce cada toma (condiciones que reflejan y reflexionan sobre las severas limitaciones a la creatividad en el ámbito mercantilizado de la cultura de masas), y la lucha de cada fan para lograr una interpretación idiosincrásica a pesar de estas condiciones. En el curso de esta lucha, los cantantes crean una versión *a cappella* del álbum en el que se basa la obra, una re-grabación que cabría describir como un "retrato" del disco original. Aunque los retratos insisten pertinazmente en el formato y la duración exactos de los álbumes originales en que se basan, excluyen de manera específica las voces auráticas y los arreglos musicales familiares de la versión original, de manera que la estrella en cuestión finalmente sólo permanece en la obra en las voces sin acompañamiento de sus fans.

La cuestión de si los retratos de Breitz celebran o critican la relación estrella-fan que representan para nuestra mirada minuciosa no es fácil de dilucidar. Los retratos no parecen censurar críticamente los efectos totalizadores de la industria cultural, ni responder de manera simplista al deseo de celebrar la creatividad del mundo de los fans. En todo caso, los retratos reflejan la ambivalencia de Breitz respecto a la cultura de masas, tal y como recoge Raimar Stange en una entrevista reciente: "Gran parte de la crítica del *pop* que hemos digerido a lo largo de las últimas décadas ha hecho hincapié en que el *pop* sólo puede degradar la memoria y erosionar la posibilidad del pensamiento histórico. Sin embargo, yo sigo sosteniendo que el *pop* tiene una dimensión histórica y que puede ser un vehículo de la memoria, a pesar de su tendencia a producir amnesia. Nuestra relación con el *pop* es, naturalmente, consumista, pero entonces la cuestión es si nosotros consumimos *pop* o dejamos que el *pop* nos consuma. El *pop* tiene dos características que logran que siempre vuelva (y me consta que eso les pasa a muchos) a por más. La primera es que, nos guste o no, la música *pop* se convierte en la banda sonora de nuestro pasado. Las canciones *pop* están latentes en nuestro presente como tantas y tantas perversas magdalenas. Evidentemente, ésta es una afirmación generacional que sólo tiene sentido desde la segunda mitad del siglo veinte pero, aun y así, cuando pensamos en nuestras vidas en términos históricos, no sólo pensamos en el lugar de origen de nuestros abuelos o del barrio e el que crecimos sino también en el primer álbum que compramos, el primer concierto al que asistimos, la primera canción que nos inspiró a tocar la guitarra de aire. Nos definimos por la música que escuchamos, por las canciones que oímos por vez primera en momentos clave de nuestro pasado. El *pop* parece ofrecer múltiples oportunidades para la auto-invención, de ahí que resulte tan seductor. El problema del *pop,* por supuesto, es que los sujetos que nos anima a inventarnos suelen ser pasivos y predeterminados, con lo cual más que ofrecérsenos un verdadero momento de auto-invención somos invitados a perfilarnos en moldes que ya han sido vertidos."

Continúa en la página 170

Breitz's recent experiments in the field of portraiture can cumulatively be described as an ongoing anthropology of the fan. Beginning with *Legend (A Portrait of Bob Marley),* which was shot in Jamaica in 2005, Breitz has subsequently set up temporary portrait studios in Berlin [for *King (A Portrait of Michael Jackson)*], Milan [for *Queen (A Portrait of Madonna)*] and Newcastle [for *Working Class Hero (A Portrait of John Lennon)*]. The portraits have thus far followed the same procedural logic, and have been governed by the same tight conceptual framework. In each case, Breitz first sets out to identify ardent fans of the musical icon to be portrayed, by placing ads in newspapers, magazines and fanzines, as well as on the Internet. Those who respond to this initial call (typically numbering in their hundreds), are then put through a rigorous set of procedures designed to exclude less than authentic fans of the celebrity in question, in order to arrive at the final group of participants.

The individuals who appear in these works have thus stepped forward to identify themselves as fans, and have been included purely on this basis: all other factors – their appearance; their ability to sing, act or dance; their gender and age – are treated as irrelevant for the purpose of selection. Each of the selected fans is offered the opportunity to re-perform a complete album, from the first song to the last, in a professional recording studio. The conditions are thus set for a typological study, as each of the participants steps into the studio, one by one, to offer their version of the same album under the same basic conditions. Having set the parameters of the experience, Breitz then allows the performances to unfold with little directorial interference. It is left up to each fan to decide what to wear, whether to use props, how to address the camera, when and if to dance, whether and how to follow the lead or backing vocals, how to behave between tracks, and

whether to mimic the original recording or seek interpretive distance from it. Diverse as they are, the portraits are collectively characterized by a riveting tension between the somewhat inflexible conditions under which each shoot takes place (conditions which both reflect and reflect upon the severe limitations for creativity within the commodified realm of mass entertainment), and the struggle of each fan to register an idiosyncratic performance despite these conditions. In the process of this struggle, the singers generate an *a cappella* cover version of the album that scripts the work, a re-recording which might best be described as a "portrait" of the original album. Although the portraits stubbornly insist on the exact format and duration of the original albums that they take as their templates, they specifically exclude the auratic voices and familiar musical arrangements from the original version, so that the star in question ultimately remains present in the work only in the unaccompanied voices of his/ her fans.

The question of whether Breitz's portraits might be read as celebratory or critical of the fan-star relationship that they stage for our close observation, yields no simple answer. The portraits appear intent neither on critically decrying the totalizing effects of the culture industry, nor simplistically motivated by the desire to celebrate the creativity of fandom. If anything, the portraits reflect Breitz's ambivalence in relation to mainstream entertainment, as expressed to Raimar Stange in a recent interview: "Much of the pop commentary that we've digested in the last few decades has insisted that pop can only degrade memory and erode the possibility of historical thought. I nevertheless continue to maintain that pop has a historical dimension, and that it can be a vehicle of memory, despite its tendency to induce

Continued on page 171

Legend (A Portrait of Bob Marley)

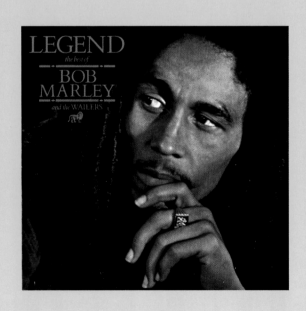

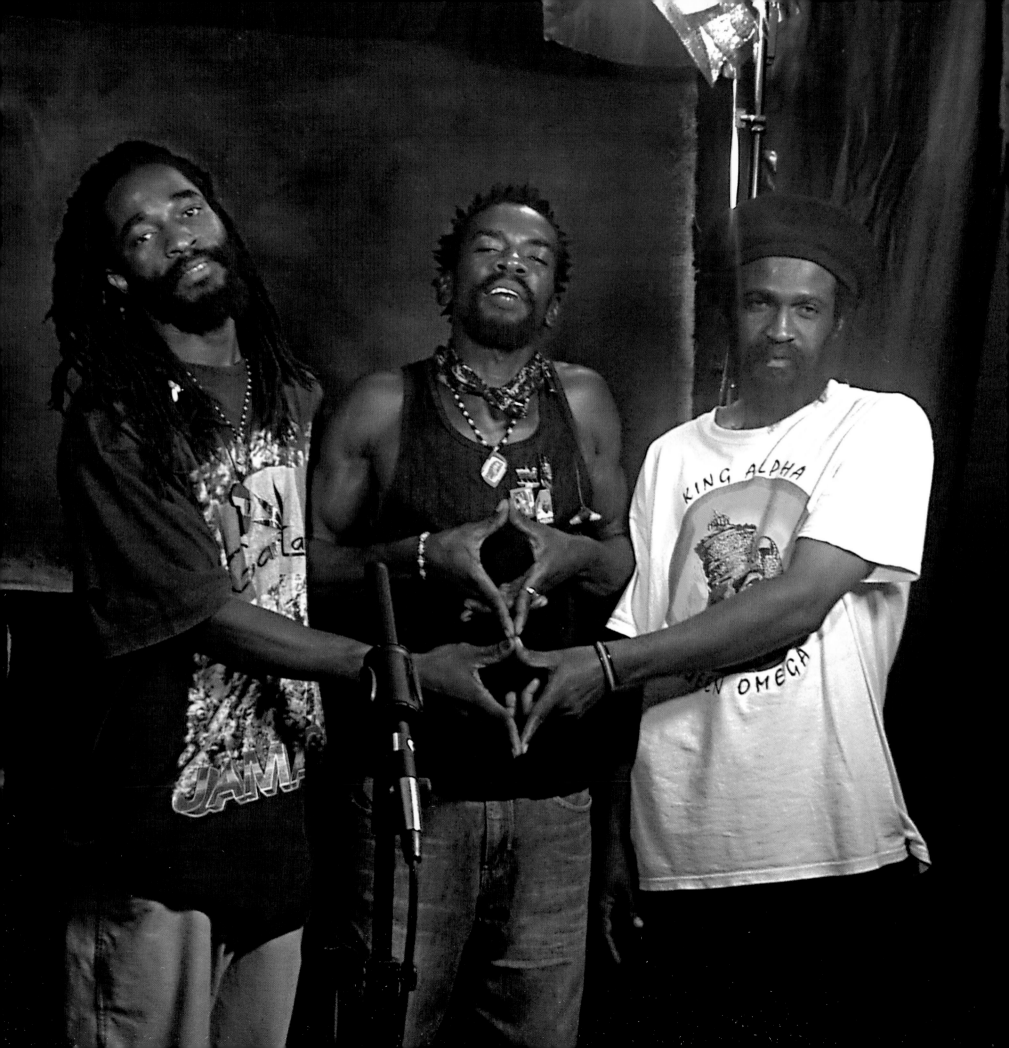

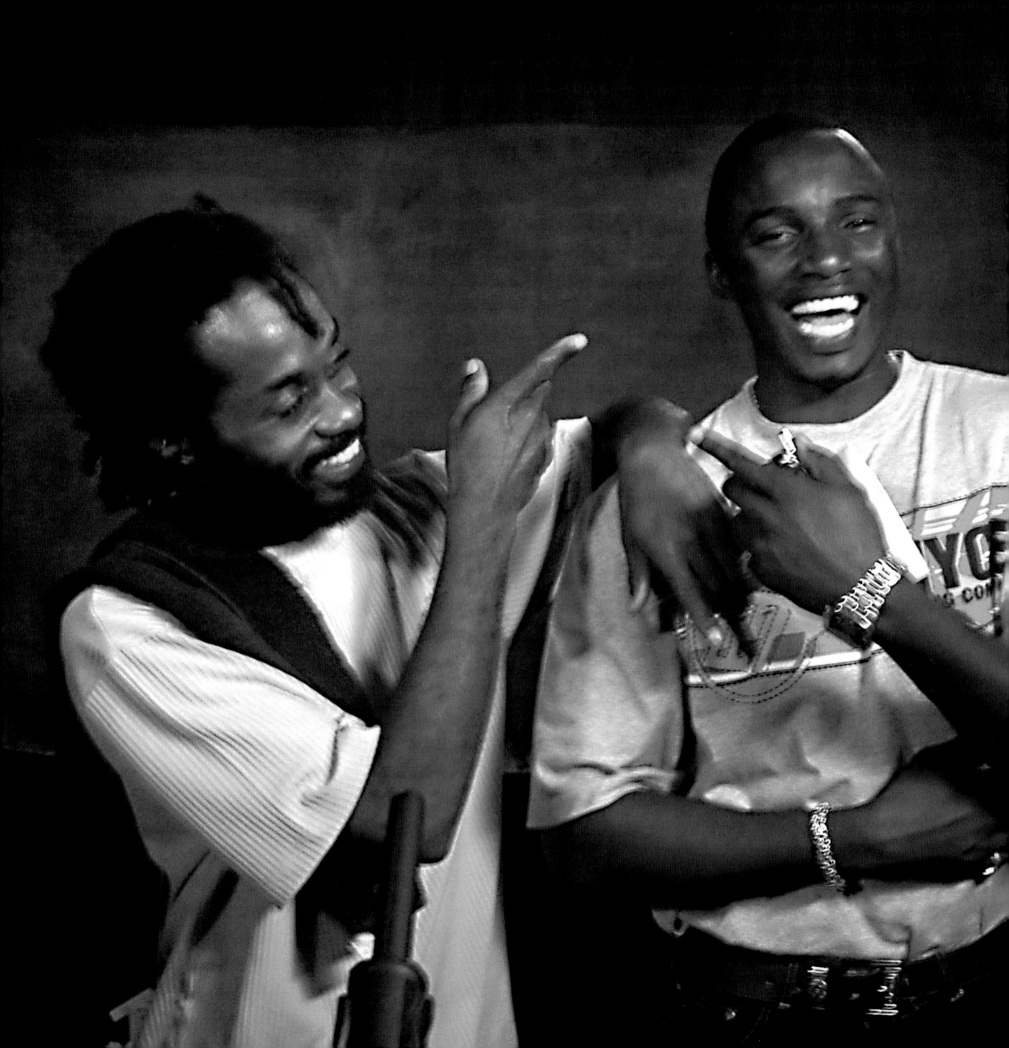

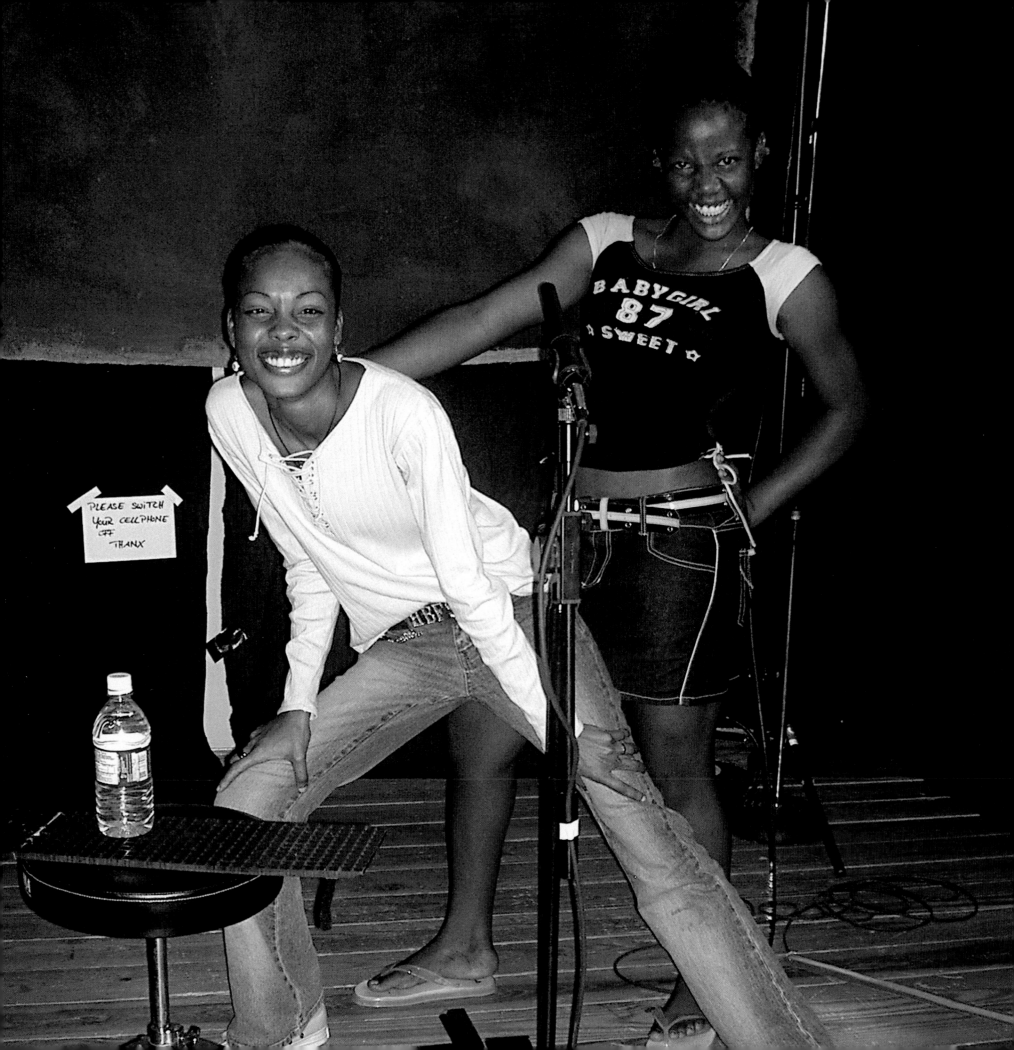

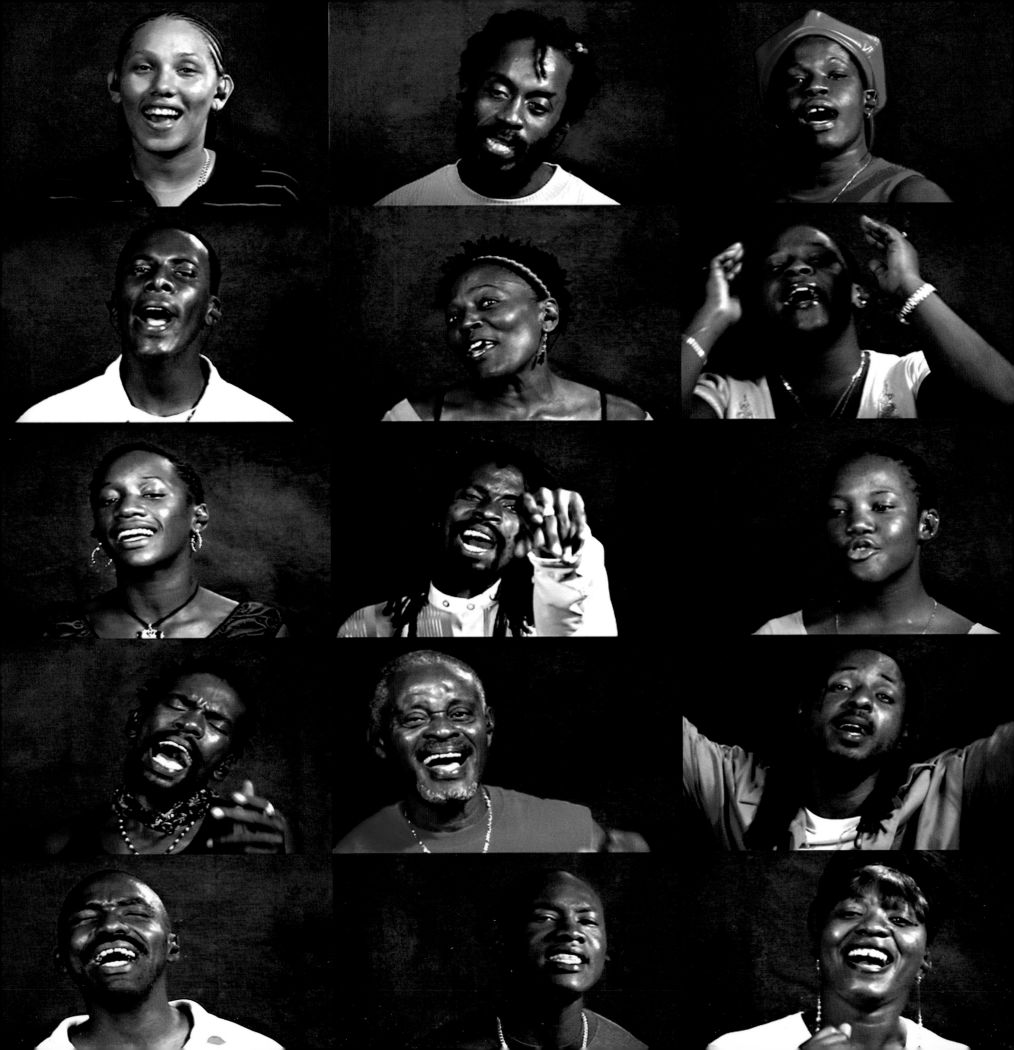

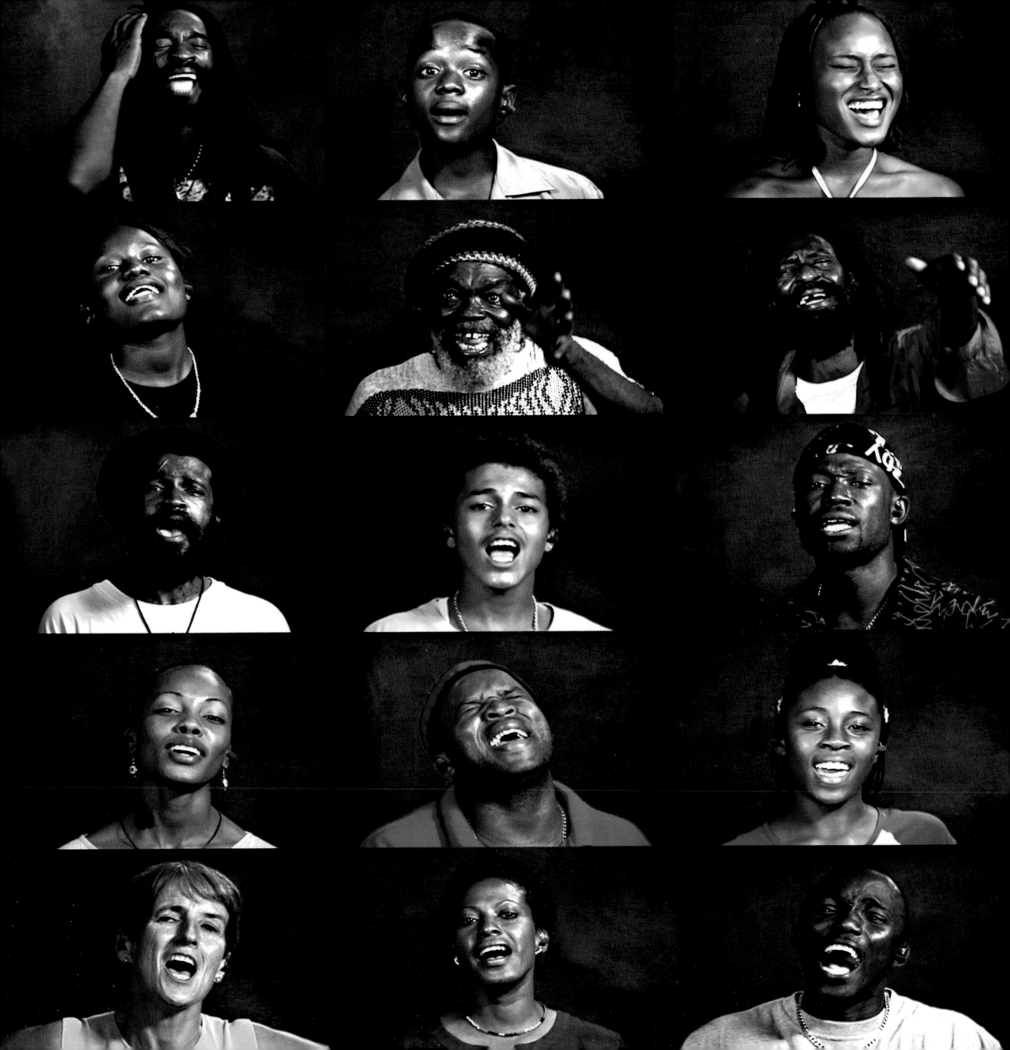

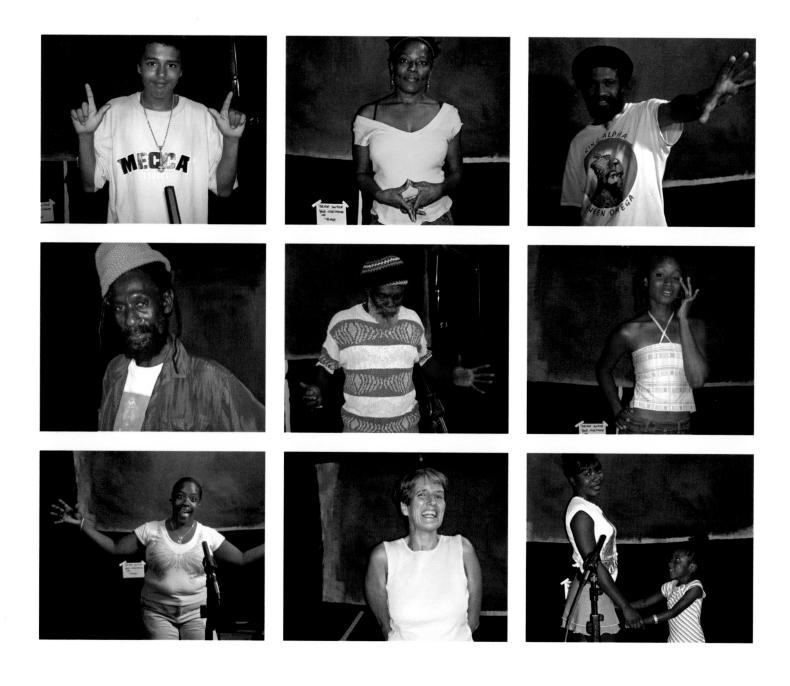

BOB MARLEY

Come see, come be... with Bob Marley.
NINE MILE
Where the legend was born!

INTERNATIONAL
BOB

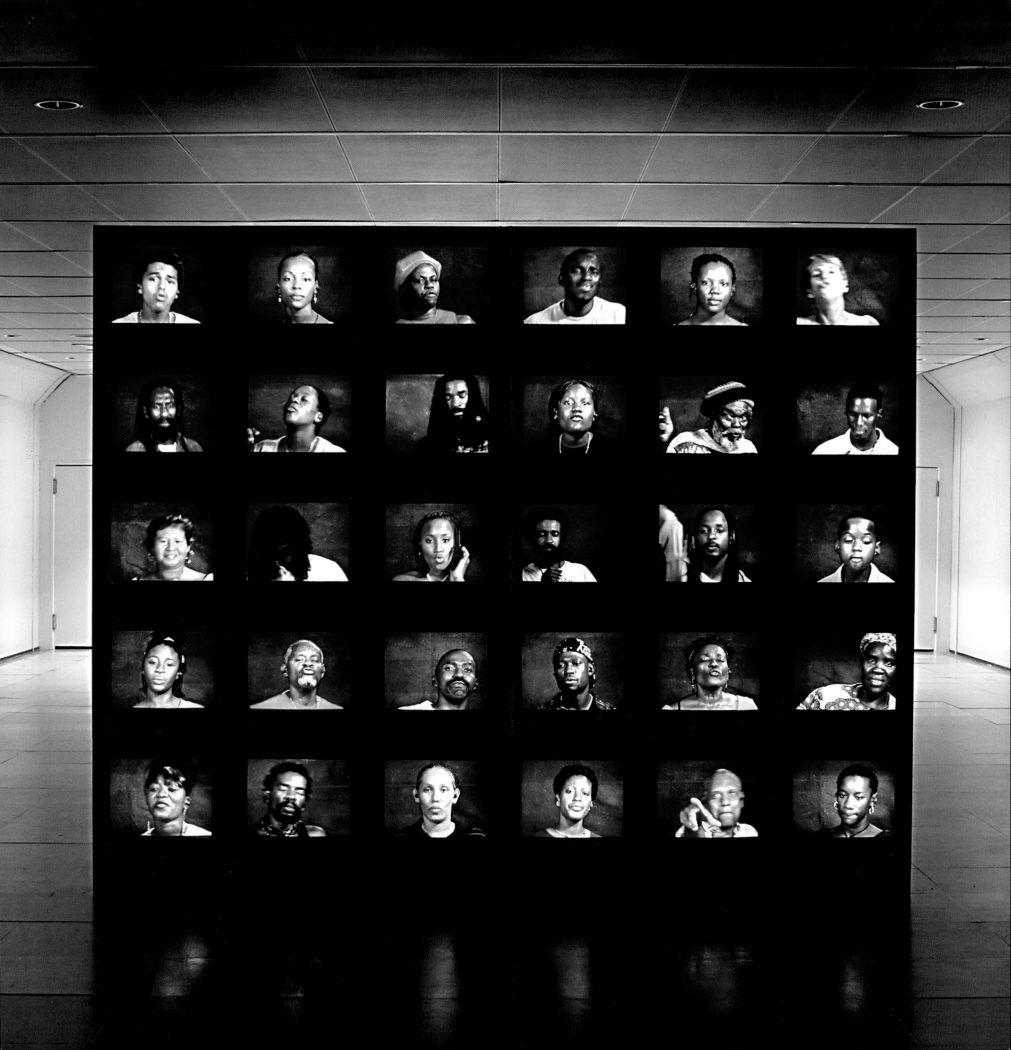

Continúa de la página 158

Aunque los retratos remiten a sus homólogos en la cultura de masas (como *American Idol* o *Pop Idol*), también se alejan bastante de sus primos de los *reality shows* televisivos: Breitz no promete ni fama ni fortuna a sus sujetos. Lo que les ofrece es una oportunidad para grabar las canciones que han formado parte de la banda sonora de sus vidas en la manera en que prefieren. Las composiciones no jerárquicas que utiliza para organizar la presentación final de los fans en cada retrato le permiten esquivar deliberadamente la cuestión de quién ha salido mejor o peor parado bajo las condiciones que ha creado para estos ensayos visuales casi antropológicos sobre la cultura de los fans. Si los que homenajean a sus iconos en los retratos son víctimas de una industria cultural coercitiva, o bien usuarios de una cultura que absorben y traducen creativamente según sus necesidades, lo decide el espectador. Si la dignidad de los fans retratados se mantiene sorprendentemente intacta, se debe a que más que inducirnos a reírnos de los fans que pone en fila, Breitz nos obliga a preguntarnos hasta qué punto se ha infiltrado la música *pop* en nuestras propias biografías.

Al titular las serie de obras como lo hace, Breitz nos pide que situemos estas instalaciones multicanal en el género del retrato y nos lleva a preguntarnos sobre su relación con este género tan humanista. Aunque el título de una pieza puede anunciar que se trata de un retrato de "Michael Jackson" o "Madonna", estos famosos siguen estando notoriamente ausentes en las instalaciones finales. Los retratos nos invitan a imaginarnos a un icono cultural carismático no como una figura monolítica y aislada sino más bien como una compleja amalgama de todos aquellos cuyas historias nos ha contado y cuyas vidas siguen siendo moduladas a través de su música. Aquí re-

tratar la fama consiste íntegramente en un conjunto de interpretaciones de una comunidad de fans. En palabras de Jessica Morgan, "La lectura que hace Breitz del 'retrato' sugiere, pues, que la representación del cantante es un reflejo de nuestra concepción o una proyección de ese personaje. Como si fuera un holograma, la tridimensionalidad que nos parece apreciar en la personalidad del famoso es resultado de su mediatización y, ante todo, nuestro propio acto de proyección o análisis. En las piezas de Breitz, el complejo efecto de la mirada (de aficionado a cantante, de cantante a cámara, de cámara a cantante y de nuevo a aficionado) parece haberse acelerado tanto que se ha perdido el control del volante, de modo que en la práctica el proceso de identificación ha borrado al famoso. Sus seguidores lo han fagocitado, y su interpretación del personaje público se convierte en el acto transformador que le permite existir. Se trata quizá del retrato más auténtico de un sujeto célebre que podría obtenerse: una amalgamación de nuestras distintas formas de identificación con la realidad prácticamente inexistente de una estrella de la canción." En primer lugar, pues, éstos son retratos que hablan de la imposibilidad de representar a las estrellas que nos prometen sus títulos.

El hecho de que éste no sea el único nivel en que estas obras ponen a prueba el género del retrato se hace evidente cuando nos fijamos en los propios intérpretes. Las imágenes de los fans, grabadas con planos que invitan a la intimidad, nos compensan generosamente por la ausencia del icono, presentando a un fan junto a otro de manera que comparar y contrastar a los intérpretes y sus interpretaciones se vuelve irresistible. Curiosamente, no es eso lo que equipara a los intérpretes (su autoidentificación como fans de un icono concreto), sino más bien son sus idiosincrasias – los caprichos y gestos que distinguen unos de otros – las que requieren una

observación más atenta. De manera enérgica y seductora, una fan de Michael Jackson baila la danza del vientre acompañando los temas del álbum *Thriller*, su lenguaje corporal en marcado contraste con el de otra joven mujer de más o menos la misma edad que contiene las lágrimas mientras actúa ante la cámara en un estado de casi parálisis. El retrato de Madonna nos presenta a un fan medio desnudo cantándole una balada lenta a su osito de peluche, mientras que un tímido travesti en otra parte de la composición aplica brillo de labios a unos labios que ya brillan. En el retrato de Bob Marley, un lozano colegial actúa al lado de un caballero maduro que sacude sus rastas hacia la cámara en un estado de éxtasis.

Continúa en la página 186

Continued from page 159

amnesia. Our relationship to pop is of course one of consumerism, but the question then, is whether we consume pop or allow ourselves to be consumed by pop. Pop has two characteristics that keep me (and quite a few others) coming back for more. The first is that, whether one likes it or not, pop music becomes the soundtrack to one's past. Pop songs lurk in our present like so many perverse little madeleines. Of course this is a generational claim that only makes sense beginning with the second half of the twentieth century, but nevertheless, when we think of our lives in historical terms, then we think not only of where our grandparents are from or what neighborhood we grew up in, but also of the first album that we bought, the first concert we attended, the first song that inspired us to play air-guitar. We define ourselves by the music that we listen to, by the songs that we first heard at key moments in our past lives. Pop seems to offer opportunities for self-invention - this is what makes it so seductive. The problem with pop, of course, is that the kinds of selves that it encourages us to invent are usually passive and predetermined, which means that rather than truly being offered a moment of self-invention, we are invited to shape our selves in moulds which have already been poured."

Though the portraits evoke their mainstream entertainment counterparts (such as *American Idol* or *Pop Idol*), they also take significant distance from their reality television cousins: Breitz promises her subjects neither fame nor fortune. What she offers them is an opportunity to record the songs that have come to soundtrack their lives in whatever way they choose. The non-hierarchical grids that she uses to organize the final presentation of the fans in each portrait, allow Breitz to deliberately sidestep the question of who has fared better or worse under the conditions that she has created for these quasi-anthropological visual essays on the culture of the fan. Whether the fans who pay tribute to their icons in her portraits are victims of a coercive culture industry or users of a culture that they creatively absorb and translate according to their needs, is left to the viewer to decide. If the dignity of the portrayed fans remains surprisingly intact, it is because rather than prompting us to laugh at the fans that she lines up, Breitz forces us to reflect on the extent to which pop music has infiltrated our own biographies.

Titling the series of works as she does, Breitz asks that we locate these multi-channel installations within the genre of portraiture, and prompts the question of how they in fact relate to this most humanist of genres. Though the title of a work may announce that it is a portrait of "Michael Jackson" or "Madonna," these celebrities remain conspicuously absent in the final installations. The portraits invite us to imagine a charismatic cultural icon not as a monolithic and isolated figure, but rather as a complex composite of those whose stories s/he has told and those whose lives continue to be inflected through his/her music. The portrayal of celebrity consists here entirely of the accumulative interpretations of a community of fans. Jessica Morgan has written that, "Breitz's interpretation of a 'portrait' thus suggests that the star's representation is a reflection of our own understanding or projection of that character. Like a hologram, the three-dimensionality that we think we see in the celebrity persona is a result of mass mediation, and above all of our own act of projection or construal. The complex effect of the gaze (from fan to star, from star to camera, from camera to star and back to fan) seems to have hurtled out of control in Breitz's portraits such that the star has in fact been erased

Continued on page 187

King (A Portrait of Michael Jackson)

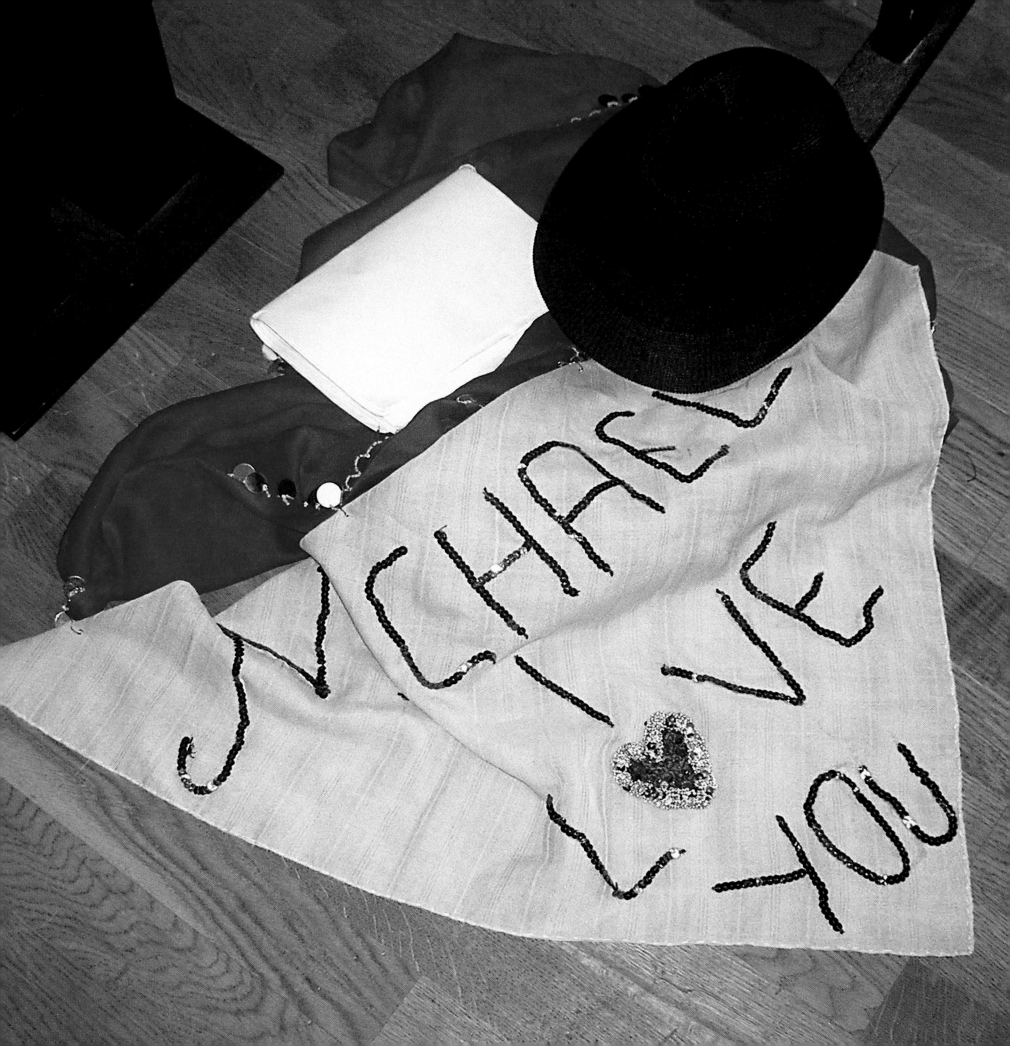

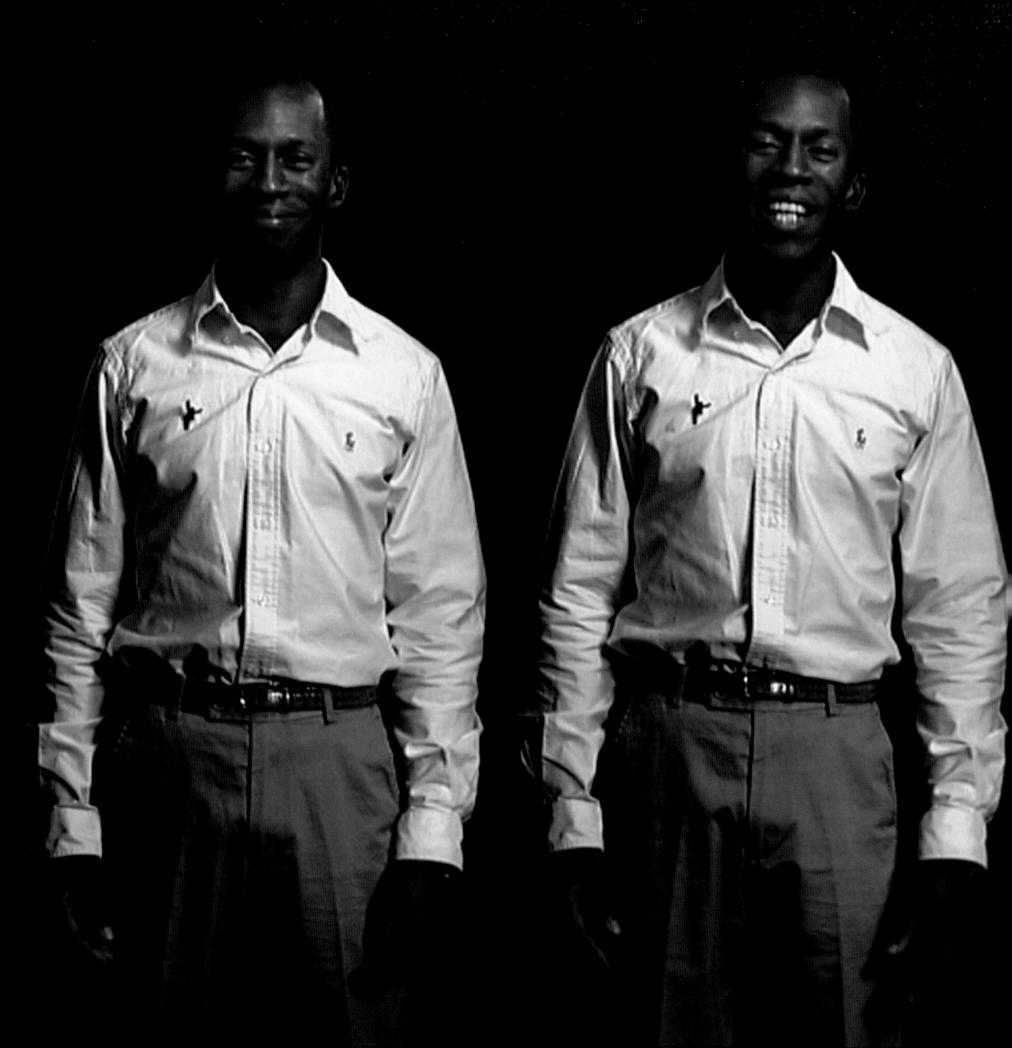

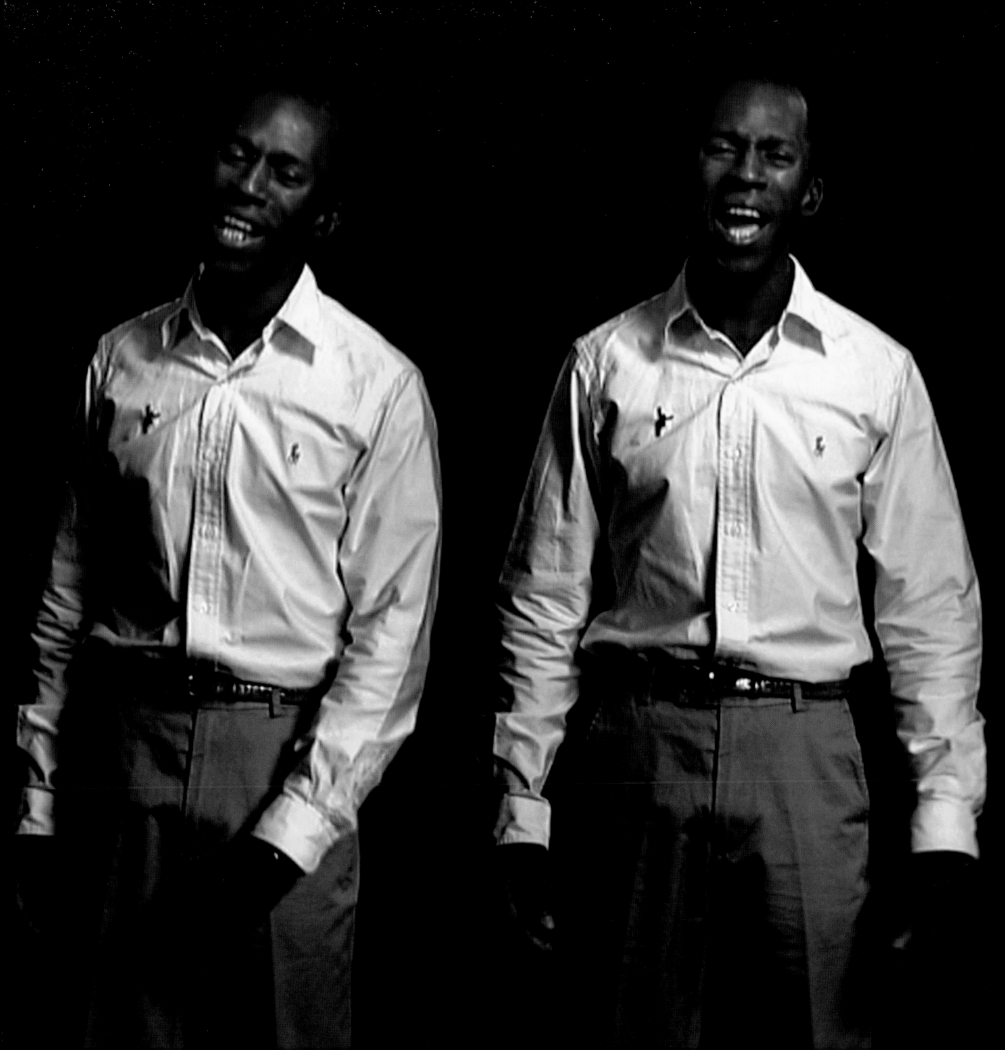

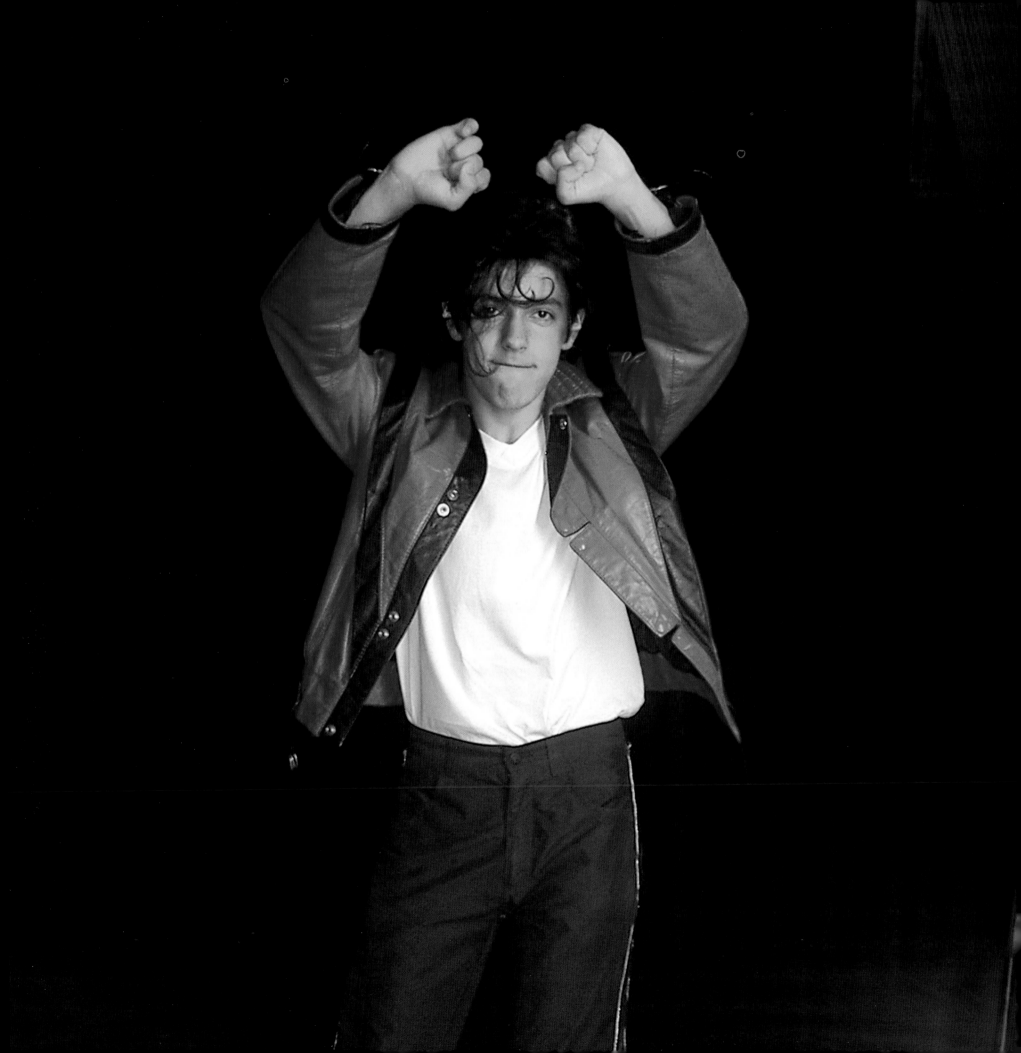

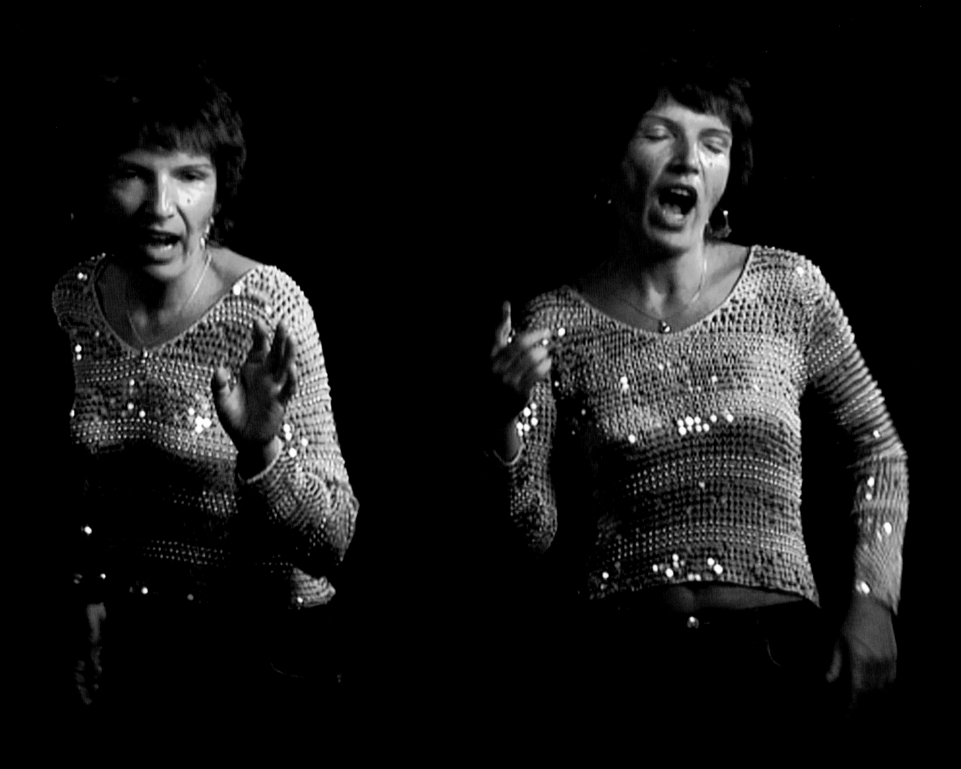

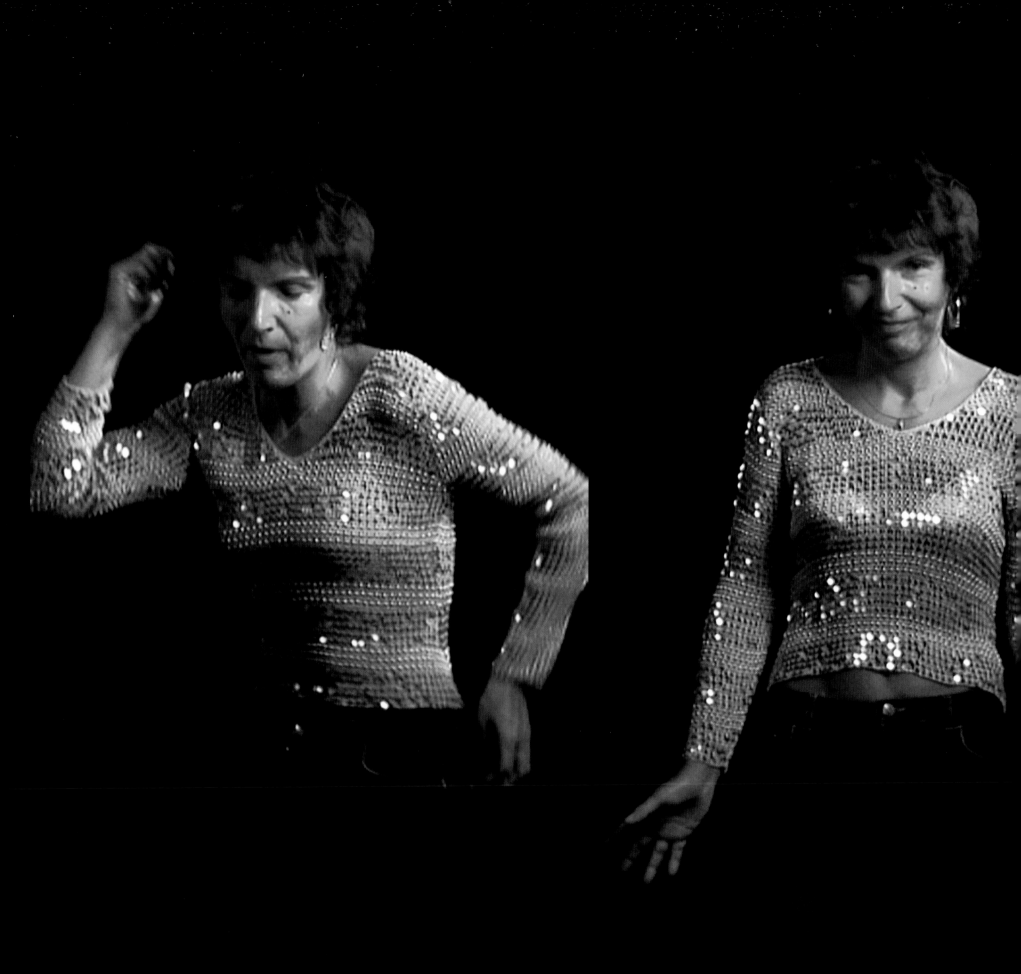

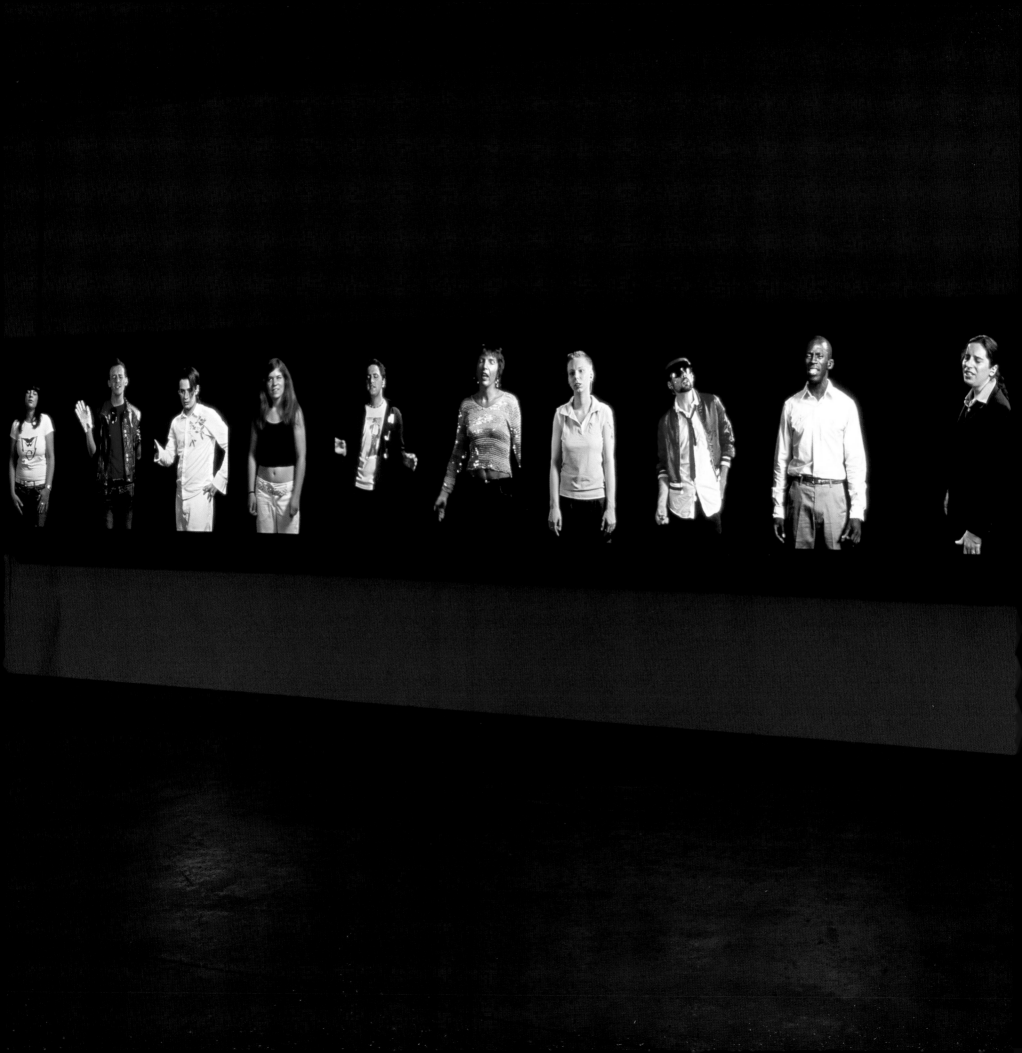

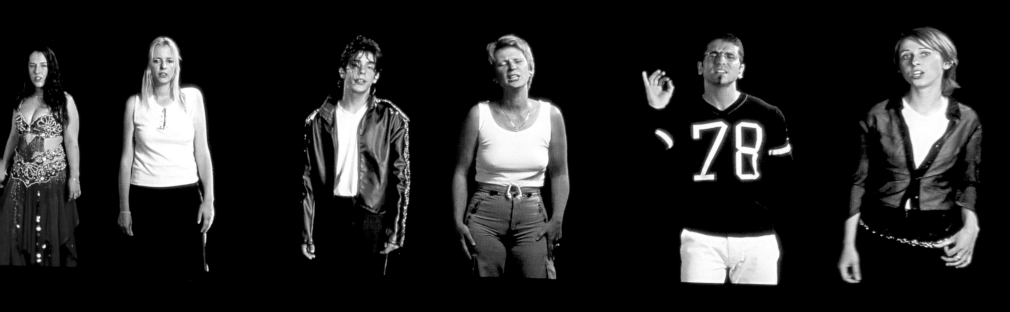

Continúa de la página 170

Puesto que la duración de cada obra equivale a la duración total del álbum original, hay tiempo de sobra para estudiar a los fans individuales. Pero en cambio, a medida en que las personalidades de los fans afloran para prometernos algo cercano al retrato, somos plenamente conscientes del hecho de que ellos son plenamente conscientes de estar siendo observados. Los fans actúan para la cámara, y ésa es la posición que ocupamos nosotros como espectadores. ¿Hasta qué punto su presencia "real" es afectada o distorsionada por la mirada implacable de la cámara, una mirada que redoblamos al enfrentarnos a los retratos? Aquí, de nuevo, Breitz parece cuestionar la capacidad del retrato de transmitir la verdad del sujeto. La tecnología invasiva utilizada para grabar la presencia de los fans los vuelve tan esquivos como los efímeros famosos que emulan. Pero en cambio hay una presencia innegable: la de la cámara. Es imposible evaluar hasta qué punto la cámara, al mediar entre nosotros y los personajes, inhibe nuestro acceso a los fans; igual de imposible es librarnos de la creciente sospecha de que los fans seguramente se comportarían de modo muy diferente si la cámara saliese de la habitación.

Al identificarse como fans del álbum en cuestión, los participantes han confirmado su lealtad a los himnos del *pop* que reinterpretan en una primera fase del proyecto. Las palabras que nos cantan, sin embargo, son dictadas literalmente por la letra del álbum, y por tanto distan mucho de constituir expresiones individuales fluidas. El formato deja poco margen para la interpretación creativa. ¿O sólo lo parece? Esta pregunta se la plantea obsesivamente Breitz aquí y en otras obras, en sus continuos regresos al universo pautado de *Karaoke,* pero también en las piezas realizadas con material encontrado en que quirúrgicamente separa la voz del sujeto parlante,

como queriendo cuestionar la integridad de la relación entre lenguaje y ser. Si bien es verdad que los fans en los retratos de Breitz están destinados a representarse a sí mismos mediante palabras que no son suyas, ¿no es éste el dilema que caracteriza al sujeto parlante en general? Entramos en el lenguaje. Nos precede. Debemos operar dentro de él, adoptar su vocabulario y dominar su sintaxis (como mínimo si tenemos el deseo de comunicarnos con aquellos que han entrado en el lenguaje junto a nosotros). En este sentido, nuestras palabras nunca son realmente nuestras. Las actuaciones dictadas que encontramos en los retratos de Breitz aluden a esta condición: a la imposibilidad de inventarse el lenguaje de nuevo y a la consiguiente necesidad de comunicarse en el marco de determinadas convenciones. Pero también apuntan a la exacerbación de esta condición en un mundo en que la subjetividad es constante y agresivamente acribillada por los productos de la cultura de masas. En los retratos y en otras piezas relacionadas con ellos, Breitz parece menos interesada en dar un toque de atención a la industria de la cultura de masas por atribuirnos palabras que no son nuestras, que en culpabilizarla de la reducción y depreciación del lenguaje, lo que en otro sitio ha denominado "el encogimiento del lenguaje".

Los retratos de Breitz fracasan como retratos en el sentido clásico al reconocer la imposibilidad de exponer la esencia de los iconos que los inspiró, en la misma medida en que admiten su incapacidad para proporcionarnos una comprensión más íntima de los fans que aparecen en ellos. Raimar Stange ha comparado los retratos con el prolongado retrato social *Menschen des 20. Jahrhunderts* [Hombres del siglo veinte] de August Sander, sugiriendo que el enfoque casi científico de Sander a la hora de documentar a la gente en su entorno más inmediato encuentra eco en el intento de Breitz de cartografiar la cultura del fan: "En el lugar de los sujetos de

Sander, definidos por sus ocupaciones, los fans de Breitz son definidos por aquello que consumen, tal y como expresa su idiosincrásica recepción y traducción de la música que aman.

Continúa en la página 204

Continued from page 171

through the process of identification. The celebrity is literally embodied by the fans, and their understanding of the persona of the star is the transformative act that enables the star to exist. Perhaps this is the most authentic portrayal of a celebrity possible: an amalgamation of our various forms of identification with the virtually non-existent reality of the star." In the first instance then, these are portraits that speak of the very impossibility of representing the stars who are promised to us in their titles.

That this is not the only level at which these works test the genre of portraiture, becomes apparent as we turn to the performers themselves. The intimately framed footage of the fans offers generous compensation for the absence of the icon, presenting fan alongside fan alongside fan such that comparing and contrasting the performers and their performances is irresistible. Interestingly, it is not that which renders the performers alike (their self-identification as fans of a particular icon), but rather their idiosyncrasies – the quirks and gestures that distinguish them from one another – that begs closer observation. A Michael Jackson fan energetically and seductively belly dances her way through the *Thriller* album, her body language in stark contrast to that of another young woman of a similar age, who fights back tears as she performs before the camera in a state of near-paralysis. The portrait of Madonna introduces us to a half-naked fan singing a slow ballad to his teddy bear, as a self-conscious transvestite elsewhere on the grid applies endless layers of lip-gloss to already glossy lips. In the portrait of Bob Marley, a fresh-faced schoolboy performs in close proximity to a weathered older gentleman who flicks his dreadlocks forward at the camera in trance-like rapture. Since the duration of each work matches the full duration

of the original album, there is ample time to study the individual fans. And yet as the personalities of the fans slowly emerge, promising something close to portraiture, we are acutely aware of the fact that they are acutely aware of the fact, that they are being watched. It is for the camera that the fans perform, and it is the position of the camera that we occupy as we watch their performances. To what extent is their "real" presence affected or distorted by the relentless gaze of the camera, a gaze that we re-double as we stand before the portraits? Here again, Breitz seems to question the ability of the portrait to deliver the truth of the subject. The invasive technology used to record the presence of the fans renders them as elusive as the fugitive celebrities to whom their performances pay tribute. And yet there is one presence here that is undeniable: that of the camera. It is impossible to assess the extent to which the camera, in mediating the personalities before us, inhibits our access to the fans; and equally impossible to shake the growing suspicion that the fans might well behave very differently if the camera were to leave the room.

In identifying themselves as fans of the given album, the participants have confirmed their allegiance to the pop anthems that they re-perform at an early stage of the project. The words that they sing to us are nevertheless quite literally dictated by the lyrics of an album, and thus far removed from the free-flowing words of individual expression. The format seems to leave little room for creative interpretation. Or does it? This question is asked obsessively by Breitz here and in other works, in her constant returns to the scripted world of Karaoke, but also in the found footage works in which she surgically peels speech away from the speaking subject, as if to question the integrity of the relationship between

Continued on page 205

Queen (A Portrait of Madonna)

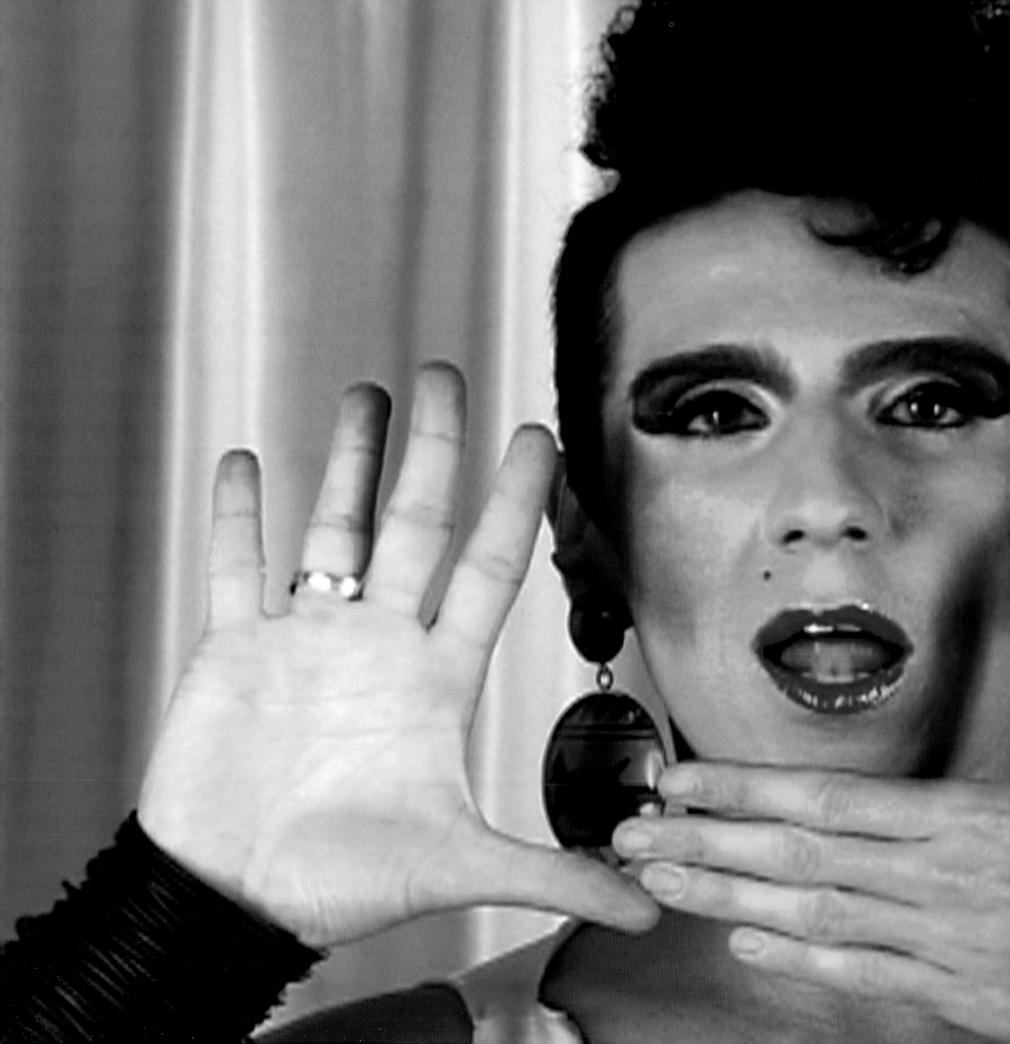

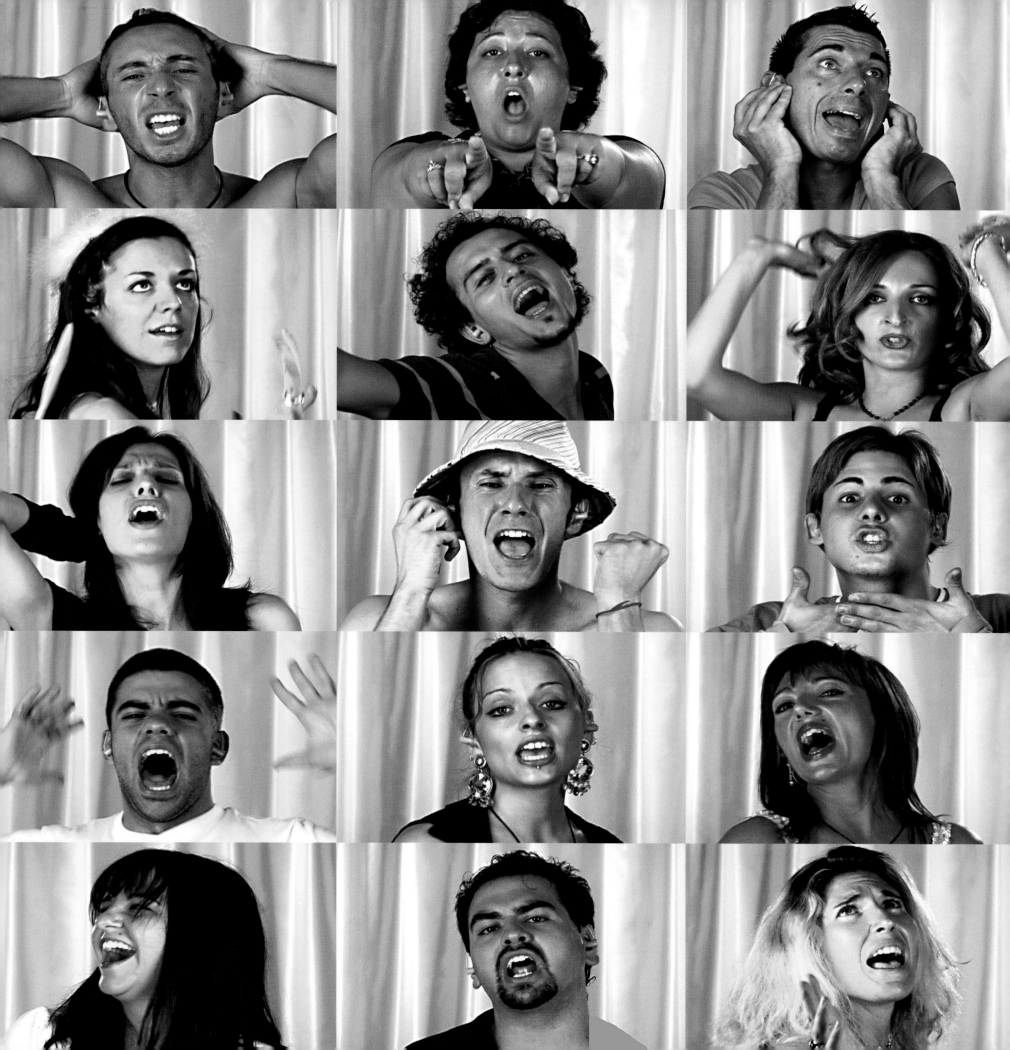

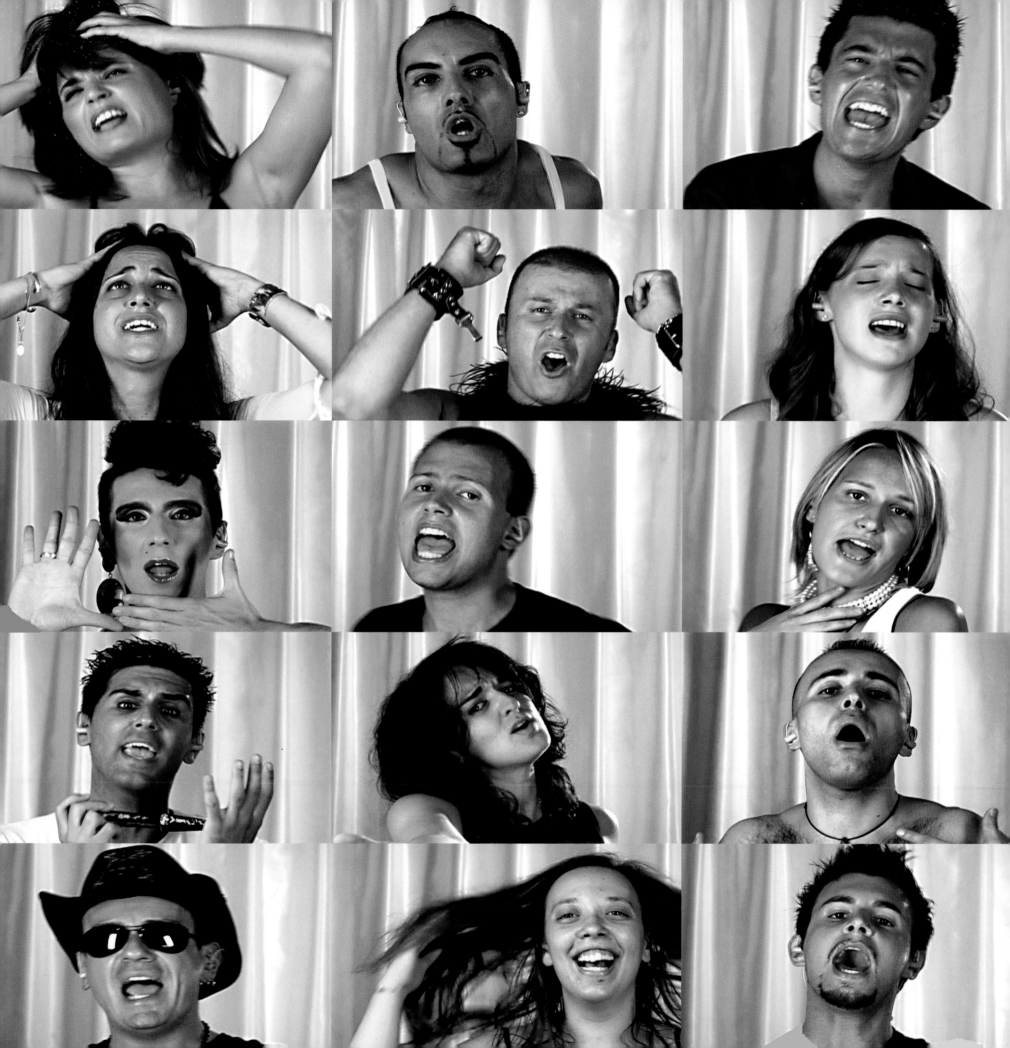

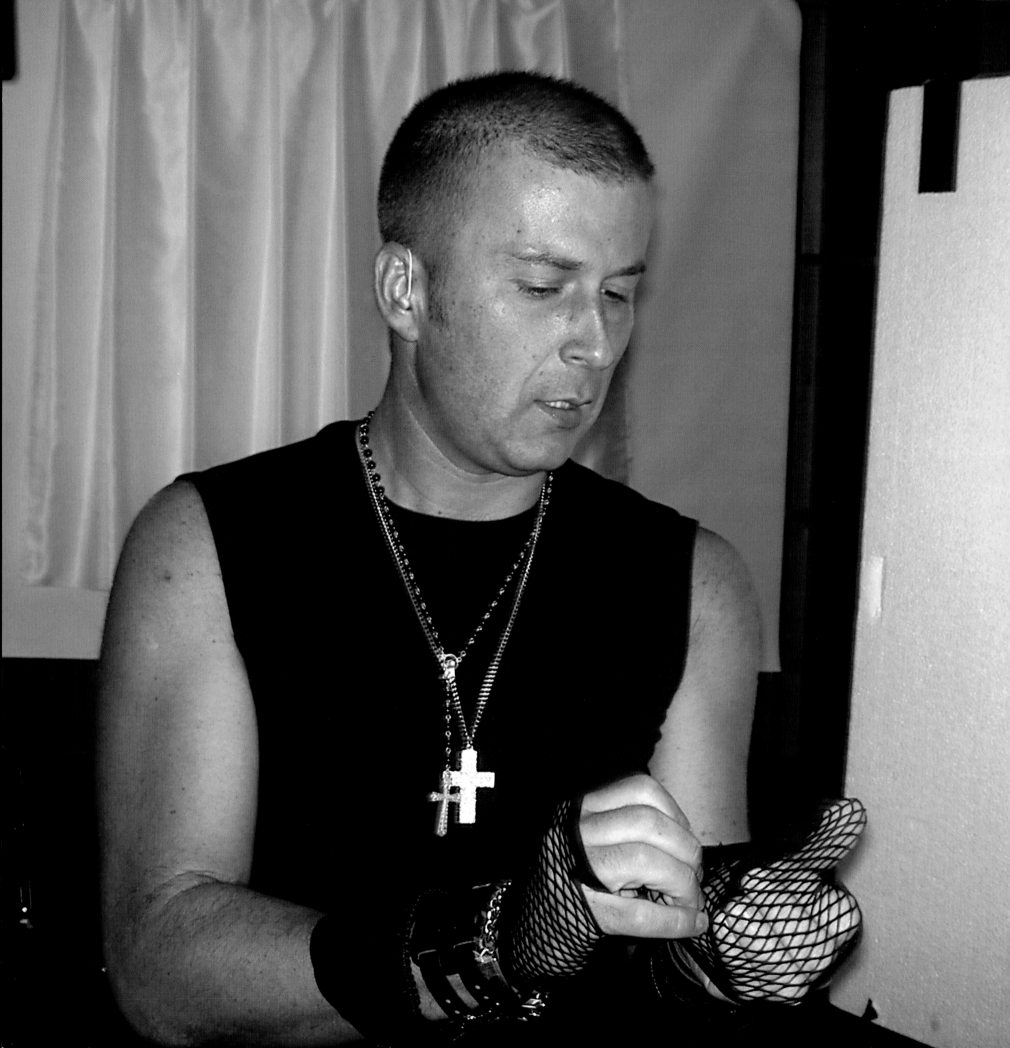

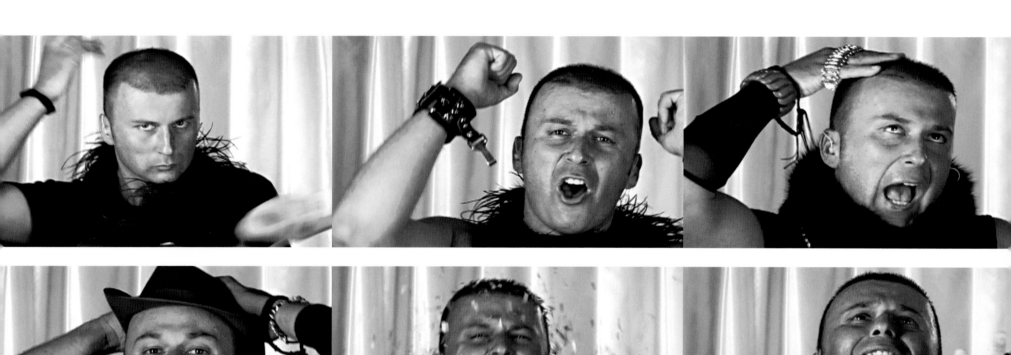

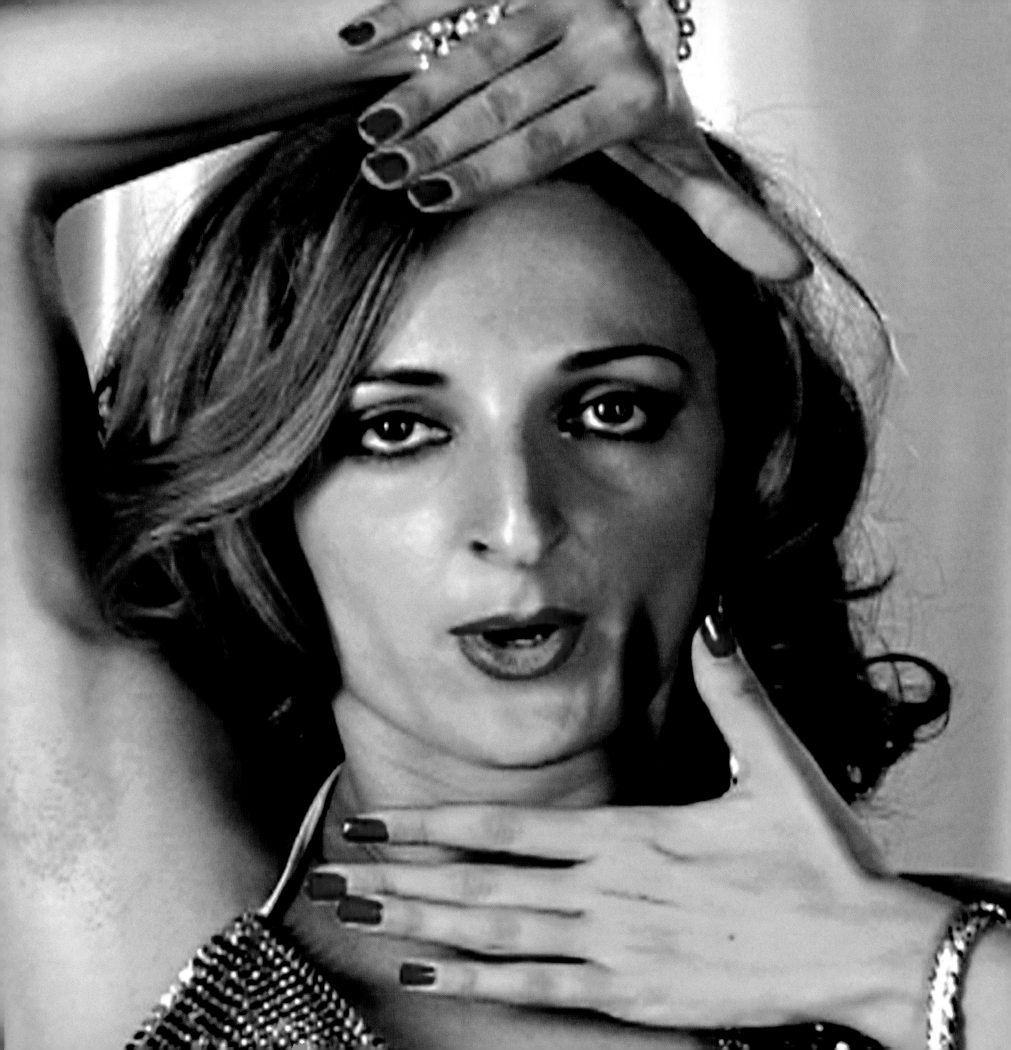

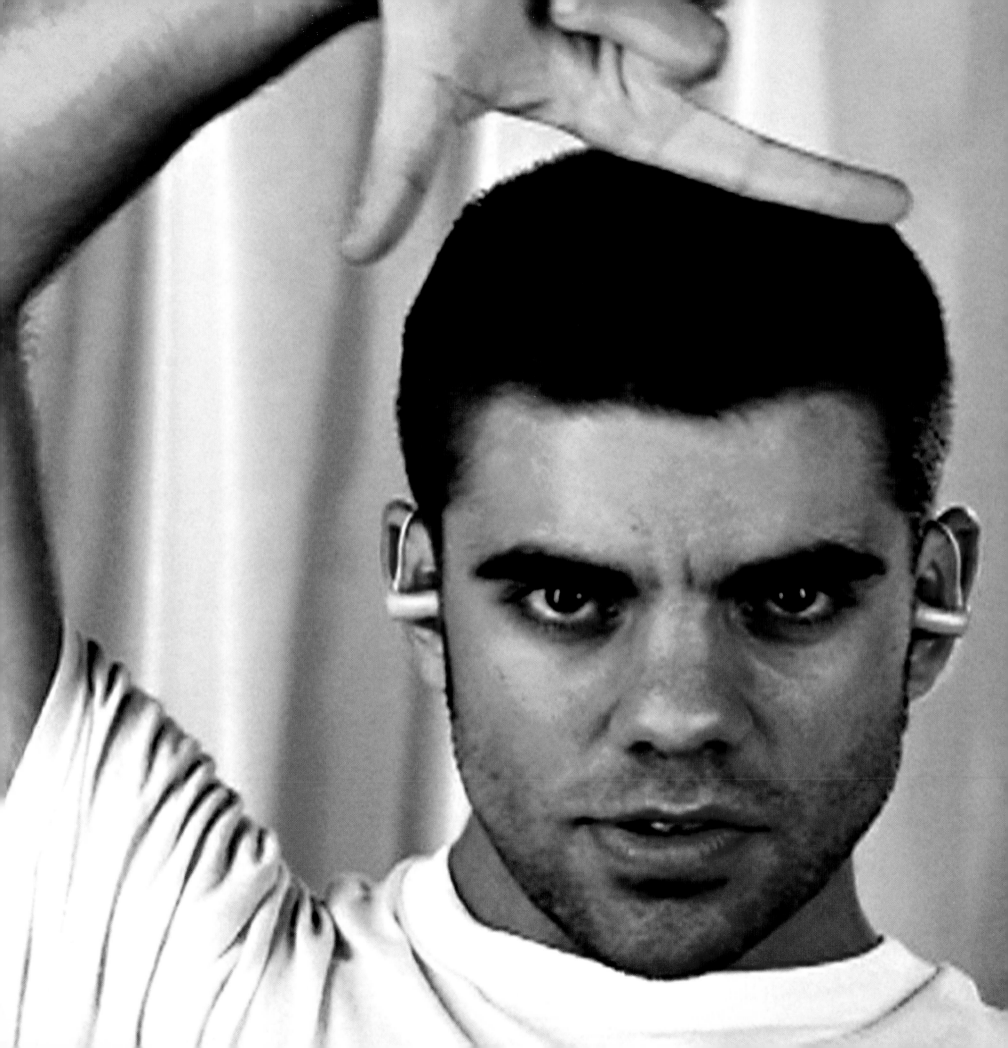

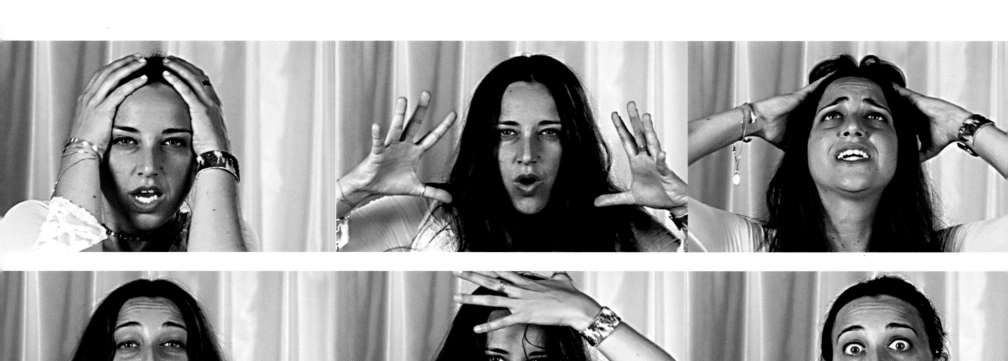

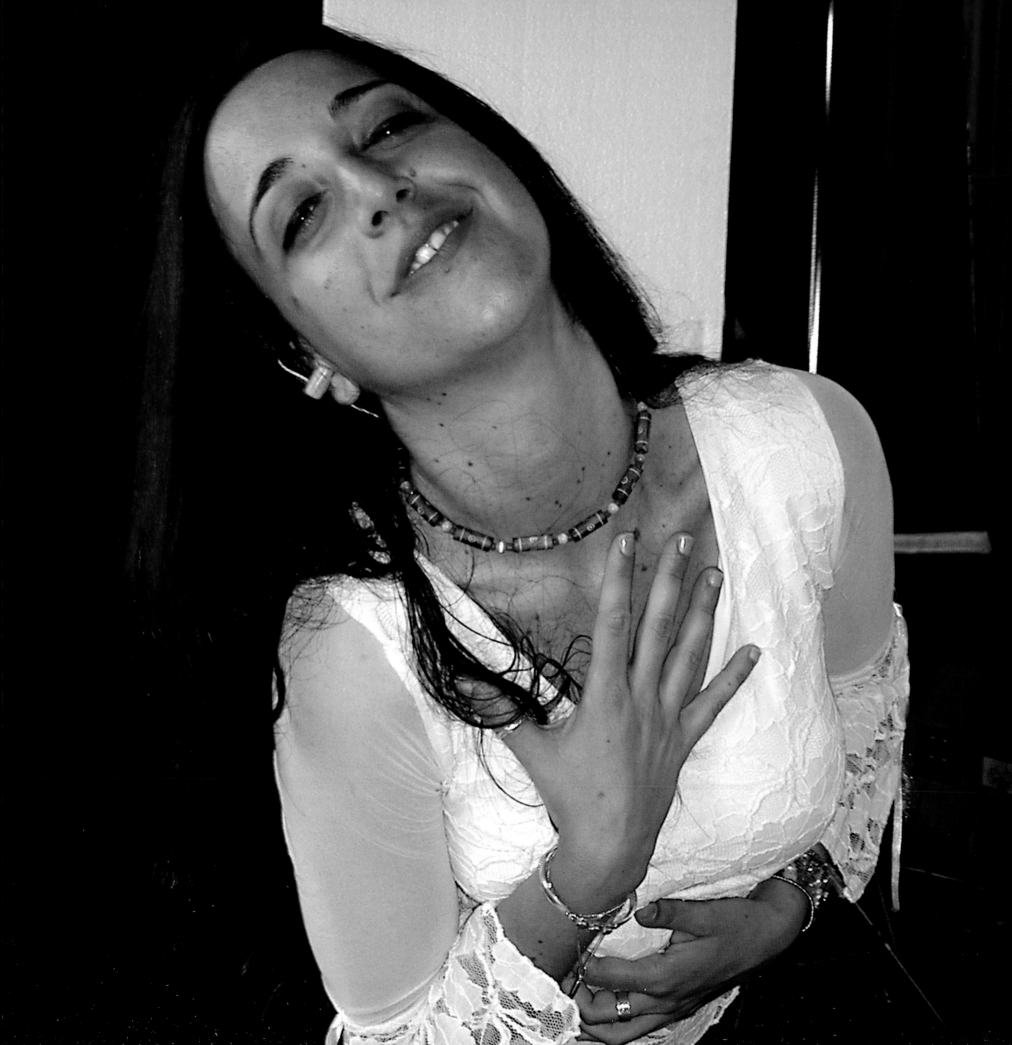

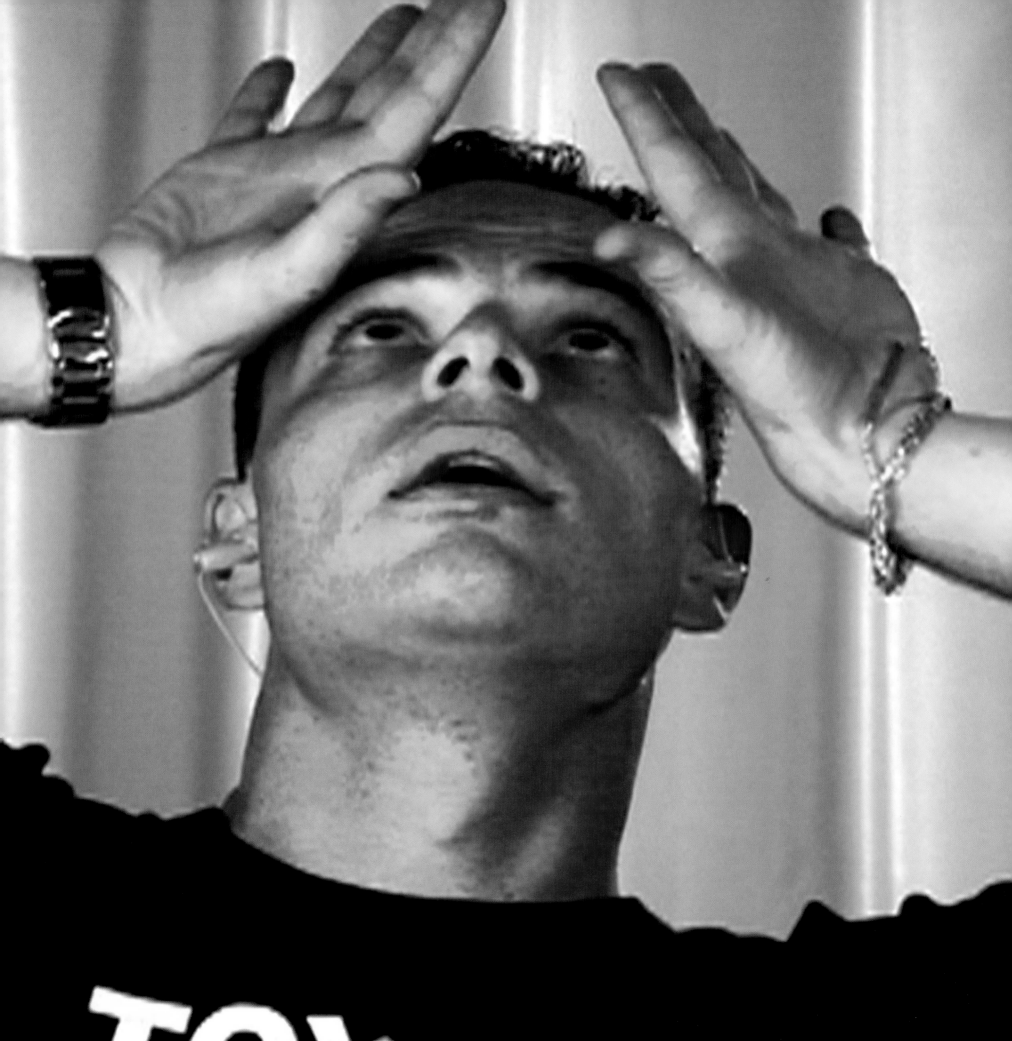

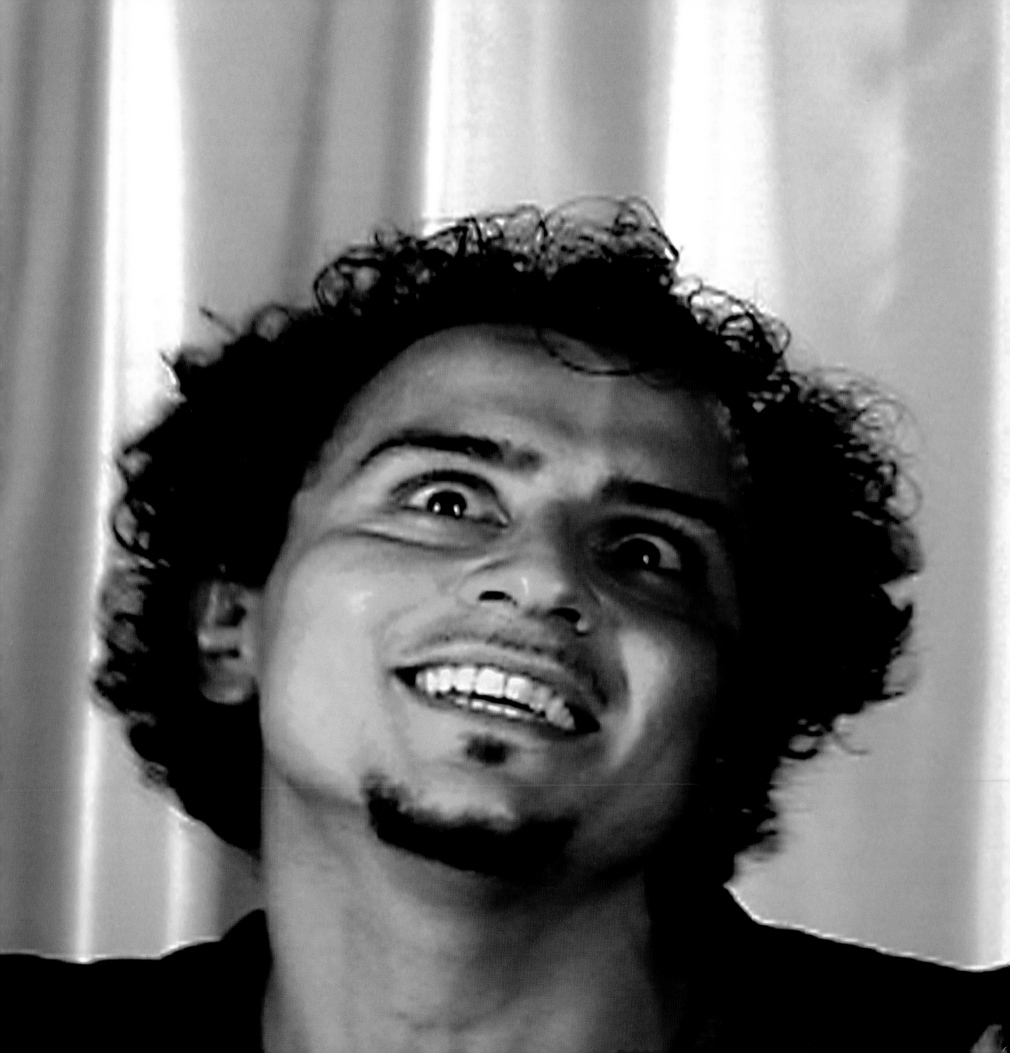

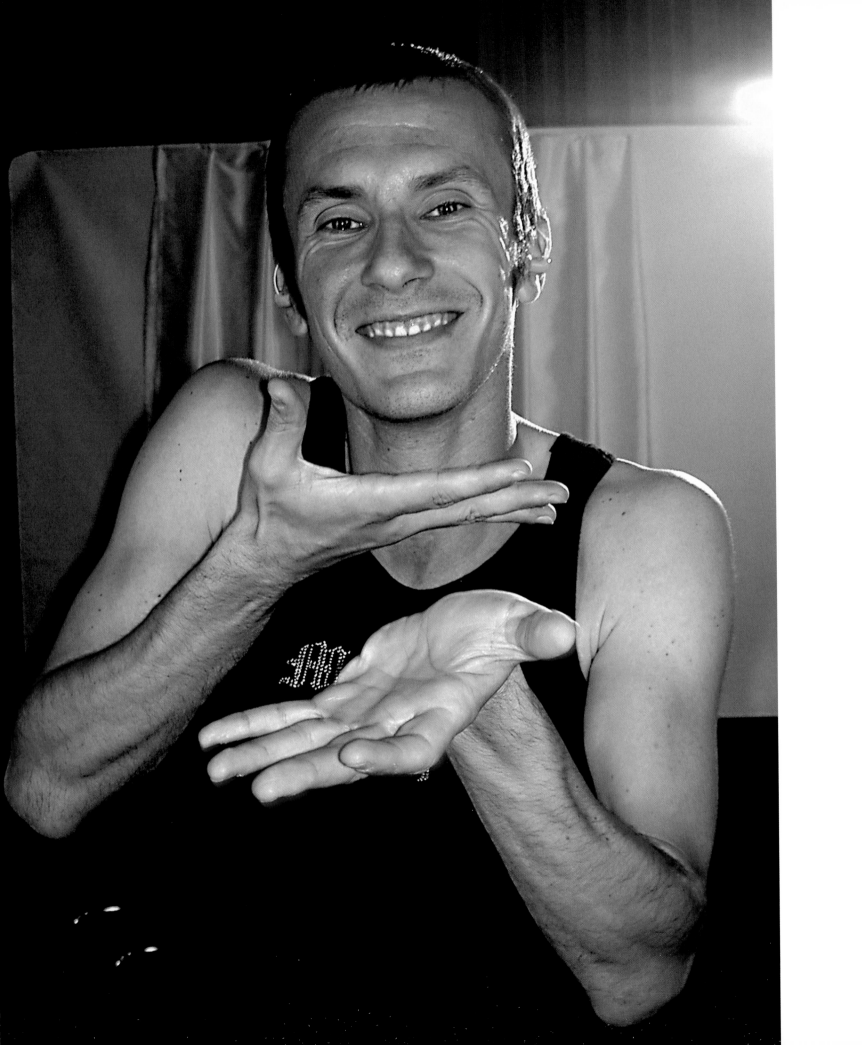

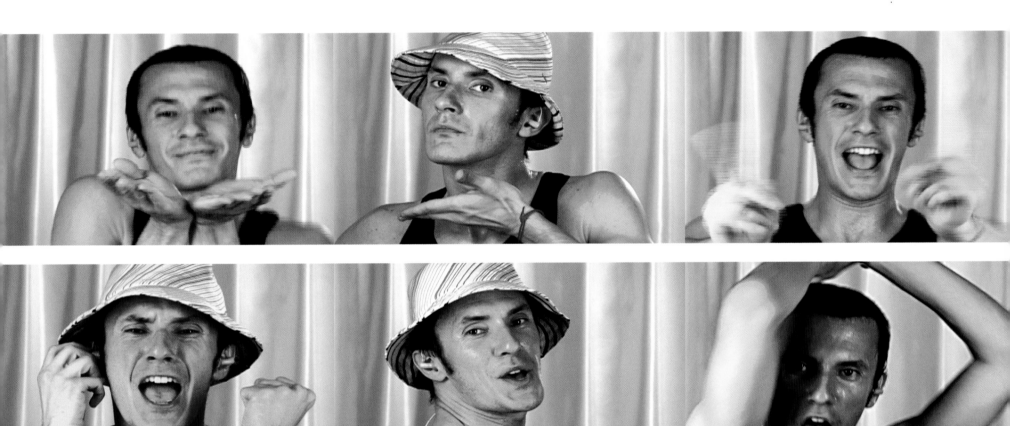

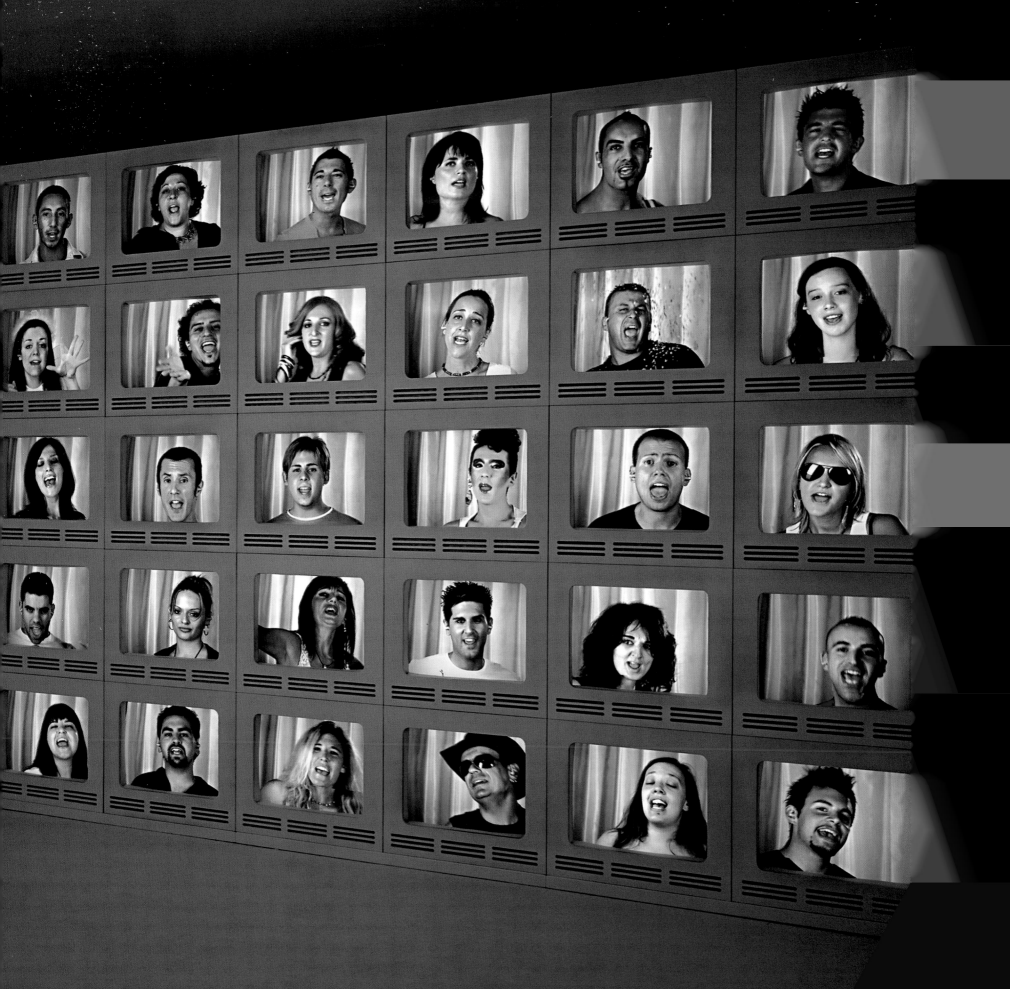

Continúa de la página 186

Este cambio – de los ciudadanos trabajadores de Sander a los fans de Breitz – señala un cambio histórico más amplio, del culto de la producción que caracterizó a la modernidad al eclipse posmoderno de la producción por la cultura del consumo." En última instancia, lo que estos retratos "retratan" de manera más precisa, parece apuntar Stange, es el número cada vez más limitado de posiciones subjetivas a nuestra disposición en el marco de una cultura que se acerca a la casi total mercantilización.

Legend (A Portrait of Bob Marley) se rodó en los estudios Gee Jam de Port Antonio, Jamaica, en marzo de 2005. Treinta fans re-interpretan el álbum póstumo de Marley, *Legend* (1984). La duración del disco y de la obra resultante es de 62 minutos, 40 segundos.

King (A Portrait of Michael Jackson) se rodó en los estudios UFO de Berlín en julio de 2005. Dieciseis fans re-interpretan *Thriller* (1982). La duración del álbum y de la obra resultante es de 42 minutos, 20 segundos.

Queen (A Portrait of Madonna) se rodó en los estudios Jungle Sound de Milán en julio de 2005. Treinta fans re-interpretan el álbum de recopilación de éxitos *The Immaculate Collection* (1990). La duración del álbum y de la obra resultante es de 73 minutos, 30 segundos.

Working Class Hero (A Portrait of John Lennon) se rodó en el Culture Lab de la Universidad de Newcastle, Reino Unido, en agosto de 2006. Veinticinco fans re-interpretan el primer álbum en solitario de Lennon, *John Lennon/Plastic Ono Band* (1970). La duración del álbum y de la obra resultante es de 39 minutos, 55 segundos.

Continued from page 187

language and being. It is true that the fans in Breitz's portraits are relegated to representing themselves in words that are not their own, but is this not the dilemma that haunts the speaking subject in general? We enter language. It precedes us. We must operate within it, adopt its vocabulary and master its syntax (at least if we have any desire to communicate with those who have entered language alongside us). In this sense, our words are never truly our own. The highly dictated performances in Breitz's portraits allude to this condition: to the impossibility of inventing language anew, and to the consequent necessity of communicating within certain conventions. But they also point to the exacerbation of this condition in a world in which subjectivity is constantly and aggressively pelted with the products of mass entertainment. In the portraits and other related works, Breitz seems less interested in taking the mainstream entertainment industry to task for putting words in our mouths, than in holding it culpable for the reduction and depreciation of language, what she has elsewhere called "the shrinkage of language."

Breitz's portraits fail as portraiture in the classical sense, in that they acknowledge the impossibility of laying bare the essence of the icons that inspired them, as much as they admit their inability to deliver us a more intimate understanding of the fans who appear in them. Raimar Stange has compared the portraits to August Sander's life-long social portrait *Citizens of the Twentieth Century,* suggesting that Sander's quasi-scientific approach to documenting the people in his immediate surroundings is echoed in Breitz's endeavor to map the culture of the fan: "In the place of Sander's subjects, who are defined by their occupations, Breitz's fans are defined by

that which they consume, as expressed in their idiosyncratic reception and translation of the music that they love. This shift – from Sander's working citizens to Breitz's fans – marks a broader historical shift, from the cult of production that characterized modernity to the postmodern eclipse of production by the culture of consumption." What these portraits finally "portray" most accurately, Stange seems to suggest, is the dwindling range of subject positions that remain available to us within a culture approaching near-total commodification.

Legend (A Portrait of Bob Marley) was shot at Gee Jam Studios in Port Antonio, Jamaica, in March 2005. Thirty fans re-perform Marley's posthumous album *Legend* (1984). The duration of the album and of the resulting work is 62 minutes, 40 seconds.

King (A Portrait of Michael Jackson) was shot at UFO Sound Studios in Berlin in July 2005. Sixteen fans re-perform *Thriller* (1982). The duration of the album and of the resulting work is 42 minutes, 20 seconds.

Queen (A Portrait of Madonna) was shot at Jungle Sound Studio in Milan in July 2005. Thirty fans re-perform the hit compilation album *The Immaculate Collection* (1990). The duration of the album and of the resulting work is 73 minutes, 30 seconds.

Working Class Hero (A Portrait of John Lennon) was shot at the Culture Lab at Newcastle University in the United Kingdom in August 2006. Twenty-five fans re-perform Lennon's first solo album *John Lennon/Plastic Ono Band* (1970). The duration of the album and of the resulting work is 39 minutes, 55 seconds.

Working Class Hero (A Portrait of John Lennon)

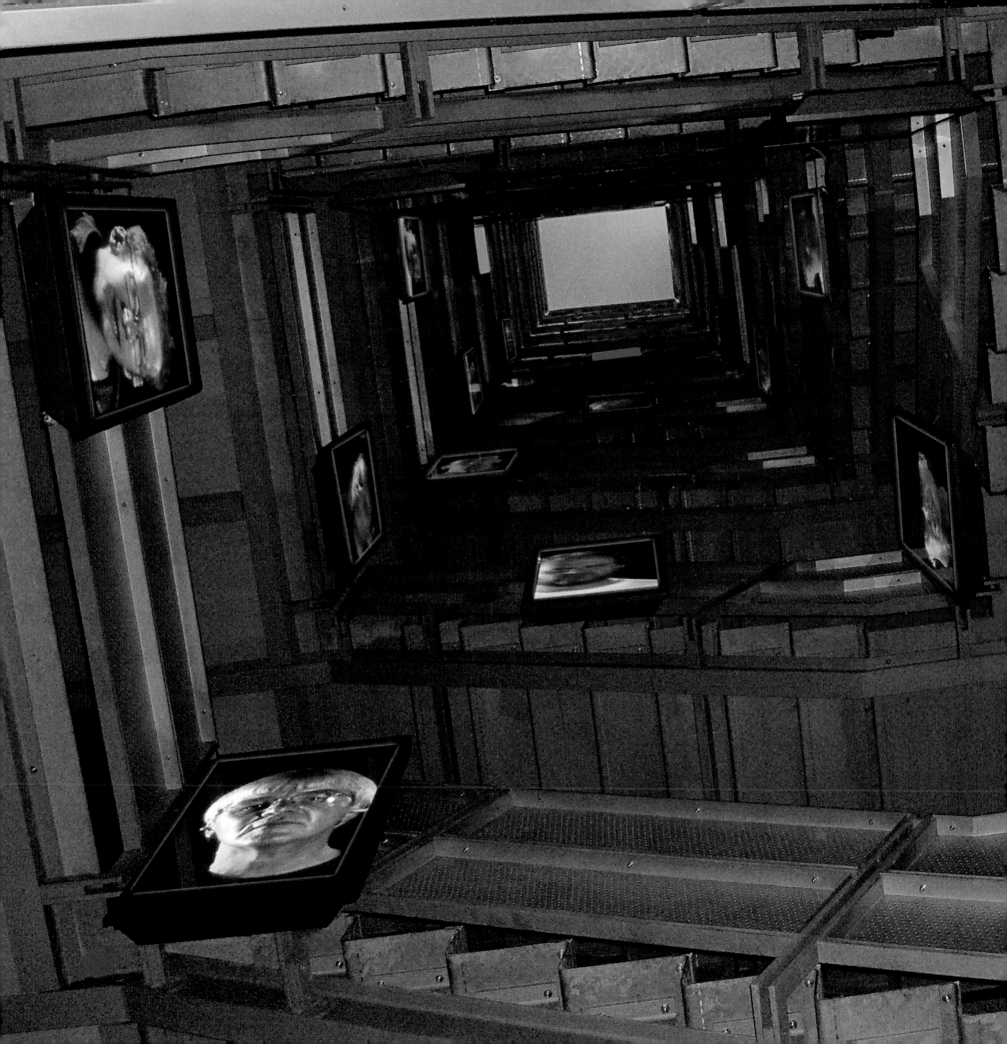

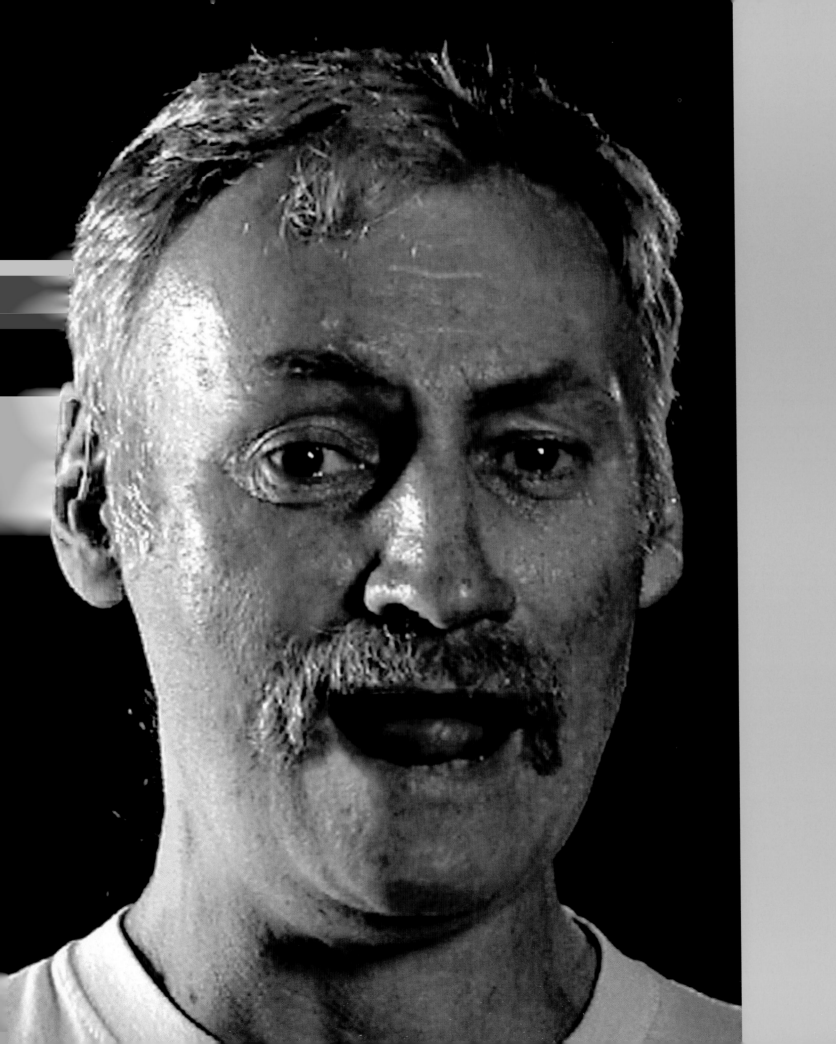

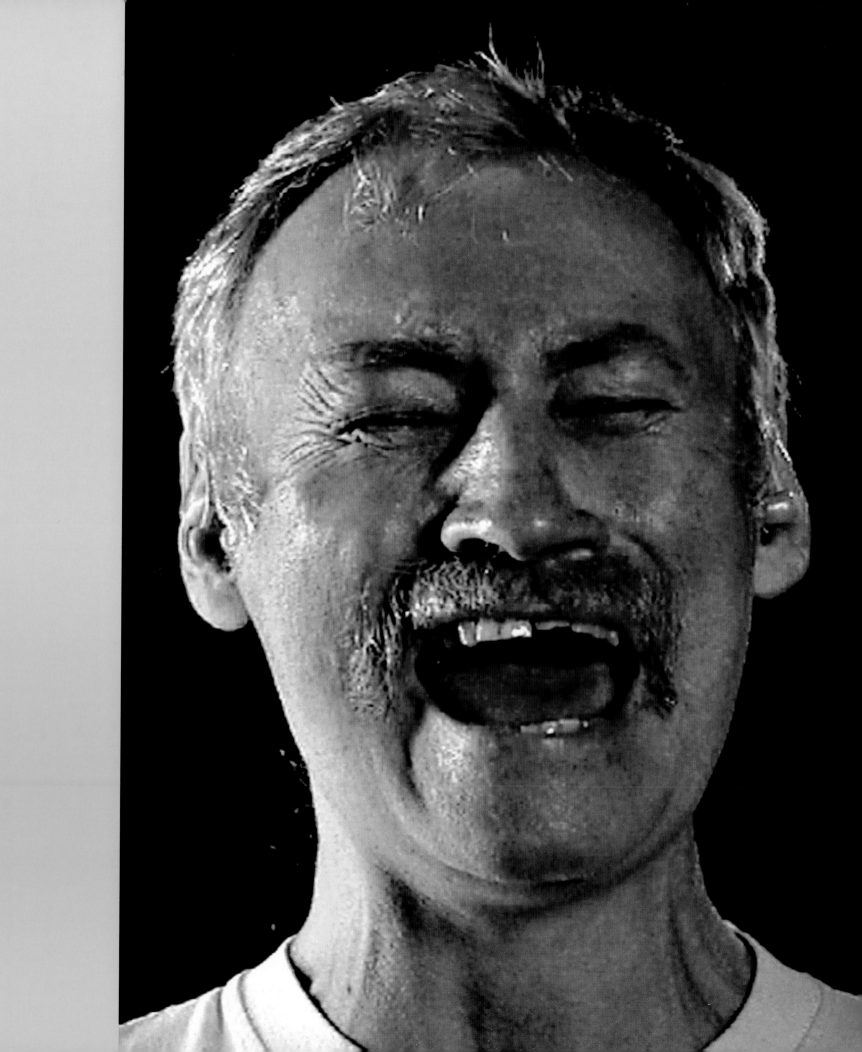

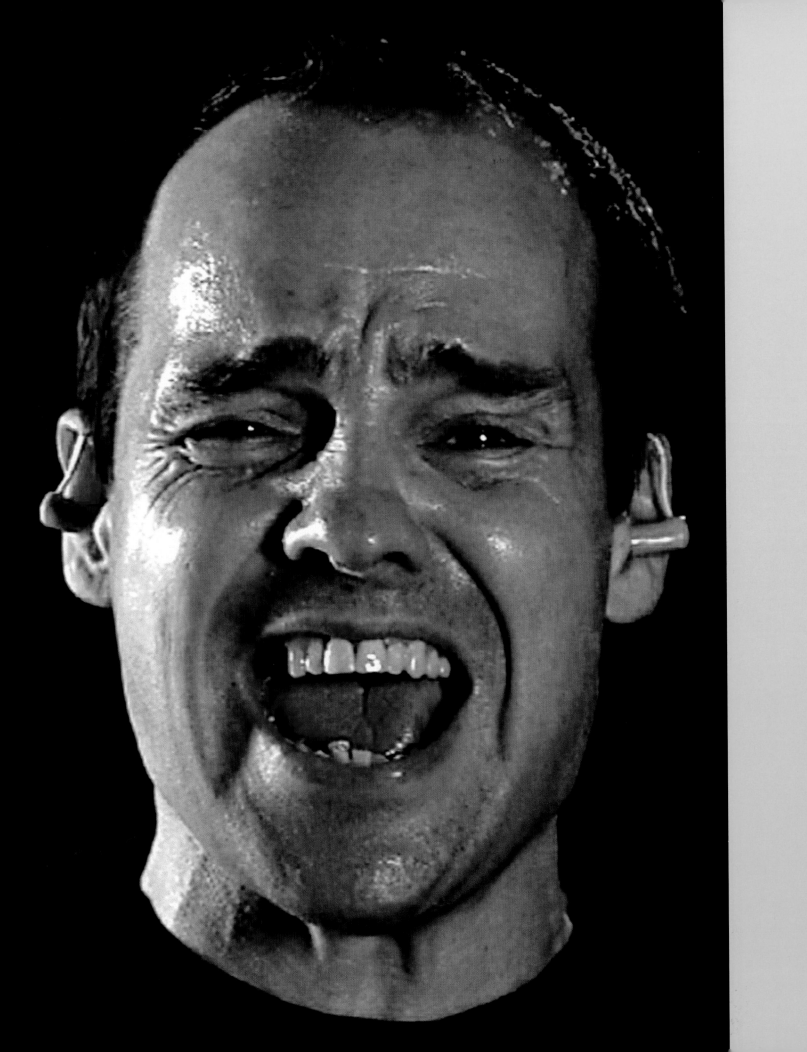

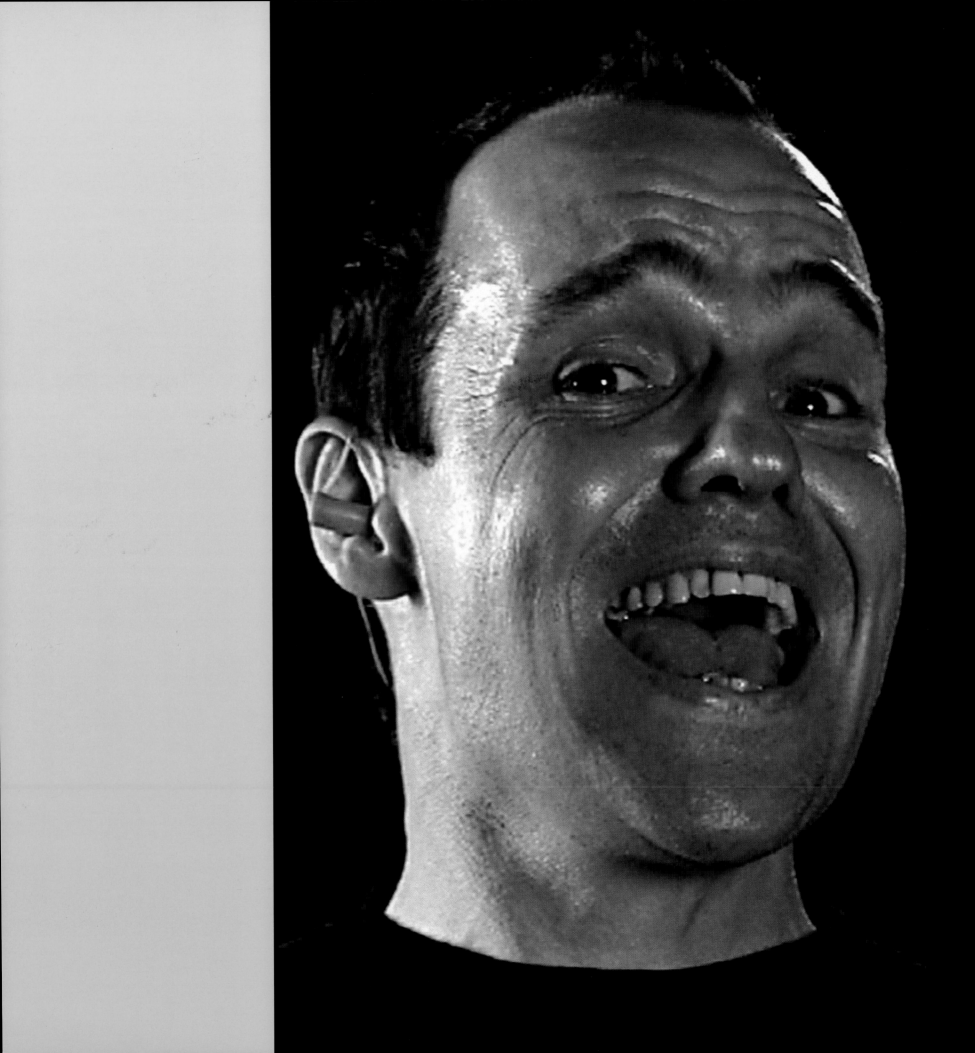

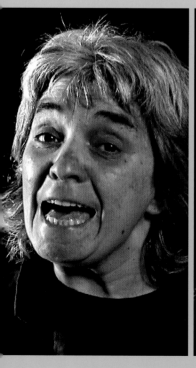
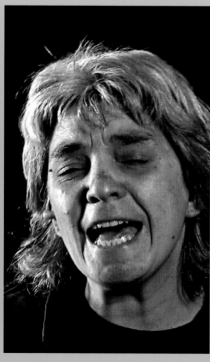
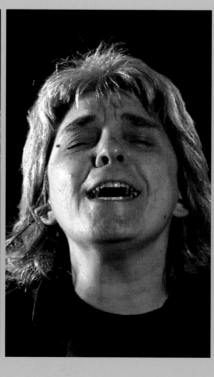
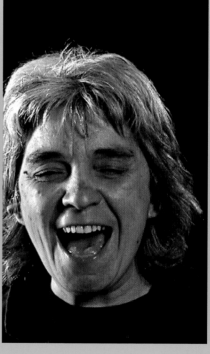
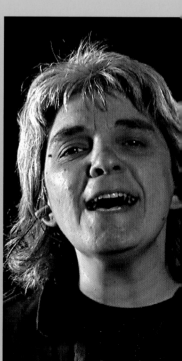
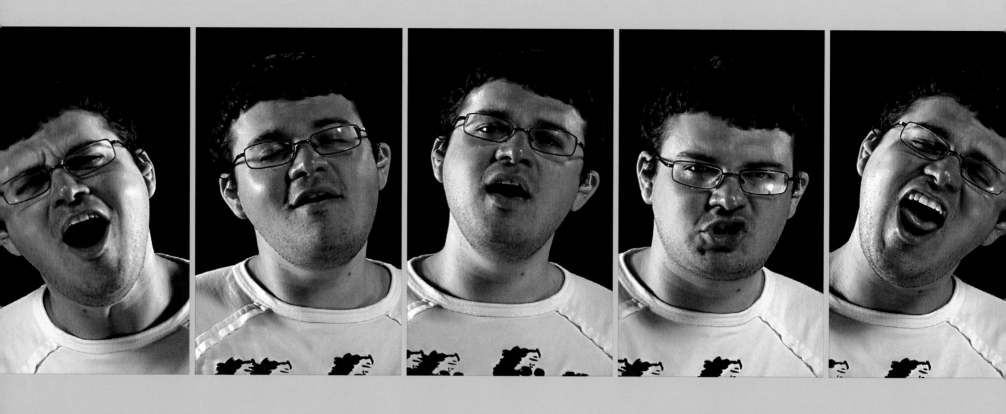

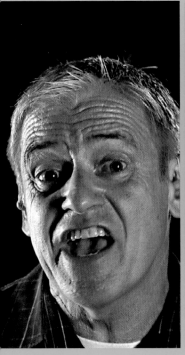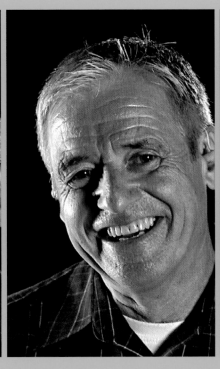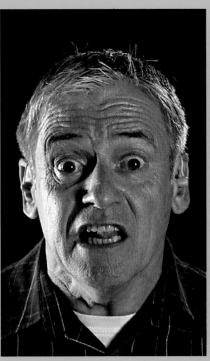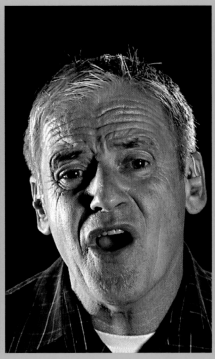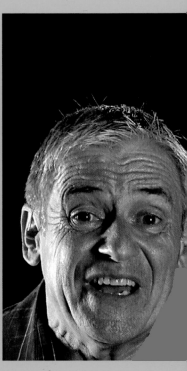
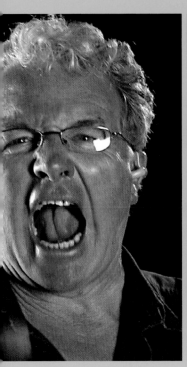

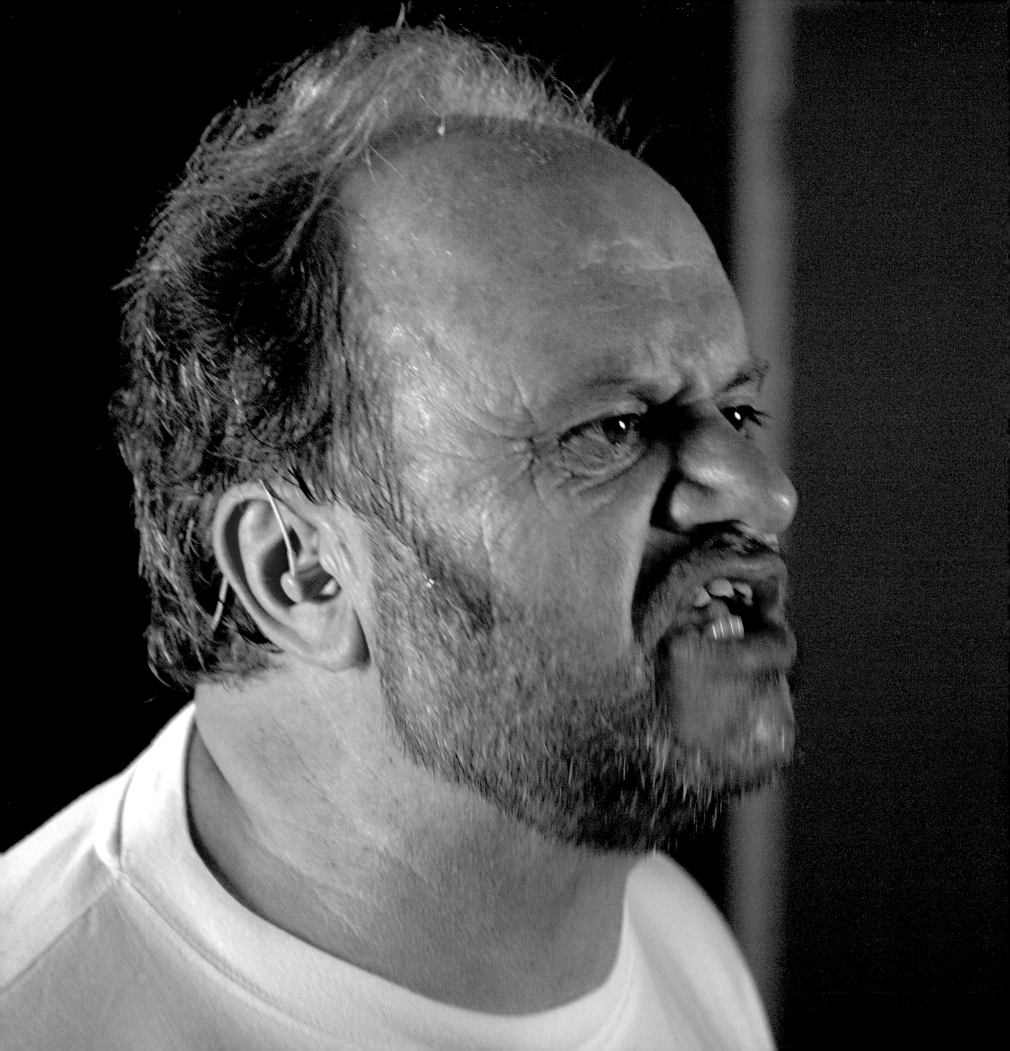

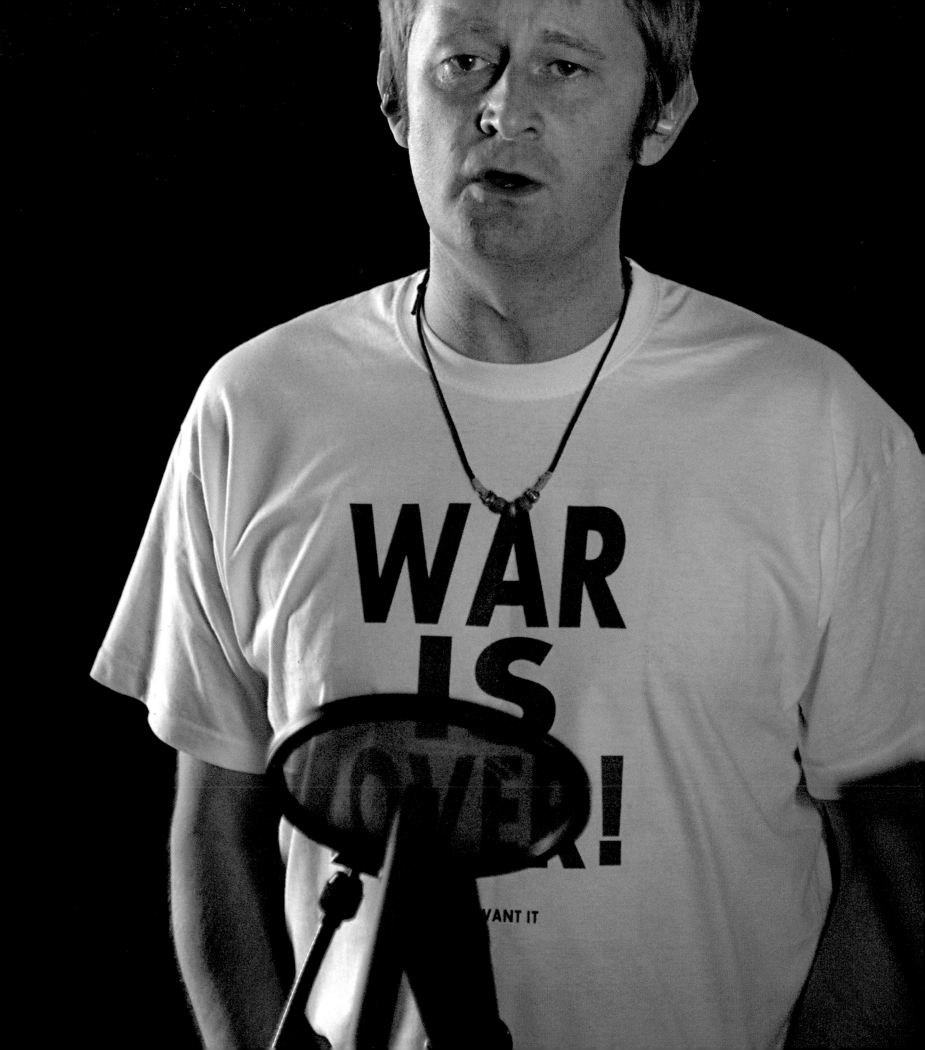

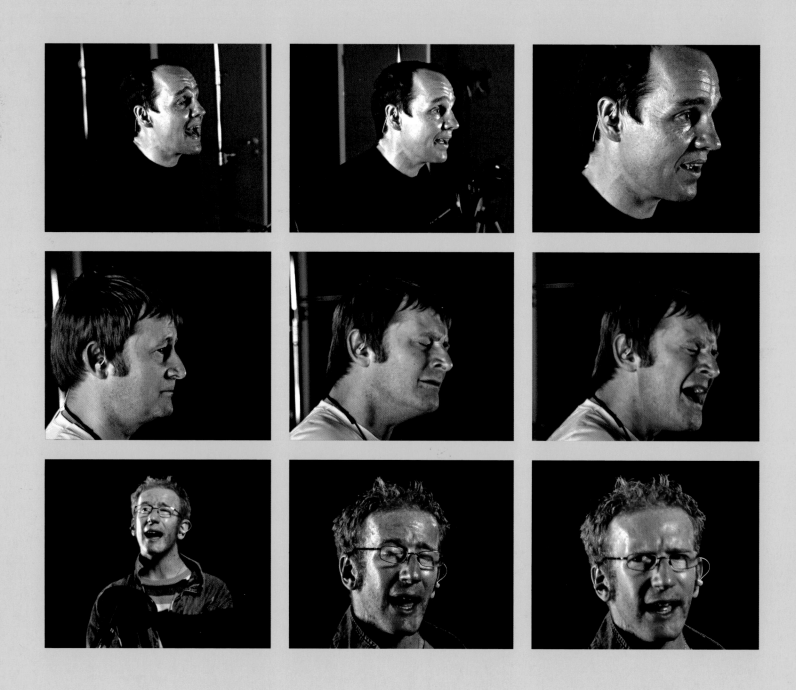

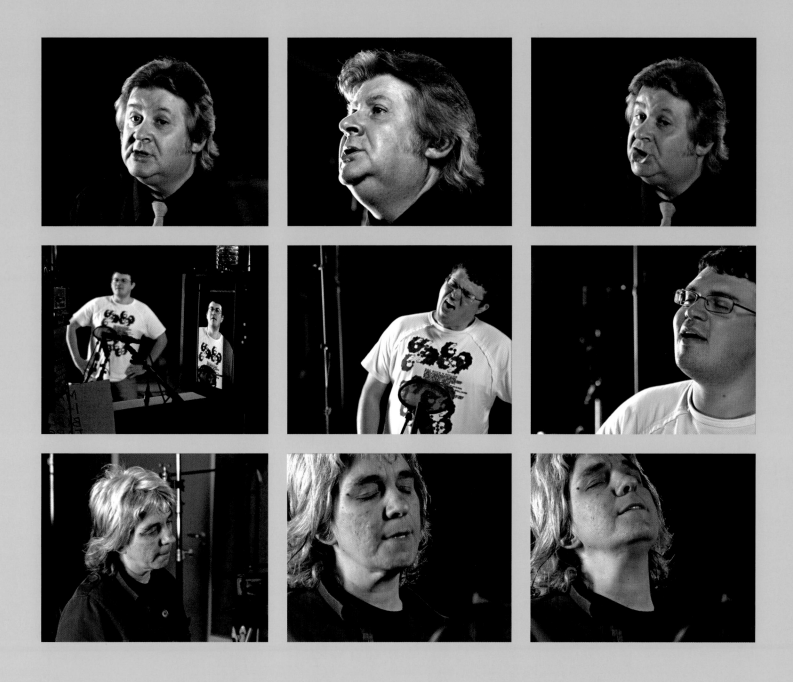

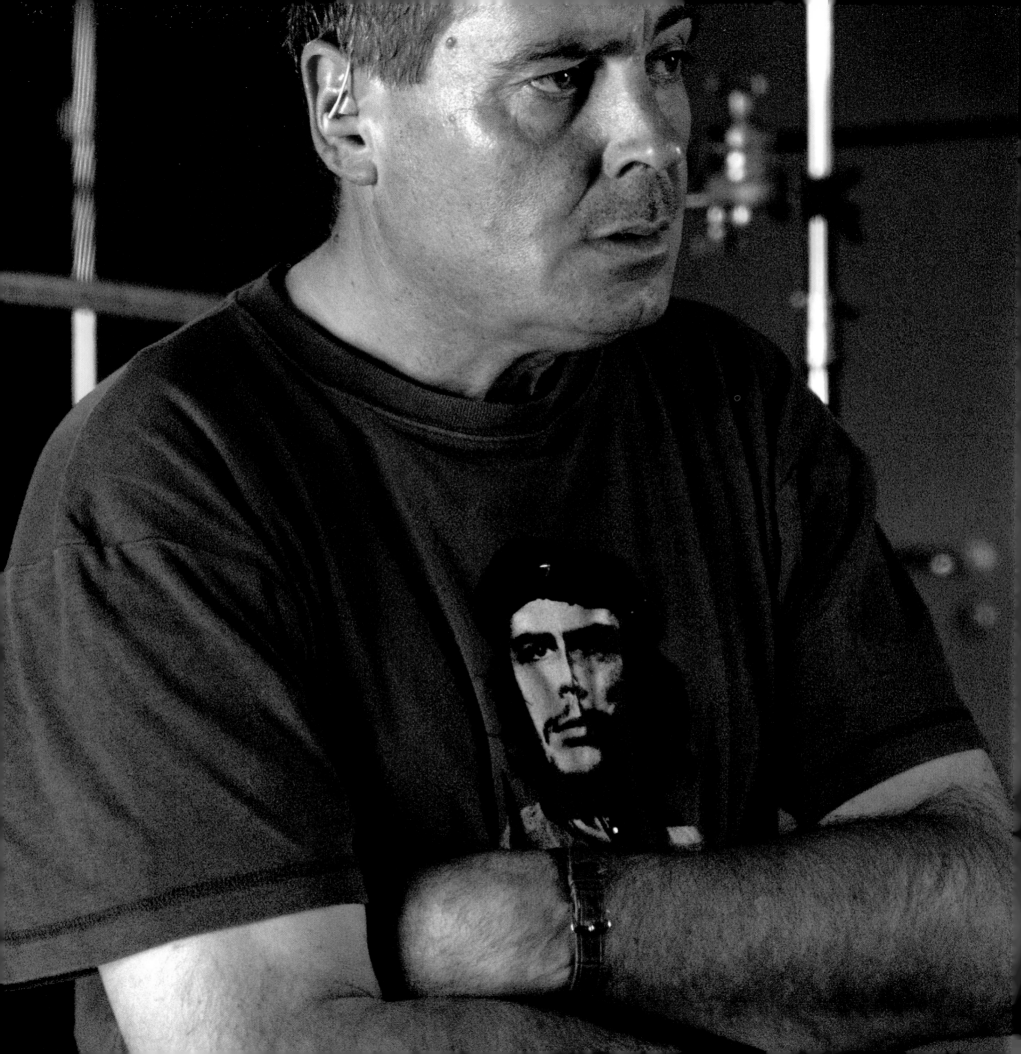

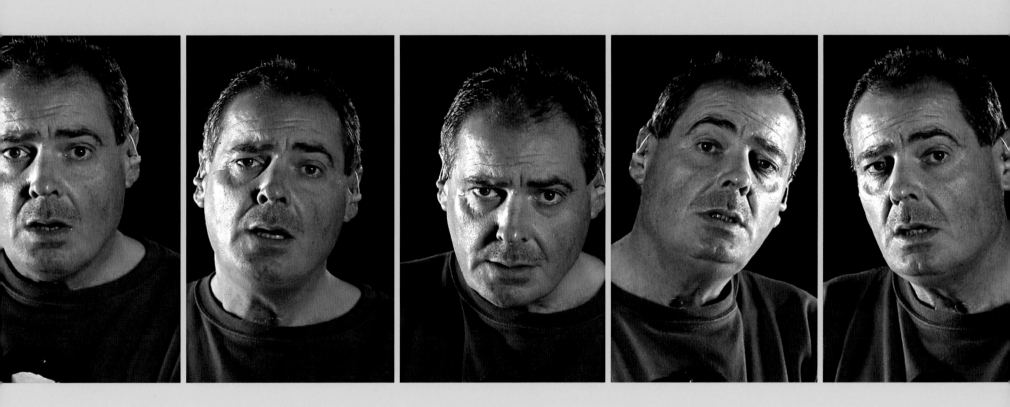

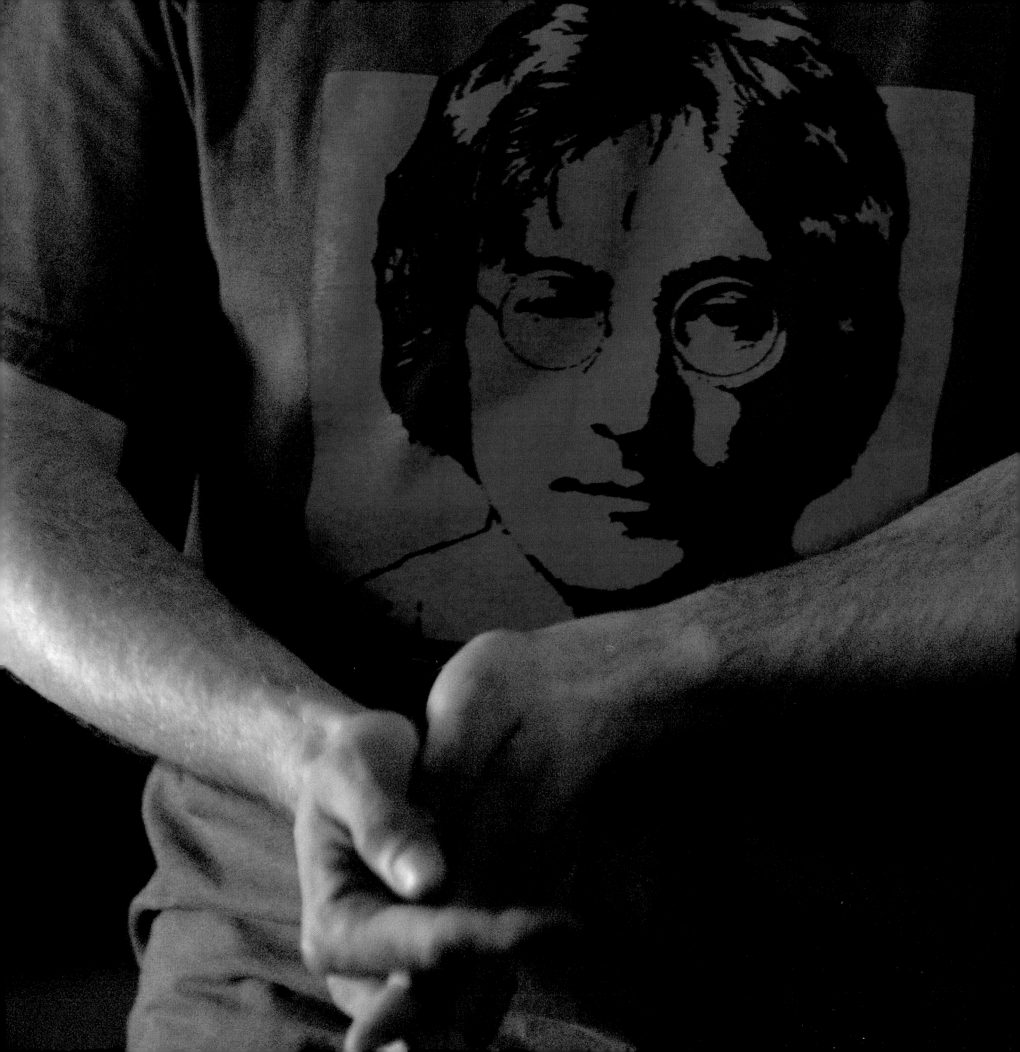

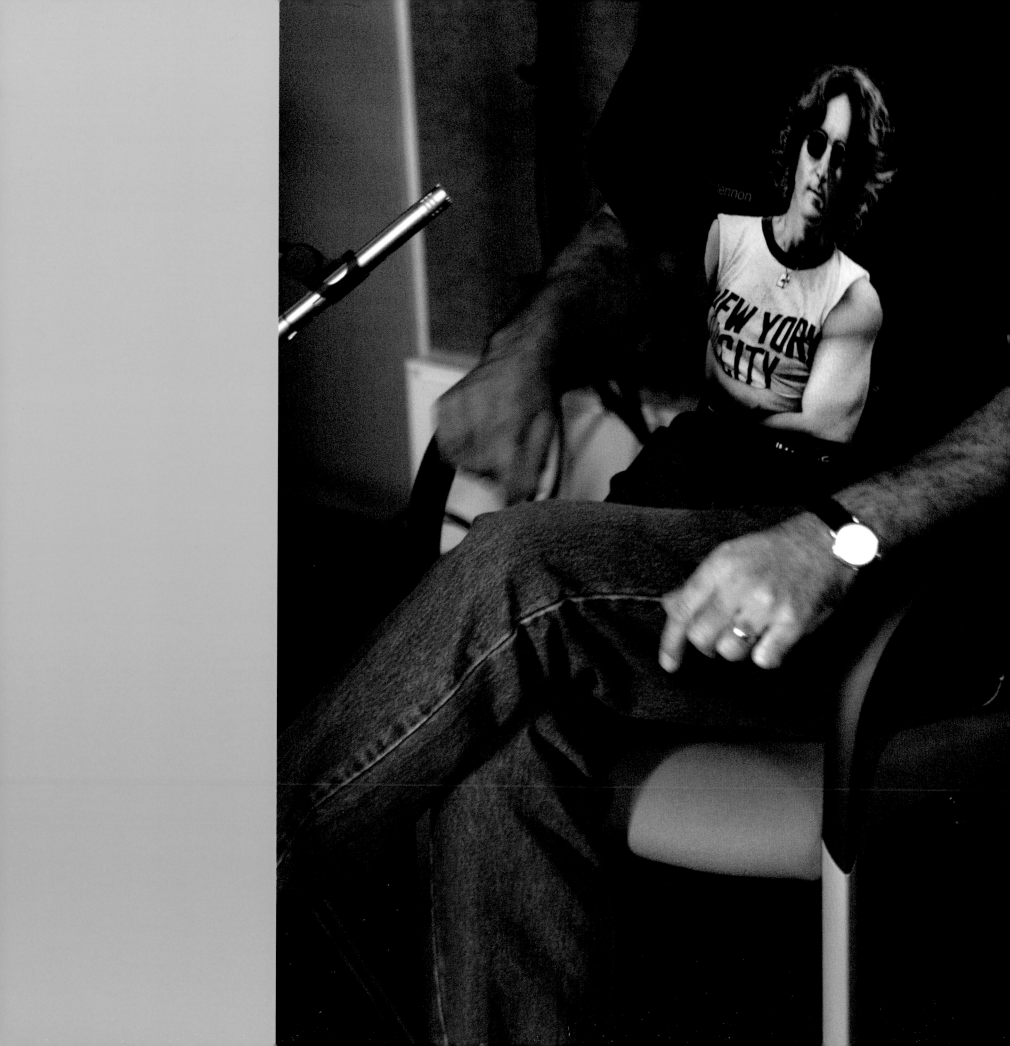

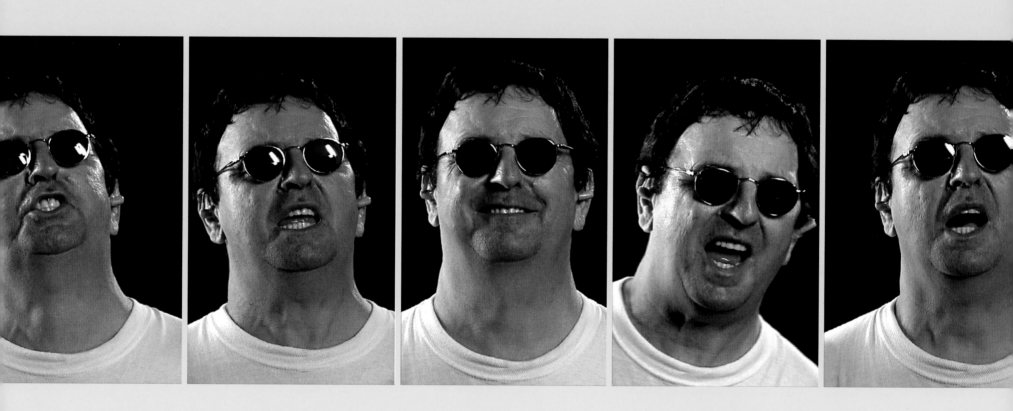

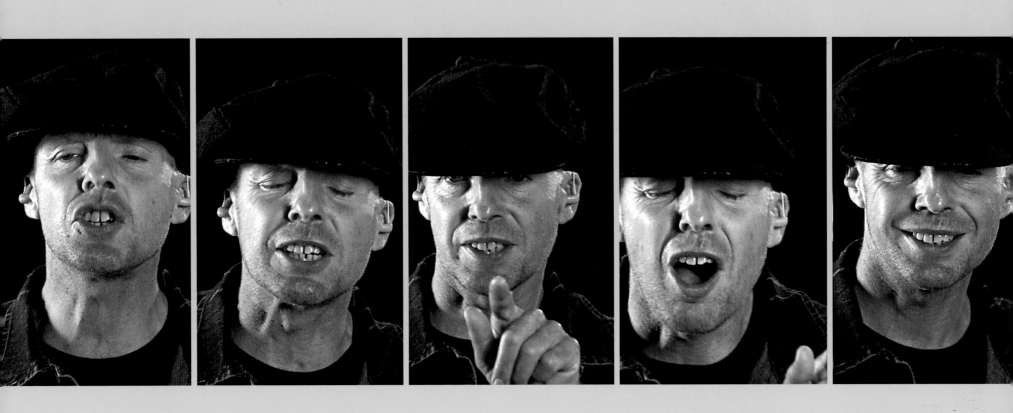

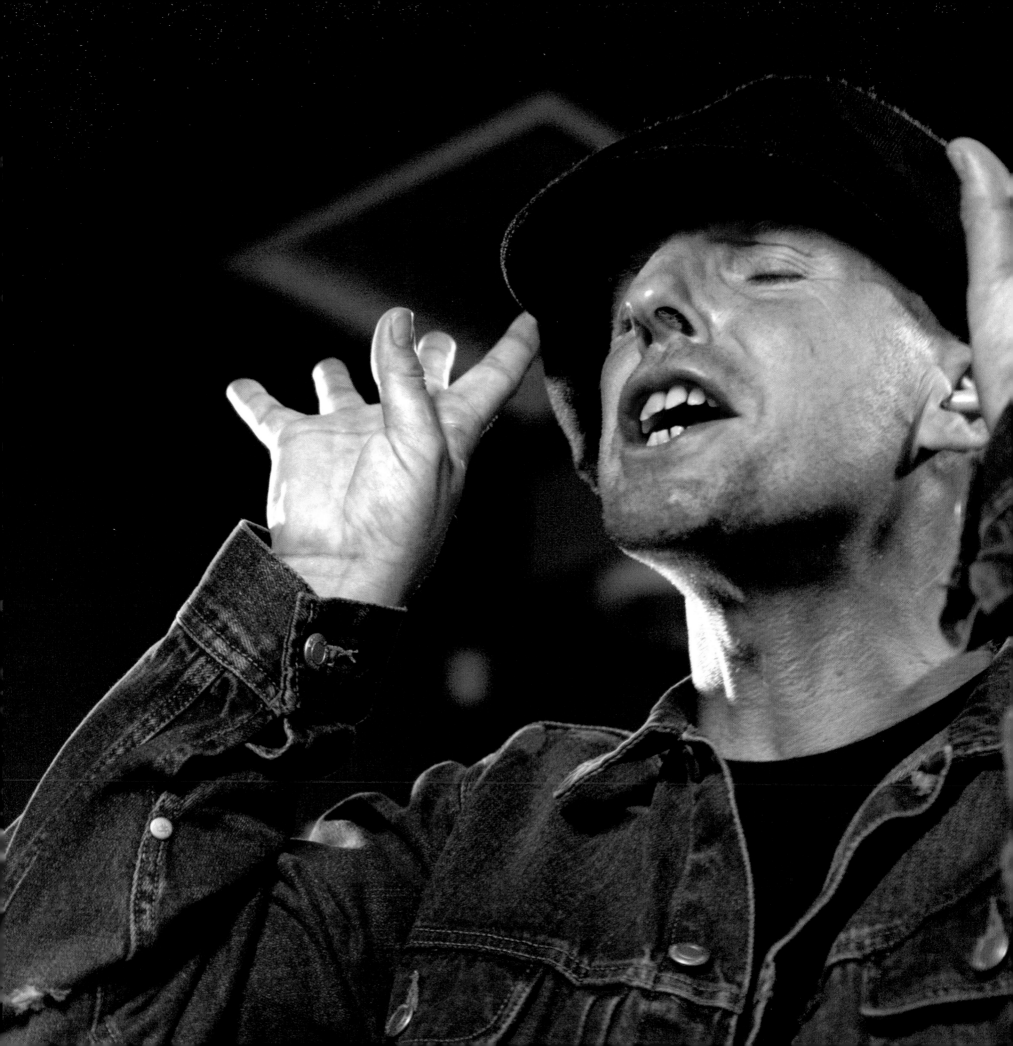

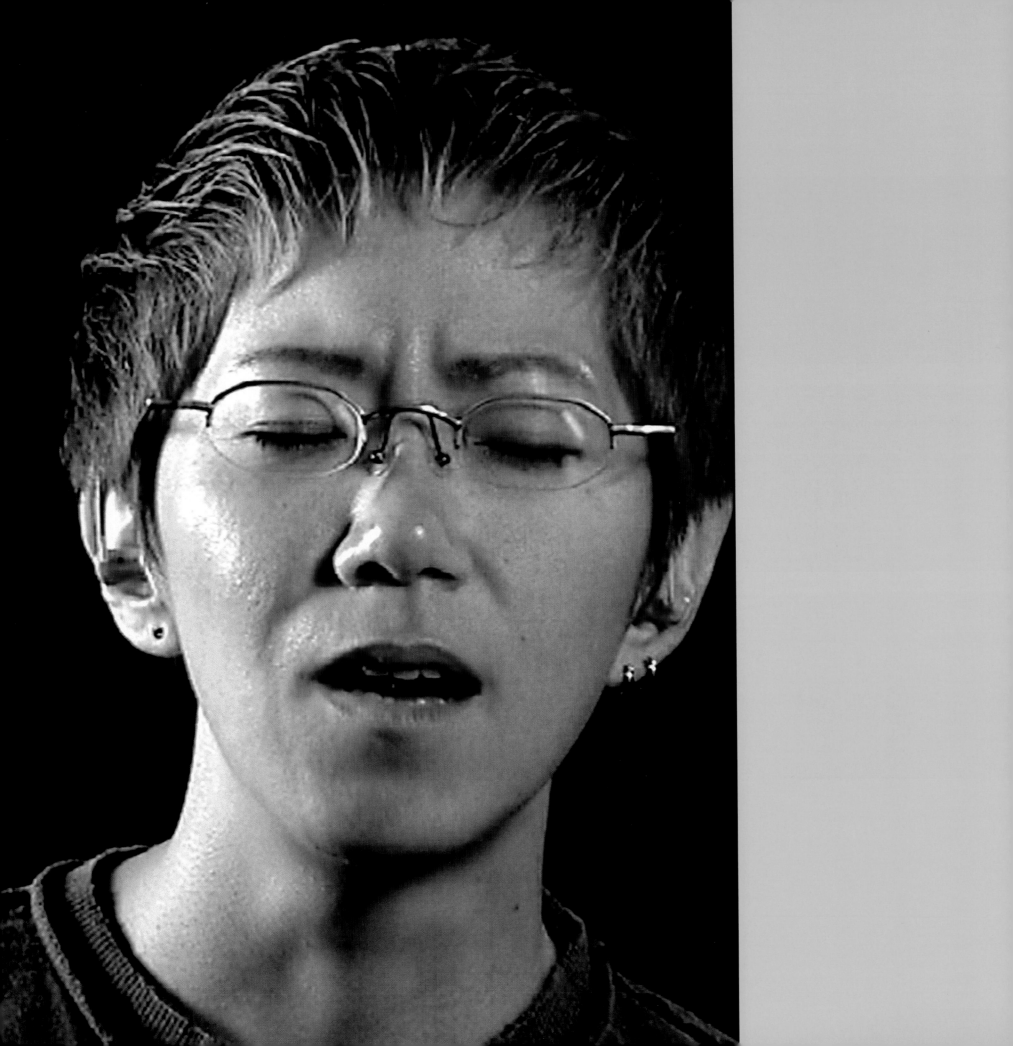

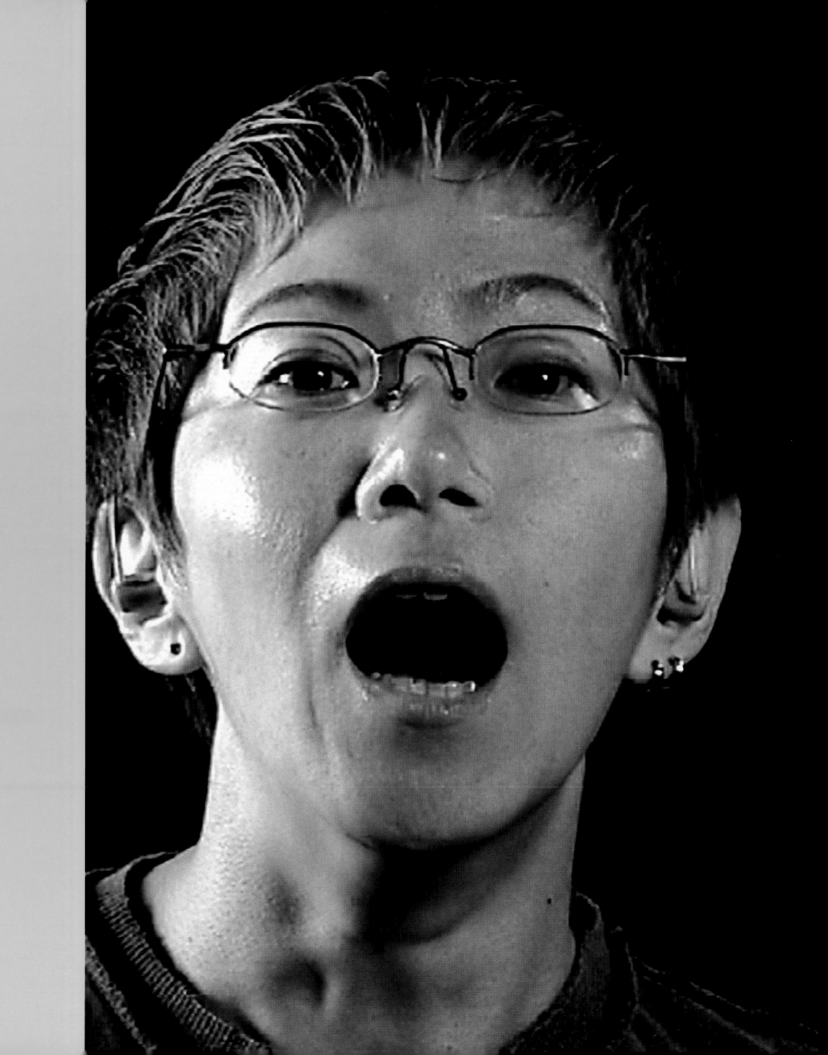

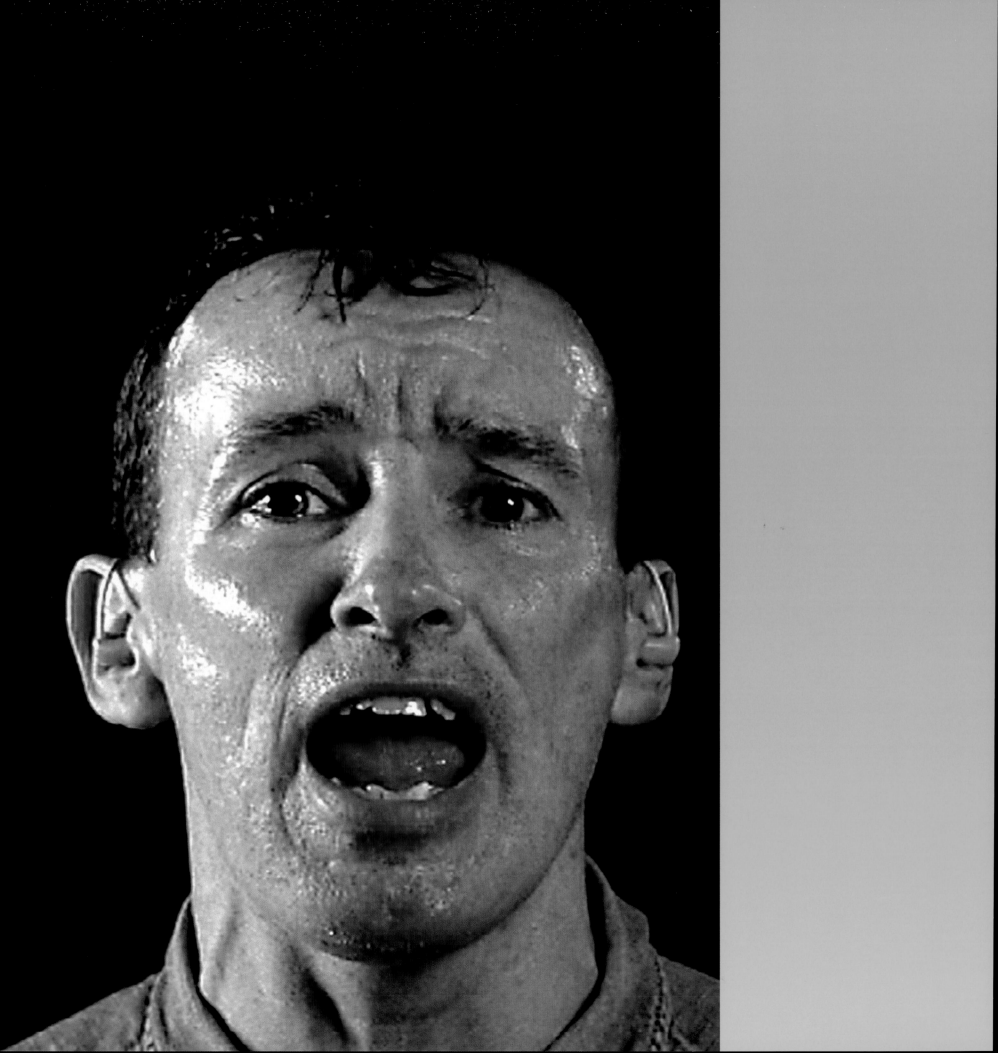

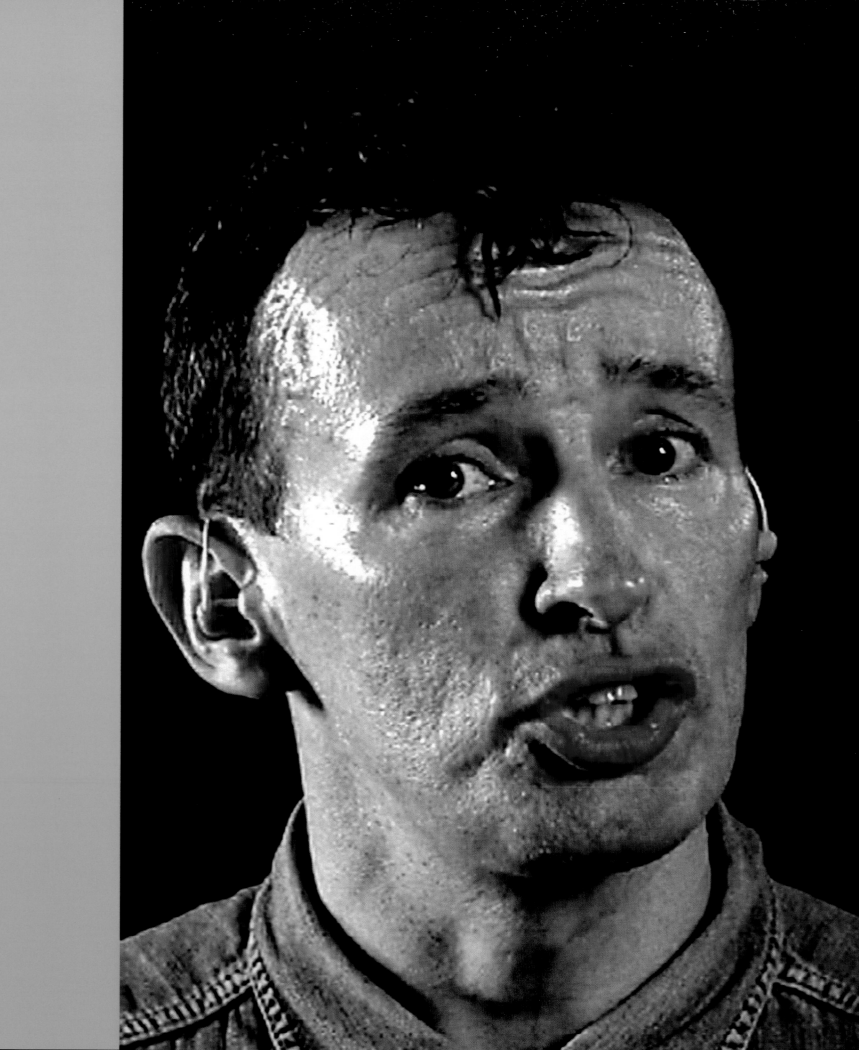

Lista de obras/List of Works

Babel Series, 1999
7-Channel Installation: 7 Looping DVDs
Edition of 4 + 2 A.P.

Pages 54-55
Babel Series, 1999
7-Channel Installation: 7 Looping DVDs
Installation View: New Museum of Contemporary
Art, New York
Courtesy: Thyssen-Bornemisza Art Contemporary,
Vienna
Photographs: Jason Mandella

Pages 56-65
Stills from the **Babel Series,** 1999
7-Channel Installation: 7 Looping DVDs
Courtesy: Francesca Kaufmann, Milan
Stills: Alex Fahl

Soliloquy Trilogy, 2000
Three Short Films on DVD:
Soliloquy (Clint), 1971-2000
Soliloquy (Jack), 1987-2000
Soliloquy (Sharon), 1992-2000
Edition of 4 + 2 A.P.

Pages 68-69
Stills from **Soliloquy (Clint),** 1971-2000
A Short Film on DVD
Duration: 6 minutes, 57 seconds, 22 frames
Courtesy: Milwaukee Art Museum, Milwaukee
Stills: Alex Fahl

Pages 70-71
Stills from **Soliloquy (Jack),** 1987-2000
A Short Film on DVD
Duration: 14 minutes, 6 seconds, 25 frames
Courtesy: Milwaukee Art Museum, Milwaukee
Stills: Alex Fahl

Pages 72-73
Stills from **Soliloquy (Sharon),** 1992-2000
A Short Film on DVD
Duration: 7 minutes, 11 seconds, 3 frames
Courtesy: Milwaukee Art Museum, Milwaukee
Stills: Alex Fahl

Page 74
Soliloquy Trilogy, 2000
3 Short Films on DVD
Installation Views: Castello di Rivoli Museo d'Arte
Contemporanea, Turin
Courtesy: Sonnabend Collection, New York
Photographs: Paolo Pellion

Four Duets, 2000
4 Dual-Channel Installations/8 Looping DVDs:
Double Karen (Close To You), 1970-2000
Double Olivia (Hopelessly Devoted To You),
1977-2000
Double Annie (Thorn In My Side), 1985-2000
Double Whitney (I Will Always Love You),
1999-2000
Edition of 4 + 2 A.P.

Page 78
Still from **Double Annie (Thorn In My Side),**
1985-2000
Dual-Channel Installation: 2 Looping DVDs
Duration: "I Loop" – 4.5 seconds/
 "You Loop" – 3.5 seconds
Courtesy: Francesca Kaufmann, Milan
Still: Alex Fahl

Page 79
Double Annie (Thorn In My Side), 1985-2000
Dual-Channel Installation: 2 Looping DVDs
Duration: "I Loop" – 4.5 seconds/
 "You Loop" - 3.5 seconds
Installation View: National Museum of Modern Art,
Tokyo
Courtesy: Francesca Kaufmann, Milan
Photographs: Alex Fahl

Pages 80-81
Stills from **Double Karen (Close To You),**
1970-2000
Dual-Channel Installation: 2 Looping DVDs
Duration: "I Loop" – 6 seconds/
 "You Loop" – 16 seconds
Courtesy: Jay Jopling/White Cube, London
Stills: Alex Fahl

Pages 82-83
Double Karen (Close To You), 1970-2000
Dual-Channel Installation: 2 Looping DVDs
Duration: "I Loop" – 6 seconds/
 "You Loop" – 16 seconds
Installation View: O.K Center for Contemporary Art
Upper Austria, Linz
Courtesy: Jay Jopling/White Cube, London
Photographs: Jason Mandella

Page 84
Still from **Double Olivia (Hopelessly Devoted To
You),** 1977-2000
Dual-Channel Installation: 2 Looping DVDs
Duration: "I Loop" – 6 seconds/
 "You Loop" – 29 seconds
Courtesy: Francesca Kaufmann, Milan
Still: Alex Fahl

Pages 104-112
Stills from **Mother,** 2005
6-Channel Installation: 6 Hard Drives
Duration: 13 minutes, 15 seconds
Courtesy: MUSAC – Museo de Arte Contemporáneo
de Castilla y León, León
Stills: Alex Fahl

Pages 113-121
Stills from **Father,** 2005
6-Channel Installation: 6 Hard Drives
Duration: 11 minutes
Courtesy: MUSAC – Museo de Arte Contemporáneo
de Castilla y León, León
Stills: Alex Fahl

Page 123
Father, 2005
6-Channel Installation: 6 Hard Drives
Duration: 11 minutes
Installation View: Castello di Rivoli Museo d'Arte
Contemporanea, Turin
Courtesy: MUSAC – Museo de Arte Contemporáneo
de Castilla y León, León
Photograph: Paolo Pellion

Becoming, 2003
14-Channel Installation: 14 Hard Drives
Consisting of 7 Dual-Channel Installations:
Becoming Cameron, Becoming Drew,
Becoming Jennifer, Becoming Julia,
Becoming Meg, Becoming Neve,
Becoming Reese
Edition of 5 + 2 A.P.

Director: Candice Breitz
Producer: Francesca Kaufmann
Location: IASPIS International Artists' Studio
Programme in Stockholm
Camera: Alex Fahl

Sound: Alex Fahl
Post-Production: Alex Fahl
Technical Realization: Neue Medien Pro, Berlin
Special Thanks: Sara Arrhenius, Bigert & Bergström.

Pages 126-127
Stills from **Becoming,** 2003
14-Channel Installation: 14 Hard Drives
Consisting of 7 Dual-Channel Installations
Courtesy: Sammlung Goetz, Munich
Stills: Alex Fahl

Pages 128-129
Stills from **Becoming Cameron,** 2003
Dual-Channel Installation: 2 Hard Drives
Duration: 31 seconds, 22 frames
Courtesy: Jay Jopling/White Cube, London
Stills: Alex Fahl

Pages 130-131
Stills from **Becoming Neve,** 2003
Dual-Channel Installation: 2 Hard Drives
Duration: 44 seconds
Courtesy: Francesca Kaufmann, Milan
Stills: Alex Fahl

Pages 132-133
Stills from **Becoming Drew,** 2003
Dual-Channel Installation: 2 Hard Drives
Duration: 37 seconds, 23 frames
Courtesy: Jay Jopling/White Cube, London
Stills: Alex Fahl

Pages 134-135
Stills from **Becoming Jennifer,** 2003
Dual-Channel Installation: 2 Hard Drives
Duration: 34 seconds, 12 frames
Courtesy: Francesca Kaufmann, Milan
Stills: Alex Fahl

Pages 136-137
Stills from **Becoming Reese,** 2003
Dual-Channel Installation: 2 Hard Drives
Duration: 41 seconds, 9 frames
Courtesy: Jay Jopling/White Cube, London
Stills: Alex Fahl

Pages 138-139
Stills from **Becoming Meg,** 2003
Dual-Channel Installation: 2 Hard Drives
Duration: 56 seconds, 3 frames
Courtesy: Francesca Kaufmann, Milan
Stills: Alex Fahl

Pages 140-141
Stills from **Becoming Julia,** 2003
Dual-Channel Installation: 2 Hard Drives
Duration: 39 seconds, 3 frames
Courtesy: Jay Jopling/White Cube, London
Stills: Alex Fahl

Pages 142-143
Becoming, 2003
14-Channel Installation: 14 Hard Drives
Consisting of 7 Dual-Channel Installations
Installation Views: Collection Lambert, Avignon
Courtesy: FNAC – Fonds national d'art contemporain,
France
Photographs: Pascal Martinez

Karaoke, 2000
10-Channel Installation: 10 Looping DVDs
Edition of 4 + 2 A.P.

Pages 146-147

Karaoke, 2000

10-Channel Installation: 10 Looping DVDs

Installation View: New York Center for Media Arts,
New York

Courtesy: Hamburger Kunsthalle, Hamburg

Photograph: Jason Mandella

Pages 148-157

Stills from **Karaoke,** 2000

10-Channel Installation: 10 Looping DVDs

Courtesy: Hamburger Kunsthalle, Hamburg

Stills: Alex Fahl

Legend (A Portrait of Bob Marley), 2005

30-Channel Installation: 30 Hard Drives

Duration: 62 minutes, 40 seconds

Director: Candice Breitz

Producer: Thyssen-Bornemisza Art Contemporary,
Vienna

Location: Gee Jam Studios, Port Antonio, Jamaica,
March 2005

Fans: Carol Alexander a.k.a Bibsy, Javaughn Bond,
Harley Brown a.k.a Cricket, H. Monty Bryant,
Somi Chen, Charles Cousins a.k.a Papa Woody,
Francine Cousins, Patrick Davis, Ronnesha Davis,
Deron Frankly a.k.a Vocal, Rohan Graham a.k.a
Daweh Congo, Ruddy Isaacs, Oneil Lawrence a.ka.
Shynz, Adoneiké Lewis a.k.a Jerine,
Anthony George Lewis a.k.a Shandy, Nadine Ming
a.k.a Nadine Queen, Joseph Morgan,
Bernice Oswald a.k.a Queen Sheba, Leon Porter
a.k.a Jay, Venessa Raymond a.k.a Vonnie,
Sharon Reece a.k.a Shar, Diana Rutherford,
Dr. Mary Sloper, Marjean Smith, Allan Swymmer,
Kadeen Whyte a.k.a Susan, Cohen Williams a.k.a
Bobby Culture, Naceta Williams a.k.a Novelette,
Pearline Wolfe a.k.a Sister Fire, Zebulun. Warm
gratitude also to Antoinette Barnaby, Fabrice Cousins,

Tracey Downer, Winston Lewis a.k.a Cávan,
Ricardo Morgan and George Thaxter a.k.a Kwami I,
all of whom sang for **Legend.**

Project Management: Colin Smikle, Alex Fahl

Casting: Colin Smikle

Camera: Yoliswa Gärtig

Sound: Max Schneider

Interviews: Candice Breitz

Post-Production: Alex Fahl

Post-Production Assistants: Janne Schäfer,
Julia Pfeiffer

Technical Realization: Neue Medien Pro, Berlin

Special Thanks: Francesca von Habsburg,
Daniela Zyman, Eva Ebersberger and Barbara Horvath
(Thyssen-Bornemisza Art Contemporary),
Patricia Francis and Del Crooks (Jampro),
Rita Marley, Yvonne Blakey, Ziggi Golding-Baker,
Colin Smikle and everybody at Alligator Head.

Pages 161-163, 166-167

The Making of **Legend (A Portrait of Bob Marley),**
2005

On location at Gee Jam Studios, Port Antonio,
March 2005

30-Channel Installation: 30 Hard Drives

Duration: 62 minutes, 40 seconds

Courtesy: Thyssen-Bornemisza Art Contemporary,
Vienna

Photographs: Candice Breitz

Pages 164-165

Stills from **Legend (A Portrait of Bob Marley),** 2005

30-Channel Installation: 30 Hard Drives

Duration: 62 minutes, 40 seconds

Courtesy: Thyssen-Bornemisza Art Contemporary,
Vienna

Stills: Alex Fahl

Page 169

Legend (A Portrait of Bob Marley), 2005

30-Channel Installation: 30 Hard Drives

Duration: 62 minutes, 40 seconds

Installation View: Das Schiff, Basel

Courtesy: Thyssen-Bornemisza Art Contemporary,
Vienna

Photograph: Fotografie Bornand, Basel

King (A Portrait of Michael Jackson), 2005

16-Channel Installation: 16 Hard Drives

Duration: 42 minutes, 20 seconds

Edition of 6 + A.P.

Director: Candice Breitz

Producer: Francesca Kaufmann

Location: UFO Sound Studios, Berlin, Germany,
July 2005

Fans: Andrew Cannon, Alexander Stolz, Rames Gouri,
Gina Behrendt, Tanja Kerbler, Isabel Röhl,
Claudia Wildner, Manuela Köllner, Katrin Orejuela,
Eren Mendez Küslümoglu de la Vega,
Melanie Diana Viereck, Kerrar Kilic,
Ceyhun Katircioglu, Adlai Ogbonna, Kirsten Köhler,
Rico Richter. Special thanks to Markus Schielke.

Project Management: Janne Schäfer, Alex Fahl

Casting: Janne Schäfer

Camera: Yoliswa Gärtig

Sound: Max Schneider

Interviews: Candice Breitz, Janne Schäfer

Post-Production: Alex Fahl

Post-Production Assistant: Julia Pfeiffer

Technical Realization: Neue Medien Pro, Berlin

Pages 12, 172, 176-177, 180-181

The Making of **King (A Portrait of Michael Jackson),**
2005
On location at UFO Sound Studios, Berlin, July 2005
16-Channel Installation: 16 Hard Drives
Duration: 42 minutes, 20 seconds
Courtesy: Francesca Kaufmann, Milan
Photographs: Candice Breitz

Pages 174-175, 178-179, 182-183

Stills from **King (A Portrait of Michael Jackson),**
2005
16-Channel Installation: 16 Hard Drives
Duration: 42 minutes, 20 seconds
Courtesy: Jay Jopling/White Cube, London
Stills: Alex Fahl

Pages 184-185

King (A Portrait of Michael Jackson), 2005
16-Channel Installation: 16 Hard Drives
Duration: 42 minutes, 20 seconds
Installation View: Sonnabend Gallery, New York
Courtesy: Francesca Kaufmann, Milan
Photograph: Jason Mandella

Queen (A Portrait of Madonna), 2005
30-Channel Installation: 30 Hard Drives
Duration: 73 minutes, 30 seconds
Edition of 6 + A.P.

Director: Candice Breitz
Producer: Francesca Kaufmann
Location: Jungle Sound Station, Milan, Italy,
July 2005
Fans: Matteo 'Mayday' Golinelli, Giancarlo Furfaro,
Maurizio Cargnelutti, Besim 'Bess' Bajric,
Sara Ballerini, Michele Albertin, Valeria Saccà,
Mariella Mulé, Marika De Sandoli, Fiammetta Fabrizi,
Fabiano Cecconi, Michele Valentino,
Claudia Garavaglia, Tommaso Tanini, Beatrice Sinisi,

Maria Zuccarino, Antonella Adriomi, Nicola Casadei,
Paolo Piovera, Alessandra Grignani, Fabrizio Canepa,
Alessia Alberti, Marco di Nola, Giuseppe Russo,
Linda Arcieri, Augusto Castelli, Roberta Giovanardi,
Silvia Celestini, Giuseppe Brocato,
Alessandro Bizzozero. Thanks also to Giorgio Galfo,
Chiara Boari Ortolani and Francesco Cappellano.
Project Management: Chiara Repetto, Alex Fahl
Casting: Chiara Repetto
Camera: Sebastian Krügler
Sound: Max Schneider
Interviews: Gianpaolo Manzoni, Chiara Repetto
Production Assistants: Gianpaolo Manzoni, Daphné
Valroff
Post-Production: Alex Fahl
Post-Production Assistant: Riccardo Zito
Backdrop: Mariarosa Repetto
Technical Realization: Neue Medien Pro, Berlin
Special Thanks: Francesca Kaufmann,
Chiara Repetto and Alessio delli Castelli.

Pages 189-191, 193, 194-196, 198-199, 201

Stills from **Queen (A Portrait of Madonna),** 2005
30-Channel Installation: 30 Hard Drives
Duration: 73 minutes, 30 seconds
Courtesy: Kunstverein St. Gallen Kunstmuseum,
St. Gallen
Stills: Alex Fahl

Pages 192, 197, 200

The Making of **Queen (A Portrait of Madonna),**
2005
On location at Jungle Sound Studio, Milan, July
2005
30-Channel Installation: 30 Hard Drives
Duration: 73 minutes, 30 seconds
Courtesy: Francesca Kaufmann, Milan
Photographs: Candice Breitz

Page 203

Queen (A Portrait of Madonna), 2005
30-Channel Installation: 30 Hard Drives
Duration: 73 minutes, 30 seconds
Installation View: White Cube, London
Courtesy: Jay Jopling/White Cube, London
Photograph: Stephen White

Working Class Hero (A Portrait of John Lennon),
2006
25-Channel Installation: 25 Hard Drives
Duration: 39 minutes, 55 seconds
Edition of 6 + 2 A.P.

Director Candice Breitz
Producer Jay Jopling/White Cube, London
Location Culture Lab, Newcastle University,
United Kingdom, August 2006
Fans Sasha V. Ames, Gordon Bray, George Burton,
Geoffrey Cowie, Peter J. Dicks, Kieran Dunne,
Kozue Etsuzen, Gerard Fagan, Stephen J. Fenwick,
Antony T. Flynn, Liliana Ghilardi, Andrew Griffin,
Peter Grimes, William J. Harrington, Philip Jones,
Paul Kindred, David John Paul George Ringo Lennon,
Steve Mathieson, James McCoy, Anthony Miller,
John M. Patterson, Roger Pounder, Spencer Taylor,
Billy J. Walker, William Watson. Thanks also to
John D. Adams, Peter Cullen, Andrew Murphy,
Michelle Ord, Frederick Rogers and Alison Suffield.
Project Management: Alex Fahl
Casting & Coordination: Katharine Welsh,
Kate Lewis
Camera: Sebastian Krügler
Sound: Max Schneider
Interviews: Candice Breitz
Production Assistants: Harry Watton, Joel Weaver
Post-Production: Alex Fahl
Post-Production Assistant: Pierfrancesco Celada
Photography: Pierfrancesco Celada
Technical Realization: Neue Medien Pro, Berlin

Special Thanks: Jay Jopling and White Cube
(Craig Burnett, Daniela Gareh, Susannah Hyman,
Susan May and Alison Ward), Peter Doroshenko and
his team at the Baltic Centre for Contemporary Art
in Gateshead (especially David Coxon, Alex Gibson,
Katie Jackson and Chris Osborne), and
Pierfrancesco Celada. My deep gratitude to
Yoko Ono for giving this portrait her blessing.

Page 207
Working Class Hero (A Portrait of John Lennon),
2006
25-Channel Installation: 25 Hard Drives
Duration: 39 minutes, 55 seconds
Installation View: Baltic Centre for Contemporary
Art, Gateshead
Courtesy: Jay Jopling/White Cube, London
Photograph: Candice Breitz

Pages 208-213, 219, 223, 226, 228-231
Stills from **Working Class Hero (A Portrait of
John Lennon),** 2006
25-Channel Installation: 25 Hard Drives
Duration: 39 minutes, 55 seconds
Courtesy: Jay Jopling/White Cube, London
Stills: Alex Fahl

Pages 2, 214-218, 220-222, 224-225, 227
The Making of **Working Class Hero (A Portrait of
John Lennon),** 2006
On location at the Culture Lab, Newcastle University,
August 2006
25-Channel Installation: 25 Hard Drives
Duration: 39 minutes, 55 seconds
Courtesy: Jay Jopling/White Cube, London
Photographs: Pierfrancesco Celada

The following works are included in the exhibition,
but are not reproduced in this book:

One Minute Of Mother, 2005
Color Photograph
202 x 900 cm
Commissioned by the Edith-Ruß-Haus für
Medienkunst, Oldenburg
Edition of 5 + A.P.

Lyric Mirrors, 2006:

Do You Really Want To Hurt Me, 2006
From the **Lyric Mirrors** series
Photograph on Mirror
109 x 81.5cm
Edition of 6 + 2 A.P.

Chains Of Love, 2006
From the **Lyric Mirrors** series
Photograph on Mirror
109 x 81.5cm
Edition of 6 + 2 A.P.

More Than Words, 2006
From the **Lyric Mirrors** series
Photograph on Mirror
69 x 51.5cm
Edition of 6 + 2 A.P.

Sowing The Seeds Of Love Again, 2006
From the **Lyric Mirrors** series
Photograph on Mirror
69 x 49cm
Edition of 6 + 2 A.P.

Sowing The Seeds Of Love, 2006
From the **Lyric Mirrors** series
Photograph on Mirror
99 x 64cm
Edition of 6 + 2 A.P.

De Do Do Do, 2006
From the **Lyric Mirrors** series
Photograph on Mirror
89 x 66.5cm
Edition of 6 + 2 A.P.

De Do Do Do Again, 2006
From the **Lyric Mirrors** series
Photograph on Mirror
89 x 76.5cm
Edition of 6 + 2 A.P.

Words, 2006
From the **Lyric Mirrors** series
Photograph on Mirror
58 x 80cm
Edition of 6 + 2 A.P.

Enjoy The Silence, 2006
From the **Lyric Mirrors** series
Photograph on Mirror
110 x 85cm
Edition of 6 + 2 A.P.

Words (Don't Come Easy), 2006
From the **Lyric Mirrors** series
Photograph on Mirror
90 x 70cm
Edition of 6 + 2 A.P.

Appendix

Biografía/Biography

1972, Johannesburg, South Africa
Lives and works in Berlin, Germany

Formación/Education

1998-2002
Doctoral Candidate in Art History. Columbia
University, New York, USA

1997
Whitney Independent Studio Program. Whitney
Museum of American Art, New York, USA

1997
M.Phil. Art History. Columbia University, New York,
USA

1995
MA Art History. University of Chicago, Chicago,
USA

1993
BA Fine Arts. University of the Witwatersrand,
Johannesburg, South Africa

Becas y Residencias/Grants and Residencies

2006
Baltic Centre for Contemporary Art, Gateshead, UK

2005
Cité Internationale des Arts, Paris, France

2003
IASPIS International Artists' Studio Program in
Sweden, Stockholm, Sweden

2002
Künstlerhaus Bethanien International Artists in
Residency Program, Berlin, Germany

2002
Artpace International Artist-In-Residence Program,
San Antonio, Texas, USA

2001
O.K Center for Contemporary Art Upper Austria,
Linz, Austria

2000
Künstlerhaus Schloss Wiepersdorf, Wiepersdorf,
Germany

Selección de Exposiciones Individuales/
Selected Solo Exhibitions

2007
MUSAC – Museo de Arte Contemporáneo de Castilla
y León, León, Spain

2006
Konstmuseum Uppsala, Uppsala, Sweden
Baltic Centre for Contemporary Art, Gateshead, UK
Hellenic American Union, Athens, Greece
Kukje Gallery, Seoul, Korea
Bawag Foundation, Vienna, Austria

2005
Castello di Rivoli Museo d'Arte Contemporanea,
Torino, Italy
Palais de Tokyo, Paris, France
White Cube, London, UK
Sonnabend Gallery, New York, USA
Edith-Ruß-Haus für Medienkunst, Oldenburg,
Germany

Mercer Union – A Centre for Contemporary Visual
Art, Toronto, Canada
Bob Marley Museum, Kingston, Jamaica
Das Schiff, Basel, Switzerland

2004
Sonnabend Gallery, New York, USA
Moderna Museet, Stockholm, Sweden
FACT – Foundation for Art & Creative Technology,
Liverpool, UK
Tokyo Wonder Site, Tokyo, Japan
Galleri Roger Björkholmen, Stockholm, Sweden

2003
Modern Art Oxford, Oxford, UK
Galerie Max Hetzler, Berlin, Germany
Aspreyjacques, London, UK
De Beeldbank, Eindhoven, The Netherlands
Goethe Institute Inter Nationes, Zagreb, Croatia

2002
Artpace San Antonio, Texas, USA
INOVA – Institute of Visual Arts, Milwaukee, USA
Künstlerhaus Bethanien, Berlin, Germany
Museum Folkwang im RWE Turm, Essen, Germany
Art Statements – Art Basel Miami Beach, Miami, USA

2001
De Appel Foundation, Amsterdam, The Netherlands
O.K Center for Contemporary Art Upper Austria,
Linz, Austria
Kunstverein St. Gallen Kunstmuseum, St. Gallen,
Switzerland
Galerie Johnen & Schöttle, Cologne, Germany
Galleri Roger Björkholmen, Stockholm, Sweden
Galeria João Graça, Lisbon, Portugal
Galleria Francesca Kaufmann, Milan, Italy

2000

Centre d'Art Contemporain Genève, Geneva, Switzerland

New Museum of Contemporary Art, New York, USA

Galerie Art & Public, Geneva, Switzerland

Galerie Rüdiger Schöttle, Munich, Germany

Galleria Francesca Kaufmann, Milan, Italy

Chicago Project Room, Chicago, USA

Künstlerhaus Schloss Wiepersdorf, Wiepersdorf, Germany

1999

Galerie Rüdiger Schöttle, Munich, Germany

Galleri Roger Björkholmen, Stockholm, Sweden

1998

Galerie Johnen & Schöttle, Cologne, Germany

Sala Mendoza, Caracas, Venezuela

Chicago Project Room, Chicago, USA

Galleri Roger Björkholmen, Stockholm, Sweden

1997

Craig Krull Gallery, Los Angeles, USA

Galerie Rüdiger Schöttle, Munich, Germany

1996

The Space Gallery, Johannesburg, South Africa

1995

Cochrane Woods Art Center, Chicago, USA

1994

Institute of Contemporary Art, Johannesburg, South Africa

Selección de Exposiciones Colectivas/
Selected Group Exhibitions

2006

Sip My Ocean. Louisiana Museum of Modern Art, Humlebæk, Denmark

Berlin-Tokio/Tokio-Berlin. Neue Nationalgalerie, Berlin, Germany

Tokyo-Berlin/Berlin-Tokyo. Mori Art Museum, Tokyo, Japan

Full House: Faces of a Collection. Kunsthalle Mannheim, Mannheim, Germany

This is America! Centraal Museum, Utrecht, The Netherlands

Dark Places. SMMoA – Santa Monica Museum of Art, Santa Monica, USA

Figures de l'acteur. Le Paradoxe du comédien. Collection Lambert en Avignon, Avignon, France

Art, Life & Confusion. 47th October Art Salon, Belgrade, Serbia

Video Venice. Adelaide Bank Festival of Arts, Adelaide, Australia

CUT: Film as Found Object. Philbrook Museum of Art, Tulsa, USA

Hiding in the Light. Mary Boone Gallery, New York, USA

Review: Vidéos & Films de la Collection Pierre Huber. Le Magasin – Centre National d'Art Contemporain, Grenoble, France

Lifestyle. Kunstmuseum St. Gallen, St. Gallen, Switzerland

Biennale Cuvée. O.K Center for Contemporary Art Upper Austria, Linz, Austria

Anstoß Berlin, Kunst macht Welt. Haus am Waldsee, Berlin, Germany

Eine Frage (nach) der Geste. Oper Leipzig, Leipzig, Germany

sonambiente 2006. Akademie der Künste, Berlin, Germany

Festival In-Presentable. La Casa Encendida, Madrid, Spain

Candice Breitz & Elfie Semotan. Galerie der Stadt Wels, Wels, Austria

Start. Hangar Bicocca, Milan, Italy

Nie Meer. De Warande, Turnhout, Belgium

International Exhibitionist Screening. Curzon Soho Cinema, London, UK

Video Program. MAC/VAL – Musée d'Art Contemporain du Val-de-Marne, Vitry-sur-Seine, France

Wonder Women: Idols in Contemporary Art. Katonah Museum of Art, New York, USA

Everyday Heroes. Kulturzentrum Mainz, Mainz, Germany

Klartext Berlin. Kunstraum Niederösterreich, Vienna, Austria

2005

51st Biennale di Venezia: The Experience of Art. La Biennale di Venezia, Venice, Italy

Superstars: Das Prinzip Prominenz von Warhol bis Madonna. Kunsthalle Wien, Vienna, Austria

CUT: Film as Found Object. Milwaukee Art Museum, Milwaukee, USA

Girls on Film. Zwirner & Wirth Gallery, New York, USA

Fair Use. Armand Hammer Museum, Los Angeles, USA

From the Electronic Eye. Works from the Video Collection. Castello di Rivoli Museo d'Arte Contemporanea, Turin, Italy

Guardami. Percezione del video. Palazzo delle Papesse – Centro Arte Contemporanea, Siena, Italy

Fusion. Aspects of Asian Culture in MUSAC Collection. MUSAC – Museo de Arte Contemporáneo de Castilla y León, León, Spain

Circa Berlin. Nikolaj Copenhagen Contemporary Art Center, Copenhagen, Denmark

Andre/Others. Sørlandet Kunstmuseum, Kristiansand, Norway

Artists Interrogate: Race and Identity. Milwaukee Art Museum, Milwaukee, USA

Manipulations. Centro Cultural Chacao, Caracas, Venezuela

Theorema: La Collection D'Enea Righi. Collection Lambert en Avignon, Avignon, France

Private View 1980-2000. Collection Pierre Huber. Le Musée Cantonal des Beaux-Arts de Lausanne, Lausanne, Switzerland

11th Biennale de l'Image en Mouvement. Centre pour l'Image Contemporaine, Geneva, Switzerland

Africa Screams. Museum der Weltkulturen, Frankfurt am Main, Germany

Scrabble. CAAM – Centro Atlántico de Arte Moderno, Las Palmas de Gran Canaria, Spain

Bring Your Own: The Teseco Collection. Museo d'arte Provincia di Nuoro, Nuoro, Italy

Senza Confine. Galleria Continua, San Gimigniano, Italy

22nd Kassel Documentary, Film and Video Festival, Kassel, Germany

36 x 27 x 10. Palast der Republik, Berlin, Germany

Global Tour. W139, Amsterdam, The Netherlands

Moving On. NGBK – Neue Gesellschaft für Bildende Kunst, Berlin, Germany

Aiwa To Zen. Tranzit, Prague, Czech Republic

2004

TV Today. Montevideo Time Based Arts, Amsterdam, The Netherlands

Africa Screams: Das Böse in Kino, Kunst und Kult. Kunsthalle Wien, Vienna, Austria

WOW: The Work of the Work. Henry Art Gallery, Seattle, USA

Video Hits. Queensland Art Gallery, Brisbane, Australia

Music/Video. The Bronx Museum of the Arts, New York, USA

Why Not Live For Art? Tokyo Opera City Art Gallery, Tokyo, Japan

Me Myself I. Kunstmuseum St. Gallen, St. Gallen, Switzerland

Shake. Villa Arson, Nice, France

CUT: Film as Found Object. Museum of Contemporary Art, North Miami, USA

Shake Staatsaffäre. O.K Center for Contemporary Art Upper Austria, Linz, Austria

Aufruhr der Gefühle. Museum für Photographie, Braunschweig, Germany

Any Place Any: Art, Immigration, Utopia. Macedonian Museum of Contemporary Art, Thessaloniki, Greece

Videothek. Galerie der Stadt Wels, Wels, Austria

Strange Planet. Saltworks Gallery, Atlanta, USA

Gewalt. Loushy Art & Editions, Tel Aviv, Israel

Africa Screams. Iwalewa House, Bayreuth, Germany

Visions of Paradise. João Ferreira Gallery, Cape Town, South Africa

Through the Looking Glass. Albany History Museum, Grahamstown, South Africa

Open House: Art and the Public Sphere. O.K Center for Contemporary Art Upper Austria, Linz, Austria

Democracy and Change. Klein Karoo National Arts Festival, Oudtshoorn, South Africa

Prototype: Works from Joe Friday's Collection. Carleton University Art Gallery, Ottawa, Canada

Weiße Nächte Kiel Oben. Kunsthalle Kiel, Kiel, Germany

100 Handlungsanweisungen. Kunsthalle Wien, Vienna, Austria

Cabinet photographique érotique. Galerie Steinek, Vienna, Austria

2003

fuckin' trendy. Mode in der zeitgenössischen Kunst. Kunsthalle Nürnberg, Nürnberg, Germany

Continuity and Transgression. National Museum of Art Osaka, Osaka, Japan

Extended Play: Art Remixing Music. Govett-Brewster Art Museum, New Zealand, Australia

Brightness: Works from the Collection of the

Thyssen-Bornemisza Contemporary Art Foundation. Museum of Modern Art Dubrovnik, Dubrovnik, Croatia

Plunder. Dundee Contemporary Arts, Dundee, UK

Against All Evens. 2nd Göteborg International Biennial for Contemporary Art, Hasselblad Center, Göteborg, Sweden

Striptease: Vom Verschleiern+Enthüllen in der Kunst. Kunstmuseum St. Gallen, St. Gallen, Switzerland

Looks of Complicity. CGAC – Centro Galego de Arte Contemporánea, Santiago de Compostela, Spain

Some Things We Like... Aspreyjacques, London, UK

Pictured. Galleri Roger Björkholmen, Stockholm, Sweden

Anemic Cinema. Sketch, London, UK

Paradigms. Longwood Art Gallery, New York, USA

Fins des Histoires? Une traversée plurielle. Cité des Arts, Chambéry, France

Gallery Opening Show. ShugoArts, Tokyo, Japan

2002

Remix: Contemporary Art and Pop. Tate Liverpool, Liverpool, UK

Arte in Video. Castello di Rivoli Museo d'Arte Contemporanea, Torino, Italy

Continuity and Transgression. National Museum of Modern Art, Tokyo, Japan

Iconoclash: Image-Making in Science, Religion & Art. ZKM – Zentrum für Kunst und Medientechnologie, Karlsruhe, Germany

Schrägspur. Hamburger Kunsthalle, Hamburg, Germany

Vidéo Topiques. Musée d'Art Moderne et Contemporain, Strasbourg, France

Screen Memories. Contemporary Art Center Art Tower Mito, Tokyo, Japan

Africaine. Studio Museum in Harlem, New York, USA

40 Jahre: Fluxus und die Folgen. Caligari FilmBühne, Wiesbaden, Germany

Emotional Site. Saga-cho Shokuryo Building,
Tokyo, Japan
*8th Baltic Triennial of International Art: Centre of
Attraction.* CAC – Contemporary Art Centre,
Vilnius, Lithuania
Superlounge. Gale Gates, New York, USA
In the Side of Television. EACC – Espai d'Art Con-
temporani de Castelló, Castellón de la Plana, Spain
Candice Breitz, Christian Jankowski, Kenny Macleod.
Anthony Wilkinson Gallery, London, UK
Sublimation. Klein Karoo National Arts Festival,
Oudtshoorn, South Africa
Metropolis. Navy Pier, Chicago Art Fair,
Chicago, USA
Total Überzogen. Edith-Russ-Haus für Medien-
kunst, Oldenburg, Germany
Solitudes. Galerie Michel Rein, Paris, France

2001

Tele[Visions]. Kunsthalle Wien, Vienna, Austria
Monets Vermächtnis. Serie: Ordnung und Obsession.
Hamburger Kunsthalle, Hamburg, Germany
*Looking At You: Kunst Provokation Unterhaltung
Video.* Kunthalle Fridericianum, Kassel, Germany
Tirana Biennale 1: Escape. Tirana Biennale 2001,
Tirana, Albania
World Wide Media Lounge. 19th World Wide Video
Festival, Amsterdam, The Netherlands
Su La Testa! Palazzo Delle Papesse, Siena, Italy
Sculpture Contemporaine. Collection Frac Rhône-
Alpes-Les Subsistances, Lyon, France
Electronic Maple. New York Center for Media Arts,
New York, USA
Post-Production. Galleria Continua,
San Gimigniano, Italy
18th Kassel Documentary, Film and Video Festival,
Kassel, Germany
Hallucinating Love Foundation. Aspreyjacques,
London, UK
My Generation. Atlantis Gallery, London, UK

En Avant. Galerie Grita Insam, Vienna, Austria
Prodigal Prodigy. White Box, New York, USA
Song Poems. Cohan Leslie & Browne,
New York, USA
Group Exhibition. Galerie Mezzanin, Vienna, Austria

2000

The Sky is the Limit! Taipei Biennale 2000,
Taipei, Taiwan
Man and Space. 2nd Kwangju Biennale Korea.
Kwangju Biennale Korea 2000, Kwangju, Korea
The Anagrammatical Body. ZKM – Zentrum für
Kunst und Medientechnologie, Karlsruhe, Germany
*The Wounded Diva: Hysteria, Body and Technique
in Twentieth Century Art.* Kunstverein München,
Munich, Germany
Das Lied von der Erde. Museum Fridericianum,
Kassel, Germany
Körper. Fotogalerie Wien, Vienna, Germany
Horizons. Galleri Roger Björkholmen, Stockholm,
Sweden
face-à-face. Kunstpanorama Luzern, Lucerne,
Switzerland
One-Night Stand. João Ferreira Gallery, Cape Town,
South Africa
Tomorrow. Rare Art Gallery, New York, USA
30th Anniversary Benefit. White Columns,
New York, USA
Translations. Bard Center for Curatorial Studies,
New York, USA
Day Against Racial Discrimination. Akademie Wien,
Vienna, Austria
One Film for One Screen. Cinéma Le Pestel,
Die, France

1999

The Passion and the Wave. 6th International
Istanbul Biennial, Istanbul, Turkey
The Anagrammatical Body. Kunsthaus Mürzzuschlag,
Mürzzuschlag, Austria

Global Art 2000. Museum Ludwig Köln, Cologne,
Germany

1998

Roteiros, Roteiros, Roteiros... 24th Bienal de
São Paulo, São Paulo, Brazil
Interferencias. Canal de Isabel II, Madrid, Spain
Transatlántico. CAAM – Centro Atlántico de Arte
Moderno, Las Palmas de Gran Canaria, Spain

1997

Permutations. Artist's Space, New York, USA
Heaven: A Private View. PS1 – MoMA, New York, USA
Graft. 2nd Johannesburg Biennale, Cape Town,
South Africa
Funny Pictures. Ten in One Gallery, Chicago, USA
Me. Clementine Gallery, New York, USA
June Show 1997. Silverstein Gallery, New York, USA
Tran<sonic. Espacio 204, Caracas, Venezuela

1996

Romper Room. Thread Waxing Space, New York, USA
*Inklusion/Exklusion: Kunst im Zeitalter von Post-
kolonialismus und globaler Migration.* Neue Galerie
Graz in Reininghaus, Graz, Austria
Interzones: A Work In Progress. Kunstforeningen,
Copenhagen, Denmark
Group Exhibition. The Space Gallery, Johannesburg,
South Africa

1995

*Black Looks, White Myths: Race, Power and
Representation.* Africus'95 Johannesburg Biennale,
Africana Museum, Johannesburg, South Africa
Taking Liberties: The Body Politic. 1st Johannes-
burg Biennale, Johannesburg, South Africa

Selección Bibliográfica/Selected Bibliography

Monografías/Monographs

Beccaria, Marcella (editor). *Candice Breitz.* Rivoli & Milan: Castello di Rivoli Museo d'Arte Contemporanea & Skira Editore S.p.A., 2005.

Cotter, Suzanne (editor). *Candice Breitz: Re-Animations.* Manchester & Oxford: Cornerhouse Publications & Modern Art Oxford, 2003.

Himmelsbach, Sabine & von Sydow, Paula (editors). *Candice Breitz: Mother.* Oldenburg & Frankfurt: Edith-Ruß-Haus für Medienkunst & Revolver Archiv für Aktuelle Kunst, 2005.

Kintisch, Christine (editor). *Candice Breitz: Working Class Hero.* Vienna: Bawag Foundation, 2006.

Lange, Christy (interview). *Candice Breitz.* Seoul: Kukje Gallery, 2006.

Neri, Louise (editor). *Candice Breitz.* London, Milan & New York: Jay Jopling/White Cube, Francesca Kaufmann & Sonnabend Gallery, 2005.

Plöchl, Renate & Sturm, Martin (editors). *Candice Breitz: Cuttings.* Linz: O.K Center for Contemporary Art Upper Austria, 2001.

Potamianou, Artemis (editor). *Candice Breitz.* Athens: Hellenic American Union, 2006.

Tannert, Christoph (editor). *Candice Breitz: ALIEN (Ten Songs from Beyond).* Essen: Museum Folkwang im RWE Turm, 2002.

Zaya, Octavio (editor). *Candice Breitz: Multiple Exposure.* Barcelona & León: ACTAR & MUSAC – Museo de Arte Contemporáneo de Castilla y León, 2007

Catálogos de Exposición y Publicaciones de Referencia/Exhibition Catalogues and Reference Publications

Atkinson, Brenda & Breitz, Candice (editors). *Grey Areas: Representation, Identity and Politics in Contemporary South African Art.* Johannesburg: Chalkham Hill Press, 1999.

Aupetitallot, Yves (editor). *Review: Vidéos & Films de la Collection Pierre Huber.* Grenoble & Zürich: Le Magasin – Centre National d'Art Contemporain & JRP|Ringier Kunstverlag AG, 2006.

—————. *Private View, 1980-2000.* Collection Pierre Huber. Lausanne & Zürich: Le Musée Cantonal des Beaux-Arts de Lausanne & JRP|Ringier Kunstverlag AG, 2005.

Basilico, Stefano (editor). *CUT: Film as Found Object in Contemporary Video.* Milwaukee: Milwaukee Art Museum, 2004.

Beccaria, Marcella & Gianelli, Ida. *Video Art: The Castello di Rivoli Collection.* Milan: Skira Editore S.p.A., 2005.

—————. *Castello di Rivoli Museum of Contemporary Art: The Castle – The Collection.* Turin: Umberto Allemandi & C. S.p.A., 2003.

Block, René & Heinrich, Barbara. *Looking At You: Kunst Provokation Unterhaltung Video.* Kassel: Kunsthalle Fridericianum, 2001.

Bourriaud, Nicolas. *Postproduction: Sampling, Programming, Displaying.* San Gimignano: Galleria Continua, 2003.

Breyer, Insa et al. *Moving On.* Berlin: NGBK – Neue Gesellschaft für Bildende Kunst, 2005.

Brown, Elizabeth. *WOW: The Work of the Work.* Seattle: Henry Art Gallery, 2004.

Burke, Gregory & Rees, Simon. *Extended Play: Art Remixing Music.* New Plymouth, New Zealand: Govett-Brewster Art Gallery, 2003.

Byrd, Cathy (editor). *Strange Planet.* Atlanta: Ernest G. Welch School of Art & Design Gallery – Georgia State University & Saltworks Gallery, 2004.

Colombo, Paolo et al. *6th International Istanbul Biennial: The Passion and the Wave: Book 2.* Istanbul: Istanbul Kültür ve Sanat Vakfi, 2000.

—————. *6th International Istanbul Biennial: The Passion and the Wave: Book 1.* Istanbul: Istanbul Kültür ve Sanat Vakfi, 1999.

Corral, María de et al. *51st Biennale di Venezia: The Experience of Art.* Venice: Marsilio Editori S.p.A., 2005.

De la Motte-Haber, Helga et al. *Sonambiente Berlin 2006: Klang Kunst Sound Art.* Heidelberg: Kehrer Verlag, 2006.

DeBord, Matthew & Enwezor, Okwui (editors). *Trade Routes: History and Geography. 2nd Johannesburg Biennale.* Johannesburg: Thorold's Africana Books, 1997.

Decter, Joshua et al. *Dark Places.* Los Angeles: SMMoA – Santa Monica Museum of Art, 2006.

——————. *Tele[Visions]. Kunst sieht Fern.* Vienna: Kunsthalle Wien, 2001.

Demeester, Anne et al. *W139 – Amsterdam. Report of an Ongoing Journey.* Amsterdam: W139, 2006.

——————. *Global Tour: Art, Travel & Beyond.* Amsterdam: W139, 2005.

Dezuanni, Rebecca et al. *Video Hits: Art & Music Video.* South Brisbane: Queensland Art Gallery, 2004.

Doswald, Christoph. *Double-Face: The Story About Fashion and Art. From Mohammed to Warhol.* St. Gallen & Zurich: Schnittpunkt – Kunst und Kleid St. Gallen & JRP|Ringier Kunstverlag AG, 2006.

Edlinger, Thomas & Fischer-Schreiber, Ingrid. *Open House. Art and the Public Sphere.* Linz: O.K Center for Contemporary Art Upper Austria, 2004.

Eiblmayr, Silvia et al. (editors). *Die verletzte Diva. Hysterie, Körper, Technik in der Kunst des 20. Jahrhunderts.* Cologne: Oktagon Verlag, 2000.

Falch, Frank et al. *Andre/Others.* Kristiansand: Sørlandets Kunstmuseum, 2005.

Ferreira, José (editor). *Sulsouth: Voyages into Mutant Technologies.* Johannesburg & Mozambique: 19th World Wide Video Festival, 2001.

Fichtner, Heidi et al. *The 8th Baltic Triennial of International Art: Centre of Attraction.* Vilnius: CAC – Contemporary Art Centre, 2002.

Fusi, Lorenzo et al. *Guardami. Percezione del Video.* Pistoia & Prato: Edizione Gli Ori, 2005.

Gisbourne, Mark et al. *Berlin Art Now.* London: Thames & Hudson, 2006.

——————. *Kunst Station Berlin.* Munich: Knesebeck Verlag, 2006.

Grant, Catherine et al. *Electronic Shadows: The Art of Tina Keane.* London: Black Dog Publishing, 2004.

Groetz, Thomas. *Galerie Max Hetzler: Berlin 1994-2003.* Berlin: Holzwarth Publications, 2003.

Grosenick, Uta. *ART NOW: The New Directory to 136 International Contemporary Artists.* Cologne: Taschen, 2005.

——————. & Riemschneider, Burkhard. *ART NOW: 137 Artists at the Rise of the New Millennium.* Cologne and Berlin: Taschen, 2002.

Hansen, Elisabeth Delin & Sheikh, Simon et al. *Circa Berlin.* Copenhagen: Nikolaj Copenhagen Contemporary Art Center, 2005.

Heinrich, Barbara. *Das Lied von der Erde.* Kassel: Kunsthalle Fridericianum, 2000.

Herkenhoff, Paulo & Pedrosa, Adriano (editors). *XXIV Bienal de São Paulo: "Roteiros."* São Paulo: Takano Editora Gráfica Ltda, 1998.

Holm, Michael Juul & Kold, Anders (editors). *Sip My Ocean: Video from the Louisiana Collection.* Humlebaek: Louisiana Museum of Modern Art, 2006.

Hsu, Manray & Sans, Jérôme. *The Sky is the Limit: 2000 Taipei Biennial.* Taipei: Taipei Fine Art Museum, 2000.

Hull, Steven. *Ab Ovo.* Los Angeles & Vicenza: Nothingmoments Publishing & Graphicom, 2005.

Kazuko, Koike et al. *Emotional Site.* Tokyo: Saga-cho Shokuryo Building, 2002.

Kotakemori, Yuka & Osaka, Eriko (editors). *Screen Memories.* Tokyo: Contemporary Art Center Art Tower Mito, 2002.

Le Bas, Clarisse. *Figures de l'acteur. Le Paradoxe du comédien. Collection Lambert en Avignon.* Paris: Éditions Gallimard, 2006.

Latour, Bruno & Weibel, Peter (editors). *Iconoclash: Beyond the Image Wars in Science, Religion, and Art.* Cambridge: MIT Press, 2002.

Martin, Sylvia. *Video Art.* Cologne: Taschen, 2006.

Marzo, Jorge Luis et al. *En el lado de la televisión.* Castellón de la Plana: EEAC – Espai d'Art Contemporani de Castelló, 2002.

Matt, Gerald. *Handlungsanweisungen.* Vienna: Kunsthalle Wien & Steidl Verlag, 2004.

————. & Mittersteiner, Sigrid (editors). *Superstars: Das Prinzip Prominenz von Warhol bis Madonna*. Ostfildern & Vienna: Hatje Cantz Verlag & Kunsthalle Wien, 2005.

Michelson, Anders & Zaya, Octavio (editors). *Interzones: A Work In Progress*. Copenhagen: Kunstforeningen, 1996.

Mosaka, Tumelo & Zaya, Octavio. *Black Looks, White Myths: Race, Power and Representation*. Johannesburg: Africus'95 Johannesburg Biennale, 1995.

MUSAC – Museo de Arte Contemporáneo de Castilla y León (editor). *MUSAC Collection. Vol I*. Barcelona & León: ACTAR & MUSAC – Museo de Arte Contemporáneo de Castilla y León, 2005.

Nakabayashi, Kazuo (editor). *A Perspective on Contemporary Art: Continuity and Transgression*. Osaka & Tokyo: The National Museum of Art & The National Museum of Modern Art, 2002.

Nohlström, Åsa & Von Hausswolff, Carl Michael. *Welcome to Reality – Against All Evens. 2nd International Biennial for Contemporary Art in Göteborg*. Göteborg: Hasselblad Center, 2003.

Pace, Linda et al. *Dreaming Red: Creating ArtPace*. San Antonio: Artpace Foundation for Contemporary Art, 2003.

Perryer, Sophie. *10 Years 100 Artists: Art in a Democratic South Africa*. Cape Town: Bell-Roberts Publishing & Struik Publishers, 2004.

Fokidis, Marina et. al. *Tirana Biennale 1: Escape*. Milan: Giancarlo Politi Editori s.r.l., 2001.

Ramljak, Suzanne et al. *Wonder Women: Idols in Contemporary Art*. New York: Katonah Museum of Art, 2006.

Ratzeburg, Wiebke et al. *Aufruhr der Gefühle: Leidenschaften in der zeitgenössischen Fotografie und Videokunst*. Braunschweig: Museum für Photographie Braunschweig, 2004.

Rollig, Stella et al. *Open House. Art and the Public Sphere*. Linz: O.K Center for Contemporary Art Upper Austria, 2004.

Savvidis, Christos et al. *Any Place Any: Art, Immigration, Utopia*. Thessaloniki: Macedonian Museum of Contemporary Art, 2004.

Scheps, Marc et al. *Kunstwelten im Dialog: Von Gauguin zur globalen Gegenwart*. Cologne: Museum Ludwig Köln, 2000.

Schneede, Uwe et al. *Monets Vermächtnis. Serie: Ordnung und Obsession*. Ostfildern: Hamburger Kunsthalle & Hatje Cantz Verlag, 2001.

Schmahmann, Brenda. *Through the Looking Glass: Representations of Self by South African Women Artists*. Johannesburg: David Krut Publishing, 2004.

Seifermann, Ellen. *fuckin' trendy. Mode in der zeitgenössischen Kunst*. Nürnberg: Kunsthalle Nürnberg, 2003.

Stange, Raimar. *Zurück in die Kunst*. Hamburg: Rogner & Bernhard bei Zweitausendeins, 2003.

Sung-Kwan, Cho et al. *Man and Space. 2nd Kwangju Biennale Korea*. Kwangju: Kwangju Biennale, 2000.

Takeshita, Miyako & Torii, Izumi. *Emotional Site*. Tokyo: Saga-cho Shokuryo Building, 2003.

Tegelaers, Theo et al. *Prodigal Prodigy*. New York: White Box, 2001.

Van den Berg, Clive et al. *Klein Karoo National Arts Festival 2002*. Oudtshoorn: Klein Karoo Arts Festival, 2002.

Wallis, Simon et al. *Remix: Contemporary Art and Pop*. Liverpool: Tate Publishing, 2002.

Weibel, Peter (editor). *Inklusion/Exklusion: Kunst im Zeitalter von Postkolonialismus und globaler Migration*. Cologne: DuMont, 1997.

Wendl, Tobias et al. *Africa Screams: Das Böse in Kino, Kunst und Kult*. Wuppertal: Peter Hammer Verlag, 2004.

Wigram, Max et al. *Brightness: Works from the Thyssen-Bornemisza Contemporary Art Foundation*. Dubrovnik: Museum of Modern Art Dubrovnik, 2003.

Zaya, Octavio. (editor). *Interferencias*. Madrid: Tabapress, 1998.

Artículos y Reseñas/Articles and Reviews

Antmen, Ahu & Kortun, Vasif. "The Istanbul Fall: A Journey Through a Sensitive Megapolis." *Flash Art International,* no 209. Milan: November-December 1999; pp. 84-87.

Althen, Michael. "Ich bin deine Erfindung." *Frankfurter Allgemeine Zeitung*. Frankfurt: 13 October 2005.

Altstatt, Rosanne. "*Killing Me Softly... An Interview with Candice Breitz.*" Kunst-Bulletin, no 6. Zürich: June 2001; pp. 30-37.

Aschenbrenner, Jenny. "Sluta gapa och svälja." *Piteå-Tidningen.* Stockholm: 15 October 2004.

Atkinson, Brenda. "Rethinking Pornography: Imaging Desire (Candice Breitz interviewed by Brenda Atkinson)." *Camera Austria,* no 56. Graz: 1996; pp. 6-8.

Auer, James. "Milwaukee Art Museum Recasts its Contemporary Collection." *Milwaukee Journal Sentinel.* Milwaukee: 22 February 2004.

—————. "Visuals Overtake Traditional Art Forms at INOVA." *Milwaukee Journal Sentinel.* Milwaukee: 27 November 2002.

Axel, Brian Keith. "Disembodiment and the Total Body: A Response to Enwezor on Contemporary South African Representation." *Third Text,* no 44. London: Autumn 1998; pp. 3-16.

Baer-Bogenschütz, Dorothee. "Barcelona: Copyright-Debatte bei der Film-Messe Loop." *Kunstzeitung,* no 120. Regensburg: Verlag Lindinger + Schmid, August 2006; p. 5.

Bester, Rory. "Candice Breitz at White Cube, London." *Art South Africa,* volume 4 issue 2. Cape Town: Brendon Bell-Roberts, Summer 2005; pp. 77-78.

Bettens, Walter. "Get up, Stand up: The Making of *Legend (A Portrait of Bob Marley)."* *DAMn° Magazine,* issue 5. Brussels: February-March 2006; pp. 142-145.

Bruhns, Annette. "Die Meisterin des Loops." *KulturSPIEGEL,* issue 11. Hamburg: November 2005; pp. 26-32.

Buhr, Elke. "Candice sucht den Superstar." *Art: Das Kunstmagazin,* no 10/06. Hamburg: Gruner + Jahr AG & Co KG, October 2006; pp. 70-75.

Büsing, Nicole & Klaas, Heiko. "Wiederholungszwang." *Kieler Nachrichten.* Kiel: 27 September 2001.

Bussel, David. "Candice Breitz." *i-D Magazine,* no 227. London: January 2003; p. 171.

Büthe, Joachim. "Kunstwelten im Dialog? Von Gauguin bis zur globalen Gegenwart." *Neue Bildende Kunst,* no 7. Berlin: December 1999; p. 36.

Cartier, Stephan. "Der Rhythmus der neuen Zeit geht in Serie." *Weser-Kurier.* Munich: 28 September 2001.

Chambers, Nicholas. "Candice Breitz: Mother + Father. Interview with Nicholas Chambers." *Artlines,* no 2/2005. South Brisbane: Queensland Art Gallery, 2005; pp. 12-15.

Cherubini, Laura. "Tre star brillano nel cielo di Candice Breitz." *il Giornale.* Milan: 22 October 2001.

Cincinelli, Saretto. "Post Production: Galleria Continua, San Gimignano." *Flash Art Italia,* no 229. Milan: August-September 2001; p. 204.

Corbetta, Caroline. "Candice Breitz: Francesca Kaufmann." *Flash Art Italia,* no 221. Milan: April-May 2000; p. 110.

Cotter, Holland. "Cinema à la Warhol, With Cowboys, Stillness and Glamour." *New York Times.* New York: 5 April 2002.

Crompton, Sarah. "Why Women Slipped out of the Frame." *The Daily Telegraph.* London: 29 June 2005.

Darwent, Charles. "Shot by Both Sides." *The Independent on Sunday.* London: 11 September 2005.

Diez, Renato. "Art Basel: Una festa per l'arte." *Arte,* no 373. Milan: September 2004; p. 73.

Dorment, Richard. "Screaming and Singing." *The Daily Telegraph.* London: 6 September 2005.

—————. "The Star Pavilions." *The Daily Telegraph.* London: 15 June 2005.

Dziewior, Yilmaz. "Candice Breitz: Galerie Johnen & Schöttle." *Artforum,* xxxvii no 7. New York: March 1999; p. 123.

Enwezor, Okwui. "Reframing the Black Subject: Ideology and Fantasy in Contemporary South African Representation." *Third Text,* no 40. London: Autumn 1997; pp. 21-40.

—————. & Zaya, Octavio. "Moving In: Eight Contemporary African Artists." *Flash Art International,* no 186. Milan: January-February 1996; pp. 84-89.

Falconer, Morgan. "Hallucinating Love. Aspreyjacques." *Time Out. What's On In London.* London: 18-25 July 2001.

Fichtner, Heidi. "Global Art: Das Lied von der Erde." *Nu: The Nordic Art Review,* volume II no 6. Stockholm: November-December 2000; p. 10.

García, Cathy Rose. "Artist Shows How Stars Influence Fans." *The Korea Times.* Seoul: 23-24 September 2006.

Gardner, Belinda Grace. "Kein Heuhaufen fällt zweimal in denselben Fluß." *Frankfurter Allgemeine Zeitung.* Frankfurt: 24 October 2001.

—————. "Ins Museum, der Fernseher wegen." *Die Welt.* Berlin: 19 May 2002.

Geldard, Rebecca. "Candice Breitz. Aspreyjacques." *Time Out. What's On In London.* London: 19-26 March 2003.

Gispert, Luis et al. "The Artists' Artists." *Artforum,* vliv no 4. New York: December 2005; p. 107.

Gohlke, Gerrit. "Schutz und Trutz, Stirn und Hand: Über Alien – eine Videoinstallation von Candice Breitz." *BE Magazin,* no 9. Berlin: Künstlerhaus Bethanien, 2003; pp. 116-122.

Graham-Dixon, Andrew. "Implosion of the body-snatched." *The Sunday Telegraph.* London: 11 September 2005.

Grosse, Julia. "Sing, und du wirst integriert." *Die Tageszeitung.* Berlin: 8 November 2002.

Grumberg, Amiel. "Art et Tourisme: le Guide du Rout'Art." *Beaux Arts Magazine,* no 242. Paris: July 2004; pp. 66-75.

Güner, Fisun. "Art Spoken from a Soapbox. Candice Breitz: *Diorama.*" *Metro.* London: 28 February 2003.

—————. "Candice Breitz." *Metro.* London: 12 September 2005.

Gupta, Anjali. "The Conversation: A Discussion with ArtPace's Candice Breitz." *San Antonio Current.* San Antonio: 21-27 February 2002; p. 15.

Haines, Bruce. "Candice Breitz: Re-Animations/Jim Lambie: Male Stripper." *Contemporary,* issue 57. London: November-December 2003; p. 71.

Herzog, Samuel. "Hätte man das Goldene Horn doch bloss ausfliessen lassen." *Basler Zeitung.* Basel: 21 September 1999.

—————. "Istanbul Sechste Internationale Biennale." *Kunst-Bulletin,* no 11. Zurich: November 1999.

Higgie, Jennifer. "Istanbul Biennial." *Frieze,* issue 50. London: January-February 2000; pp. 92-93.

Himmelsbach, Sabine. "Body Check. Konstruktionen des Körpers." *Ethik und Unterricht,* issue 2/2001. Nordhorn: Erhard Friedrich Verlag, 2001; pp. 12-19.

Höbel, Wolfgang. "Casanovas, Freaks und Patrioten." *Der Spiegel Online.* Hamburg: 5 September 2005.

Hoffmann, Justin. "Inklusion: Exklusion." *Kunstforum,* no 136. Linz: February-May 1996; pp. 350-353.

Hofmann, Isabelle. "Serientäter unter sich." *Kunstzeitung,* no 64. Regensburg: Verlag Lindinger + Schmid, December 2001; p. 9.

—————. "Vom Gesetz der Serie: Die Hamburger Kunsthalle präsentiert eine große internationale Ausstellung." *Hannoversche Allgemeine Zeitung.* Hannover: 26 November 2001.

Hunt, David. "Candice Breitz: Fighting Words." *Flash Art International,* no 211. Milan: March-April 2000; p. 85.

—————. "Sixth International Istanbul Biennial." *Art & Text,* no 68. Sidney: February-April 2000; p. 94.

Jahn, Wolf. "Flimmern in der Höhle: Videokunst in der Galerie der Gegenwart." *Hamburger Abendblatt.* Hamburg: 13 April 2002.

Johnson, Ken. "Girls on Film." *New York Times.* New York: 26 August 2005.

—————. "Tomorrow." *New York Times.* New York: 14 July 2000.

—————. "West Side: The Armory Show on the Piers Just Keeps Growing." *New York Times.* New York: 23 February 2001.

Jones, Alice. "My family and other actors." *The Independent.* London: 5 September 2005.

Kandel, Susan. "Feminine Perspective." *Los Angeles Times.* Los Angeles: 18 April 1997.

Kedves, Jan. "Interview: Candice Breitz." *Zoo Magazine,* no 12. Berlin: October 2006; pp. 138-145.

Keller, Claudia. "Idylle mit Leichen." *Der Tagesspiegel.* Berlin: 23 August 2000.

Kibanda, Nadine. "Out of Africa: La Storia Oltre Le Frontiere." *Flash Art Italia.* Milan: February-March 2000; p. 78.

Kent, Sarah. "Screen Idols." *Time Out. What's On In London.* London: 21-28 September 2005; p. 57.

Kojima, Yayoi. "People: Candice Breitz." *Esquire Magazine,* volume 17 issue 1. Tokyo: January 2003; p. 47.

Knöfel, Ulrike. "Kunst kommt von Zappen." *Der Spiegel,* no 33. Hamburg: 13 August 2001. p. 167.

Korotkin, Joyce. "Candice Breitz: Sonnabend Gallery, New York." *Tema Celeste,* no 103. Milan: May-June 2004; p. 93.

Kravagna, Christian. "Mr. Livingstone, I presume..." *Springerin,* volume iii no 2/97. Vienna: Springer-Verlag KG, 1997; pp. 39-43.

Kröner, Magdalena. "Candice Breitz: Schreien, Stottern, Singen: Das Playback des Ich: Ein Gespräch mit Magdalena Kröner." *Kunstforum,* no 168. Linz: January-February 2004; pp. 276-283.

Krumpl, Doris. "Sanfter Tod mit Liebesliedern: Candice Breitz mit Cuttings im Linzer O.K Centrum für Gegenwartskunst." *Der Standard.* Vienna: 4 July 2001.

Lange, Christy. "Crazy for You: Candice Breitz on Pop Idols & Portraiture." *Modern Painters.* London: September 2005; pp. 68-73.

Law, Jennifer. "Ghost Stories: Democracy, Duplicity and Virtuality in the Work of Candice Breitz." *Frauen Kunst Wissenschaft,* issue 29. Hamburg: June 2000; pp. 45-59.

Liebs, Holger. "Wenn der Skorpion auf die Grille trifft." *Süddeutsche Zeitung.* Munich: 12 November 1998.

Louis, Eleonora. "Candice Breitz: Cuttings." *Springerin,* volume vii no 3/01. Vienna: June-August 2001; p. 68.

MacAlister, Katherine. "Chewing up pop culture." *The Oxford Mail.* Oxford: 12 September 2003.

Marchart, Oliver. "Geschüttelt, nicht gerührt." *Falter Verlag.* Vienna: 3 October 1996.

Mayer, Gabriele. "Frauen brauchen schußsichere Kleider: In der Nürnberger Kunsthalle treffen sich Kunst und Mode." *Frankfurter Allgemeine Zeitung.* Frankfurt: 14 January 2004.

Menin, Samuela and Sansone, Valentina. "Focus Video and Film. Contemporary Video Art Today (Part I)." *Flash Art International,* no 228. Milan: January-February 2003; p. 89.

Mullins, Charlotte. "Sigmar Polke and Candice Breitz: Taking Pot Shots at a Media-Saturated World." *The Financial Times.* London: 1 October 2003.

Murray, Soraya. "Africaine: Candice Breitz, Wangechi Mutu, Tracey Rose, Fatimah Tuggar." *Nka Journal of Contemporary African Art,* no 16/17. Ithaca: Cornell University, Fall/Winter 2002; p. 88.

Nemeczek, Alfred. "Regie führt das Leben." *Art: Das Kunstmagazin,* no 9/00. Hamburg: Gruner + Jahr AG & Co KG, September 2000; pp. 40-50.

Nilsson, John Peter. "Få vågar så." *Aftonbladet.* Stockholm: 25 May 2003.

Nochlin, Linda. "Venice Biennale: What Befits a Woman?" *Art in America,* no 8. New York: September 2005; pp. 120-125.

Noè, Paola. "Candice Breitz: Galleria Francesca Kaufmann." *Tema Celeste,* no 78. Milan: March-April 2000; p. 106.

Nord, Cristina. "Zu viele Männer." *Die Tageszeitung.* Berlin: 8 September 2005.

O'Toole, Sean. "A Star Astride the World Stage." *Business Day.* Johannesburg: 1 September 2006.

——————. "SA's Loss Becomes a Global Gain." *Business Day.* Johannesburg: 5 March 2004.

Orrghen, Anna. "Breitz ställer masskulturen i konstens tjänst." *Svenska Dagbladet.* Stockholm: 9 October 2004.

Peacocke, Helen. "Art: Candice Breitz and Jim Lambie: Modern Art Oxford." *The Oxford Times.* Oxford: 19 September 2003.

——————. "Stars and stripes of art gallery's season: Candice Breitz and Jim Lambie at Modern Art Oxford." *The Oxford Times.* Oxford: 12 September 2003.

Perra, Daniele. "Candice Breitz: Castello di Rivoli Museo d'Arte Contemporanea." *Tema Celeste,* no 109. Milan: May-June 2005; p. 89.

Phillips, Christopher. "Report from Istanbul: Band of Outsiders." *Art in America,* no 8. New York: April 2000; pp. 70-3, 75.

Piccoli, Cloe. "People: Candice Breitz." *Carnet Arte.* Milan: June-July 2004; p. 68.

Pollack, Barbara. "Africa's Avant-Garde – The Newest Avant-Garde." *ARTnews.* New York: April 2001; pp. 124-129.

Powell, Ivor. "Watch This Artist." *The Weekly Mail and Guardian.* Johannesburg: 18-24 March 1994.

Preuss, Sebastian. "Viel Heu, wenig Mitte." *Berliner Zeitung.* Berlin: 9 January 2002.

Rappolt, Mark. "Lucky Star: Candice Breitz."
i-D Magazine, volume II/XVI no 266. London:
May 2006; pp. 118-121.

Ratnam, Niru. "Up Front On The Verge: Candice
Breitz." *OM: Observer Magazine.* London:
24 August 2003; p. 15.

Richter, Peter. "Wann platzt die Blase?" *Monopol,*
no 4/05. Berlin: Juno Kunstverlag GmbH, August-
September 2005; p. 20.

Robecchi, Michele. "Candice Breitz: Francesca
Kaufmann." *Flash Art Italia,* no. 231. Milan:
December-January 2001-2002; p. 93.

——————. "Candice Breitz." *Contemporary,*
issue 76. London: Autumn 2005; pp. 34-37.

Ross, Christine. "The Temporalities of Video:
Extendedness Revisited." *Art Journal,* volume 65
no 3. New York: Fall 2006; pp. 83-99.

Schaufelberger, Peter. "Babylonische Sprachverwir-
rung: Video-Installation von Candice Breitz in St.
Gallen." *Südkurier.* St. Gallen: 12 May 2001.

——————. "Mit Haut und Haar: Striptease, vom
Verschleiern und Enthüllen – eine Austellung im
Kunstmuseum St. Gallen." *Südkurier.* St. Gallen:
14 June 2003.

Schellen, Petra. "Obsessionen... Zählen, bis man
von der Zeit eingesogen wird: Serien Ausstellung in
der Kunsthalle." *Die Tageszeitung.* Berlin:
25 October 2001.

Schlüter, Ralf. "Monets Vermächtnis: Im Rausch
der Wiederholung." *Art: Das Kunstmagazin,*
no 12/01. Hamburg: Gruner + Jahr AG & Co KG,
December 2001.

Schmitz, Edgar. "Candice Breitz: Re-Animations."
Kunstforum, no 167. December 2003; pp. 346-348.

Schoch, Ursula Badrutt. "Augentauchen: Das
Kunstmuseum St. Gallen enthüllt in einem künst-
lerischen Striptease sein Können."
St. Galler Tagblatt. St. Gallen: 2 May 2001.

——————. "Kakofonie im Weltdorf: Candice
Breitz im Kunstverein im Katharinen in St. Gallen."
St. Galler Tagblatt. St. Gallen: 29 March 2003.

——————. "Kunst und Kleid eröffnet." *St. Galler
Tagblatt.* St. Gallen: 2 September 2006.

Smith, Roberta. "A Medium in the Making: Slicing
Familiar Films Into Something New." *New York Times.*
New York: 29 July 2005.

Sonna, Birgit. "Cindy Shermans kleine Schwestern."
Süddeutsche Zeitung. Munich: 26 August 1998.

——————. "Namen sind nur Schall und Rauch."
Süddeutsche Zeitung. Munich: 31 March 1999.

Spiegler, Marc. "Candice Breitz: Max Hetzler,
Berlin." *ARTnews.* New York: March 2004; p. 140.

——————. "The Venice Effect." *The Art Newspaper.*
London: 15 June 2005; pp. 1, 10.

Stange, Raimar. "Candice Breitz im Museum Folk-
wang." *Kunst-Bulletin,* no 11. Zürich: November 2002;
p. 46.

——————. "Candice Breitz in der Galerie Hetzler:
Monitor mit Nabelschnur." *Der Tagesspiegel.* Berlin:
4 October 2003.

——————. "Candice Breitz: Galerie Max Hetzler."
Flash Art International, no 233. Milan: November-
December 2003; p. 104.

——————. "Candice Breitz: Mediale Aliens."
u_Spot, no 0/03. Berlin: Kolbe + Fricke Gbr, 2003;
p. 13.

——————. "Pop Goes Politics: Art, Music, Politics."
Flash Art Italia, no 244. Milan: February-March 2004;
pp. 124-126.

——————. "Raimar Stange über Candice Breitz."
Artist Kunstmagazin, no 54. Bremen: Banane Design
GmbH, 2003; p. 24.

Sumiyoshi, Chie. "Mito: Candice Breitz." *Brutus,*
volume 5 issue 1. Tokyo: 2002; p. 155.

Sumpter, Helen. "Candice Breitz: Re-Animations.
This is not a Love Song." *The Big Issue.* London:
29 September 2003.

Tatot, Claude-Hubert. "Parole et parole et parole...
Candice Breitz: *Babel Series.*" *Papiers Libres Art
Contemporain,* no 21. Geneva: July 2000; pp. 27-28.

Van Teeseling, Steven. "Worsteling met de echte
wereld." *De Groene Amsterdammer.* Amsterdam:
1 July 2005.

Vetrocq, Marcia. "Venice Biennale: Be Careful
What You Wish For." *Art in America,* no 8.
New York: September 2005; p. 113.

Vogel, Matthias. "Mythos Cyborg: Der Maschinen-
mensch als Thema der Gegenwartskunst." *Neue
Zürcher Zeitung.* Zurich: 13 March 2003.

Volk, Gregory. "Candice Breitz at Sonnabend." *Art in America* no 11. New York: December 2005; p. 136.

Wainwright, Jean. "Candice Breitz: Modern Art Oxford." *Art Monthly,* no 271. London: November 2003; pp. 18-19.

——————. "Can we talk about contemporary video and film art in terms of genres?" *PLUK,* no 2. London: September-October 2001; pp. 28-41.

Weil, Rex. "Candice Breitz: De Appel, Amsterdam." *ARTnews.* New York: Summer 2002; p. 184.

Wendland, Johannes et al. "Neue Heimat: Warum ausländische Künstler in Berlin leben." *Zitty,* issue 8/04. Berlin: 1-14 March 2004; p. 23.

Werneburg, Brigitte. "Reigen der Affekte: Aufruhr der Gefühle." *Die Tageszeitung.* Berlin: 20 August 2004.

Weskott, Hanne. "Schlagerkitsch und meditative Landschaften." *Süddeutsche Zeitung.* Munich: 11 October 2000.

Whetstone, David. "Stairwell with a Lennon touch." *The Journal.* Newcastle: 10 October 2006.

Whitfield, Sarah. "Exhibition Reviews: Candice Breitz at White Cube." *The Burlington Magazine,* volume cxlvii no 1232. London: November 2005; pp. 766-767.

Wilsher, Mark. "Candice Breitz: *Diorama.* Asprey-jacques." *Time Out. What's On In London.* London: 19-26 March 2003; p. 24.

Wittneven, Katrin. "Utopia: Candice Breitz über die Zukunft der Sprache." *Monopol,* no 6. Berlin: December-January 2005; pp. 101-103.

Wright, Annabel. "Challenging Meaning in Contemporary Art." *The Daily Yomiuri.* Tokyo: 14 November 2002.

Wulffen, Thomas. "51. Biennale Venedig. Nach dem Rundgang: Notizen zu Künstlern." *Kunstforum International,* no 177. September-October 2005, pp. 95, 276.

Zaya, Octavio. "Global Art: Candice Breitz." *Flash Art International,* no 191. Milan: November-December 1996; p. 97.

——————. "Reflections on Candice Breitz's *Rorschach Series.*" *TRANS.* New York: Winter 1998; pp. 62-67.

Zolghadr, Tirdad et al. "Venice Biennale 2005." *Frieze,* issue 93. London: September 2005; p. 101.